Art Therapy with Offenders

of related interest

Art Therapy in Practice
Edited by Marian Liebmann
ISBN 1 85302 057 5 hb
ISBN 1 85302 058 3 pb

Art Therapy and Dramatherapy
Masks of the Soul
Sue Jennings and Åse Minde
ISBN 1 85302 027 3 hb
ISBN 1 85302 181 4 pb

Group Work with Children and Adolescents
A Handbook
Edited by Kedar Nath Dwivedi
Foreword by Dr Robin Skynner
ISBN 1 85302 157 1

Handbook of Inquiry in the Arts Therapies
One River, Many Currents
Edited by Helen Payne
Foreword by John Rowan
ISBN 1 85302 153 9

What Do You See?
Phenomenology of Therapeutic Art Experience
Mala Betensky
Foreword by Judith A. Rubin
ISBN 1 85302 261 6

A Multi-Modal Approach to Creative Art Therapy
Edited by Arthur Robbins
ISBN 1 85302 262 4

Art Therapy with Offenders

Edited by Marian Liebmann

Foreword by Judge Stephen Tumim

Jessica Kingsley Publishers
London and Bristol, Pennsylvania

First published in the United Kingdom in 1994 by
Jessica Kingsley Publishers Ltd
116 Pentonville Road
London N1 9JB, England
and
1900 Frost Road, Suite 101
Bristol, PA 19007, U S A

Library of Congress Cataloging in Publication Data
Art therapy with offenders / edited by Marian Liebmann.
p. cm.
Includes bibliographical references (p.320) and index
ISBN 1-85302-171-7 (PB)
1. Arts in prisons Great Britain. 2. Art therapy--Great Britain.
I. Liebmann, Marian, 1942-
HV8883.A77 1994
365'.66--dc20

British Library Cataloguing in Publication Data
Art Therapy with Offenders
I. Liebmann, Marian
364.3

ISBN 1 85302 171 7

Printed and Bound in Great Britain by
Biddles Ltd., Guildford and King's Lynn

Contents

List of Illustrations

Acknowledgements

I would like to acknowledge the help and support of colleagues in Avon Probation Service, especially John Anthony, Chief Probation Officer, and Pip Clements, for their encouragement and constructive comments.

I would like to pay tribute to all the contributors for their hard work, to their employers for their far-sightedness, and to all the prisoners and clients who have been brave enough to let us use their work.

Finally, special thanks go to my husband, Mike Coldham, my daughter Anna, and my colleagues at MEDIATION UK, for their boundless patience and practical support.

Marian Liebmann
October 1993

Foreword

If the Prison Service is to fulfil its stated duty 'to help prisoners lead law-abiding and useful lives in custody and after release', this book must be one of the more important guides on how to achieve it. There is only a very modest literature on the practice of art therapy in our institutions, although the pioneer work of Edward Adamson is well recorded in *Art as Healing*.

Art Therapy with Offenders gets down to the specific. Contributors are chosen to cover a wide range, from long term high security prisoners, through young offenders and women prisoners to vulnerable prisoners, some of the mentally disordered, and those on probation. The illustrations actually illustrate.

In Marian Liebmann's introduction, she sets out most clearly (at pages 9 and 10) some of the benefits of art therapy. It is interesting to turn to a lifer, as described by Colin Riches. The paintings of his cell are cool and precisely drawn. 'My life', says the prisoner (in fact, only too truthfully if I have identified him correctly) 'has been a mess, so I like my pictures to be tidy'.

The making of art in prison provides an 'enabling space' for the prisoner overwhelmed by the clatter and disruption of prison life. I see the provision of some sort of art centre as an essential component of a proper regime. To anyone who attended the performance of musicals in the London prisons over the last two years, it is clear that the therapy has extended beyond its obvious aims. It opens a prospect of useful work for those who can take part in it, one way or another, and it opens the possibility of a more creative life for many after release.

'Prison art' seems to me a misleading phrase. There is no artistic style common to prisoners, and to them alone. But art therapy with offenders seems both necessary and desirable at this stage of regime development, and each chapter in this book provides fresh ideas for it.

His Honour Judge Stephen Tumim
HM Chief Inspector of Prisons
February 1994

Introduction

Marian Liebmann

The writing and compiling of this book arose out of my own experience of doing art therapy with offenders. I felt a sense of isolation, of doing something strange that was regarded by others in the criminal justice system as rather marginal and not very important. On the rare occasions when I met others engaged in similar work, they had similar stories to tell.

Yet the potential of art therapy, based on the results of existing work, is enormous. At a time of increasing concern over rising crime and the search for ways of redirecting offenders, it seems vital to look properly at what art therapy has to offer.

The literature on art therapy with offenders is sparse, to say the least. Joyce Laing (1984) contributed a chapter on art therapy in prisons to the first British art therapy book, *Art as Therapy* (Dalley 1984). She and Christopher Carrell completed a more comprehensive book (Carrell and Laing 1982) on their work in the Special Unit, Barlinnie Prison, where Jimmy Boyle discovered his talents as a sculptor – which changed his life.

I contributed examples of my work at a day centre for ex-offenders to Tessa Dalley's book (Liebmann 1984) and also to *Art Therapy for Groups* (Liebmann 1986). These were concerned with using art therapy with offenders in a group setting. In *Art Therapy in Practice* (Liebmann 1990) I wrote a chapter on individual work with offenders on probation, using art therapy to look at their offending behaviour. More recently I have been consulted by and exchanged information with a mature student surveying existing art therapy work and literature concerning offenders (Maddock 1993).

As far as I know, there is little American literature either. A recent book by Harriet Wadeson (1989) includes a chapter on 'Making Art in a Jail Setting' by Day and Onorato, who refer to earlier work by Levy (1978) and Rylander (1979). Two articles describe art therapy work to raise self-esteem,

one with juvenile delinquents (Larose 1987), the other with an incarcerated paedophile (Ackerman 1992). An article by Connie Naitove (1987) charts the history of arts therapy approaches to work with child molesters.

There are also a few reports on arts activities in prisons, some of which may overlap into art therapy. The work of Anne Peaker and Jill Vincent (1989, 1990) and Colin Riches (1990, 1991) will be described later in this introduction.

Given the paucity of literature and isolation of the few art therapists known to be working in the field, I was not sure if there was enough experience to fill a book. The number, range and depth of the contributions to this volume is proof that there is. There are also several others who are not represented here, but who are also doing valuable ground-breaking work in this area.

Theory and practice with offenders

It is worth looking at some of the changes in theory and practice with offenders over the years. The way offenders have been viewed has influenced the sentences and treatments made available, and this has affected the provision of art therapy.

The Victorian system of criminal justice was based on legal justice, retribution ('just deserts') and deterrence. The economic *laissez-faire* climate emphasised the responsibility of the individual. All were equal before the law, and could therefore expect equal punishment if they transgressed. The main penalty, after the decline of transportation, was imprisonment (Garland 1985).

Changes towards reformation and rehabilitation were initiated by Acts of Parliament in 1907, 1908 and 1914. These established the Probation Service (which evolved from the Court Missionaries started in 1876), Juvenile Courts, Borstal Training and a range of new penal institutions which, while acknowledging their punitive aspects, also tried to introduce reformative and educative elements.

The use of probation also introduced the idea of alternatives to prison for 'low-tariff' offenders (i.e., first or second-time offenders), so that prisons came to hold a larger proportion of recidivists. The new sanctions were tailored to the types of characters and their problems, rather than the gravity of the offences, so that treatment was no longer uniform. Deterrence and retribution were still goals, but criminals were presented as individuals to be pitied, cared for and, if possible, reclaimed (Garland 1985). Reform was the central aim.

One consequence of this shift was the enhanced role of experts in psychology, psychiatry and social work, concerning the most appropriate sentence – and the diminished role of the responsibility of the individual. On the positive side, this led to a greater humanity towards poor people and social misfits; on the other hand it sometimes led to a patronising attitude or to long sentences for trivial crimes 'to achieve personal reform'.

The debate continues as to whether the law or the human sciences should decide issues of personal behaviour which is in transgression of society's norms. The decision whether someone is 'sad, mad or bad' is a complex one, but important as it suggests the flavour of the remedy. The 'sad' label seems to indicate practical help to remedy poor circumstances, while 'mad' suggests the need for psychiatric treatment. The 'bad' may be seen as having no excuse, and therefore deserving punishment and prison.

In practice, until recently, the criminal justice system has operated with a 'legal justice' base, with reformative additions. Probation officers dealt mostly with minor or first-time offenders, and their role was to 'advise, assist and befriend' them. Those who did not respond soon found themselves on the road to prison. Custodial institutions for young offenders still tried to provide education as an integral part of their regime, but adult prisons were plainly punitive. Since the 1980s, developments have provided a major shift which has affected work in prisons and probation rather differently. I will look at each separately.

Recent developments in prisons

There has been increasing disillusionment with prison as a means of reforming people. The shortened form of the Prison Service's Statement of Intent, which greets all inmates and visitors, says:

> Her Majesty's Prison Service serves the public by keeping in custody those committed by the courts. Our duty is to look after them with humanity and to help them lead law-abiding and useful lives in custody and after release.

However, it is well known that most ex-prisoners reoffend quite soon after leaving prison, and even the Government White Paper *Crime, Justice and Protecting the Public* (Home Office 1990a) says 'Prison can be an expensive way of making bad people worse'.

For some years there had been concern about the overcrowding and poor conditions in prisons, and the prison riots in six custodial establishments in England in April 1990 showed that something urgently needed to be done. The Woolf Inquiry was set up under Lord Justice Woolf and Judge Stephen

Tumim (Chief Inspector of Prisons), and resulted in the Woolf Report, published in 1991.

The Report made several recommendations concerning the material side of prison life, but also made comments about the regime. It pointed out the special care needed for prisoners suffering from mental health problems or disabilities (an increasing number, following the closure of many hospitals) and suggested that at least some of them could be diverted from prison if suitable community facilities were available. The Report also emphasised the importance of rehabilitation and of using time constructively to avoid future offending – a view which was also endorsed by inmates and prison officers. 'The argument in favour of extending educational opportunities as far as resources will allow is overwhelming' (Paragraph 14.101).

The Woolf Report was followed up by the Government document *Custody, Care and Justice* (Home Office 1991), which also responded to the worrying increase in prison suicides by suggesting a variety of sources of help for those in despair. For the general prison population, it recommended programmes which '…challenge sentenced prisoners about their criminal behaviour – so that they leave prison better adjusted, less likely to be bitter about their experiences, and more likely to lead constructive and law-abiding lives' (Section 7.2).

While the reality is always less than the rhetoric, especially in times of financial constraint, the Home Office has initiated some programmes for sex offenders and those convicted of violent crimes. There is a recognition that, if some people have to be in prison, they should be enabled to attend activities likely to reduce reoffending on their release.

Recent developments in probation

In the time of the Court Missionaries and the early days of the Probation Service, the main arguments used to save offenders from their 'just deserts' were moral and religious ones, such as mercy in return for the promise to reform (McWilliams 1986, 1987). From the 1930s to the 1960s the 'diagnostic ideal' held sway, in which moral arguments were replaced by psychosocial explanations from experts. Psychoanalysis was the predominant theory used, and helping probation clients became 'case work'. This work was seen as diagnosis followed by treatment, with clients seen as having psychosocial problems, the solution of which would prevent them committing further crimes.

The late 1960s and 1970s saw the demise of treatment, when the belief that penal treatments could cure offending was officially abandoned (McWilliams 1987). Several pieces of research failed to find any demonstrable

improvement, and this was summed up in the 'Nothing works' philosophy (Martinson 1974).

The Probation Service had doubled in size during the 1960s (Harding 1987) and had taken on a greater diversity of work, including more prison after-care and community service orders. This led to the need for a more managerial approach concentrating on policy for service delivery of the increasing variety of kinds of work. While some concentrated on this, others looked to radical social work (seeing clients as politically oppressed) or continued to offer individual help, but in a more pragmatic way. There was also a concerted effort to offer probation supervision to 'higher tariff' clients in an effort to keep them out of custody.

Despite the view that 'nothing works', some newer and better pieces of research showed that some programmes did work, and helped to prevent reoffending. These included several different kinds of work with different groups of offenders (McGuire and Priestley 1985, *What Works* Conference 1991).

There was also a new interest in offence-based work, partly because this had never been rigorously tried before (McGuire and Priestley 1985). A new awareness and concern for victims of crime demonstrated the harm being caused by offending and the need to tackle offending more directly.

Meanwhile, the Government was preparing new initiatives designed to reduce the prison population, for reasons of cost (the number of new prisons needed continued to increase), as well as ineffectiveness. To avoid accusations of being 'soft', the ethos of punishment was to be moved to the community. The Green Paper *Punishment, Custody and the Community* (Home Office 1988) outlined the Government's ideas, and the White Paper *Crime, Justice and Protecting the Public* (Home Office 1990a) laid the foundations for the Criminal Justice Act 1991. A further Green Paper *Supervision and Punishment in the Community: A Framework for Action* (Home Office 1990b) discussed probation more in terms of punishment and control than help, and this was seen as a step backwards by most probation officers, as was the suggestion that they become managers of programmes to be carried out by the voluntary sector.

National Standards for the Supervision of Offenders in the Community followed in 1992. It includes the wording of the Criminal Justice Act 1991 concerning the statutory purpose of supervision under a probation order:

- to secure the rehabilitation of the offender
- to protect the public from harm from the offender; and/or
- to prevent the offender from committing further offences

Thus there is still a recognition of preventative and rehabilitative work – however, there are so many other requirements concerning reporting, breach proceedings and statistics that many probation officers no longer have time for in-depth client work.

Psychiatric secure units

In the 1950s, with the advent of new drugs and an emphasis on rehabilitation, psychiatric hospital wards began to open their doors. One consequence of this was that those patients who needed a more secure environment could no longer be accommodated in ordinary hospitals (Gordon 1985).

Several reports (the Emery Report in 1961, the Glancy Report in 1973 and the Butler Report in 1974) pointed to the urgent need for secure units for difficult and violent psychiatric patients. There was a gap between the Special Hospitals (Ashworth, Broadmoor and Rampton) and ordinary psychiatric hospitals, especially for offenders whose crimes (usually serious) were linked to mental illness, and who required treatment beyond the scope of other institutions.

The Regional Secure Units were set up by Regional Health Authorities in the 1980s, and there are now approximately 600 places in 21 regional units. The accent is on therapy and a gradual move towards discharge into the community. The Adolescent Forensic Mental Health Service was set up with a similar philosophy, for young offenders needing separate provision from adult patients.

Arts activities in prison and probation

There has been a long tradition of arts activities in prisons, mainly through education classes, but also through individual activity by inmates in their cells. The Koestler Awards and the Burnbake Trust have encouraged prison artists in their creativity. More recently there have been artists' residencies, exhibitions, performances of plays and operas, and workshop events in prisons.

However, there was no systematic information available on these arts activities in prisons, and this led to a research project (funded jointly by the Arts Council and the Home Office) undertaken by Anne Peaker and Jill Vincent of Loughborough University. They produced *Arts Activities in Prisons* (1989), a directory of prison activities in visual arts and crafts, literature, film, drama, dance and music. This was followed by *Arts in Prisons: towards a sense of achievement* (1990), which gives an account of their research and their

findings and makes recommendations for making arts activities available in a more coherent way.

Peaker and Vincent outline the personal and therapeutic benefits of arts activities: fostering creativity, encouraging choices and decisions, increasing self-respect and self-esteem, developing self-awareness and understanding, channelling emotions in a constructive way, expressing feelings, concentrating and making an effort. These can all counteract the apathy and conformity of prison life. There are also social and group benefits which spring from the personal ones.

Other national events continued this work. Colin Riches organised a conference on *The Visual Arts in Prisons*, attended by 140 delegates, in April 1990, and produced a report in September 1990 (Riches 1990). This was followed a year later by a symposium which put forward suggestions to the Prison Department for the development of the visual arts in prisons. Riches also completed his M.A. thesis (1991) *There is Still Life* on his work setting up an Art and Craft Centre in a maximum security prison, and a report on art in American prisons (1992).

The Government document *Custody, Care and Justice* (1991), already mentioned, stated:

> There should be opportunities to develop artistic and other skills so as to give prisoners a sense of personal achievement and self respect.

The Home Office itself set up an Arts in Prisons Working Party to look at the whole issue. It started meeting in 1992, with several sub-groups looking at different aspects. The 1992 Lilian Baylis Lecture by Vivien Stern also looked at the contribution of the arts in captivity.

Arts activities in probation have had a much lower profile. On the whole they have not played much part in ordinary probation supervision, which has concentrated on individual work. Most day centres (now called Probation Centres) have used arts activities, usually visual arts, often drama and occasionally music. These activities have usually been seen as opportunities for probation clients to discover new and constructive hobbies, rather than for any specifically therapeutic benefits.

There are some very exciting programmes, such as the Cave Arts Centre in Birmingham (specialising in music), the Insight Arts Trust in London (involving probation clients in drama), the Geese Theatre Company (performing plays and running workshops, centred on offending behaviour), Theatre in Prisons and Probation in Manchester (promoting theatre/drama work within the criminal justice system) and the Artist Residency Scheme in Northumbria (researching the effects of five artists placed in day centres,

including writing, ceramics, photography and music/composition). How-
ever, there is as yet no systematic directory of these comparable to the one
for prisons.

Art therapy in prisons and probation

The list of personal benefits of arts activities given above has already given
an indication of the overlap between arts activities and arts therapies.

The main difference between arts activities and arts therapies is the
difference in purpose. As a general 'rule of thumb', most arts activities have
as their main expressed aim an external product, such as a mural, concert,
play or mask. In the process of accomplishing this there may be great benefits
to the participants, often an increased sense of self-worth and ability to
communicate.

Arts therapies tend to look more explicitly at the personal processes
involved, and have this as their aim. The finished product is secondary,
although there are many art therapy sessions where participants are rightly
proud of what they have produced. Because the processes are personal ones,
there is no external judgement or standard.

It may be useful to think of a continuum, with arts activities concentrating
on very external products at one end, and very personal arts therapies at the
other end. In between there will be arts activities which shade into therapy,
and it is not always easy to separate the two.

There used to be a feeling that prisons were not appropriate places to
introduce any kind of therapy, because the whole atmosphere and regime
works against the self-disclosure involved, and there is little therapeutic
back-up. The traditional lack of communication between different disci-
plines in prison also impedes a coherent therapeutic approach. This is still
the case in many prisons. However, the fact that several art therapists have
been successful in establishing art therapy suggests that it can be a valuable
service, despite the acknowledged difficulties. There is also some limited
provision of other therapies in a few prisons.

Most art therapists in prisons work through the education department,
although one (Eileen McCourt) works through the probation department,
and the art therapy provision at Holloway Prison (Pip Cronin) is in the form
of an independent project. The Arts in Prisons Working Party has an Arts
Therapies sub-group which is looking at the most appropriate way in which
art therapy can be made available in prisons. This working party has led to
a collaborative research project (1993–6) between the University of Hert-
fordshire's School of Art and Design, Grendon Prison and the Prison Service

into the effectiveness of art therapy in countering offending for prisoners serving long sentences.

In psychiatric secure units, it seems more 'normal' to establish art therapy because there is already an assumption that treatment is what is needed.

In probation day centres, art therapy has been established either because the arts worker happened to be a qualified art therapist and the other staff saw the relevance, or because the centre decided to look for an art therapist to fill the arts post. The same may be true of sessional work in hostels for offenders.

Benefits of using art therapy

It is worth summarising the benefits of art therapy. Of course, not all the benefits listed will apply to each person or group. There may also be groups or situations where art therapy is not helpful.

One definition of therapy is a process of engendering favourable change which outlasts the session itself. Applying this definition, art therapy may then be described as the use of art in the service of change on the part of the person who created the artwork.

Some of the benefits of using art therapy are:

1. It can be used as a means of non-verbal communication. This can be important for those who do not have a good mastery of verbal communication, or for those who are 'over-verbal'.

2. Pictures can act as a bridge between art therapist and client, especially where the subject matter is too embarrassing to talk about, or has negative connotations for the client. In a psychotherapeutic setting, the picture may be where the transference takes place.

3. It can be used as a means of self-expression and self-exploration, especially for experiences which are 'hard to put into words'.

4. It can sometimes help people to release feelings such as anger and aggression, and can provide a safe and acceptable way of dealing with unacceptable emotions.

5. The concreteness of the products makes it easier to develop discussion from them. It is also possible to look back over a series of sessions and note developments.

6. Active participation is required, and this can help to mobilise people.

7. It can be enjoyable and lead to the development of a sense of creativity. It can be an opportunity for adults to be allowed to play.

Themes addressed by the contributors

The first six contributors all work in ordinary prisons, the first four with 'normal' offenders (Julie Murphy, Eileen McCourt, Celia Baillie, Colin Riches), the other two with 'vulnerable' prisoners (Pip Cronin, Shân Edwards). Two work in regional secure psychiatric units, one with adults (Barbara Karban), one with young people (Lynn Aulich). Two contributions look at work with adolescent sex offenders (Lynn Aulich, Maralynn Hagood), using very different approaches, and the latter uses material from the US. The last two contributions are concerned with art therapy outside custodial settings, one at a probation day training centre (Barry Mackie), and one using art therapy in the course of normal probation work (Marian Liebmann).

All those writing about prisons give graphic descriptions of prison life: the anonymity, the alienation, the regimentation, the infantilisation, the drab sterile environment, the dragging of time. Although I might have removed some of these accounts, to avoid repetition, they form integral components of the contributors' chapters, and each one highlights prison problems slightly differently.

Most of those working in prisons, especially the high security ones holding long-term prisoners, comment on the way in which art therapy can help counteract the apathy and alienation experienced. Art therapy is seen primarily in terms of helping inmates through their sentences, although some may gain further insights which may stand them in good stead on their release.

Those working in psychiatric institutions and those working in probation focus far more on offenders' behaviour, thoughts and feelings which have brought them to offend, in the hope that something can be done to make offending less likely in the future.

The contributors use a wide variety of theories and approaches, from psychodynamic to cognitive/behavioural. Jung, Simon and Winnicott are just a few of the names which have influenced working models and theories. Some have emphasised the interaction between the offender and the art therapist while others concentrate on the artwork produced in a therapeutic setting and the creativity of the individual. One contributor writes from the perspective of a fine artist, looking at the overlap between art and art therapy.

Most contributions are concerned with groups – sometimes for financial reasons, sometimes for social reasons. Within these groups, individual work and progress is described. Some contributions also include specific art

therapy work with individuals, and most of these quote the client's own words as a commentary.

The art therapists find themselves in very different situations. Often they are very isolated in their work, as the only person in their sphere, and have to obtain support from art therapists elsewhere. A few are part of a therapeutic team, such as those working in psychiatric settings and the probation day centre. Most of them comment on the relationships with other staff in their institutions, and how they work with them.

It can be seen from the list of contributors that most of the art therapists involved are women. It is well known that most prisons are for male offenders. Even in mixed settings, male offenders predominate. Many issues arise for women art therapists working in male prisons, and several contributors discuss these.

Just because the criminal justice system is predominantly male, it is easy to overlook the needs of women. We have made an effort to ensure that some work with women has been included.

Race issues have not been discussed by the art therapists in this volume to any great extent, although several of the participants in art therapy have been black, and this has been acknowledged.

Obtaining illustrations has been a problem for some art therapists. Prisoners often have so little that they want to keep a tight hold on the few things they possess, and some are not prepared to let their creations out of their sight. This means that some chapters have several illustrations while some have none at all.

Considerable care has been taken to ensure that all the inmates and clients whose work is described and shown have given their permission. However, there are a very few instances where this intention was frustrated by a sudden, unexpected move of an inmate to another prison; these cases have been more heavily disguised to preserve anonymity. All names have been changed, unless there was a request from the inmate or client not to do this. The institutions too have been formally approached for their consent to the writing and publishing of this material. None refused, and this gives cause for optimism about the progress towards a more open outlook than may have been true in the past.

This collection demonstrates a high standard of work and commitment by art therapists to working with many damaged and dangerous individuals who reside in our institutions for offenders. It is difficult work, but extremely worthwhile if it can contribute to a reduction of offending in the long term.

References

Ackerman, J. (1992) 'Art therapy intervention designed to increase self-esteem of an incarcerated paedophile', *The American Journal of Art Therapy, 30.*

Carrell, C. and Laing, J. (1982) *The Special Unit, Barlinnie Prison: Its Evolution through its Art.* Glasgow: Third Eye Centre.

Dalley, T. (ed)(1984) *Art as Therapy.* London: Tavistock Publications.

Day, E.S. and Onorato, G.T. (1989) 'Making Art in a Jail Setting' in H. Wadeson, J. Durkin, and D. Perach, (eds) *Advances in Art Therapy.* New York: John Wiley.

Garland, D. (1985) *Punishment and Welfare – a History of Penal Strategies.* Aldershot: Gower.

Gordon, D. (1985) *Forensic Service in the North West Thames Region.* Information leaflet from North West Thames Regional Secure Unit, Ealing, London.

Harding, J. (ed)(1987) *Probation and the Community.* London: Tavistock Publications.

Home Office (1988) *Punishment, Custody and the Community.* Cm 424. London: HMSO.

Home Office (1990a) *Crime, Justice and Protecting the Public.* Cm 965. London: HMSO.

Home Office (1990b) *Supervision and Punishment in the Community: A Framework for Action.* Cm 966. London: HMSO.

Home Office (1991) *Custody, Care and Justice.* Cm 1647. London: HMSO.

Home Office (1992) *National Standards of the Supervision of Offenders in the Community.* London: HMSO.

Laing, J. (1984) 'Art therapy in prisons' in T. Dalley (ed) *Art as Therapy.* London: Tavistock Publications.

Larose, M.E. (1987) 'The use of art therapy with juvenile delinquents to enhance self-esteem'. *Art Therapy,* 4(3), 99–104.

Levy, B. (1978) 'Art therapy in a women's correctional facility'. *The Arts in Psychotherapy,* 5, 157–166.

Liebmann, M. (1984) 'Art games and group structures' in Dalley, T.(ed) *Art as Therapy.* London: Tavistock Publications.

Liebmann, M. (1986) *Art Therapy for Groups.* London: Croom Helm. (Now published by Routledge).

Liebmann, M. (1990) '"It Just Happened": Looking at Crime Events' in M. Liebmann (ed) *Art Therapy in Practice.* London: Jessica Kingsley Publishers.

McWilliams, W. (1986) 'The English Probation System and the Diagnostic Ideal'. *The Howard Journal of Criminal Justice, 25(4),* 241–260.

McWilliams, W. (1987) 'Probation, Pragmatism and Policy'. *The Howard Journal of Criminal Justice, 26(2),* 97–121.

McGuire, J. and Priestley, P. (1985) *Offending Behaviour.* London: Batsford.

Maddock, D. (1993) *Art Therapy with Offenders.* Unpublished MA dissertation. School of Social Work, University of East Anglia, Norwich.

Martinson, R. (1974) 'What works? – questions and answers about prison reform. *The Public Interest, 10,* 22–54.

Naitove, C.E. (1987) 'Arts therapy with child molesters: an historical perspective on the act and an approach to treatment'. *The Arts in Psychotherapy, 15,* 151–160.

Peaker, A. and Vincent, J. (1989) *Arts Activities in Prisons.* Loughborough: Centre for Research in Social Policy.

Peaker, A. and Vincent, J. (1990) *Arts in Prisons: towards a sense of achievement.* London: Home Office.

Riches, C. (ed)(1990) *The Visual Arts in Prisons.* Conference Proceedings. London: Royal College of Art.

Riches, C. (1991) *There is Still Life, a Study of Art in a Prison.* Unpublished MA thesis. London: Royal College of Art.

Riches, C. (1992) *Art in American Prisons.* Report presented to the Winston Churchill Trust.

Rylander, B. (1979) *Art therapy with prisoners in solitary confinement.* Proceedings of the Tenth Annual Conference of the American Art Therapy Association. Washington, DC: AATA.

Stern, V. (1992) *Creativity in Captivity,* a Lilian Baylis Lecture. London: NACRO.

Wadeson, H., Durkin, J. and Perach, D. (eds)(1989) *Advances in Art Therapy.* New York: John Wiley.

What Works (1991) *Conference Proceedings.* Manchester: Greater Manchester Probation Service.

Woolf Report (1991) 'Prison Disturbances April 1990, Report of an Inquiry' by the Rt Hon Lord Justice Woolf and His Honour Judge Stephen Tumim. Cm 1456. London: HMSO.

'Mists in the Darkness'
Art Therapy with Long-Term Prisoners in a High Security Prison – A Therapeutic Paradox

Julie Murphy

Paradox (n) a person or thing that is made up of contradictory elements.

The purpose of this chapter is to explore whether it is possible to work with a process which has growth and change as its aims, inside a system which depends on containment and conformity for its existence.

> The prison is a place of rampant paradox: simultaneously a place of emotional intensity and of utter stultification. An informational void filled with rumour. It is about as hard a reality as you could get, yet nowhere also could fantasies grow so fast and thick. It is a place where anger grows steadily like a fire set to last all night, yet at the same time, so well hidden as to be almost always inaccessible, exists a great tenderness. (Page 1992, 48)

Kathy Page wrote this about her time working as writer in residence at HMP Nottingham, but it seemed to sum up for me many of the ambiguous feelings that are part of working in the prison in which I am employed as part-time art therapist (HMP Perth). I suspect these feelings would resonate with many employed within such institutions, particularly those employed as therapists of various kinds dealing with thoughts, feelings and emotions. The very words of therapy – 'holding', 'containing', 'inside/outside', 'boundaries' – resonate with new and different meanings in this context, and the therapist must struggle to make sense of his or her own feelings about a strange, alien environment.

> An environment which has as its reason for existence in the fact that one group of people deprives another group of people of their liberty is in essence unnatural and liable to be subject to considerable tension. (Coyle 1991, 258)

There is much talk of change in the Scottish Prison Service at present. Documents are published which talk of giving people opportunities for self-development, of treating people with respect and maintaining human dignity. Recently a conference held at HMP Perth discussed the concept of the 'Responsible Prisoner', and acknowledged that the way society has treated its imprisoned population has been inhuman and degrading.

HMP Perth is a high security jail, and the fortress-like walls and razor wire leave one in little doubt that security is the main priority, although in fact few prisoners actually want to escape: being on the run is not freedom. There are many forward-thinking and motivated people now working within the Scottish Prison Service, and many prison officers who are hoping to be more than 'turn-keys'. However, change is frustratingly slow and there are still many of the 'old school' in the system. One group of people locking up another group must always be an abnormal situation because of the power invested in the holder of the key.

So what can art therapy offer to a person serving a very long sentence, whose future may be so far in the distance as to be meaningless, whose past undoubtedly contains devastating events, and whose present reality is the bleakness and boredom of jail life? Sometimes it seems that the barriers, as much mental as physical, are too strong to break. At other times, it has been important simply being there, being honest and trying to do my job as well as I can. I am aware that something is happening which is hard to define – and even harder to evaluate.

The work is not always about producing 'art' or images, but is something to do with living creatively and being able to respond positively to a difficult situation. My background and training shapes my view of the world and my responses to people, and 'being' an art therapist gives me a particular outlook, with an emphasis on the importance of the senses, emotions, thoughts and feelings. This in itself may be helpful in giving people an alternative perspective on their own experience.

In this chapter I refer a great deal to the work of D. W. Winnicott (1896–1971), a child psychoanalyst whose model of the parent/child relationship makes sense in the context in which I am working. This model suggests a view of the prisoner as someone who is made relatively powerless or 'infantilised' by circumstances, and who must depend on the institution to provide shelter and nourishment.

Nourishment is not simply about providing enough food. What is needed for healthy emotional growth is an environment which can tolerate the successes and failures of experimentation, but which is ultimately reliable. Winnicott (1981) describes this as the 'holding environment' or the 'facilitating environment', in which the person has the freedom for creative growth through play, but at the same time is safe in the knowledge of the care and protection of the parent. The space within which this happens is known as the 'potential space'. Winnicott states that the parent does not have to be (and cannot be) perfect, but simply 'good enough' to allow the child to develop a sense of true self in relation to those around it.

The prison, on the other hand, is a harsh environment in which things are done to people, and it is hard to find either physical or mental space in which to develop or grow. My aim in this chapter is to explore the potential for art therapy as a facilitating and empowering means of expression which may allow people to respond creatively to their situation and to recognise and develop their own strengths.

Rehabilitation: myth or paradox?

So why are people locked up? This is not the place to enter into a philosophical treatise on the concept of crime and punishment; however, it is necessary to look at what is generally believed to be the aims of imprisonment, and how this may differ from what actually happens. There still exists within society a hazy view that prisons exist to rehabilitate people in the sense of 'making people better', but it has become clear that it is not possible to force people to change.

The concept of rehabilitation has been linked with conformity and good behaviour, but how a person behaves in prison may bear no relation at all as to whether he may re-offend, or indeed what feelings he may have about his offence, for this is a matter very personal and private to many men. Therefore the 'treatment' model of the first half of the century was replaced by the 'justice' model, which was simply and more honestly based on what society might deem a just retribution for a crime committed. This leads to the idea of prison as punishment in terms of loss of liberty. Despite what certain newspapers might say, no prison is a holiday camp, and however well-appointed the surroundings might be, the deprivation of liberty is the genuine pain of imprisonment.

In a statement of the task of the Scottish Prison Service, the following points are included:

> To provide for prisoners as full a life as is consistent with the facts of custody, in particular, making available the physical necessities of life; care for physical and mental health, advice and help with personal problems.
>
> To promote and preserve the self respect of prisoners.
>
> To enable prisoners to retain links with family and community.
>
> To encourage them to respond and contribute positively to society on discharge.

In the document *Opportunity and Responsibility*, published by the Scottish Prison Service in May 1990, there is stress on the importance of opportunities for personal development. Within these aims, there would seem to be a place for 'therapy' as a tool for finding the potential for human growth and change from within. However, there is still some confusion between the aims of the prison and those of the prisoner, who needs to find a way to preserve his self respect and identity.

Sometimes this struggle for self-determination may bring a prisoner into conflict with the prison authorities. For instance, I may be referred people because they are finding it difficult to 'settle into their sentence'. This difficulty appears to me a healthy response to the prospect of being deprived of liberty for an indeterminate time (in the case of life sentence prisoners), whereas over-conformity may lead to institutionalisation and an inability to function in society on release. Above all, the prisoner has an overwhelming desire to leave prison at least the same person as he was when he entered the jail (Bettelheim 1960).

To enter the prison, you must pass through an airlock where every gate locks solidly behind you, cameras follow your route through the yard, and you have to wait until someone else decides to open a door before you can go through. It can feel very claustrophobic and sometimes unnaturally silent for a place housing 400 men and approximately 150 staff at any one time. There is a sense of being watched from many windows and many cameras.

It is an institution which 'holds' people, but unlike Winnicott's 'holding environment', it does not provide the potential space necessary for growth and development. Rather this is replaced by a sort of vacuum, a negative space in which growth is severely curbed. Although things may gradually, too slowly, be changing, the prison takes away self-determination and creates people who are infantilised by their lack of power over their own lives. The prison feeds, clothes and contains people, but is not a 'good enough' parent – like a mother who could slide three meals a day through the bars of her infant's cot to keep it alive, but not emotionally nourished. The prison does

not provide emotional nurture, and this makes creative living almost impossible.

Winnicott separates the idea of creation from works of art, saying that creation can be a painting, a garden or simply a child playing. What he felt was important was living creatively (Winnicott 1971).

So how does the prison as 'parent' differ from the healthy relationship between caregiver and receiver? The difference seems to lie in the nature of the power relationship. The good enough mother provides the conditions for the child to develop his/her own sense of self through creativity and play and enables self-discovery. By contrast, the prison does things to people, often without explanation, and they have no sense of being part of the decision-making process.

This sense of powerlessness is illustrated vividly by an image created by Angus, a highly intelligent young man in the early stages of a life sentence. He often felt himself to be wrongly perceived by those around him, although he had the insight to realise that this happened because of the persona he presents. He could appear as aggressive and confrontational to staff, which

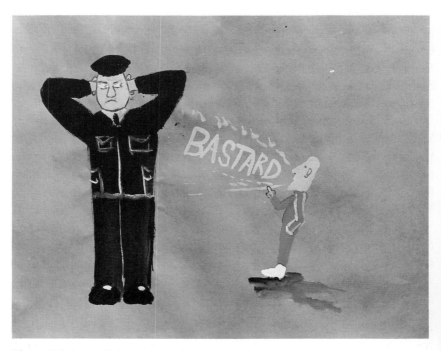

Figure 1.1 Angus: Prison communication

led to situations in which he was misunderstood as people reacted to the superficial 'don't care' attitude he tended to show.

Physically tall, he depicted the prisoner in his image as tiny, yelling out his frustration at a huge prison officer, symbolic of a system which will not or cannot listen to what he needs to say. Unfortunately this leads to a wider gulf, as prison officers (often powerless to help) respond by reinforcing their own shell to withstand the fear of verbal or physical aggression. The paradox is that, in having to shout all the louder, there is a danger of not being heard at all.

The aims of art therapy

Patsy Nowell-Hall has pointed out the paradox of trying to write about art therapy as, by its nature, 'Much of its essential healing power lies beyond words – experiencing is perhaps the best way of understanding' (Nowell-Hall 1987, 157).

I will describe the setting I work in, with particular reference to the experience of running an art therapy group for long-term prisoners. I still work with some of these men, so will not discuss any cases in detail, except those where I have special permission from the men concerned. Certain issues recur which are common to the experience of long-term prisoners, and these are worth stating as they help others understand their pains and problems. However, I am aware (and it is often pointed out to me) that nobody can really understand what it feels like to be locked up unless they have experienced it.

That the post exists at all reflects the present governor's concerns to address these issues. Originally the post was set up in February 1991 after consultations between Tayside Regional Council, the prison social work team and prison management, as part of an initiative to work with sex offenders. This remains an important part of the job, but after many offenders against children were re-located in the specialist units at HMP Peterhead, it became possible to expand the parameters of the post to include other groups of prisoners. As HMP Perth is a high security prison, there are many men serving very long or life sentences. The sheer length of time involved produces particular problems and needs, and art therapy and creativity are appropriate means to address or acknowledge at least some of them.

Some of the issues are obvious. The most important one for all the men was contact with family, or rather lack of it, as imprisonment makes it very hard to hold family relationships together. Visits are often stressful, especially the anticipation, the difficulty of saying what needs to be said in a short time, and the pain of seeing people leave. Other issues include coping with

a long time in prison and the difficulties of day-to-day existence. Trust and confidentiality are issues that arise time and time again, linked with the fundamental issue of power and powerlessness in an institution where personal information about somebody gives power or control over them – most obviously between staff and prisoners, but also between prisoners themselves.

Prisoners are in prison for committing an offence, and how they deal with their offence is a major issue. It is important not to lose sight of the victim, or victims, and men differ in their response to this. Some see themselves as the victims – of circumstance, of society, of environment and so on. Within the political context of poverty and unemployment, there is some truth in this, but people must nevertheless take responsibility for their actions. The aim of therapy is to help people do this, and it can be painful for prisoners to accept the damage they have caused to individuals and their families.

The art therapy room is situated in the surgery building. It is the old kitchen, and although rather small, does contain a sink and two large windows. Unfortunately the recent construction of the new education block about three feet away from these windows has diminished their effectiveness! The room is a bit cramped for group work, as it is hard for people to find a private place to work, but works well for individual work, being equipped with two large tables, a couple of easels and two easy chairs situated in the coffee-making corner. There is a kettle and a tape player, as music often seems to be a good way of shutting out the ever present 'jail sounds' of shouts, workmen, stamping feet and false riot alarms.

My aim in the layout of the room is to provide a 'place apart' from the rest of the jail, and a space that people can use as they want. There are art materials readily available, pictures on the wall, and collections of objects, stones, shells, boxes, cards and various odds and ends. Despite warnings (from the prisoners themselves) that things would be stolen, very little has disappeared.

HMP Perth is a Victorian, castellated edifice, a listed building and a paradox in itself. The walls on the outside are being stone-cleaned and there are flower beds (with regimented ranks of flowers), but inside the halls is everything one imagines about jails or sees in films: rows of doors on metal landings, greeny-grey institutional paint, sounds of doors slamming, keys jangling, ritual staccato chants of 'Sheds!' 'Check Up!' (the shorthand of jail talk seems not to include verbs), the unmistakable jail smell – disinfectant and yesterday's offering from the kitchens.

However, despite the antiquated facilities, it is often described as a better place to 'do time' than some of the more modern jails, as the way people are treated is more important than integral sanitation and modern surroundings. I try to counteract the sensory deprivation by creating a place which has colour, good sounds, things to touch and explore, the smells of oil paint, turps and clay, and good quality coffee and biscuits. I recognise my own needs in trying to fill this sensory vacuum, and at times saw myself as the mother bird trying to feed the insatiable hunger of its young. Now I can stand back and smile at the impossibility of this task, but there was a danger of becoming too involved, possibly resulting in burn-out, which would not be helpful to anyone. Instead I attempt to 'provide the protective conditions to let things happen' (Champernowne 1969), and this includes protecting myself.

The confidentiality and trust needed for art therapy can never be taken for granted in the prison and is very easily shaken. An article in the *News of the World* (21st June 1992) magazine entitled 'Rogues Gallery', which claimed to tell from their art what goes on in murderers' minds, caused a great deal of consternation and is still creating ripples of anxiety in a world where anything that might represent 'mind-games' is rightly viewed with deep suspicion.

People use the space in various ways. There are those who come looking for a 'skive' or the coffee, but when they see that therapy is hard work, often do not come back. Some people make artwork in the session, some bring drawings or paintings they have made in their cell, sometimes no actual images are produced at all – but that is also all right. It feels good not having the pressure of the teacher to produce results. Martina Thomson, in her book *On Art and Therapy* (1990), writes: 'There is never nothing happening'.

I used to be concerned that things did not seem to happen quite as it said in the books, and when I began working one day a week in a psychiatric hospital, I was amazed how people made images and talked openly about them. Perhaps this reflects the difference between those who perceive themselves as patients with the expectation of 'healing', and those who have only one thing in common – that they do not want to be there. In retrospect, it was helpful to work in the prison first as I had no set expectations of what should happen, or what such an institution would be like. This meant I was open (and still am) to learning about and adapting my work to an environment which highlights human pain and despair. It is necessary to keep reminding myself of this – it would be too easy to get used to the place. I am often asked, 'Do you like working there?', and it is a hard question to answer: maybe another paradox? I believe passionately in my job, but have

to hate what imprisonment and the penal system can do to people's lives – not just the prisoner, who must take the consequences of his actions, but also his family and children, who have done nothing wrong.

Between a parent and a child there must be a space which can provide the conditions for creative growth. Winnicott calls this the 'potential space', which is concerned with an individual's experience of living rather than just existing. It is a space which is neither 'inside' in the world of dream or fantasy, nor 'outside' in the world of shared reality, rather it exists as a paradox, neither inside nor outside. Inside the harsh boundaries of the prison walls, a place that may feel not quite 'Inside', even though it cannot be 'Outside', is important.

Herbie is a young man serving an eight-year sentence for serious assault, a drug addict who has spent much of his youth in jail. He is now keen to try and make sense of his chaotic life, and the confusing and disturbing thoughts and feelings that surround him. Verbally he can describe these feelings vividly, and he has some insight into the reasons for the events which resulted in his prison sentence. However, I find even listening to him exhausting, because the feelings seem too intense. He had spent several months in solitary confinement, and when I first met him, he seemed to laugh at the slightest provocation, resulting in the staff labelling him as a 'daft lad'. The laughter, however, was a defence, a way of dealing with the difficulty of coming out of solitary confinement and meeting people again.

He said he had never done any art, so in the first session I invited him to experiment with paint on wet paper, and he soon became absorbed in the way the colours mixed and spread out into the wetness. He seemed to get real pleasure out of having actually created something, and we talked about the fact that it was unique and unrepeatable: 'I did that!'. He also linked the random lines and shapes in the image to the way his thoughts and feelings were mixed up and difficult to untangle. He described a deep feeling of anger which would sometimes lead him to hit the sides of his cell, and which in the past had resulted in him lashing out at staff. Beyond his anger, he recognised unresolved feelings from his past of sorrow, emptiness and loss.

As Herbie explored the art materials with delight, he was experiencing 'play', in the sense that Winnicott described it as living creatively, in which play is a serious matter and necessary for healthy existence.

> Psychotherapy is done in the overlap of the two play areas, that of the patient and that of the therapist. The corollary of this is that where playing is not possible then the work done by the therapist is directed towards bringing the patient from a state of not being able to play into a state of being able to play. (Winnicott 1971, 63)

The art therapy group

Beyond the common factors of a serious offence and a long sentence, there is not necessarily any relationship between prisoners, and they would not necessarily associate outside the jail. Inside prison, real friendship is rare, rumours abound, and a complex and powerful network exists which dictates who is OK and who isn't, so that sides or 'camps' are often the only means of feeling part of a group. This makes it very difficult to choose a group for therapeutic work (in which trust may grow), because no worker will know the underlying story between one 'con' and another. The group which I set up was formed with the help of referrals from a psychologist who had worked with the men and knew them quite well. The aims of the group were discussed as being:

1. To build up trust and, in time, to share thoughts and feelings about present and past experiences.

2. To use art work as a means for communication which does not depend on being verbally articulate.

3. To use the art room as a safe and confidential space in which nobody is judged, assessed or criticised.

4. To help people develop a sense of their own creativity, and therefore enable a positive outlet for energy, anger or frustration.

5. Enjoyment and fun.

These lofty aims were summed up rather more succinctly by Jim, who later wrote:

> I came along to the group to get away from all the shit and hopefully succeed in finding out what I am about as a person, with a bunch of other people that want to come and relax, open up a little, express in words and paintings what's inside our heads and hearts.

It didn't always work out like that – the timing of the group on a Wednesday afternoon sometimes clashed with prison officers' union meetings, and the men would arrive late and 'pissed off'. Sometimes the group felt chaotic and volatile and seemed impossible to contain, but despite this it also sometimes felt 'together', with a strong sense of people wanting to work together, open up and share. I was often surprised how much people would expose the softer and more vulnerable side of themselves, in talking about problems and feelings. 'If we cons can't help each other, it's a sad sad situation – we are all in the same boat away from our loved ones.'

The group was structured roughly in three stages, beginning by coming together to check out how people were feeling, letting off steam if necessary, or having a general discussion. Then there was a longer period making images, and finally a time to share, and to talk about the paintings if they wanted. Sometimes I suggested a theme, which often emerged from the discussion, but most often the sessions were fairly open and non-directive, with a loose theme or suggestion floating around if requested. I did experiment with some loosening-up art games in the interests of 'fun', but these risked being compared to 'play school', and not in keeping with the macho con image.

On the first day I came into the group, I asked Jim to put the kettle on, which he did, then said, 'You'd better check it – I haven't done that for 13 years!' It was said in a half-joking way, but it brought home to me the strangeness of a world in which normal acts become alien events.

Jim was thirty years old when I met him, having received the juvenile equivalent of a life sentence at the age of 17. He was now waiting for word from the Parole Board as to whether he would be given a programme for release and, the greatest prize, a date. Life sentence prisoners in Scotland have no idea how long they may spend in jail.

An uncompromising Glasgow East-ender with a strong character, Jim had often fought against the 'system', for his sanity and sense of self, and had thus incurred some setbacks in his sentence. His reputation for being difficult and having an 'attitude' had followed him through various penal establishments and led to a tendency for staff to stereotype and label him. Jim found it difficult to trust anyone, but within the group he gradually began to open up and share his confusion about himself, his hopes and fears for the future, and his anger and frustration about his prison experiences.

> I've been battered and bruised,
> confused when I lose,
> fighting the tears
> for all of these years.
> But the wall I must climb is my own.

Many of his images explored his anxieties about his future. He had a burning desire for freedom, but this was tinged with the fear of returning to Glasgow, where social conditions had created the sheer financial necessity for crime, and where being a 'lifer' would carry considerable stigma. He painted an image of a country cottage, representing the 'good life' and hope, a place where he could get away from the 'rat race' and live in peace. He was only too aware that reality does not provide country cottages – and this also

represented for him the difficulty in finding a sense of inner peace. He also drew himself standing at a crossroads, with a question mark above his head, trying to decide which path to take. The figure looked confused, vulnerable and in danger.

Despite a legacy of bitterness from his prison experiences, he appreciated the love and support of his family and friends, and was able to confide hopes of finding love and happiness in the future. He painted a big red heart, which he described as being open, or empty... but ready to be filled with good feelings. It is protected on either side by spikey trees, and is constrained by a grey sky above. I always find this image very powerful as it seems to make a statement about something life-giving and precious, yet easily damaged, which can withstand negative forces but not be destroyed by them.

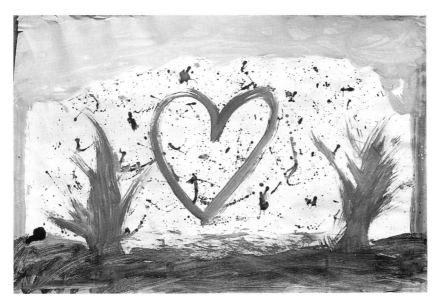

Figure 1.2 Jim: An open heart

A later image shows a very solid tree trunk, on which is inscribed a red heart containing his initials and those of a girl he loved before he came into jail. The tree opens out into foliage at the top, and there seems to be hope of new growth. It feels like a 'tree of life' linking past, present and hopes for

the future. The trunk is harsh and stark, but may lead to the possibility of brightness and space.

In each case the heart is surrounded and protected by the solidity of wood. Jim described how, over the years, he had to find a way to preserve parts of himself. There is always the fear that the bad feelings, the bitterness and hatred, will overwhelm the good. Other trees Jim painted are battered by storms and have lost all their leaves. It looks as though they may not survive the fierceness of the winds and forces that sweep over them, and yet the roots seem anchored in the ground. Ironically, by struggling to keep himself intact, he came up against authority and incurred more years inside, with further risk of destruction of the self.

'Nobody is who they really are'

When people come into prison, they are stripped of their identity as clothes, property, privacy, freedom and responsibility are taken from them. The prison as a large bureaucratic organisation, Goffman's 'total institution' (Goffman, 1961), is based on the assumption that everything will run better if the individual's uniqueness is played down, thus both staff and prisoners are forced into uniformity. The old self is destroyed by the lack of autonomy, and to regain some feeling of power over one's life it is necessary to build a new self. The inmate culture becomes the only meaningful social group, and 'you live in this other world so you feel they are not in control of all your life'.

A 'false self' is constructed, and many people describe living behind a mask, sometimes of several layers. This enables them to survive, and to project a certain image which confirms the macho culture of male prisons. Intimate contact and sharing of emotions is avoided, and socialising is kept to a superficial level, because of the danger of information or any sign of weakness being used against the person at another time.

In Colin's image, information is so sensitive that it is too dangerous to have anything out in the open, including your 'self'. Eyes look through spy holes in doors, written information has to be burned, and ears may drip blood. The outward appearance of things and people may be benign and friendly, but may mask a quite different message. There is of course a threat of real physical violence, but the danger to the mind is far more potent. Many fear that they will never escape from prison paranoia, even on release, and feel they will find it hard to trust again.

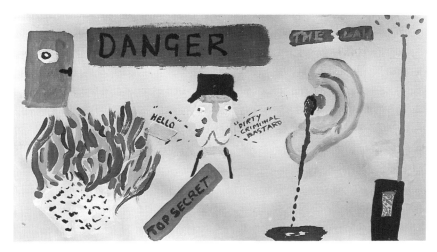

Figure 1.3 Colin: Two faces

Without a full consciousness of the way in which the everyday world has been broken for the long term prisoner, we can underestimate the pains he experiences, and assume that his apparent ease represents a natural adaptation to prison conditions, and not one that has been personally constructed as a solution to intolerable problems. (Cohen and Taylor 1972, 54)

Thus this 'false self' is necessary for survival in an alien and abnormal world, and this poses a fundamental problem for the therapist in an environment which is anything but therapeutic; for to break down these barriers may leave a person too exposed and vulnerable to deal with the harshness of his everyday world. The 'clever therapist' who exposes painful feelings may leave people with more problems if, feeling vulnerable or volatile, they lash out at a member of staff or fellow prisoner. There simply is not the support system to help people contain these feelings in between sessions. However, a paradox exists, in that people have an overwhelming desire to come out of prison 'undamaged' – and are only too aware that, over time, their 'false self' may become indistinguishable from the real person. Thus there is a delicate balancing act between coping with a situation or adapting to it.

But to adapt too easily may not be healthy. For just as a depressed child may present as coping and compliant, so may a prisoner who seems to be adapting and conforming. He may have simply cut off the part of himself

that feels and relates to people, in order to protect himself against hurt. The 'false self' thus created is experienced as empty, meaningless and inauthentic.

> Compliance carries with it a sense of futility for the individual and is associated with the idea that nothing matters and that life is not worth living. (Winnicott 1971, 76)

Thus the creation of the false self is a defence against the unthinkable, the total annihilation of the true self. A person who is experiencing the extremes of environmental deprivation such as 'lock down' (solitary confinement), develops a means of coping in which he reaches a stage where nothing else can affect him.

Joe McGrath is serving 23 years and writes of his experiences in Peterhead Prison:

> How did I cope then? I coped by shutting my system down. I turned to stone. I became neutral about everything and everybody. I thought about everything else, just to stop thinking about myself. I ran, I ate and slept. I stayed alive... So, every day I would send you a message. Every time you looked in my face for the agony, the suffering, the time, I stared back at you with granite eyes in a granite face: You do not touch me. There is nothing you can do to me that you have not already done. (McGrath 1992, 17)

Winnicott stated that where there was a high degree of split between the true self and the false self, there is a reduced capacity for using symbols and a poverty of cultural living.

> Instead of cultural pursuits one observes in such persons extreme restlessness, an inability to concentrate and a need to collect impingements from external reality so that the living time of the individual can be filled with reactions to these impingements. (Winnicott 1965, 150)

I work one morning a week in the 'Time Out Unit', and those who come to it for a temporary spell have often been in solitary confinement for months or even years. They complain of feeling alienated and 'spaced out', and often have an inability to concentrate or to become motivated. They do not trust the environment, and find it hard to accept that the officers who work there may be motivated by more than money and mind-games. Some can never allow themselves to see beyond the uniform to the person behind it, for that would threaten their personally constructed reality. Many times people say that they would rather go back to solitary confinement, that they 'knew where they were then'.

People get used to being by themselves, and what begins as a punishment becomes a way of life for months or years. In a situation where the system cannot take anything more away from the person, he retains a kind of control in which he does not have to ask for favours or experience a 'knock-back'. Ultimately this is self-destructive, as it becomes more and more difficult to relate to people, and families cannot comprehend what is happening to the person they care about. However, seen in terms of adapting to an extreme environment, it becomes all too understandable.

Ally was very anxious about leaving jail, wondering how he would cope when released into a world which is not easy, particularly when he had no money and had lost contact with family and friends. He felt he had 'cut off' so much during his time in jail that he no longer knew whether the real person was there any more. He said he had no feelings for anybody, but remembered a time when he had the support of friends, and when he cared about people.

He talked about how he used to push people away when they got too close to him, because he felt they would be bound to desert him anyway. He constantly punished himself for his offence and felt he wasn't worthy of people's friendship. To pre-empt people leaving him, he would often engineer arguments or make unreasonable demands of people. This pattern was repeated in the therapeutic relationship, where he would become very angry with me at something quite minor and refuse to see me, sometimes sending back any art materials he was using. I often felt frustrated, hurt and angry at his behaviour but recognised the counter-transference, and how other people in his life must have felt. But when he talked about Scotland, his animals and people he knew, I could see genuine warmth, and also great loneliness.

Ally painted landscapes of Scotland and pictures of the pets he had left behind, and made collages which expressed his frustration. In the first one he made, he is 'just hanging on' and he described living behind 'a mask that never slips'. In the top left hand corner he cut out the words 'I'll battle them till I quit breathing', which he did (with words rather than violence), hating to see any sort of injustice for himself or others.

The 'wall of shame' was cut out from a magazine article about the Berlin Wall, but to Ally it had personal meanings as well. Most obviously it represented the prison walls, but it also described the wall he constructed around himself. He was afraid to allow others in, as they might be tainted by the shame and guilt he felt concerning himself and his offence.

Figure 1.4 Ally: Just hanging on

He brought a second collage to the art room after making it in his cell. At a time when he was verbally stating his 'cut-offness' and his lack of feeling for anything or anybody, the most prominent words of the collage, cut out of a magazine and placed with care, were:

> I want to hold, just to love!

To return to my original question, to what extent is it possible to do 'therapy' at all in such a totally non-therapeutic environment? I believe that the specific qualities of art therapy may offer something unique within the jail, through the concreteness of the art product, which may safely contain fears and feelings too dangerous to say out loud. Winnicott has described the drive of the artist as a paradox, consisting of a strong desire to communicate, co-existing with a need not to be exposed. This makes sense in the prison context, where people have an urgent need to be heard, but where revealing too much is risky. People appreciate the personal space the art room allows, and the opportunity to open up and be themselves for the first time in many years.

'Everything with substance casts a shadow'

In 1917, in his essay 'On the Psychology of the Unconscious', Jung speaks of the shadow as the 'other' in us: 'By shadow I mean the "negative" side of the personality, the sum of all those unpleasant qualities we like to hide'.

For Jung and his followers, therapy becomes the means for the potentially destructive shadow side to become assimilated into the whole person. This releases the potential for growth, for moving forward into positive life energy.

Sometimes other staff will warn me about a client, 'Watch out for him, he's a bad one', or they imply that I will only see the 'good' side of the person, for example because I am a woman and/or not an officer, and that deception is inevitable as the 'bad' side is hidden from me. But all people have various aspects, and only portray what they want at a particular time. In this sense we live behind a mask all the time.

Derek was talking to me about a poem he had just given me, which tried to make sense of his feelings of loss and rejection about being put into care at the age of eight. He looked hurt and vulnerable, and was also greatly missing his own young son. We were interrupted by a governor needing some information from Derek, who reacted aggressively, feeling he was being patronised and manipulated, as he had felt many times in the past.

But which was the real Derek? Each of us would have a different perception of the incident according to our experience of the other. The governor saw an aggressive, belligerent, potentially violent young man. Derek saw the governor as a symbol of the powerful bureaucratic system which had kept him from those he loved, from childhood on. I saw two people misunderstanding one another, not really 'meeting' at all. But the fact is that people respond to what they see. 'It is impossible to conceive of someone who is all bad, whatever the word "bad" may mean, that is to say, who contains only persecuting elements' (Winnicott 1986).

The prison is full of misunderstandings and barriers put up by both staff and prisoners, and these can create a seemingly impenetrable mental wall. Winnicott describes this sort of wall as one which holds opposing forces away from each other, but simply postpones conflict. The power imbalance within the prison dictates that the definitions of good and bad belong to the group which has the most power, and are not open for discussion by the other group.

Jung stated that the shadow should not be seen as a 'bad thing'. The dark side of man is, after all, a side of man. The aim is to be able to integrate the shadow into wholeness, to admit the inadmissible, yet human, parts of the person. Jung's concept of the shadow is fundamental to the potential for

therapy within a prison, which in itself could be described as the shadow part of society.

It is often said that society does not really care about prisons, and championing prisoners' rights is not a vote-winner. Society prefers to distance itself from offenders, while still being fascinated by crime, shown by the popularity of such shows as *Crimewatch* and innumerable TV detective series. The criminal is chosen to embody ugly and unwanted traits so that society can remain straight, good and law-abiding. Perhaps, deep down, we recognise and fear our own potential violence and dishonesty, and are afraid of being caught.

R.D. Laing describes the process of psychotherapy as 'an obstinate attempt of two people to discover the wholeness of being human through the relationship between them' (Laing 1967, 45). In art therapy there is a third aspect to this relationship, embodied in the image which has its own existence, where transference can be explored, or simply as a map of experience. The image can contain, conceal or 'give shape' to powerful feelings, and the image-maker always has the choice of whether to try to verbalise these feelings; equally it is accepted that it may not be possible. However, because the image exists, it can be put away safely and referred to later. The creator is often surprised at how the image reveals more to him than it did when it was made.

The war between good and evil can be played out symbolically, and it is possible for the person to see different aspects of himself, both good and bad, as parts of the whole. This is not to underplay or find excuses for the actions which led people into prison. Rather, as therapy empowers people to make discoveries about themselves and to find their own solutions for the future, it also puts responsibility for past actions firmly in the person's own hands. This can be painful, but may also be a first step to acceptance and integration.

Ross explored in his images his desire to reach a stage of personal worth allowing his return to his religion. But he was struggling to combat drugs, and was finding this very difficult. He saw any weakness in his resolve as a failure, and evidence of his lack of worth. He then became depressed and slipped right back, creating a vicious circle which he could not break. I respected Ross's need for his chosen religion, but found it judgemental in its rejection of a man at the time of his greatest need.

Ross's images contained roads and paths, which he hoped might eventually reach the place where he wanted to be, where he could be part of his church and could find happiness. It was a difficult place to reach, and the

world seemed to be a place of black or white, of good or bad, of right or wrong.

In the image shown in Figure 1.5 Ross divided the paper into two, with all that he saw as good on the left. He felt that if he could live up to his own high ideals he might be worthy of happiness. However, on the right of the picture, shaded in the darkness of night, a boxing ring symbolises the struggle ahead. He felt his heart was broken and would never be mended if he lost this fight. There is a large question mark in the drawing, as there was over his future. He was soon to be released from prison and knew he had many difficult choices to make.

Figure 1.5 Ross: Good or bad

When he talked about his images, Ross recognised that he was setting himself a goal of perfection he could never achieve, and we discussed whether it might be possible to accept and live with parts of himself which he did not like. I tried to convey to Ross that, although the crimes he had committed were socially unacceptable, there was more to him than these actions, namely a genuinely warm and caring person with much to give.

Everything with substance casts a shadow. The ego stands to the shadow as light to shade. This is the quality that makes us human. Much as we would like to deny it, we are imperfect. And perhaps it is in what we don't accept about ourselves, our aggression and shame, our guilt and pain, that we discover our humanity. (Zweig 1991, 3)

Time

Outside prison, time is simply part of 'life', and we break it down into a set of pigeon holes which dictate when it is time for a meal, or time to go to work. We schedule time, it ticks by, and sometimes we do not have enough of it to do the things we want. But long-term prisoners are given 'time', which must be served, not used – after all, it is someone else's time, 'prison time'. Prisoners are given the advice to 'do your time, don't let the time do you'. Many long-termers resist thoughts of the future, but the paradox is that, without these, their lives are over when they enter prison. A long-term prison sentence is not a short intermission in the real business of life – it is the real business of life.

> The unreality of time is palpable. Each second falls slowly. What a measureless gap from one hour to the next. When you tell yourself in advance that six months or six years are going to pass like this, you feel the terror of facing an abyss. At the bottom, mists in the darkness. (Serge 1970, 56)

My friends' families become measures of time passing, as their babies become toddlers, and then children. For the long-term prisoner, this is the most painful of all, the awareness that his children are growing up and that he will have missed the ordinary day-to-day events which mark their progress. People describe a gulf in even the closest of families, where changes in children, parents, brothers and sisters, scarcely registerable to those who are experiencing them, become sudden and magnified when the person and home are seen less regularly.

The prisoner is separated from his family because he has committed a crime for which he must be held accountable, but it is often acknowledged by the person in custody that his family too are serving a sentence. Their sentence may be the harder one, as not only do they have to deal with the pain of separation, but also the harshness of real life, with its problems, bills and leaks in the roof.

The separation and the burden of guilt for one's family can be hard to watch, and may lead to a desire to 'cut off' from them. This is understandable, as prison does not enable people to take responsibility for their families in

any real financially supportive way. Rather it highlights the powerlessness of the prisoner's situation, and many relationships break down under the strain.

Visits are often stressful as communication becomes more difficult. The family does not want to burden the prisoner with outside problems, or even talk too much about good times, because it emphasises what is being missed. In turn the prisoner does not want to worry his loved ones by saying how he is really feeling or by talking about the jail. The arts in general can provide a powerful forum for communication with families, as paintings and craft-work can be handed out to them. For instance, it is possible to use calligraphy and poetry to express words that are too hard to say in the impersonal surroundings of the visit room. Involvement in art exhibitions, music or drama projects provides something totally beyond the prison to talk about. This can also give the families something to be proud of, and builds a feeling of self-worth in the person concerned.

Thus all the arts are 'therapeutic' in a general sense, while the specific qualities of art therapy can provide a means to explore personal issues and problems in more depth. Receiving a long-term or life sentence is a bereavement in itself, and people go through the grief process for their own freedom as well as the many other losses they may have incurred. This process includes shock, anger, guilt, depression, and perhaps finally an acceptance of the situation.

Art therapy does not provide any magical solution, but may provide a forum through which pain can be acknowledged and shared. One common fear people have is that they will deteriorate in some way during their sentence, or go mad. They need reassurance that they are not going crazy, but are going through a perfectly normal reaction to an abnormal situation. After all, prison is still part of life, and people can be happy, sad, anxious, hurt, afraid, calm or content. In a place where people describe themselves sometimes as 'merely existing', can art therapy be a way of passing time meaningfully – or of giving meaning to time?

Conclusion

It is a struggle within the prison to find the space to be an art therapist. The prison is a hard place, even more so for those who cannot leave at the end of the day. I am warned that the prison will change me, make me harder, and rub its poison off on to me. But I work within a supportive team of social workers and have regular life-saving supervision, and so hope this will not occur.

I also receive much nourishment back from the people I work with. Being introduced to someone's family as 'the person who keeps me sane', or receiving a note from someone who has left saying how much they appreciated being able to talk, makes the knocks and frustrations easier to cope with. I am often bemused by the things that people say have been helpful. I may think I have been making significant therapeutic comments, but what is noticed is the throw-away remark – this keeps things in perspective!

I try to be objective – as an 'outsider', perhaps I can see things from a different viewpoint, where it is not all 'us and them'. It must be frustrating for other staff to see people talking openly to me, while they are treated as 'uniform'. Prison officers have a stressful job, and many are genuinely interested in working more closely with prisoners. But it is harder for them than it is for me, either to see the real person or to be seen in turn as a human being with feelings that can be hurt by rejection. I am sometimes accused by the prisoners of 'sitting on the fence', and that can feel very uncomfortable and isolated – after all, the fence is made of razor wire even if the view is great!

Art therapy is often described as a bridge between the conscious and the unconscious, between inner and outer, and this bridging is very much part of its role in HMP Perth. There are many physical chasms which need to be bridged in a prison: between staff and prisoners, between community and prison, between management and officers, the list is endless. Is the bridge the therapy or the therapist? I am aware too, that bridges can sometimes get swept away in a storm, or may crack down the middle.

It is necessary to construct personal boundaries to provide some shelter from the strong emotions which are stirred up by working in prison. I am not a 'blank screen' therapist (there are too many blank walls in the prison already), and prefer the analogy of 'keeping one foot on the bank and one foot in the water'. My anchors include the social work team, supervision and the straightforwardness of prisoners who point out that nobody who hasn't been locked up can ever understand what it actually feels like. Of course I can't, but sometimes as I am waiting at one of the many gates, somebody may joke about not letting me out, and I suddenly feel an urgent need to get through that gate. There is something fundamentally alien to human nature in being captive.

I have my profession which nourishes me, constantly surprises and delights me, and which provides my strength. Even in such a hard place, creativity seems to be such a powerful force that it will find its way through, given the slightest chance.

It is sad to read that some art departments in England are under threat, and the spectre of privatisation must throw a question mark over the future of an activity which is hard to evaluate in terms of profit and material benefit. Those who have already found this channel of expression will not stop producing images, but it is important to provide the environment in which this can happen – the physical and mental space in which to grow.

I hope I have been able to show in this chapter that art therapy can provide an experience which may enable prisoners to learn about themselves, and to look at their lives, problems and experiences from a different perspective. The space in the art room is not just physical space but also breathing space. Where prison walls can contain the body, art therapy can contain fears and feelings, and image making can liberate the mind. With this freedom may come real change, growth and responsibility. Thus art therapy, while appearing to some a luxury, is entirely in line with the stated aims of the Scottish Prison Service: 'to provide an environment in which the growth of self respect, self esteem and self determination is possible'.

Acknowledgements

I would like to thank my supervisor, Caroline Case, and the staff at HMP Perth for their support for this new initiative, particularly Mr Kite, the Governor and John Bone, Senior Social Worker. I would like to give special thanks and appreciation to all the prisoners I have met and worked with, for the trust they have shown me and for what they have taught me, in particular Jim for his honesty and help in writing this chapter.

References

Bettelheim, B. (1960) *The Informed Heart*. London: Thames and Hudson.

Champernowne, I. (1969) 'Art therapy as an adjunct to psychotherapy'. *Inscape No. 1*.

Cohen, S. and Taylor, L. (1972) *Psychological Survival: The Experience of Long Term Imprisonment*. London: Penguin Books.

Coyle, A. (1991) *Inside: Rethinking Scotland's Prisons*. Edinburgh: Scottish Child.

Goffman, E. (1961) *Asylums*. London: Penguin Books.

Jung, C.G. (1917) 'Two essays on analytical psychology', in G. Adler, M. Fordham and H. Read (eds)(1966) *The Collected Works of C.G. Jung*. London: Routledge and Kegan Paul.

Laing, R.D. (1967) *The Politics of Experience and the Bird of Paradise*. London: Penguin Books.

McGrath, J. (1992) 'Time'. *Scottish Child June/July,* 17.

Nowell-Hall, P. (1987) 'Art therapy: a way of healing the split', in T. Dalley, *et al. Images of Art Therapy.* London: Tavistock Publications.

Page, K. (1992) 'The Family Inside'. *Prison Writing, Vol.1,* No.1, 48.

Serge, V. (1970) *Men in Prison.* London: Gollancz.

Scottish Prison Service (1990) *Opportunity and Responsibility.* London: HMSO.

Thomson, M. (1990) *On Art and Therapy, an Exploration.* London: Virago.

Winnicott, D.W. (1965) *The Maturational Processes and the Facilitating Environment.* London: Hogarth Press.

Winnicott D.W. (1971) *Playing and Reality.* London: Penguin Books.

Winnicott D.W. (1981) *Boundary and Space.* London: Karnac Books.

Winnicott D.W. (1986) *Home is where we start from.* London: Penguin Books.

Zweig, C. (1991) *Meeting the Shadow.* Los Angeles: Jeremy P. Tarcher, Inc.

Building Up To A Sunset

Eileen McCourt

Introduction

In deciding on the format for this chapter, it seemed immediately apparent that the art-work of a client should form its core element. As art therapists, we are constantly taught by our clients about the power of the creative process. I consider that showing this series of work by Joseph (whose name has been changed) is a way of honouring it, allowing others to share it. Joseph's willingness and ability to write about his art also contributes in a very direct way to an understanding of the nature of art therapy.

The chapter begins with a brief summary of the origins of art therapy in the Probation Service in Northern Ireland, followed by a description of my practice and its relevance, as I see it, in working with offenders. Art therapy within the prison setting is considered and the context outlined in which Joseph's work was created.

Images and words follow, and attention is then paid to the period since Joseph's release, including the preparation time for this chapter. The main benefits of art therapy in Joseph's case are then considered.

For this purpose, I employ the theoretical framework outlined by Rita Simon in her book *The Symbolism of Style: Art as Therapy* (1991), which encompasses her 40 years' experience as the initiator of art therapy in Northern Ireland. Her classification of four basic styles in art therapy, the archaic and traditional, each with a linear and massive form, is profoundly interesting and has contributed in a major way to my understanding of art therapy processes.

In my writing, I have described the therapist as 'she' and the client as 'he', since the main area of my practice involves the male population.

Art therapy and offending

My career as an art therapist arose directly out of my dissatisfaction with using words — too often they seemed to block communication rather than aid it. I pursued therapeutic art initially for myself, and it took some time before it dawned on me that I could use this medium in my professional life as a probation officer.

But how was I to connect the theory and practice of art therapy to working with offenders? My experience as a probation officer was built on a fairly directive style, however unwillingly adopted. Asking for and receiving information, monitoring progress, planning activities and containing behaviour — the stuff of my working week seemed so far removed from the pleasure, even joy, which I experienced in spontaneous activity with paint and clay.

A way to connect both 'worlds' was found when my employers, the Probation Board for Northern Ireland, agreed to send me on post-graduate training in 1986 to St Albans College of Art and Design. My contract was to return to work as an art therapist and develop art therapy as a method of work with offenders. After being 'on probation' for a year, it was felt there was sufficient interest in and take-up of the service to merit my post being confirmed as permanent. Art therapy is now offered in its own right in, for example, groups in prisons, hostels, a day centre, and a young offenders' centre. It is also an integral part of other programmes, such as residential provision for juveniles, a job training scheme for offenders, community support programmes and a non-residential facility for sex offenders. Individual work is also undertaken.

I wish to state at the outset the principles on which I base my practice. I see the creative process as the main therapeutic agent in art therapy. The therapist's role is to create a safe place for this to occur — to be aware of the various stages during a session and to intervene appropriately to enable the art-making to continue. The art object is the focus of attention of both creator and therapist — the images may later be spoken about and mused upon by the creator.

A session begins with an invitation to 'play' or whatever the acceptable equivalent word may be to the individual or group. I regard an inability to begin or a lack of motivation as something which arises out of the fear of risking playing. This tests the skills of the therapist in providing a safe, holding situation. I do not consider that offering a theme is conducive to depth of expression, or the most appropriate way to address fear. My style of working therefore could be described as non-directive, based on 'play' with the materials, with little verbal contact during the art-making process

(the non-verbal communication being paramount). Verbal communication may take place after the art object is created, when it may be spoken about directly or in a symbolic way – I take my cue from the creator's attitude to the image or object and respond to this – looking, listening, repeating and reflecting.

What is the relationship of this approach to offending behaviour? Working with people who deny, minimise or justify their offending, one has to find alternative ways to communicate, so that verbal rationalisations are redundant. In attempting to understand behaviour which is motivated both consciously and unconsciously, we are only using half our resources if we ask clients to examine its conscious, overt aspects. If we expect verbal proficiency from those offenders whose verbal communication is poor, we limit the range of options available to us.

I see offending as a response to an intolerable imbalance between the individual and his environment, a response to an internal conflict. It is felt by the offender to be the only solution at that time, given the circumstances and the individual's range of responses.

Creative activity interrupts a pattern – one of self-destruction, self-deprecation, meaninglessness or 'boredom' – and replaces it with a dialogue. One is taken out of oneself and put into the material; this can be disowned and treated as 'something out there' until the individual is ready to own its connection to him. In art therapy, an experience is offered for safe ventilation of feelings which are normally projected outwards in the form of offending behaviour. This initiates the possibility of a change of attitude on behalf of the creator.

Using an art therapeutic method is tackling the offending from a different angle. Rather than focusing on it directly, art therapy involves the part of the person which is still intact and healthy – the part that the offending hasn't reached! Engaging the positive, both conscious and unconscious, in the spirit of playful image-making, allows ventilation of feelings and thoughts needing a safe place for expression.

Art therapy in prison

The practice of art therapy within a non-therapeutic environment demands that a language be sought by which the therapeutic mode can be understood by other professionals. Words are the usual currency in the probation service and in prison. Art therapy introduces visual communication and is therefore liable to misinterpretation – literally! It is either seen as teaching: 'Do you have any budding Van Goghs?'; or analysis: 'Can you read people's personalities from what they put on paper?'. Art therapy offers 'art' as available and

accessible to all, contradicting a general attitude that it is only for those with skill or talent. It also dares to talk of 'therapy' with its connotations of 'illness' and 'treatment'. Such scope for misunderstanding! But art is also attractive and gains colleagues' attention – 'I've always wanted to paint...' or 'My mother is an artist' or 'I dabble a bit myself – but I'm not very good...!' There is an immediate response when a portfolio is being carried, and I find that I can capitalise on this.

The art therapy group in which Joseph's work was created took place weekly for a 1½ hour period in an old, Victorian, high-security prison. Although this is mainly a remand prison, it is also serves a dispersal function, as a place where sentenced prisoners stay for a short assessment period before allocation to other establishments. Within one of the four wings there is a small number of sentenced prisoners who remain in this prison, all convicted of sexual offences and serving sentences of between six months and 2½ years. Normal association periods are not open to these men because of the nature of their offences, and they spend even more time in their cells than others in the prison. Art therapy was offered partly as a means of alleviating the stress caused by this situation.

My experience in developing an art therapy service within probation confirms that if the manager of a team – Senior Probation Officer, Principal Officer – can be convinced of the relevance of the service, then the work is much easier. Most members of the probation team within the prison had already taken part in workshops which I had run, and the Senior Probation Officer had thoroughly enjoyed these on her own behalf, and also seen the potential contribution to the prison population. An experiential session had also been held with the education department in the prison, to create debate, dispel myths and clarify the boundaries between art teaching and art therapy. The main practical problem was securing a classroom in a context where available space is at a premium. After much negotiation, a free classroom was found on the relevant wing for a two-hour period after tea and before lock-up, when others were at association and these men would otherwise be locked in their cells.

The probation officer on the wing, in her daily contact with the men, took on the task of initiating and encouraging interest in the potential art therapy group. Since she also had attended the workshops and had had a taste of spontaneous art-making, she was able to indicate clearly the nature of the group and what might be expected. The outcome was that on the first evening six men arrived in the classroom.

After the initial core group was formed, referrals came from the members themselves, who encouraged newcomers on the wing to attend. It was a very

successful group in that there was always an aura of work (playful work!). During many evenings, application to the art process resulted in almost complete silence for the main working period of an hour. I often feel that the length and quality of the silence is an indicator of the success of an art therapy group. And there was humour! The group had an affectionate regard for each other's work, and banter was always tempered with a respectful acceptance of the significance of the picture to its creator.

Conditions were hardly conducive to spontaneous work, and yet it occurred. The group met in a small colourless classroom, too cold in winter and too warm in summer. A large box of materials, portfolio of paper and the men's work were locked in a cupboard in the next classroom. Water was fetched in a bucket, and the room was just big enough to house four tables. Everyone helped to clean up afterwards, and wet paintings had to be left on top of the aforementioned cupboard. Amazingly, nothing ever went missing.

I sat on a chair within the open doorway with my back to the corridor wherein sat a prison officer whose evening duty it was to cover both groups – an education class was held in the next room. Contact here before and after the group, while materials were being prepared and locked up, always afforded opportunities to explain about art therapy, and meet curiosity and interest in the subject. Occasionally, I tempted a receptive officer to sit with sketch pad and crayons, chalk or pencil in his corridor 'studio', hoping to help him find a more creative way to spend his enforced watch.

Materials offered were a variety of two dimensional media – clay is not allowed in this prison for security reasons. Poster paint, chalk, crayons, charcoal, oil pastels, pencils and pastels comprised the range. Brushes and sponges were the painting tools. Various sizes of paper were available; white, cream and coloured sheets were on offer.

In thinking about the value of the art therapeutic process to Joseph, it helps to describe the effects of spontaneous art on myself. Once begun, the activity of making marks, creating form and colour, takes on a life of its own – it becomes all-absorbing. Outer reality recedes, and the concentration of energy is on the art object and the creator – this dialogue predominates, everything else is subordinate. I see the activity as 'creating oneself', acting upon the paper and drawing out from within that which has been dormant, making it visible and tangible, providing structure or form, giving meaning to life!

When these men were invited to participate in an art therapy group, all this was not said or even implied – they discovered it. I find it difficult to describe in words what the non-verbal process may yield, before an individual experiences it – I am not even sure if this is advisable. Although it sounds

vague to suggest that one might 'play', and that one can 'allow things to happen', what materialises in the session provides the motivation and impetus to go on. One way of describing the effect of creating art, is that it energises – one feels differently after the process, the art object is an externalised statement, a symbolic representation of what is felt or thought.

That this process is particularly relevant in prison is beyond question. A main commodity is time, time in which to think and create fantasies, but with few outlets to express these inner processes. Prison structure provides no opportunity to retain individuality and no incentive to link past, present and future. It is as if time stands still, in a world which is artificial and disconnected from the realities of everyday life. Powerlessness, helplessness and frustrated energy are the characteristics of prison life. At the most basic level, spontaneous art brings choices and decisions, extends the arena where these can be played out – the opposite of restriction and limitation. The tools for self-communication are in the prisoner's own hands – now he has the power. Each mark he makes confirms his identity and uniqueness. In making a symbol for his experience, he is speaking of it indirectly, in images rather than words, and in so doing he affords himself the opportunity to look at it rather than denying it. In this way personal and inner experience can be brought into focus.

Joseph's work

Joseph was a 46-year-old man who had not painted before coming to the art therapy group. He had been in work all his adult working life, mainly in the retail trade. He was on bail before receiving a prison sentence of two years for sexual offences. While on bail he had been a positive contributor in a group run by his local probation office on cognitive/behavioural lines, for men involved in similar offences.

I asked Joseph whether he would like to submit his work for this chapter because of his commitment to the art process and the obvious benefit he had gained from the art therapy group. Initially hesitant about his ability, he quickly entered into the spirit of it and 'really enjoyed' writing about his work. This has motivated him to begin writing more extensively about the rest of his work and his time in prison. This may be the next book on art therapy! All pieces of work are on cream cartridge paper measuring 27" x 20" unless otherwise stated.

In total, Joseph completed 15 pieces of work over a period of nine months in the art therapy group. His first two pieces, each taking a session, were completed on coloured paper (23" x 16") using crayons.

The first, on orange paper, depicted a view of his immediate neighbour-hood as if one was looking out of the window of his house. The perspective was mixed: on the left hand side of the page stands a large tree with a branch lopped off, and a little dog standing near the base. The style of the picture is linear, with a pavement, hedge, grass verge and road appearing as if stacked up on top of each other. A road traverses the length of the page and bends downwards to the right and off the page. On this curve there is written the word 'SLOW'. Beyond the road is a small orchard. In this first picture, I felt that Joseph was sharing what lay 'outside', setting the scene. He worked intently with crayon, using small strokes, confidently and with assurance, in spite of his unfamiliarity with art.

On the second occasion, Joseph immediately began working on a pale green sheet. He drew his own house and part of his neighbour's house, filling the sheet; the houses face us, and in the foreground appear the garden, hedge and pavement, seen now from a different angle. Joseph's house, on the left, has a darker aspect than his neighbour's. This picture was a source of great displeasure to him – he appeared annoyed and disappointed. He felt that it was 'like a shack' and expressed his intention of making 'a better house' the following week. This he did, and the result is shown in Figure 2.1.

Joseph: When I worked on this picture, I was at a pretty low ebb. I missed my home, friends and my two faithful dogs, so what better to draw than a picture of my home as I could see it in my mind's eye? I could look at it and think to myself – well, all that I love and care about is behind those windows – some day I will be back there again. My thoughts as I drew this picture were about how glad I was that I came to this art therapy group. I felt it could help me.

Joseph was quite clear about the materials he wanted to use – pencil, coloured pencils, sharpener and ruler! This 'better house' was built up brick by brick over a period of five weeks – five weeks of detailed, planned, exact work. This was almost 'technical drawing'. He deliberated and took care in choosing colours and shading areas between lines. Pastel colours predomi-nate in the drawing and these are naturalistic – everything is orderly and thought-out. Occasionally Joseph would make a little foray towards the pastels, then reject them ostentatiously, saying that they weren't appropriate. The drawing became a focus of interest in the group over its lengthy period of creation; humour abounded: a group member would ask, 'How is that

Figure 2.1 Untitled

house coming along?', and Joseph would reply, 'Oh, well, the bricks haven't been delivered today – these fellows must on strike!'.

I enjoyed the manner in which Joseph brought alive the various parts of his drawing. He complained that his daffodils weren't growing. We had a discussion about the soil – was it good enough? Eventually the daffodils emerged.

Nearing the end of this five week period, the house being almost complete, Joseph said to me, 'Alan told me that last week you were cross because I left a mess'. My response, 'Joseph, I'd be delighted if you left a mess', was based on my feeling that he was asking permission to 'make a mess'. Would I be 'cross'? What would happen? Was it 'safe' to make a mess here?

During the previous weeks I was also aware of my own counter-projections in relation to Joseph and his work. Having begun in a manner showing he could use the sessions to 'play', I felt he had retreated into the safety of facts and lines, using the guarantee of a ruler to ensure that nothing escaped his control. I realised he needed this safety, but also had to contend with my own feelings of disappointment and impatience. I strove to keep in the forefront of my mind the word 'SLOW' which had appeared in his first picture.

Using Rita Simon's theoretical formulation, this drawing is in traditional linear style, unadulterated by any emotional aspect. In this mood, Joseph is intent on conveying facts. Detail is important, and marks are small and specific – he is working 'with his head', planning, controlling and allowing nothing to interfere with the task in hand.

Joseph: In the next session I painted a picture which is not included. I then missed a session, due to letting some worries and problems get on top of me. Alas, once again I had become very depressed. Thankfully help was near at hand in the person of my art therapist who came to visit me. After our long and searching talk, I got the strength and encouragement to hold my head up once more, and get back to the art therapy group the next week.

In the next session, Joseph spoke of his wish to 'throw his mop at people' (he was a prison orderly) because of his angry feelings. I encouraged him to use the materials to express such feelings, and he tried out the paints for the first time. His action in approaching the pastels and in speaking of 'making a mess' conveyed to me a desire, however disguised or unconscious, to use the materials in a different way. However, I felt after this session that I had allowed my own wish for Joseph to get in touch with feelings to influence my behaviour unduly. Instead of waiting for Joseph to choose, I had suggested using paints, linking this with his feelings of frustration and anger. The picture shows the beginning of a sunset, a reflection of a pale orange circular sun, surrounded by flat pale blue sky and sea. However, the lower half of the cream paper is devoid of colour, the painting is incomplete…

Joseph did not come to the following session, and I decided that if he were not sought out, he would be unlikely to return. In my probation officer role, I paid him a professional visit, where he had the opportunity to talk at length about many worries. This contact renewed the connection between us and also allowed Joseph another outlet.

Figure 2.2 A storm at sea

Joseph: I remember on this night sitting at my table, paints and brushes before me, wondering what I could paint.

'Paint your mood, start off by making a mark,' encouraged my art therapist.

'If I was to do this, I would just stick my fingers into the paint and plaster the paper with it.'

'That is what art therapy is about,' came her reply. 'If that is what you feel like doing, do just that.'

That particular night I was feeling a lot better. I wanted to make a plaster (i.e. cover the whole paper), but I decided on brushes not my fingers. I now felt a lot happier using the paints, so I fetched myself four or five different colours, yellow, blue, green, red and orange. After arming myself with a sheet of paper and a reasonably thick paint brush, I proceeded to make my plaster. I just dipped my brush into the paints. Three or four different colours at a time – I

wanted to experiment with mixing and seeing what would happen. I attacked my paper that night – this was something new to me. I had no plan. I did not study my work. I just felt I wanted to cover my paper with paint as quickly as possible.

When the painting was completed on my sheet of green paper, the background showed up with various shades of brown and streaks of yellow and red coming through. You can see these in the white marks of the photograph. I conjured up in my mind that these could resemble lightning strikes. Could I ask you for a minute to really study this photograph very carefully? Can you imagine in your mind's eye, a small boat, maybe a lifeboat, bobbing up and down in the middle of the picture? Lightning strikes all around, in a background of sombre rolling colours – can you see a storm at sea? I could, so I immediately said 'I will call it *A Storm at Sea*.' It was very easy to paint – just my mood at the time put down on paper. After the period of depression, I was now feeling pretty good – agitated, maybe even a bit angry at having to be here, but at least that was an improvement, so I showed it in the painting. To me this picture shows a lot of anger – what better way to get feelings like this out of your system than putting them down on paper? I really was starting to understand the benefit of this art therapy now.

I was pleased to see Joseph return to the group. *A Storm at Sea* was a joy to watch in process! He was in a different mood from any I had seen hitherto – the painting reflects this, and Joseph's writing captures the feeling of the piece: 'I attacked my paper that night – this was something new to me. I had no plan. I did not study my work'. The painting shows the 'archaic massive' style in Rita Simon's formulation. Exactly the opposite of Joseph's previous drawing, it is full of feeling, involving the spontaneous use of materials with large marks, strong colours and much over-painting.

Joseph said in retrospect of this painting (while selecting pieces for inclusion in this chapter) 'There must have been a lot put out on that page, for me to come and be more settled the next time'.

Joseph: This next picture I have chosen was painted the next week. As you can probably see, it is quite a contrast from my other two, *A Storm at Sea* showing anger, and the drawing of my home showing a lot of loneliness. Well, I had now come to accept my lot in here. My sentence was going in, almost six months

had passed, so I just painted a lazy, happy-go lucky type of
painting. To me it was just a plaster of paint once again, but
done in a different mood. I suppose I could say I was happy
– well, as happy as anyone could be in prison. Although
there was no reasoning behind my work in this picture, it
told me a lot. It told me that anger and depression had gone
and peace of mind was coming to me once again.

Figure 2.3 A peaceful flower garden

In this session Joseph seemed comfortable with the idea of using paint, and
was keen to begin. He seized a large cream sheet, and having discovered the
previous week 'what the paint could do', he proceeded to experiment with
colours, using brushes in different ways, waving and turning, stippling and
dabbing with delight. The painting consists of masses of brightly coloured
small circular shapes; in some areas they combine to create larger patterns.
Joseph thought there might be a stream or river running through it. He felt
it could be called *A Peaceful Flower Garden*.

Figure 2.4 The patchwork quilt

 Joseph: Around this time I was in quite a steady frame of mind. Home
leave at weekends was doing wonders for my morale.
Unfortunately you can only see this picture in black and
white, but in reality it is a mass of very bright and warm
colours. I told my art therapist – who, as far as I was
concerned, was not just a tutor but a friend whom I could,
and still can, trust and talk to, that I was putting my mood
for the night in paint. I didn't want any dark colours, only
bright, warm colours would do. The result of my work that
night told her at a glance that I was coping well. On a lighter
note, one of the other group members asked me if it was a
patchwork quilt I had painted. From then on the picture was
known as *The Patchwork Quilt.* I really liked the name and the
painting itself!

By this stage, Joseph had completed numerous pieces of work, and was nearing the end of his sentence. Fully committed to the art therapy group, he painted with enthusiasm, exploring colour, texture and pattern. In this painting (Figure 2.4), he added a sponge to his repertoire of tools, dripping with paint to create warm, glowing swathes of colour.

Figure 2.5 Sunset

Joseph: This final picture I have chosen was painted on my very last evening at the art therapy group in prison. It was a Thursday. I remember well – I was excited – my sentence was nearly up. I had got through with flying colours! How appropriate! This is my effort at painting a sunset. I had tried to paint a picture like this about nine months earlier, but due to my unsettled frame of mind in the early months of imprisonment, it finished up a total disaster! Maybe as I look back on it, it was a reasonable attempt at a time when I was feeling pretty low and not very happy in my new surroundings. When I discussed the initial painting with my art therapist all those

months ago, I told her then that before my sentence was completed, I would like to have another go at it. Well, this was my last chance to keep my promise to her and to myself. So, paint to paper and in my happy mood, I had a go – the result is not a masterpiece by any means but I was pleased with my efforts. I had done it! This black-and-white photograph cannot begin to convey just how the original painting looks.

On my large sheet of paper and using my sponges, I painted a bright orange circle in the middle of the page. This was the beginning of my sunset. I had made a start and already I was anxious to see it finished. I had only one night. What a difference nine months can make! This painting just had to be right, and as I looked at my circle that night, I was more confident that I could do it. A bright blue sky came next – sponges, hands and table top were covered in blue paint, but I enjoyed myself. Some white clouds were needed – so in they went. The sea came next – a nice soft green. My painting was starting to take shape – what was needed now was a 'reflection' in the sky and sea. So once again, with a clean sponge and a copious amount of bright orange paint, I started to attack both blue sky and green sea. The result – a radiating glow of bright orange as the sun sets in the horizon. I was pleased – I had painted the sunset on my last night. How different a person I felt now compared to my first night at the group!

To finish, I would like to say how much art therapy helped me through my sentence. I was able to put my different moods, my anxieties, my sorrows and my depression down on paper. I could show my art therapist more about how I was feeling inside than I could ever try to explain to her. Art therapy and my art therapist helped me tremendously through my time in prison. I now know the benefits to be gained from putting my innermost thoughts down in paint, and I am grateful for being given the opportunity to share my thoughts with you, the reader of this book.

Joseph came into the session saying, 'I don't know what I'm going to paint this evening' – then, 'I suppose there's no point in asking you what to do?', a humorous comment on how he had not been 'told what to paint' over the

previous months. As always, inspiration came and he said 'I know!', asking me as he began whether I knew what it was (I didn't in the early stages). As it progressed, I realised that it was a sunset! There was a blue sky scattered with clouds, and a bright orange circle of sun in the middle, which in the last seconds spilled its colour into a greenish sea. Joseph was excited about this picture – 'I did what I couldn't do nine months ago'. I feel that these words related to more than painting a sunset; here he was also talking of being able to handle the paint, to flow with his mood, to express feelings. This was a very different sunset from his previous attempt where, as he said later, he had tried to recreate a peaceful scene. This present picture was a whole-hearted, immediate expression of energy and confidence, a fully-experienced pleasurable meeting with the materials.

To add to the understanding of Joseph and his paintings, it has been valuable to view in retrospect his work over the period of his sentence, of which the selected paintings are only a sample. The first opportunity to have 'a retrospective' came just before the end of his sentence, when we laid out all his 15 pictures in sequence, in an empty classroom in the prison. The intervening months between the pictures' creation and their review, provided distance and lent objectivity. One is also looking with the additional experience of that intervening period.

Joseph, therefore, nearing the end of his sentence, could look at the house which he built over five weeks, and remember that, in the initial stages of his sentence, it had helped him to retain connections with his life at home. 'I could relate to the outside. When I was doing this I felt free from prison. When I drew the windows, I relived the times when I had worked on them. When I worked on the flower-bed, I remembered burying my dog some years ago – everything came back.' Joseph was able to tell me of his awareness of my attitude during the lengthy creation period. 'I know you wanted me to go on to something else – but I had to spend time doing this. I couldn't have done anything else.'

On his release from prison, Joseph was quite certain that he wanted to take his work with him – a fairly rare event, in my experience. I asked his permission to take slides of his work, so that I could have a record. The slides also then became a means whereby we could review and remember the process of his creativity while in prison. The link which the art therapy provided was also a vehicle for our maintaining contact. The months after his release were characterised by resettlement problems, so the focus of our relationship changed. Acting in my capacity as a probation officer, I referred him to other resources for practical help, such as the Employment Unit within the Probation Service, and a financial advice agency.

We maintained contact with regular appointments, in which Joseph talked about his attempts to re-integrate, and his hopes and fears for the future. Art therapy was still on offer and he regularly reviewed his pictures at home. Eventually Joseph found a responsible position, which involved long hours and hard work. The major hurdle of employment overcome, Joseph's depression and vulnerability surfaced again. He had already begun selecting work for this chapter, and memories of the value he had found in spontaneous painting exacerbated his feelings of hopelessness. At that point, he talked with great intensity about *A Storm at Sea*, and how the picture conveyed a positive and possible way forward. Shortly after this, he was able to work on a small area of the painting which had always frustrated him. 'I'm in love with this painting!' he exclaimed, commenting instinctively on everything which art therapy offers. Other discoveries throughout this 'selection period' merit sharing:

Joseph: Every one of these pictures represents an attitude.

The painting doesn't get rid of the feeling – but it's shared with somebody.

The benefits of art therapy don't finish just because the picture is finished – it carries on, surely. When we walked away (i.e. when the group left the classroom) – that wasn't the end of it – otherwise what was the point in keeping the pictures? It's still progressing, still helping in the present and I am looking at how it can continue in the future...

Conclusion

What was achieved by Joseph in this weekly group over the period of nine months?

From my point of view, he discovered how to 'play', and found that this was a way to help him maintain balance during his prison sentence. After initial marks with crayons, delineating first his neighbourhood, then his actual home, he set himself the task of making 'a better house', on which he worked for many weeks with detail, care and attention. During these weeks, I learned much about my own counter-projections on Joseph and his work – I found it difficult to 'hold' the situation patiently, knowing (how clever of me!) that he needed to find a different way of using the materials, if he were to express feelings, rather than control them by working in a planned, linear manner. His first attempt at using paint remained unfinished, and I felt that this premature exploration was not self-initiated but prompted

by my impatient wish to force his pace. I took stock and fortunately was able to retrieve the situation.

A Storm at Sea was a turning point for Joseph. Here was a different kind of energy from that which went into his 'house'. Here were spontaneous marks where Joseph allowed the materials to have their say, instead of trying to control them. This was 'play'. It continued into the next week, resulting in *A Peaceful Flower Garden*. On this occasion, Joseph explored – he explored colours, how they merged and mixed, the nature of different tones and how they looked in relation to each other; he experimented with different brush strokes – stippling, circling, turning, sweeping. Intent on discovery, he was absorbed in a dialogue with his creative energy. Further adventures with the paint followed – sponges and bright tones came to the fore and, in a celebration of colour, *The Patchwork Quilt* was created.

His last picture is a culmination of his confidence and experience in the group during the previous months. It could also be seen in its subject matter – a sunset – as the bringing to a close of a particular period of his life. In warm glowing tones, the sunset spills colour over sky and sea. Joseph wielded the sponge with authority and dexterity – the materials and his mood were in unison, flowing in harmony. In this painting, as in *A Storm at Sea*, he was working in an emotional manner, a profound change from his initial drawing with its intellectual detached view.

In the art therapy group, Joseph was able to find a place for safe expression of his feelings. His work changed from a linear to a massive style. He had begun his series by working in a traditional manner; by the end of his prison period he was able to gain access to an archaic form of expression, where he played out feelings of anger and frustration as well as pleasure and excitement. Some two years after his release, Joseph still used the paintings to prompt himself towards a more satisfactory outlet during a period of depression.

Reference
Simon, R.M. (1991) *The Symbolism of Style. Art as Therapy*. London and New York: Tavistock/Routledge.

Art as Therapy in a Young Offender Institution

Celia Baillie

Introduction

I worked as a part-time art teacher in a B category young offender institution on Portland for two years. This prison took young men, of between 17 and 21 years of age, from a catchment area bounded roughly by Wales, the Midlands, Cornwall and Hampshire. At times, the prison took some overspill from prisons such as Brixton in London. Sentences being served ranged from a few months to several years. The young men lived in wings which were huge stone buildings, straight out of a Daumier painting, dwarfing everyone. Movement in the prison was restricted; parties of young men had to be escorted by prison officers, or, in ones and twos, by an orderly who was an inmate held in some measure of trust.

Prison officers talked of how, when the prison had been a borstal, most inmates had had work during the day (and so had experienced an outlet for natural energy); now, with the conditions of the 'Fresh Start' legislation, with its restrictions on overtime, many inmates were confined to their cells for the major part of each day. The cells were mostly single, each with a small barred window which looked out over either a vast sea/sky or the 'cliffs' of the other buildings. Communication from one cell to another was made by standing at a window and shouting into the void; disembodied voices wafted round the roofs.

There was a visitors' room at the entrance to the prison; families and friends often travelled many miles to visit, some on the weekly coach from Cardiff to Portland. Inmates were exposed to painful uncertainty concerning

visits; apart from the rigours of getting there, many family members were vulnerable and chaotic, or inept and puzzled.

The young men were infantilised by a system which is required to control and monitor all aspects of their lives. They were addressed by their surnames only, and dressed from a common pool of clothing; trousers and jackets were made from denim, and sweatshirts were a nondescript grey. Although most tried to maintain some neatness and dignity, clothes could be ill-fitting, or damaged in some way (sometimes intentionally) by a previous wearer. Letters were opened and read; possessions were restricted and available to be searched; and money paid to inmates for work was derisory, maybe £2 or so per week.

These young men were (and are still) in need of models of autonomy, and adulthood, so that they could come to terms with themselves and their actions, and act responsibly towards their families and dependents (many young men had children). The prevailing status symbols, in the absence of a more positive framework, were narcissistic and self gratifying, and it was very difficult to encourage a different perspective in a setting which robbed them of integrity itself, as a punishment. These young men had been raised on punishment, and were used to maintaining their defences against it, entrenching themselves in established patterns of behaviour.

In my work with them, I tried to enable experiences of the creative process, which I believed would encourage a sense of integrity. I used the cycle of creativity described by Rosemary Gordon (1978), of conscious struggle (the original idea), followed by muddled suspense (when things don't work out), leading to illumination (sticking it out and being open to new thought) and reunification (working at the new idea). I see this cycle as describing change itself.

I was also influenced by another description of a process of change, by Sluzki and Ransom (1977), which they call 'Saltus', from the Latin for 'leap'; at a certain point in time (the crisis), there is a sudden change to a completely new system. Nothing new has been added, but there is a re-organisation following a triggering event. The conjunction of 'event', 'feeling' and 'significance' can stimulate and precipitate change. I believe the experience of art work itself, the use of materials, the making of effort, can provide an analogy for the management of daily living, and be a healing experience.

I tried to bear in mind the young men's reluctance to change, remembering the characteristics of a fragmented ego, described by Redl and Wineman (1951), and the autistic barriers, described by Tustin (1986).

I shall describe the art work experience of seven young men to illustrate how, in circumstances which were almost totally uncongenial to conventional

therapy, growth and healing were nevertheless achieved. The focus was always on the task or piece, and my role was to perceive the opportunities for change. I will try to show how the everyday duties of teaching can contain therapeutic responsibilities; I tried to construct opportunities for the 'event' to happen, allow the 'feeling' during the making, and hold the 'significance' of the piece. As art therapist, I was responsible for the choice of medium, sense of order, the balancing of active and passive participation, appraisal of the work, fostering the therapeutic alliance, receipt of feelings, and awareness of issues of interpretation and transference/ counter trans-ference. Elements of these factors come into each example of work, to varying degrees.

The young men were assigned to the Education Block following assess-ments (on entry to prison) of their academic needs, or on application from officers on their wing. They could be removed at a moment's notice for bad conduct or on the recommendation of any staff, as well as by removal to another prison. I worked with those assigned to the special needs depart-ment, which constituted one side of the education buildings and was housed in converted cells, long narrow rooms with four tiny high windows apiece. I also ran an evening class in an art room once a week, for which anyone could apply, and the atmosphere in this was more recuperative and carefree.

In the special needs department the young men had learning difficulties or severe gaps in their education, and many had minimal literacy and numeracy skills. I introduced wood carving, clay and plaster into the carpentry room, which was dreary and dirty, with random heaps of scrap wood, making logical choices of material impossible. The concern for prison security regarding woodworking tools had to be taken very seriously. Being a teacher was not a bridging role, rather it made me the butt of suspicion, from officers and inmates alike; I felt in a double bind. Because this made me feel so trapped and helpless, I used my own feeling as a metaphor for how the inmates might feel. This 'trial identification' (Casement 1985) enabled me to experience something of what it is like to be in the prison system, from both sides.

I came to see it as my responsibility that dangerous tools could not be stolen, so that the group could relax. It became my aim to be seen to be polite to inmates and officers alike, so that both would perceive impartiality. I felt it was important to confront, in a non-retaliatory way, the petty thefts of materials from me, and the spiteful or negligent damage of each others' work, so that the group could experience the idea of consequence. There were frequent demands for me to allow infringements of minor rules; any flexibility could backfire, with those allowed leniency becoming very dis-

ruptive in subsequent classes. This conveyed a message to me about the need for clear boundaries.

The base line was that I had to prevail, willy nilly; within the system I had to maintain my strength and be seen to do so. I set myself the aim of being pleased to see them each time – anything else would be a bonus. In extreme situations, where mayhem might ensue, I had to enforce the official machinery of prison discipline. This seemed to make the group feel safer, but it was a very distressing experience to administer, as well as to undergo. (I put three lads on report and fined six in the two years). All I could do for the individual was to try to convey in my report the potential which was being blocked by his current disruptive behaviour. The concept of fairness was experienced subjectively, and almost impossible to achieve in the prison atmosphere of persecution; everyone, in their own way, suffered and imposed stereotyped projections.

Everyday events cut across intentions, and nothing could be taken for granted as established; in prison routine the monotony of institutionalisation is punctuated by random decisions by 'other people'. Defining oneself, in such circumstances, by more refined criminal behaviour makes perfectly good sense. Art work offered the young men experiences of autonomy and inner progress which could be achieved, acknowledged and absorbed, without threatening their management of daily life in the prison setting.

Very few men came both to my day and evening class; if anything, I believe it was quite hard for those who did. In the evening class they could experience the more indulgent atmosphere, when officers were less obviously present in the corridors, and there was no academic brief. In both classes I tried to be equally lenient about their ideas and needs, and equally firm about artistic discipline, but, essentially, one class was 'work' and the other 'recreation'.

The frustrations of the system, the short working times of 1½ hour sessions, the compensations of tobacco and intrigue, and the need to express oneself, all vied with each other, so that it was hard for the young men to commit themselves to any effort. When they did work, it was often as an attempt to escape and retreat, rather than explore and develop, and they valued copying photographs, Pre-Raphaelite-type paintings, fantasy posters, cartoons, motifs, whose associations were often voyeuristic, overly sentimental, aggressive, sexy and /or sadistic.

Producing a good copy was almost always beyond their own skills, and this failure served to reinforce existing low self-esteem. Maybe more importantly, adequate success in copying served autistic tendencies of rigidity, to the extent that the skill could be used to blot out uncertainty. At first I tried

to counter this, but came to see my efforts as 'ripping off scabs', and began to appreciate such work as a survival technique.

I bought plaster cast moulds which I chose for their potential as symbols; a pierrot, for instance, may evoke sadness, an Alsatian dog may suggest pride or aggression, and a family group might facilitate associations of co-opera-tion. Although there was no creativity involved in making these models, by painting them the young men could use their imaginations. I always bought the best quality acrylic paints so as to make the task as easy as possible, and I left the prices on the boxes so that the class members could see I valued them enough to 'buy the best'.

The following case studies describe the work done by a few of the young men who came regularly to the classes. All the names have been changed to maintain confidentiality, except for one, where the reason will be made clear.

Thompson

Mostly feelings remained unconscious, but occasionally someone would portray, and maybe own, something of their own emotions. Such a person was Thompson, a rather literal, amenable young man who chose to come to my evening class. He agreed, rather passively, to try working with clay. His energies in class were often taken up with conversations and gossip about daily happenings. These conversations sounded dull and detached, with flurries of interest about events; it was as though his feelings did not and could not reach him.

As he worked on a clay head, he added another face on the back as a joke. He seemed curious when I encouraged this and went on to add 'provocative' features: one face had slit eyes and a vomiting mouth with its tongue lolling out; the other had excavated eyes and a joint/fag stuck in its mouth. He asked how to manage shared ears and I suggested headphones. He had to hollow the head for firing and this released the image of an 'empty head'. He said he felt being in prison was like this and, when the head cracked, this only added to his opinion. He painted it in garish colours and had no intention of keeping it.

I felt he had become less passive as his ideas were accepted and his interest became engaged; he had offered his own interpretation and allowed himself access to his feelings. I felt my relationship with him (as art therapist) had been important in eliciting the feelings portrayed in the work. These feelings may have surprised him, arising through rather different channels from usual. He experienced portraying the feelings, reviewed them and dispensed with them 'in the bin', a strong symbolic statement in itself, which can gain in impact from being seen by the therapist.

Deverell

All the other young men I shall describe came to the special needs education classes. One, Deverell, also surprised himself by making heads; he had shown unusual verve, wielding the clay deftly from an amorphous mass. He was pleased by the results, and was surprised that I encouraged him and helped him prepare the work for firing. He completed several heads, one of which is shown in Figure 3.1.

Figure 3.1 Deverell: Head with monocle

He was absorbed while he was working, and emerged as from a reverie. He preferred life in prison, saying he had 'nothing on the out'. He had been in care since he was four, and he passed through the education department three times in my two years there. On one release he was re-arrested after four days, and he felt satisfied when he had a four year sentence and could relax.

After his third admission he was looking at photographs of his work, and the heads seemed to provide him with links between prison and the world outside. He was surprised that any fuss had been made of them, and remarked of one rather absently, 'Oh, the railway porter'. He spoke of the heads as though it puzzled him that they might continue to exist, and that he had actually made them. It was important to him to have the heads owned

by others; he gave me the 'railway porter', a painted punk was on display in the prison, and the 'monocled man' was with friends. I felt the heads 'stood in' for him, to give shape to some of the people, events and impressions of his chaotic life.

He could not tolerate much delay, and technique had to be kept to a minimum. I made repairs at home when such things such as ears and eyebrows fell off during firing, because I felt it was important that his images held together; he did not have enough ego strength at that time to tolerate the delayed gratification entailed in learning good technique. I was able to praise his innate talent, hopefully giving him a starting point of self-esteem, which he might sometime recall.

Figure 3.2 Fielding: Head

Fielding

Fielding, on the other hand, had a much stronger ego. He was a thoughtful young black man who worked inventively and thoroughly, having great patience, tolerating mistakes or adaptions. He was reflective and, in the group, could often proffer an alternative, less biased view-point in emotive discussions. He was often on the periphery of the group physically, and while engaged on this piece (Figure 3.2), was working quietly at the back of the room.

The face was constructed like a mask, with the empty back supported by a lump of clay. After a couple of sessions, Fielding said it was finished and I photographed it. I praised it and suggested he might like to work on the back of the head to prepare it for firing, as the solid lump of clay could explode; the scarf and shoulders were in the round, did he want the head in

Figure 3.3 Fielding: Head, transformed

the round? I left him to it and was astonished when I next looked, for he had utterly transformed it. Over the next few sessions he developed it to the head in Figure 3.3.

He asked for help with the eyes, and I constructed an eyeball and skull socket in another piece of clay as a sketch. Nothing was said about the transformation as a developmental step, but I consider that a great leap in maturity had been made: he had used my suggestions, my involvement in the piece, then taken his own initiative, risked everything, and arrived at his own illumination. He had been able to return to the therapeutic alliance for advice about eyes, and move off independently yet again. He was very proud of the head and handed it out to his parents when they visited him.

I had wondered if my suggestion was appropriate, and in his case such an intervention had been tolerable; he could have survived failure, and we did have a photograph. The art therapist needs to be sensitive to the issue of success or failure for a piece of work, and what that may mean to the individual at the time; Deverell and Fielding had very different tolerances. It is important to follow the needs of each person, to abandon hunches that are inappropriate, and to be prepared for surprise developments.

This approach was also a major factor in the work with Herbert and Bailey (see below), but with them there was more chance of failure exacerbating chaotic behaviour.

Herbert

Herbert was particularly immature, probably connected with brain damage from childhood batterings. I had first met him when he was on probation and I had been working at the Probation Day Centre (from which he was eventually banned). He was curiously susceptible to intrigue, and functioned as a catalyst for chaos and provocative random reactions amongst clients and staff alike. When he recognised me in the prison, he became excited and vigorously tried to dredge up details about me 'on the out', information he felt would embarrass me and disrupt my authority in the class. The attempts themselves were pathetic (like trying to remember my first name, whereas it was written on all my books in the book box!), but the atmosphere became heightened by his agitation. I had to warn him of the disciplinary action I would take, and then put him 'on report'. I saw him regaled by the others as to the awesome consequences of this, and he became subdued.

On making the report, I voiced my belief that he was incapable of self-control, and was relieved to hear that he had pleaded for clemency from prison officers on the wing. I felt he had experienced me as being able to set a boundary (which I had not had the authority to do at the Day Centre); it

was as though he needed to be frightened before he could gauge things. I surmised that a state of fear had been so habitual in his past that he did not feel 'normal' unless he was experiencing fear, or was part of a chaotic tension. In class he became anxious to be well behaved, and constantly asked me if he was, as though this was a variable he could not assess (and this was probably true).

He was able to achieve a definition of boundary more creatively in his work, which was a relief carving of a fish. A fish was a popular theme with the young men, and was tackled with varying degrees of skill and enjoyment. The benefit of working on a relief is that, from the start, the outline is secure and the promise of eventual success established. In Herbert's case, this outline, this boundary, kept vanishing: however precisely I answered his constant pleas for meticulous direction, he did not seem able to carry through an intention, and his work degenerated repeatedly into a morass of haphazard and chaotic strokes. I had to keep restoring the fish's outline, modifying the frequent obliteration of its form, and I began to feel he would not achieve anything independently. It was imperative to complete the work quickly, partly because his sentence was short, and partly because the piece would not survive long. So I brought in two different stained varnishes, one dark and one light. Herbert used these to distinguish fish from water and, although he found decisions regarding the outline difficult to make, he did manage to establish the fish and contain it. He was inordinately proud of it, bearing it home with him.

As an art therapist, I had a chance to contribute to the process of change through technical skills in the handling, care and presentation of the materials. Ingenuity, especially on a restricted budget, was also important; devising ways of overcoming obstacles to the fulfilment of Herbert's idea, may have provided a symbol of overcoming psychic blockage, albeit at an unconscious level (since Herbert could not discuss his experience).

Bailey

My contact with Bailey was more prolonged and involved more therapeutic issues. The transference was more particular, yet could not be owned or dealt with openly: I relied very much on the young man integrating his experiences through the success of the work itself.

Bailey was a very excitable young man whose agitation conveyed itself in noisy disruptive behaviour laced with seductive charm; he received regular sedation. He chose to work with clay, made a dish, then had a clear idea for a helicopter. We spent several weeks struggling to achieve this; it seemed very important that this improbable notion should succeed, should hang together

somehow, and I made many running repairs as Bailey cheerfully added protuberances. He tolerated the fractures well and did not seem disturbed by necessary modifications, like backing a surface with card or wire. When it was ready to be painted, he chose black and white paint, and had very clear ideas, portraying the pilot from three angles, and writing 'ACID ACID' and 'ENGLAND' on the main blades. He could accept the delays while the paint dried. (I had purposely provided quick-drying paint.) His behaviour in class was still boisterous; he threw clay when he could and then denied it; I conveyed that I knew what he was doing but was not provoked.

I brought in a small log for him, feeling that he would respond to something in its natural state. He fell upon this with relish, stripping it of bark and hacking it into a horse's leg – his ambition was to be a farrier. It was always difficult to know whether to forestall failure, or help someone survive it. I kept an eye on Bailey and as the leg took, and then began to lose shape, I suggested he might enjoy a small tree I had been given. He was delighted by this, and by the spectacle of me hauling it in for him! The tree was about six foot long, with roots but no branches. He was going to make 'a rasta' with the roots as hair. (He himself was white.)

At this stage Bailey became less troublesome in class; he no longer threw things around, and seemed able to be part of the group. He was also able to work more independently. Nevertheless, I felt I had to be more careful than ever, since there seemed to be a positive transference towards me, embodying maternal care. He had commented on our names being the same and had called me 'Mum', suggesting I could easily adopt him. Answering this was largely solved for me by other lads suggesting themselves instead, and we all spoke in jocular vein, although grounded in pathos. After this Bailey told newcomers to the group that I was his Mum, and I found a way of saying languidly 'Yes, yes, that's right', which conveyed tolerance of the 'joke'. It seemed important, with Bailey, to hold his infantile exuberance, and to defuse its possible anarchic impact on the group, who watched keenly to see how all members were treated.

To work on the tree, Bailey decided to stand on the work bench with the tree upright in the vice; this became his own 'place'. He then asked for protective clothing and I brought him in an old pair of dungarees, which he put on at the beginning of each session before leaping up to his perch. I felt the dungarees had associations with me as provider, and also with him as worker. He did not take advantage of these permissions, and I felt they served a deep unconscious need in him. By accepting calmly what I believed to be transference manifestations, I hoped to help him consolidate his sense of

self. Bailey was able to use the lessons for regression in a contained format, via the dungarees, the work bench and the special wood.

When the 'rasta' was about to be exhausted, nothing definite having emerged from the engrossed activity, I suggested Bailey might make a 'group' out of pieces of wood. The wood supply was largely of scrap, with many abandoned and half-worked pieces which gave rise to useful and interesting shapes. By hunting, choosing, collecting, selecting and assembling these, using glue and nails, with all the attendant (legitimate) excesses of fierce hammering, components of the group could be completed within his concentration span and with fail-safe success. I hoped this would also provide an analogy of wholeness from parts.

He had very grandiose notions for 'the group' (Figure 3.4) and while some of these were impossible, his ideas could be reassessed in relation to what he had collected. The more modest configurations could be seen as positive compromises rather than failures. As and when Bailey's competence or concentration waned, I tried to find possible ways forward for him and for 'the group'. (We still called it a 'group', although he did not have the stamina to do more than one person.) I tried to assess when he was likely to exhaust a positive attitude and be pitched into random behaviour, and at this point would introduce a new motif or modification.

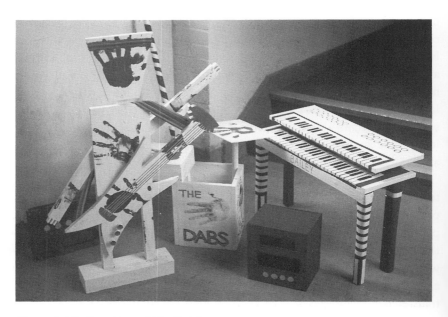

Figure 3.4 Bailey: Group 'The Dabs'

When Bailey painted 'the group', I concentrated on establishing a sense of sequence and order; some pieces were to be white, some black, and the inside and outside faces, backs and fronts needed covering. I protected a large area with newspaper so that his mess would be contained. Colourful car spray cans were not allowed in the prison, so I brought in tins of black and white enamel, and he painted during several sessions. The hand prints were suggested by me as decoration, at a point when his hands were messy anyway, and he delighted in the extravagant process, and also in cleaning himself with the 'special' Swarfega I kept for the class to use.

There was a lot of interest (some vicarious) in 'the group', partly as it was 'daft' and yet obviously taken seriously by me. Naming the group 'The Dabs' was a joke we all enjoyed. I bought some screw-on knobs for the guitar and Bailey was astonished at money being spent on him. I brought in coloured bands and a silver felt-tipped pen (for the strings), and this all added to his sense of self-esteem. The most dramatic touch, however, was made by him using a reel of white insulation tape. I had wondered how he would manage the keys, and had thought strips of insulation tape would serve. Bailey was entranced and spent several hours neatly, methodically and symmetrically decorating the keyboard, so that all that is white on it, in the photograph, is tape! He asked me to do the black keys with marker pen, and his name was emblazoned on the front.

The finished group was prominently displayed, to his consummate pride, praised by officers, teaching staff and some inmates. In prison, what was generally praised was intricate, highly varnished work in matchsticks, or photographic copies of detailed fantasy pictures. Bailey's work was exuberant and innocent and, I believe, probably matched his emotional needs. Unfortunately, soon after this he was withdrawn from classes for a razor attack on another inmate, and was also sectioned after attacking an officer.

Probably both Herbert and Bailey were too damaged to apply their experiences with art to their personal lives. I believe all I can do, as a therapist, is to try to understand what it feels like to be 'Herbert' or 'Bailey', and give of what it is like to be 'me' – offering my conscious consideration of them to their unconscious.

When a therapeutic alliance does lead to healing, there is often a progress from passive to active. After experiencing symbolic nurture, the recipient can start to take on responsibility for his own success. In art therapy, the art materials provide an analogy for inner work; working with that material helps to establish a personal sense of order, and provides a symbol of his own capacity for development. The art therapist as creator is an important example

for the inmate, and can contribute to his ability to function more creatively in everyday life.

Cook

Cook was a personable young man who alternated between sensitivity and aggression. He wanted to go to Grendon Underwood Prison to address his capacity for violence, yet he spoke proudly of having got his pals to threaten witnesses. As it was, he had a long sentence and would 'graduate' to an adult prison to see it out. He described a family well acquainted with prison life. He had a girlfriend and an infant son, and alternated between possessive devotion and possessive ruthlessness in his attitude towards them. He spoke of intending to steal his son, and of battering the mother (he had broken her nose in one incident) if she did not fulfil his demands. His two front teeth were missing from fights and he looked a curious mixture of man and boy.

When his appeal against his sentence failed he was furious; the law, anyone, was there to be outwitted or bullied. It will be seen how he struggled with these opposing factors in himself during his time in my class.

When he joined the group, Cook's diffidence was his main defence; he was illiterate (as were many of the young men) and he resisted looking at the art books I had in class. He agreed to my idea of making building blocks for his infant son. I suggested this because, as with Bailey, much of the work was already done on the scrap wood; all Cook needed to do was choose and collect, then saw pieces into lengths. I was careful not to suggest symmetry or measuring. Cook chose lots of wood and we discussed which pieces were better prepared, or suited for variety. As time went on, he pruned down his lavish intentions and, just as he started to wilt, I brought in brightly coloured varnishes so that the bricks could be stained and sealed quickly. The effect was disappointing in that the harder woods did not take the colours as well as the softwoods, but Cook had enjoyed the planning and painting, and he was pleased with the result.

In another class he made and embroidered a bag for the bricks. When I suggested we photograph the bricks, he was ambivalent but arranged and photographed them. Another class member suggested a better arrangement, and Cook watched as he rearranged the bricks for a second photograph. I felt Cook needed to see other people value his work before he could do so himself. He gave the bricks out during a visit from his family.

Cook was in a group which I took several times a week; later I arranged to work only in the woodwork room, but at that time I had a general art class too, in the converted cells. In one of these classes I drew the young

men's portraits as part of them posing for each other. Cook was entranced with this and captivated by seeing himself 'through my eyes'; he had less regard for the others' drawings, though they captured something of him too. He saw it as 'magic', and I felt there were several levels of meaning to this. One was that he liked the drawing; another was that he saw himself 'seen'; another was that he assumed I could produce it with ease, and could not grasp I had to work at the drawing. He wanted to hand the drawing out to his mother but it got lost in the cumbersome and sometimes callous prison procedures. On one level these things were quite ordinary, but on another I believe they were details of transference, in which Cook was trying to be 'seen' positively by others, especially his mother.

At this point Cook took a great interest in photographs of my own work and asked me to bring in some pieces. I did so and he was outspoken to newcomers about the sculptures 'Miss' did. Generally the group became more at ease with the nudity portrayed in my carvings. There were comments about male nudity, but also curiosity in the female, since these carvings were different from the usual things they saw, and they sensed that I, as a woman, was involved in how I carved women. They could also see I took liberties with form and detail, and were impressed that I sold my work. I felt that many of their stereotypes about women were being challenged.

Cook said he wanted to copy one of my carvings and asked me to bring in a large piece of wood. I was worried about this, not because of the copying as I had got used to this – but because the pose was almost certainly beyond his skill. The log I brought in did not suit the original idea, and we discussed what pose would suit it. Cook worked enthusiastically and earnestly, and very much saw the wood as 'his'. He stripped the bark and so got used to the gouges and mallet. Then I showed him how to saw off blocks to release the head. The carving took many months to complete. The early work on a carving is very generalised, establishing directions and planes, and I had to tell Cook exactly what to do. He found it hard to grasp that this stage is taxing, however skilled one is, and saw me as 'knowing' and himself as 'not knowing'. Cook started to experience the stress of uncertainty for himself, the 'muddled suspense' Rosemary Gordon (1978) describes; he tried to avoid it and clamoured for instruction, but I could not direct him without appropriating the work. At this point he became very angry and possessive, protesting fiercely and explicitly that my job was to help him rather than the newcomers to the group. I told him I could not help him through this phase because: first, I could not see into his head to know what he wanted; second, he now knew all the technique he needed and just had to 'do' it; and third, I was there for the whole group however angry it made him feel.

I wondered if his anger would overwhelm him as he started to carve furiously, and I could not tell if he was battering it, or maybe even sabotaging it. I concentrated on remaining calm and seeming preoccupied, hoping to convey I had every faith in his capacity to act alone. At the end of the lesson he brought me the carving, bearing it almost as he would a child, and with a flushed wide-eyed face. It was an exciting moment; he had moved on and created a form very different from one I would have made. He was obviously very satisfied with himself, and I said how excited I was, that he'd done it, and made it his own. I believe he could now see that I had not withheld help maliciously.

After this his attitude to the carved girl figure softened, and he more or less ceased his jokes about 'knockers' and 'bums' and 'beating her up'. He spoke of her with pride and took all the chances he could to work on her. He asked for help with the face and plait, and I followed his instructions. I

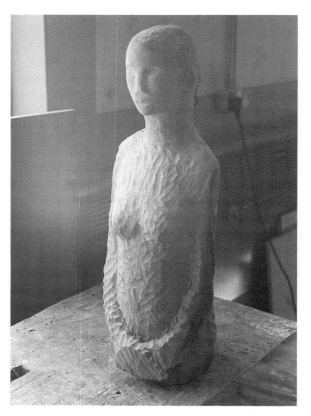

Figure 3.5 Cook: Young girl

felt he understood better, how it was effort for me too, not just 'magic', and was able to accept me more as a person. He was also able to be dissatisfied with aspects of my carving, which were not as he had conceived.

Cook wanted a base for his carving and asked for a log, so that it would show how his piece had once been. I brought in a large log of oak and Cook sawed off a piece for his base, putting the rest by for his next carving. He knew I was leaving at the end of term and he wanted to be sure he could continue. When he fitted the base, there were several jokes about 'drilling into her bum' and the use of dowels, but his tenderness returned in setting her on the base and varnishing her. Another young man, Howell, helped him with planing the surfaces.

Cook asked me to write out instructions for him for his next carving, as he was worried how he would get on without me. I did this, with diagrams and drawings, put it in a special folder and got clearance for it to go over to the cells. He was pleased and said it was just what he wanted. I don't know if he will ever use it because it is unlikely that carving will continue in the prison, but I kept the language simple (for his reading ability) and left a message in it saying, 'Be patient, be proud'.

Because of his long prison sentence, and his good academic progress, he was shifted to a work placement (with a capable motherly woman instructor) to learn office cleaning, and he did very well. When I visited the prison a year later, Cook had become Education Orderly, a position of merit and trust. He entertained me to tea in the orderlies' room, and we chatted in some depth about carving. Some time later, he intervened to break up a brawl in one of the classrooms, coming to the aid of a teacher whom he admired and who had treated him with dignity.

Roberts

While Cook was working on his girl, several other members of the class started to carve female figures too. There were some similarities of identification with my work, but there were also differences. Roberts, who was in Cook's group, was another diffident young man, waspishly adverse to suggestion or effort. After making the usual small box from scrap plywood, and seeing someone else's carved love heart (another favourite motif), he started on a 'rose in a heart'. In relief carvings it is possible to achieve an effective result with a minimum of skill, if advice is clear cut, and Roberts was very satisfied with his heart, taking more initiative towards the end. I bought him fixtures to hang it, and he wrote 'Mum' on it with a marker pen.

He then wanted to carve a figure like Cook's, so I started him on a piece of wood about 12 inches long (much smaller than Cook's piece of 29

inches). Roberts became engrossed in this and worked fairly independently. At that time he was being insufferable in other classes; the end of term was approaching, and when he asked to have extra sessions in the woodwork room, staff readily agreed. This meant him joining different groups, but he applied himself to his work and countered jibes with calm sarcasm. As his figure progressed, he willingly allowed her belly to be pregnant, which surprised me, given his cynicism and the general lewdness in classes (although no comment was ever made). There was a curious innocence about the piece and his mood; it was to be for his mother (as was the heart), and he worked hard to finish it for her next visit.

I felt here, as with much of the work generally, that there was often a deeper symbolism involved, albeit unconscious. I believe there is an archetypal framework which is well represented in myths but also has visual expressions. Thus people may use images or symbols intuitively, which point to the stage where development of the self was disrupted. It is important not to impose interpretation of archetypal work, as understanding must come from the person in his own way. It may be enough for that person to have portrayed something, for an affirming process to take place. I hoped my acceptance of the work might enable the creator to tolerate a wider range of feelings, and learn to handle those feelings in real life.

I became aware that I had expected far too much from my students. Their main task was to remain intact within the penal setting, and their previously acquired defences were still useful to them. My early hopes that the young men could use their art work to liberate their feelings explicitly had been thoroughly unreasonable; they had to be able to return to their cells where there was no question of support, as therapists understand it. Many officers offered paternalistic contact, and maternal influence was mainly provided by female teachers. Most sectors of prison personnel felt misunderstood, so acted within their own parameters. Many staff members held the same views as the young men about what was 'good art', and I found it hard to convey what was of value about 'unskilled' work.

Despite this lack of understanding and support, there were worthwhile gains. I knew little about most men's offences, and I concentrated on each person as I found him. By behaving honourably, civilly and imaginatively, I hoped that these qualities might be absorbed and become part of a new pattern of behaviour.

When I knew I was leaving, I tried to prepare the groups for my departure. On the last day I held two parties, and took in biscuits, coffee and cards for everyone, made from photographs of my work. We played board and card

games, and I felt the parties themselves contained elements of 'Saltus': the event, the feelings and the significance affected us all.

Deverell's group exhibited a primitive need, greed and longing during the party, and left in a rather numb way. Cook's group had a much more integrated feel; members were able to share round the biscuits, and we talked together of what we would be doing in the future. When this group left for the mid-afternoon break, Cook and two others lingered, one being Howell who had helped Cook with the base. I shook hands with Howell as he left the room, but when I shook Cook's hand, he suddenly gave me a kiss on the cheek and so did the third young man. I was very touched, as it was something quite new for them to have emotion for a teacher (given the early struggles), let alone show it. Later these three returned before joining the queues to be frisked and taken back to the cells. They said they'd come to say cheerio again and Howell came forward and kissed my cheek too; I felt this emphasised their conscious decision and acceptance of feeling. I accepted their farewells as gifts.

Looking back over these events, there are many times I have described the sort of interaction which is 'not done' in therapy, such as punishment and suggestion, yet I believe such interaction was based on sound therapeutic principles. We had a bond, the art, and we achieved the therapeutic alliance in its progress. I set out to enable each person's autonomy by attending to the particular significance of his work for him, concentrating on practical criteria. My original basic aim, somehow to steel myself to be pleased to see each group each time, had been transformed in me too, to something genuine in its pleasure, despite the difficulties in the situation.

Healing aspects of the work had been available albeit unconsciously; an atmosphere had evolved over the months through the young men sensing the involvement we all experienced as the work was done. I hope that the experience of creative work itself had served to strengthen aspects of each young man's ego. For myself, I was grateful for the therapeutic principles, and the structured attitude towards the processes of change and creativity, as these gave me a thread to unwind in an often confusing, muddled situation.

References

Casement, P. (1985) *On Learning From The Patient*. London: Tavistock/Routledge.

Gordon, R. (1978) *Dying and Creating*. London: Society of Analytical Psychology.

Redl, F. and Wineman, D. (1951) *Children Who Hate.* New York: Macmillan Publishing Co. Inc.

Sluzki, C. and Ransom, D. (Eds). (1977) *Double Bind.* London: Academic Press.

Tustin, F. (1986) *Autistic Barriers in Neurotic Patients.* London: Karnac Books.

The Hidden Therapy of a Prison Art Education Programme

Colin Riches

Introduction

In 1986 I set up an Art and Craft Centre in HMP Albany, which was then a maximum-security prison. The Centre was a pioneer development in the Prison Service, providing full-time employment and teaching for up to 18 prisoners, most of whom were serving long-term sentences for violent crimes. Two full-time and two part-time teachers conducted the work programme, which included painting, drawing, wood-carving and print-making; projects were also undertaken for charitable organisations in the local community. A three-year research project at the Royal College of Art enabled me to evaluate the contribution the Centre made to the prisoners' welfare and to the prison regime; I also made a comparative study of art in prisons on a Churchill Fellowship visit to the USA.

Art is about risk-taking, self-exploration and self-expression; prison is about regulation, imposed controls and the minimising of risks. These two apparently incompatible worlds can combine in a fruitful partnership yielding therapeutic benefits for prisoners and more equable regimes for prisons. This chapter identifies some of the benefits arising from the artwork of long-term prisoners attending the Art and Craft Centre in HMP Albany.

Art in prisons – an unlikely partnership

Displayed on strategic sites throughout every prison in the country is the Prison Service statement of purpose. It reminds staff of the two principle functions of imprisonment as defined by the Prisons Board: to keep in

custody those committed by the courts and 'to look after them with humanity and help them lead law-abiding and useful lives in custody and after release'. Imprisonment is intended to punish, confine and deter criminals while reforming and rehabilitating them.

However, these functions can be in conflict when they are implemented in the daily life of a prison, because custodial discipline often has to be relaxed in order to accommodate treatment and reform programmes. Subversive prisoners can exploit this relaxation of discipline and so cause disruption. This is one reason why such activities are perceived by some, usually more authoritarian, prison staff to be a threat to their primary responsibility of maintaining security and control in the prison. An official report on a special hospital (*Report of the Review of Rampton Hospital* 1980) identified the difficulty of providing therapeutic activities in institutions where security is a priority. It stated that anything approaching total security would only be achieved at the expense of most, if not all, therapeutic activity.

Treatment and reform programmes, including art education and art therapy, are generally successful when prisoners, prison staff and teachers or therapists enjoy a measure of mutual trust, and respect and discipline is not jeopardised. Some tensions are inevitable at the interface of the two different worlds of art and prisons, and the success of this unlikely partnership depends on each partner respecting the skills and needs of the other in the pursuit of a common goal.

The effects of imprisonment are many and varied, and both prisoners and staff develop strategies to enable themselves to survive its pressures. Most prison staff acknowledge that prisoners are not improved by imprisonment. On the contrary, the attitudes and behaviour of many prisoners deteriorate as they adjust to the boredom, tedium and stress prevalent in many regimes.

Mick, an Albany prisoner, wrote:

> Separated from all civilian life and influences, and without domesticity, values become blurred, language coarsens and the mental processes become locked into formalised channels. The more sensitive instincts soon become blunted and the prisoner progressively cares less. Self-confidence is quickly eroded, which can lead to a prisoner feeling embarrassed and vulnerable. This will lead to a show of aggression, which can then lead to actual violence, if only to cover up his own misplaced loss of confidence.

Many prisoners are acutely aware of (and fear) the potential for deterioration implicit in imprisonment. Mark, a category A prisoner* serving 18 years said, 'We're all failures, otherwise we wouldn't be here, and we need help.'

In recent years numerous Home Office and Prison Department reports have underlined the need for constructive, creative and purposeful activities to offset the deleterious and dehumanising effects of prison life. Arts programmes are able to make an important contribution to this end, encouraging personal development, self-esteem and a small degree of autonomy.

Art, art education and art therapy – a continuum

Before prisoners and their work are discussed in detail, it will be helpful to clarify and differentiate the purposes of an artist, an art teacher and an art therapist. Although the boundaries between their respective disciplines are fluid, the practitioners of each discipline are generally careful to distance their respective roles one from another.

An artist is in the business of making art. He (or she) investigates issues which force him to explore his ideas imaginatively and to discover visual forms with which to clothe those ideas. Art teachers are concerned to develop the same skills in their students. There is a value in teaching drawing and painting skills, which may equip students to enjoy art as a leisure activity or, in the case of a few, to develop a career.

Art and craft education also serves a more general cognitive function by enabling us to acquire knowledge about the environment through our senses. The organisation of this knowledge is part of the process of sensory perception, and enables us to make sense of the infinite complexities of the world. Art education develops and strengthens these faculties, thereby enlarging our awareness of ourselves, of society and of the environment.

A particular advantage of art education for prisoners is that it is taught by demonstration and practice. It is 'learning by doing' and is therefore especially relevant to those who have failed, or who have been failed by, an

* Sentenced prisoners are categorised from A to D according to the degree of security required to keep them in prison. Category A prisoners are those whose escape would be highly dangerous to the public, the police or the state; they are held in a small number of 'dispersal prisons' among category B prisoners, under conditions of maximum security. It is thought safer and more humane to disperse category A prisoners among several prisons than to concentrate them in one fortress-style prison. During the period covered by this chapter, Albany was one such dispersal prison, having approximately 12 per cent of its population as category A prisoners. The Art and Craft Centre had a significantly higher proportion (22%) of these prisoners on its roll.

academically biased education system. Success in the art room can also encourage prisoners to participate in an academic education programme from which they have previously felt excluded by past failure. The information officer of a youth detention centre in Houston, Texas, said of that centre's art programme:

> The kids relate more readily to the artist. They think of themselves as ugly, so to make something beautiful is a new experience, it gives them hope in a miserable existence. The art class... also helps them to become re-engaged in the classroom process.... It gives them a memory of success when they go back to their home environments.

Another function of art education is to nurture an individual's wholeness by integrating intellect, emotions and manual skills so that personal experiences can be explored and expressed. Communication is implicit in this concept of wholeness. Art education encourages students to validate their experiences by giving them independent visual form. This is particularly important for prisoners, many of whom have limited verbal skills. Dennis, a life prisoner who became a competent painter, said, 'My biggest trouble at the moment is that I am very withdrawn... Because I can't speak easily, I use art as a means of expression.'

It is clear that several aspects of art education are closely linked with the therapeutic process, in particular those aspects which encourage the growth of an individual's self-esteem. The relationship of art, art education and art therapy is that of a continuum in which each discipline has its distinct goals. Art therapy focuses primarily on the healing processes and insights which can be generated by the making of visual images and symbols. This process can make denied or unacceptable feelings accessible to a person, so that they can then be integrated into the personality. The finished art work and the development of artistic and aesthetic skills are of secondary importance. For the art therapist, a painting is a means to an end, not an end in itself.

The definition attributed by the different specialists to the word 'therapeutic' will depend on where their understanding of the meaning of the word is located in the art/art education/art therapy continuum. In this chapter, 'therapeutic' is defined in broader terms than those normally associated with the specific discipline of art therapy. Here the definition will encompass any artistic activity which encourages positive and observable changes in prisoners, even if these changes are temporary and can only be quantified 'negatively'. For example, it could be said that the behaviour of a violent prisoner is improving, if his rate of assaulting other prisoners is reduced from ten to five assaults a year. If that improvement is even partially

attributable to his participation in an art programme, then that programme can be said to have some therapeutic benefits for him.

In this context, the definition of 'therapeutic' can even embrace the opinion expressed by a category A prisoner, who said of the Albany art programme, 'It's therapeutic because it helps to pass the time.' Arts programmes in California's state prisons have also been described as therapeutic by one researcher, because they permit prisoners to have a period of relaxation and expression, without being exposed to recriminations.

These hidden therapeutic benefits often arise unbidden and unrecognised in a prison art programme, and are, by definition, difficult to identify and quantify. Nevertheless, they can make significant contributions to the welfare of both the individual and the institution.

The art and craft processes

The work of prisoners at Albany is representative of what a visitor will see in many prison art classes or at exhibitions of prison art. A high proportion of the work is characterised by technical virtuosity in the depiction of predictable subject matter. In an evaluation of a sample of 82 art works from Albany (carried out by three of the Art and Craft Centre's teachers to identify characteristics that might typify prisoners' work), 79 per cent were rated as good or very good in technical skill and composition; this was particularly the case with those pieces that had only minimal direction from an art teacher or an artist (Riches 1991). It is painting as a demonstration of craft and virtuoso skill, where the prisoner assumes the attitudes and methods of the craftsperson rather than the artist.

There is also a small proportion of work where technical skill is subordinate to the notions of art as exploration, research and expression, where the artist is finding a voice in his work, in order to say something authentic about himself. This kind of work is less predictable in subject matter and treatment. It often deals with issues which reflect the artist's engagement with his current situation in prison.

As a broad generalisation, the former category of work is characterised principally by the craft process and the latter by the art process. These two definitions are not mutually exclusive, as in practice there is considerable overlap. But they do serve to identify two broad categories of prisoner work, both of which have differing therapeutic benefits.

The craft process is prescriptive. A craftsperson uses specific materials, skills and processes to make a particular end product. There are principles of good practice which govern the use of tools and materials, and which can be taught by demonstration. There are also clear measures of quality to

evaluate progress, gauge success and ascertain the value of the end product. For the craftsperson, the process is a means to an end, the product is all important. If the end product is successful, the maker can enjoy the rewards of personal satisfaction: a marketable end product, the admiration of other people and a consequent improvement in self-esteem.

A small proportion of prisoners' work is less concerned with skill and more to do with the prisoner finding a voice in visual expression. This work is associated with the art process. Unlike the craft process, the art process is unpredictable and non-prescriptive, it has neither a clear beginning nor a well-defined objective. The process is a continuum in which the artist's ideas surface and are explored; but they may submerge into his unconscious for a period before they re-emerge in visual imagery. The painter Graham Sutherland, describing the early stages of his working method, said:

> I may go for a walk. There is everything around me. I look: certain things that one sees, almost by accident, seem to strike me more than others... I don't always understand what I am doing – or what I am likely to do... My mind is receptive – but vacant... Gradually an idea emerges... one's encounters become redefined, paraphrased and changed into something new and different from that of the first encounter – yet the same.' (Sutherland 1973, 14)

Often the artist has no clear idea of what he wants to communicate until he has made his idea communicable. His objective is realised as a result of the many decisions he has to make 'in the dark', while he explores his idea and tries to give it tangible form. There is always the risk that he may discover he has nothing to say, and the outcome is a void. The taking of risks is intrinsic to the art process; an artist must be prepared to tolerate the threat of inner chaos, fragmentation and a loss of identity, if there is to be the chance of a positive outcome to his efforts. He has to sustain the impetus of the original idea, while grappling with the constraints of the medium. The materials, techniques and skills he employs are subordinated to the exploration and expression of his idea. Once an idea has been given expressive form, the artist faces further uncertainties, because there are no clear and objective criteria of quality to evaluate the expressive content of his work. A sense of satisfaction or fulfilment is likely to be elusive or short-lived. The non-prescriptive nature of the art process makes the identification of shortcomings difficult: for the same reason the process is not easily taught, although it may be facilitated.

The therapy of prisoners' art as craft

The visual characteristics of prisoners' crafted artwork are determined largely by the preconceived popular standards of how 'good paintings should look'. The principle concern of these prisoners is to 'get it to look right', rather than to explore and communicate ideas. They resort to the prescriptive methods of the craft process to achieve this end. So, although they are ostensibly pursuing art objectives, in practice their painting, drawing or sculpture is treated as craftwork. Most prisoners who are interested in art have a concept of how they think a good painting should look, and what it should be about. These preconceptions determine their choice of subject matter as well as their techniques.

Many prisons are visual deserts from which visual stimulation can be gained only by determined effort. It may be that some prisoners would depict the prison environment if it were more stimulating; but most of them choose the easier option of second-hand imagery mediated through photographs in books and magazines. This literature ranges from the step-by-step books on how to draw and paint, through reproductions of work by famous artists, to magazines and colour supplements. The subject matter, inevitably stereotyped, includes landscapes, portraits of celebrities, nudes from girlie magazines, animals, still lives, and the fast cars and motorbikes which celebrate a macho life-style. There are also more imaginative paintings that have a surreal quality, using existing fantasy material as a source of ideas. The treatment of all the material often contains elements of sentiment, nostalgia and protest expressed in visual cliches. There is a significant lack of work based on prisoners' perceptions or experiences of prison.

Prisoners' preconceptions about how paintings should look when they are finished also determine their working methods and techniques. They eschew the risks inherent in experiment, exploration and expression, preferring instead the reassurance of the craft process with its prescriptive methods, predictability and clear measures of quality. Preconceptions about painting extend to the choice of media; oil paint is frequently used because it is perceived to be the correct medium for a painter.

Often, the more accomplished a prisoner is at painting, the more rigid he becomes in his attitudes, and the more unwilling he is to push his technique beyond well-tried formulae. One prisoner firmly believed that the techniques of the High Renaissance were the only painting methods that were suitable for him to use. He dismissed Impressionism and Modern Art as 'rubbish'. Disappointed in his attempts to get tuition in the glazing techniques of the old masters, he persisted in teaching himself, with considerable success. However, the bikers he painted, in a mural panel of a

medieval battle scene, looked most incongruous painted in the manner of Titian!

The primacy of technique and the preconceived ideas about appropriate content mean that prisoners can assess the quality of their paintings according to unambiguous criteria. Success is determined by how well a likeness of the original subject matter has been achieved. Dennis, the life prisoner mentioned earlier, was an accomplished painter of prison interiors. He said:

> You show a lot of people an Impressionist picture and they say it doesn't look like anything. A lot of guys in prison want to see photo-realism. They've not looked at art as a whole, they say it looks good if it is exact. I've come across that a lot. They like my cell paintings because they are real.

The perfecting of a likeness is of paramount importance for prisoners, who regularly undertake portraiture for themselves or 'on commission'. Photographs of family or friends are passed to a skilled artist, who enlarges the image as a painting or drawing. A passport-sized snapshot is thus rendered more potent, and its status elevated to that of a work of art. These portraits can attain a high standard of technical expertise, but only occasionally do they show a personal engagement with the subject being portrayed.

Out of the research sample of 82 art works mentioned before, one-third were known to have been copied from photographic sources (Riches 1991). The visual aridity of the prison environment and the need to escape mentally from its pressures are two reasons why copying is commonly practised by prisoners, especially when they paint with little or no formal tuition. Copying is art as a craft activity, where technical skills can be perfected and displayed. For many prisoners, copying is also a means of aspiring to the status of a recognised artist without having to endure the discipline of a training. For them, copying is a short-cut to success in the same way that armed robbery may have been a short-cut to wealth.

There has been a long tradition, throughout the history of art, of copying for the purpose of learning. This tradition has declined in the mid-twentieth century, but is re-emerging as an acceptable method of tuition; a lot of prison art, knowingly or otherwise, is part of that tradition. Copying can be a legitimate 'way in' to artistic development for some prisoners; for them it can be the first step towards a more real encounter with both the media and the content of art.

One prisoner who said he had no experience beyond 'painting my front room at home', copied a dozen Impressionist pictures from an art book, and in the process developed a remarkable facility with oil paint. This led him

to make a sensitive picture of his wife from memory, and an expressive self portrait, both of which were exhibited in a national exhibition of prison art. He was incredulous and dismissive about the praise from the teachers, thinking they were mocking him. Shortly after completing the paintings, he participated in a portrait-drawing course, but showed a complete lack of drawing ability and confidence. It is interesting to speculate whether he would have had sufficient self-confidence to sustain his interest in drawing had he valued his paintings more highly.

Dennis described how he first learned to paint by progressively copying another prisoner's work:

> I knew a lifer who painted. He was brilliant at painting portraits and prison scenes. I asked him to lend me some materials and show me how to do it. He did just that. He'd draw it out on a board and grid it up and give it to me. Then I'd do the same on another piece of board. Then he'd take back his board and do the base-coat and give it back to me to copy. I carried on doing that until I'd mastered the use of the brushes and the paints.

Artists and art teachers have had an abhorrence of copying because it prevents an engagement with the visual world at first hand, and encourages misplaced artistic values. But the artistic concerns of prisoners do not always equate with those of their teachers; their concerns, although different, can be just as valid.

The personal benefits gained by prisoners from crafted artwork are associated with the craft process mentioned earlier. The activity is itself an acceptable way of 'doing' time and it has a predictable and valued end-product. There is satisfaction to be gained from pride in a job done well, which elicits the praise of prisoners and prison staff alike, and which confers some much needed self-esteem on the maker.

In addition to providing personal satisfaction, crafted artwork may be made for two other purposes, both of which may contribute to an increase in a prisoner's sense of self-worth. A large proportion of prisoners hand out paintings, drawings or small sculptures to their family or friends on visits. Brian, another life prisoner, said, 'It's nice to have something to hand out to your visitors, because it's a way of saying, "thank you" to them for visiting you. You don't feel so helpless, you can at least do something for people'. This is also a way of locating a part of themselves in the world outside, so that they continue to be a presence in it, rather than just a memory.

Occasionally a more bizarre gift is handed out, as in the case of a life-sized human skull, skilfully carved in wood. John, its maker, commented:

I've made several presents for my wife. I'm giving her the skull I carved. She knows what she's getting but she doesn't want to see it; she wants me to wrap it up with a bow on top so it can go by the Christmas tree. Can you imagine, her opening up the skull at Christmas!

Some works, ostensibly made for the prisoner himself, are later discovered in the ownership of another prisoner. Painted portraits from family snapshots, referred to above, are often bartered for other goods or exchanged for an ounce or two of tobacco. Some prisoners are also suspected of clearing their debts by payments in kind, an activity which infringes prison rules.

If the word is defined in its broadest sense, the benefits associated with crafted artwork could be said to be therapeutic for the many prisoners who undertake it. Some of the pains of imprisonment are relieved, and survival is made easier; in addition, self-esteem is enhanced by the praise and admiration of other prisoners and staff.

The therapy of prisoners' art as self-expression

When prisoners are prepared to take the risks inherent in the art process, they are better able to find a voice to say something authentic about themselves and their circumstances. (However, very few prisoners pursue this path without first having had some encouragement and maybe tuition from a teacher.) Visual images are used to articulate real experiences, either related to a prisoner's physical world or to a personal, inner world. Technical skill is not a preoccupation but a means to an end, the articulation of the prisoner's ideas. The lack of prescription in the process applies equally to the results, which can appear unexpectedly, in isolation, or as part of a longer process of tuition and nurturing. The work is neither a copy nor an interpretation of someone else's idea, but a genuine response to a stimulus.

In Albany, prisoners' inhibitions about starting this kind of work have sometimes been circumvented by drawing self-portraits, which are some of the most authentic pieces of prisoners' work. This self-portrait by a life prisoner (Figure 4.1) was an expressive response to observing himself directly, a marked departure from the meticulous but lifeless copied wild animal pictures he had done before.

The building of trust and self-confidence are particularly important in the art process, because a prisoner can feel he has nothing to say, or that his work will be criticised or ridiculed. These and related anxieties will be discussed later.

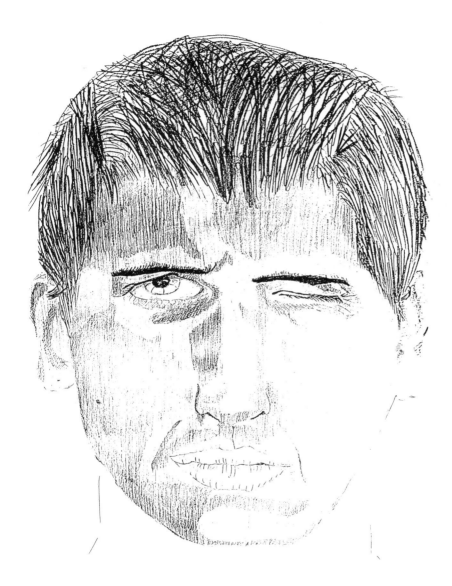

Figure 4.1 Self-portrait by a prisoner, HMP Albany 1992. Pencil on paper

The work of five prisoners from the Art and Craft Centre in Albany will be described as examples of this kind of expressive art work; the therapeutic benefits of their work will also be identified. The first two examples highlight the need that exists for therapeutic programmes in prison regimes.

Danny

Three weeks after the Centre opened, Danny arrived with a reputation for being subversive. He did very little work during his eight weeks there, preferring to discuss his problems with other prisoners, thereby being a disruptive influence. However, he took note of the work of another prisoner, who had successfully carved a head from a scrap piece of thermalite building block, using rudimentary carving tools. Danny then set to work himself with a frenetic energy quite out of keeping with his usual dilatoriness. Within two weeks he had carved two heads and completed them with poster-paint and wood varnish. The heads had wide-eyed, gaping-mouthed faces which seemed to scream in a manner reminiscent of Munch's painting *The Scream*. They were powerful and disturbing expressions of rage. A teacher suggested that he pursue this idea by drawing a head in charcoal. The resulting image was contrived and lacked the authenticity of the carvings. This dissatisfied him and, his concentration dissipated, he relapsed into his earlier state of talkative inactivity.

It is interesting to note that Danny, who had resisted the teacher's efforts to persuade him to work, was compelled into action by watching another prisoner at work, and by seeing the end product. An unintended practical demonstration succeeded where verbal persuasion had failed. The demonstration had triggered the process whereby he was able to express some of his painful feelings through the medium of the thermalite block. Danny's handling of the tools and the medium flouted the conventions governing their normal use, but his unorthodox working method enabled him to express his feelings in a most powerful way. The making of these two heads illustrates some of the key elements of the art process at work in someone who was otherwise completely untutored in art educational processes.

Unfortunately, Danny's behaviour became disruptive again, and he was sacked from the Centre as a result. Shortly after his departure from the Centre he was transferred to another prison, but then returned to Albany 18 months later. He was interviewed by a prison psychologist who found him very disturbed. During the interview, Danny talked about one of the carvings he had made nearly two years previously; he described it as 'dead and black, like me inside'. A month later his behaviour deteriorated to the point where he smashed furniture in his cell, and had to be restrained from continually

banging his head against the wall. The surprising fact was that Danny, after an 18-month period of deteriorating mental health, still remembered his carving as a significant expression of his feelings of non-being. In a more supportive and therapeutic environment, he could have been encouraged to explore this image and maybe gain a measure of healing for his emotional pain.

Chris

Chris was a life prisoner whose self-imposed silence and isolationist attitude were part of his strategy for coping with imprisonment. Despite threats of assault from several prisoners, he maintained a resolute silence while he energetically trowelled thick layers of oil paint on to large sheets of hardboard. His paintings underwent a transformation from crudely executed, mud-coloured pictures in a quasi-abstract expressionist style, to clearly defined, hard-edged shapes in bright, flat colours. The latter were reminiscent of Arp's relief shapes and some of Miro's imagery. His work patterns were cyclic, at times he seemed to be acting out, rather than depicting, his frozen aggression; then his imagery changed and became more precise and deliberately controlled; he would then return to the earlier more chaotic painting.

In a rare mood of communication, he once described why he painted: 'I paint out my feelings – anger, hatred. All artists paint their feelings, it's the only way to paint... if I don't paint my feelings out, I'll kill somebody'. Chris stayed in the Centre for nine months, considerably longer than many prison staff had predicted, until he was sacked for intimidating behaviour towards a teacher.

Painting enabled Chris to act out some of his frustrations and aggressive fantasies. Had it been possible to encourage him to articulate these feelings verbally and visually, as part of a more structured therapeutic programme, he might have broken the cyclic pattern of behaviour evident in his work, and in turn reduced his introverted attitudes.

Neil

This example shows the development of the expressive and technical skills of a prisoner whose work chronicled the effect of imprisonment on him. Neil was at the beginning of an 18-year sentence when he came to the Centre. He was intelligent and articulate, and familiar with antiques and works of art, but had no practical painting skills. His arrival in the centre coincided with the introduction of the foundation course of the Open College of the Arts, which he readily undertook.

One of the early assignments on the course was a self-portrait. He painted a passable likeness of himself, but his handling of both paint and colour was crude. A year later he completed a second, more sensitive self-portrait; this was followed by a third some three months later. Between the painting of these pictures, he continued the OCA assignments, which included making wood reliefs and copying old master paintings. He became very interested in the work of Monet, whose paintings he copied on four occasions. He confined himself to painting self-portraits and copying because, he said, subject matter was limited in prison. 'In an ideal world I would be out with my easel, painting on a cliff-top somewhere... I would not want to paint prison scenes.'

Six months after the third self-portrait and two years after the first one, he completed a full-length self-portrait by using three mirrors. This showed a degree of psychological insight as well as a mastery of the medium and an understanding of spatial composition. When Neil reviewed his work, he reflected:

> I've done four or five self-portraits – the first ones were naive to the point of looking as though a seven-year-old child has done them. Gradually they've got more mature, more developed. I feel more confident, and the last one was done much more quickly than the previous ones, which is a sign of growing confidence, I think, less timidity.

Neil believed that art has an important function as a means of enhancing the low self-esteem of prisoners 'I think art can and does help one to find out about oneself. It helps an individual grow and also will enhance his view of himself.' He continued by saying that many prisoners have a very low opinion of themselves, which contributes to their unsocial behaviour. 'This,' he said, 'is an area where art comes in, because when you express yourself in a way which is good and constructive, you realise that there is more than one way. There is another way.'

Bill

This illustrates the emergence of authentic personal expression in the work of a prisoner who had long experience of craft work and painting, both dominated by an over-riding preoccupation with technique. Bill was intelligent and articulate, but had spent half his forty years serving a series of sentences. During this time, he had become an accomplished self-taught artist/craftsman, and was described by a visiting art college lecturer as a 'gifted amateur'. He had developed skills in a range of techniques, and his

work demonstrated great ingenuity in the face of the constraints imposed by imprisonment. However, his willingness to explore a variety of media did not extend to the content of his work, which was nostalgic and at times bordered on the 'twee'.

One of the signs of change in his work came when Bill was six months into his 3½-year stay in the Centre. A local Roman Catholic primary school commissioned a 'madonna and child', which he agreed to carve from a section of a yew tree trunk. The half-length figure of the mother was life-size, and she was carved holding the child in front of her, both figures looking at the spectator. The carving was strong, austere and devoid of the sentiment often associated with this kind of religious imagery. This was followed by a totem-like carving reminiscent of African tribal sculpture; Bill described it as a 'kind of walking dead idea'. In the process of confronting the challenge of working on a large scale, Bill had been able to let go of his craft concerns and discover some personal expression.

The shift of emphasis away from technique took longer to affect his painting. He first spoke of his concern to express how he felt in a painting, during discussion of a double portrait he had made of two prisoners who had been threatening him. The paint had been applied thickly in rich, dark tones. Unfortunately, the tactile quality of the paint was hidden by several coats of gloss varnish, and the finished work held few clues about his real feelings concerning the intimidation.

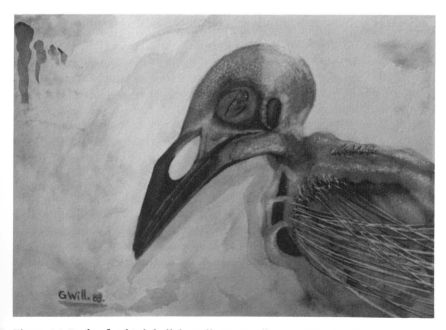

Figure 4.2 Study of a bird skull, by Bill, HMP Albany, 1989. Acrylic on paper

A breakthrough occurred in the last 12 months before he was due to be released, and after he had decided to apply for a full-time course at art college. For some time, teachers had been encouraging him to do more drawing from real life. Bill began to make studies of prison life, and then worked them up into monochrome paintings. They were stark but evocative paintings, of which the most powerful was a study of a bird skull he had found behind the cell-blocks (see Figure 4.2).

The difference between the art and craft processes meant that Bill found it more difficult to evaluate his later work, because of its non-representational content. He had to face the added difficulty that it did not elicit the admiration of other prisoners in the same way as his craft-oriented work. His acceptance of this difficulty was itself a sign of his increasing confidence and self-worth.

A year earlier he had admitted to being very sensitive to criticism about his work. Even the non-verbal attitudes of others would undermine his self-confidence. Half way through his period in the Centre, he had been verging on the suicidal as he contemplated his future. On the one hand, he was desperate to leave prison life behind him once and for all. On the other hand, he knew that, without some kind of full-time occupation, he would soon commit an offence and repeat the cycle he was desperate to break.

> ... I went through a period where, if I hadn't been such a coward, I
> think I would have been prepared to finish it off. I couldn't see a way
> of changing anything for the better for myself. All I could see was a
> guarantee of another sentence, another one, then another one.

Maybe it was this sense of desperation that forced Bill, as he put it, '... to call into question all I have done so far', in order to face the challenge and risks involved in undertaking a full-time art course. After some set-backs, he was offered a place on a foundation course, which he took up after his release.

Dennis

The final example demonstrates a problem familiar to some professional artists, the inhibiting effect of acclaim. Dennis, the life prisoner mentioned earlier, arrived in the Centre as an accomplished painter. He had been awarded an 'outstanding entry' prize in a national exhibition, and his work had been bought by a collector. He had learned to paint in prison, and it was also his subject matter. In this latter respect, he differed from many prison artists, most of whom regard painting as a means of escape from, not confrontation with, prison. He said:

> I paint what I see around me all the time. I'm not consciously
> interpreting what is in front of me. I see my paintings as a record for
> history so that people in the future can see what a cell was like in the
> 80s and 90s.

The paintings are carefully observed studies of his cell; they are cool and
precise visual records of his surroundings, simple statements of fact devoid
of any overt connotations of protest or propaganda. Dennis readily admitted
that one reason he painted like this was because he could sell his work: '… and
that's how I want to make a name for myself'. He also gave a second and
more significant reason: '… my life has been a mess, so I like my pictures to
be tidy.' He also freely acknowledged that painting had helped him to
become more expressive and articulate.

In fact, Dennis did very little painting during his fifteen months in the
Centre, the one exception being a large picture of a cell window in a
segregation unit, for submission to the Royal Academy's Summer Exhibition.
Instead he spent most of his time on woodwork projects and wood carving.
He gave two reasons for not continuing to paint; he thought he had
exhausted the possibilities offered by the prison as subject matter, and he felt
hampered by the lack of white spirit which he regarded as vital for his work.

Both these factors could have persuaded him to broaden his scope as a
painter, in terms of both subject matter and media, but he resisted any such
moves. Having found a formula which had brought him success and much-
needed self-esteem, he seemed loathe to let it go. He therefore found himself
in an impasse, from which woodwork provided a temporary release. Despite
this limitation, painting had opened a channel of communication for Dennis
who (as was noted earlier) found difficulty in communicating verbally.

Dennis also discovered an enjoyment of classical music as a direct
consequence of his study of art. He told me how this had happened:

> It started when I picked up a book about artists and composers. In
> the composers' section I read about a 'masterpiece', and I wondered
> how music could be compared with a masterpiece in painting. So I
> listened to it one day. It was *The Planets*. I especially like violin music
> – I can feel it, and it relaxes and excites me.

Fears of vulnerability

From these examples and others, it is clear that expressive art does provide
release from stress for some prisoners. Given the very strong emotions
engendered by imprisonment, it is strange that relatively few prisoners use

this legitimate means of exploring, communicating and defusing those emotions.

One reason for this reluctance to explore and express personal experiences is prisoners' fears of making themselves vulnerable through displays of personal feelings. Many prisoners survive imprisonment by hiding behind an aggressive mask, which, as noted by Mick at the beginning of the chapter, conceals embarrassment and loss of confidence. The fear of criticism, misunderstanding and ridicule is a powerful inhibitor of self-expression for many prisoners. Danny expressed this fear when he said:

> I think a lot of people would be frightened off art therapy because they would think they are going to be analysed. A lot of people in prison are scared to show their feelings; I was like that and I still am a bit. It's a fear of being taken advantage of. But I believe a lot of people want help.

Danny also refers here to another anxiety, which stems from the largely mistaken belief that prison staff, especially psychologists, are able to discern hidden meanings in the imagery used in prisoners' artwork. Prisoners always perceive these meanings as detrimental to themselves, and assume they are written down on their prison records. One life prisoner, a very competent painter with an A level in art, admitted that, for some years, he had avoided using red in his pictures because someone had told him red indicated anger and violence. He did not want 'them' to think that he was violent.

Another reason why many prisoners seem reluctant to explore their personal experiences in expressive art lies in the exacting and unpredictable nature of the art process itself. This process makes demands which prisoners often cannot meet, because their ability to tolerate anxiety and uncertainty is already fully extended in coping with the stresses of their prison sentences. Their resistance is strengthened by fear of the pain and chaos they may encounter within themselves, once they have embarked on the process.

The anxiety of one prisoner from the Centre illustrates the frequent fear of mental breakdown. He was another student on the Open College of the Arts course, and had successfully completed the first project, but lost his nerve part way through the second one. This involved 'free-expression' – making marks using a variety of media and equipment. He had filled a large sheet of paper with energetic brush marks in black paint. In discussion with a teacher, he voiced considerable anxiety about his work, because other prisoners had suggested it indicated he was probably very depressed. It was only after some persuasion that he completed the exercise, carefully conceal-ing the results from everyone else.

Occasionally a prisoner is able to disregard the opinions of his peers and explore a wide range of imagery with a refreshing lack of inhibition. This was the case with Matt, a category A prisoner, who used a variety of unconventional materials to make vigorous, colourful and tactile paintings, about which he said, 'There's a lot of pain in my work; it's there if you know what I mean. I express anger in it too. I suppose there's a message there for people. It's to do with masks as well – I've always been interested in masks' (see Figure 4.3).

Figure 4.3 Mask, by Matt, HMP Albany, 1992. Pen on paper

A degree of trust is essential for a prisoner to explore and express his feelings honestly through visual art work. A prisoner who has little or no art training has to take encouragement and guidance from his teacher. Their relationship

can be a positive and healing force in a place where fear and emotional pain are predominant. It is at this point that the two seemingly incompatible worlds of prison and art are poised in a partnership which can be remarkably fruitful.

A hidden role of the art teacher is to help ease some of the pains which arise from the injustices of imprisonment. This is achieved by accepting a prisoner as he or she is, thereby affirming the prisoner's dignity. The prisoner is neither a scapegoat nor an anti-hero, but a fellow human being. The nature of their relationship is characterised by the word 'care', using the root meaning of that word, which is 'to grieve, to experience sorrow or to cry out with'. There is a degree of mutual identification, where the social outlaw (the criminal) meets the creative outlaw (the artist or art teacher).

The teacher's role is that of a facilitator or catalyst. By caring for prisoners and acknowledging their common humanity, he allows himself to be sensitive to their environment and to be in touch with their pains and tensions. Through the medium of the art, he is able to reflect back imaginatively some of their feelings which, once shared, become acceptable and therefore more manageable. The teacher collaborates with the prisoners so that they can, through their own imaginations, put their pain to a more constructive use. The art work, in turn, reflects back on the prisoners, whose sense of worth and self-esteem may be enhanced by their achievements.

The art room offers prisoners a safe space in which they can, if they choose, begin to explore their own inner worlds of feeling and imagination. Such exploration involves risks, and demands honesty and courage; it can only be undertaken in a situation where there is a degree of mutual trust. Expressive art is particularly suited to this kind of personal exploration and self-processing. The risks and uncertainties of creative self-expression are closely linked with the risks and uncertainties of personal exploration and growth. The more craft-oriented art activities offer an alternative means for the enhancement of their self-esteem to those prisoners for whom the risks of the art process are too great.

'There's something more than the daily grind of nothingness'

The case studies have illustrated some therapeutic aspects of a prison art education programme. There are also other benefits which can contribute to the programme's general therapeutic effect, although they are not unique to art programmes.

Prisoners in the Centre at Albany rate very highly the opportunity to take a personal interest in their work, the choice of work and the freedom to do it their way. It is hardly surprising, given their tightly controlled life-style,

that they value an activity which affords them some autonomy in their daily lives. It has been said that the hallmark of a person is that he orders his life by his own deliberate choices. In this respect, prisoners' self-esteem may be strengthened because they can choose, within limits, the work they under-take and how they go about it. In the act of making choices, they are affirming their individual identities in an establishment where conformity to an imposed norm is the rule. One prisoner expressed his views about the Centre in this way:

> In other workshops the work is monotonous, you are like a robot, in here if you get fed up with a job you can try something else. The environment in here is more relaxed, so people are more willing to work. There's more give and take, you're not breathing down our necks all the time.... You're banged up in your box and you feel dejected, but you come in here and you begin to feel yourself, it's a kind of therapy.

A second benefit is some respite from the pressures of imprisonment. Prisoners mention most frequently the tedium and regimentation of the prison routine, a feeling of alienation and isolation, and a belief that the establishment has no interest in their welfare, being intent on their continued punishment. Any activity which relieves these pressures is welcomed by prisoners; for example, tedious industrial work is undertaken to pass the time and relieve boredom. Such activities, along with art and other educational programmes, have been described as 'removal activities' which enable pris-oners temporarily to blot out the environment in which they are forced to live.

Comments by prisoners indicate that this was an important function of the centre at Albany:

> This place is an oasis... it's a world apart.

> When we come in here, we are not in the prison, we leave the prison sub-culture behind.

> It gets me out of the nick.

> Being in here makes it a lot easier to cope with the pressures, because I'm enjoying myself, it's escapism. When I'm here, I don't think I'm in prison, I'm escaping from prison.

> A tension is lifted off you when you come in here, it's unlike anywhere else in the prison. I can lose myself completely in here without giving prison a thought.

When it was suggested to one prisoner that some artists found their work quite stressful, more like a battleground than a playground, he laughed and said he already had enough pressures around him – painting enabled him to escape from these pressures.

The concept of 'removal activity' helps to explain why prisoners reject prison life as a fit subject for their artwork. Asked why he thought there was so little painting about prison, Neil said:

> I think that's part of the desire to get out of prison. I would not want to paint prison scenes. They would give me nothing; it's indelibly enough printed on my mind anyway, without me putting it on paper. I want to paint nice things, things which give me pleasure... the idea of painting a prison building, fences and barbed-wire, that doesn't appeal to me at all.

Exhibitions of prisoner art bear this out. In the annual national Koestler Exhibition, less than a quarter of the work depicts prison life, and this proportion has recently been as little as 2.5 per cent. Much more common are landscapes, wild animals and fantasy imagery, which can achieve a temporary escape from prison life.

A third general benefit, related to the 'removal activity', is speeding the passage of time. Prisoners in the Centre at Albany were asked whether time spent there passed more quickly than elsewhere in the prison. The majority agreed it did, none thought time passed more slowly, and a few were undecided. An art programme is only one of several options available for prisoners to 'kill time', but it is an effective one.

A resource for the prison

Data from prison records in Albany and anecdotal information from the staff suggest that the therapeutic benefits of the Art and Craft Centre's programme extend beyond the Centre. The factors influencing prisoners are complex, and it is not possible to establish a conclusive cause and effect link between arts programmes and perceived improvements in behaviour. Nevertheless, the evidence does suggest that there is a relationship between the two.

One way of quantifying this relationship is to study the number of discipline offences prisoners commit before entering and while participating in an art programme. These offences range from mutiny to idleness at work, along with the general charge of 'an offence against good order and discipline'. An analysis of the prison records of 36 prisoners who attended the Albany Art and Craft Centre during a 13-month period, showed a 29 per cent reduction in discipline reports when compared with the same

prisoners' records prior to their attendance in the Centre. Six particularly disruptive prisoners showed a significant reduction.

A comparison was also made between the populations of the Centre and an adjoining prison industrial wood-workshop. This showed that the proportion of improvements in behaviour in the Centre were 18 per cent higher than in the wood-workshop. In addition, the offence of 'refusing to go to work' did not occur in the Centre population during the two-year research period. In the industrial workshop, 17 per cent of the population refused to go to work during 12 months of the same period.

This statistical data is corroborated by observations of prison officers, who rated behaviour in the Art and Craft Centre as generally better than that in the industrial workshops and accommodation wings, and comparable with that in the vocational trade training workshops. An officer who patrolled the Centre said, 'Over the last six months that I have been a regular discipline officer in the shop, I have never needed to place an inmate on report or even to caution one.'

Wing governors (who supervise the prisoners' living quarters) also recorded improvements in prisoners' attitudes to work, and in their ability to occupy themselves in their cells. There is an element of in-built security in an activity that prisoners value – they know it is in their own interests to protect what they enjoy doing, by imposing their own constraints.

Both officers and prisoners have observed that relationships between them often improved in the more relaxed environment of the Centre. Another officer patrolling the Centre said, 'You don't half notice the difference in this shop. You can wander around and have a natter with the blokes if you want to. You can't do that in the other shops.' A prisoner also commented, 'The screws from other wings have a chat to me about what I'm making; it helps to improve relationships... it takes the barriers away between officers and inmates.'

It has been said that relationships are the most significant feature of control in long-term prisons, and that tuning in to prisoners' needs reduces the need for external control. In this sense, the Centre's relaxed atmosphere contributed as much to the welfare of the prison as it did to the welfare of the prisoners.

However, not all prison staff regarded the reduction in discipline offences as a positive benefit. One of the senior management team in the prison criticised the Centre staff for operating a policy of 'peace at any price'. He rejected the idea that a workshop should operate by encouraging the co-operation and goodwill of the prisoners.

There is no other research in the UK on the relationship between arts programmes and prisoner behaviour, but it has been studied in the USA (Brewster 1983; California Department of Corrections Research Unit 1987). When the California Arts in Corrections Programme started in 1977, it placed professional artists in the State's prisons to work as artists and to encourage prisoners to participate in their particular disciplines. By 1987, the programme had expanded to provide arts activities in 17 prisons for 43 per cent of the 90,000 population. A research study undertaken in 1983 found that infringements of prison rules by AIC participants were reduced by between 75 per cent and 81 per cent. A second study in 1987 found that, two years after their release, 69 per cent of parolees who had participated in the AIC programme remained out of trouble and at liberty, as compared to 42 per cent for those who had not taken part. As one prison administrator said, 'We cannot afford not to pay the cost of AIC'.

Conclusion

It is now more widely accepted that arts programmes have an important role to play in psychological healing and growth. Such acceptance is more difficult to achieve in prisons, where punishment is the norm, and where the caring professions operate at best with limited institutional support and, at worst, face indifference and even hostility. Art teachers in prisons often feel isolated and undervalued by the establishments for which they work, and the concepts of personal growth and therapy may be viewed with suspicion by prisoners and staff.

However, towards the end of the 1980s, the Prison Department began giving a higher priority to prisoners' welfare by encouraging governors to develop more purposeful and creative regimes. Concurrently prison arts programmes began to gain a higher profile at both establishment and headquarters levels.

It is clear that there are important therapeutic benefits implicit in visual art programmes. For a serving prisoner, these benefits may simply help him to survive his sentence. This was the case for a category A prisoner with a 16-year sentence who, nine months after his arrival in the Centre at Albany, said, 'I've got three paintings on the go at the moment. I couldn't hold a pencil when I came in here, but now it's the only thing that keeps me going in this place.'

Some prisoners are reluctant to expose their feelings, but at least one prisoner thought there was a place for this in Albany. He said:

Even if it awakens a hidden stirring in someone, then that has potential for good rather than potential for evil. The evil is already there.

He continued:

Even if emotions are exposed and cannot be adequately treated, at least it proves that the emotions are still there to be exposed. There is something more than the daily grind of nothingness.... I don't think there are any risks, because one is already consigned to a dustbin.

For a few, the benefits of a visual arts programme may extend beyond prison to life after release. Towards the end of his foundation year at art college, Bill was able to reflect on the personal growth and healing that had taken place as he developed his artistic skills:

I arrived at that workshop in 1986 as an embittered old lag who could not even relate with his fellow inmates. The freedom to try so many different crafts, the pride and pleasure at discovering my dexterity, helped me to like myself. I wanted to expand intellectually as well, and for the first time, believed it was possible.... I've been very lucky, I have found something that's going to help me.

References

Brewster, L.G. (1983) *An Evaluation of the Arts-in-Corrections Programme of the California Department of Corrections.* Prepared for William James Association, Santa Cruz, California and California Department of Corrections.

California Department of Corrections Research Unit (1987) Unpublished paper quoted in Peaker, A. and Vincent, J. (1990) *Arts in Prisons: Towards a Sense of Achievement.* London: Home Office.

HMSO (1980) *Report of the Review of Rampton Hospital.* Cm 8073. London: HMSO.

Riches, C. (1991) *There is Still Life, A Study of Art in a Prison.* Unpublished M.A. Thesis, Royal College of Art.

Sutherland, G. (1973) 'Recent Work', Exhibition Catalogue, Marlborough Fine Art, London.

Ways of Working
Art Therapy with Women in Holloway Prison

Pip Cronin

In this chapter I will consider ways of working as an art therapist in Holloway prison, and the potential of images and art therapy to provide containment in the therapy setting. In particular, I will describe work with women as they experience the uncertainty of imprisonment, in which interventions may be brief.

Introduction

HMP Holloway is a women's prison in north London with a population of just under 500 inmates. In the 1970s the original Victorian prison was replaced by a new red-brick building planned on hospital lines, with the emphasis on the treatment of a 'mad' rather than 'bad' female prison population. Plans that (by the late 1970s) Holloway would hold all female prisoners in England and Wales did not materialise. With an increase in the overall female prison population, women's prisons were regionalised. Furthermore, theories of treatment of female offenders were revised, and women's prisons, including Holloway, were reorganised to run on the lines of male establishments.

The present building is on five levels, and encloses a large central garden and exercise area. In addition to the main residential units there is a hospital area and a wing for mothers and their babies. A circular route runs on each level around the building, allowing women access to their place of work or chosen activity at designated times each day. Work includes attending education or employment in the gym, kitchens, gardens, staff mess or shops.

Services within the prison include those provided by the chaplaincy and the medical, probation and psychology departments.

Currently the prison holds both sentenced and remanded women, with sentenced women outnumbering those on remand. Lengths of sentence vary from women serving life to those imprisoned for a few weeks. The majority of the population is made up of European, Afro-Caribbean and Black African women. Offences include murder, manslaughter, other forms of physical and sexual assault, theft, robbery, arson and drug offences. Theft and drug importation are the most common offences at present. Although ages range considerably, there is a high representation of women between the ages of 25–39.

The medical area can accommodate about 90 women in two separate units. The more disturbed and vulnerable women are held on the psychiatric unit, while the medical admissions unit has a high proportion of drug users. The latter has a rapidly changing population, as many women move on to other residential areas after a short detoxification period. Women on either unit may be waiting for psychiatric reports to be completed before their cases can be heard in court; others will be awaiting transfer to psychiatric hospital under one of the Sections of the 1983 Mental Health Act.

Some inmates who do not fall into a category for hospitalisation, may remain on one of the medical units for their whole sentence, because they are considered to be at risk of suicide or self injury, or are generally unable to cope in the main part of the prison. Offences such as arson, damage to property, petty theft and threatening behaviour are typical amongst this group of women, who are often caught in a 'revolving door syndrome', returning to prison shortly after their release, sometimes due to lack of suitable after-care. For a number of these women, prison is a preferable alternative to the instability of their lives outside. Other women likely to be held in the medical areas are those charged with sexual offences, murder or crimes involving children. They may be particularly vulnerable to aggressive behaviour from other inmates, and are held on the medical units for their own protection.

For many women, imprisonment may be part of a destructive lifestyle in which drug and alcohol abuse, arson, and aggressive or violent behaviour can indicate an inability to express feelings in an appropriate way. On imprisonment, women may find themselves without the props that have enabled them to block out their unmanageable feelings. A common response to the re-emergence of painful experiences, for example in drug withdrawal, is to act out feelings with angry outbursts or through self-destructive behaviour.

Access to art materials can provide an alternative way to express reactions to upheaval, change and distress – and sometimes enable women to symbolise that which is unspeakable. Initially, art materials might be used to 'act out' angry and aggressive feelings. Here the physical boundaries of the materials and images can offer women in chaotic and vulnerable states a means of containment for the difficult feelings, thereby lessening the likelihood of acting out in a more destructive form. This work is about beginnings and containment; exploring the content of imagery comes later.

Prison is indisputably a place of great uncertainty for many women. Separation from family, friends and familiar surroundings, plus long periods waiting on remand and the stress of appearing in court, all contribute to feelings of insecurity. The cumulative effect of all this can be for inmates to feel overwhelmed by problems. In short-term work with women on remand, images can be something tangible when other parameters are indefinable; they provide a focus for what is happening now.

Prison is associated with punishment, and loss of freedom and choice. It can be argued that offering therapy, with its implication for change, does not rest easily in this environment. However, for some women, being in prison enables them to step back temporarily from the patterns of their lives outside, and provides an opportunity for reappraisal. Parallels can be drawn between the space created by prison boundaries, and the space for reflection in a therapeutic setting. The usefulness of images here is their potential to be associated with several experiences simultaneously, thereby giving an inmate the opportunity to make links between the content of therapy sessions, prison and offending behaviour.

Thoughts about the problems encountered by many women in Holloway in finding a suitable way of describing their experiences brought to mind a conversation with Lena, at that time held on a medical unit. She was also a member of the pottery group that I will describe later. At the beginning of her time at Holloway, she spoke to me of her anxiety about appearing in court. She said she didn't have the words to say what she wanted, as she was confused by the formalities. Her world was very different from that of the judicial system, whose language she did not understand. She sounded sad and desperate.

As I thought about this later, there was another way to understand what she had said; that being in prison was the culmination of a series of events that had begun in her early life; and that her sadness might be saying something about the impossibility of putting her feelings and experiences into words. Later on I describe how Lena participates in a pottery group, and

begins to use her own images to contain feelings which are overwhelming and potentially destructive.

Areas of work

At the time of writing, I work both in the education department and for the prison Art Therapy Project, briefly described below. As a member of the education staff, I work in the Skills Training Unit which provides a pro-gramme of arts, crafts and basic education for women on the medical units. The emphasis is on working in small groups, and providing a safe and supportive environment for women as they begin to leave the medical units and join in other activities. We are a small team with varied skills and training, such as teaching, occupational therapy, drama and art therapy, so between us we offer considerable diversity in the styles of our groups.

The Art Therapy Project has been funded (by the King's Fund and the Baring Foundation) for a two-year period up to July 1994 to provide art therapy and evaluate its usefulness throughout the prison. It is hoped that this evaluation will lead to further support and funding. The project operates as an independent department in the prison, with two art therapists, a visiting art therapy supervisor and support from the prison psychology staff. There is a system for referrals and assessment to consider the appropriateness of a referral in relation to a woman's progress in the prison system. As far as possible, we try to ensure that a woman will be in the prison for a minimum period in order to establish a contract of art therapy which the prison agrees to support. Whereas my work in education is entirely groupwork, the funding of the art therapy project makes it possible to offer individual sessions when this is felt to be more appropriate.

I will go on to describe groups which are part of the Skills Training Unit programme. The first is an art group that takes place on the medical admissions unit. I will consider the issues of working with a largely remand population and the problems faced by women adjusting to imprisonment. My work, at least in the short term, is primarily concerned with helping inmates deal with the reality of imprisonment. Here images can be seen to function in a 'holding capacity' for some of the fears and uncertainty felt by women on remand.

This is followed by an account of a twice-weekly pottery group which takes place in the education department. It is attended by women from the medical units. Frequently, group boundaries are questioned – in this instance the limits of what I provide in the group. Lena, whom I mentioned earlier, challenges how much I am prepared to help her with her work while another group member, Jennifer, explores her ambivalent feelings about leaving the

prison and the relationships she has built, via the issue of my not providing tea or coffee in the group. The group members use clay objects to enact and explore their own potential to take some responsibility for themselves.

In the latter part of the chapter I will look at four individual art therapy sessions with Maria, a woman who was referred to the prison art therapy project. My interest here is how images offer a particularly vulnerable woman a way to begin to express her confusion about her own internal and external boundaries. Her images and the paper itself function as a visible container for her chaotic feelings.

Art groups on a medical unit

These take place on the admissions unit, which has an atmosphere of instability due to the high turnover of inmates, and the difficulties of accommodating approximately 40 women with wide-ranging emotional and physical problems. Some women go to daytime activities, but many new arrivals have to see the doctor or other specialist staff, and are therefore on the unit for long periods each day. The art group, held three times a week, is available to women, without making a formal application. Many women respond enthusiastically to the immediacy of what is on offer.

Originally I held the groups in a dining area which opened on to a corridor. The accessibility of this public space made it possible for women to check out what was happening before committing themselves to joining in. The disadvantage was that it did not provide the safety and containment for the more isolated women on the unit to make use of the group. More recently I have moved to a quieter room, wanting to focus my work towards the more vulnerable women and those who do not mix easily with other inmates.

Unit staff may suggest inmates who have shown an interest in art, or those who need encouragement to take part in some activity. I follow their referrals by talking to individual women, to see if they would like to attend. I emphasise the opportunity to try things out and that being 'good at art' is not important. I tell them the starting and finishing times of the group, and suggest they come for as long as they feel able. The groups are an hour and a quarter long.

On this busy admissions unit, with its predominantly remand population, women are regularly called for medical appointments and legal or family visits. In the groups, it is important to acknowledge and work with these and other practical concerns. In this way, the art group can be a place where women begin to address their anxieties about being in prison. The work tends to remain focused on the immediate problems, such as visits, rather

than long-term issues: anticipated visits may generate powerful feelings about being cared for, with the worry of being let down. Often a woman in an art group indicates these feelings as she waits for family or friends to visit, perhaps with a comment that it is not worth bothering to start a drawing, or that she expects her attempt to start will end in failure. Focusing on her difficulty in engaging in this process, may enable her to express underlying anxieties associated with the visit and the people concerned.

Day and Onorato (1989 p.129) describe the importance of the therapist accepting the prison setting for what it is:

> He or she focuses on helping the inmate deal with the reality of incarceration, rather than on establishing himself or herself in an adversarial role with the institution. In this way, the inmate does not become a confused child with quarreling parents.

My experience is that it is very easy to be tempted into that adversarial role, especially when the work is fragmented by disruptions. Greater familiarity with the environment and its limitations has shown me that I can negotiate and discuss the problems with other staff in order to preserve the necessary therapeutic boundaries. Humour and flexibility are vital!

First steps

There are many reasons for coming to art, and drawing may not be highest on the agenda. It may be a woman's first attempt to take part in some activity, so my aim is to allow her to proceed at her own pace. On her first visit to the art group, a woman might ask 'What do you want me to do?'. Being in prison is not generally associated with making choices, and I am often aware of the struggle a woman faces when asked to think independently. Associations of art with school are common, and in this context there are the added feelings of dependency and loss of adult status in prison. The infantilising process of women's imprisonment is discussed in more detail by Pat Carlen in her study of Scottish women prisoners (Carlen 1983 p.109).

In negotiating the first steps towards making an image, a woman may talk about her uncertainty, lack of confidence and fear of failure. Addressing these thoughts through the images may lead to recognition and expression of feelings about being in prison. Although I talk to women individually in these sessions, such conversations may allow other women to share their own responses to imprisonment.

Each session has to be treated as a 'one-off', because there is no guarantee of the length of time a woman will be on the unit. In these circumstances, the picture may function as a mediator; the imagery may be left unexplored,

while dialogue and negotiation focus on the picture and what happens to it. Some women do not finish their pictures by the end of a session, and become very frustrated by the possibility of being moved to another unit before the next art group. I offer them the option of taking their pictures with them, or of storing them in my cupboard. Sometimes a conversation about what happens to a picture can create an opportunity to contemplate returning to the group in the future. For a woman due to appear in court and hoping for a non-custodial sentence, thoughts about returning to the group may elicit hitherto unexpressed fears about returning to prison.

If a woman tells me, 'I've come to watch', I respect this direct communication about not getting too involved – although curiosity or some other reason has nonetheless brought her this close. I try to find an opportunity to talk to her, and mention again that skills and expertise are not necessary. I may encourage her to find out what the different materials are like. Sometimes I suggest using one of the books I keep in the art cupboard. Sitting with a woman and discussing pictures which interest her, can establish the trust necessary for her to start using the materials. Engaging in this tentative manner may be a significant step for a woman whose experiences of relationships are anything but good.

For several months, Mandy sat and mostly watched others drawing. She presented a tough exterior and had established herself as a spokeswoman on her section of the unit, well able to voice her dissatisfaction with staff and the prison system. She was not at all happy that, for disciplinary reasons, her release date had been put back to an unknown date. Occasionally she would pick up some paper and become absorbed in a wax or pastel drawing, making patterns that resembled mountains or landscapes. On finishing, she might question dismissively why she'd drawn the patterns, then, with an apparent lack of interest, leave the picture lying on the table.

It was clearly very difficult for her to allow the pictures to have any overt significance, and she did not want to talk about them. Each time she abandoned a picture I made a point of suggesting I keep it in the cupboard. Sensing that I had to respect her distance, looking after the pictures was a way I could acknowledge and value her efforts. In between drawings, there were long periods of watching, and it seemed very difficult for her to develop a relationship to her art or to me.

When Mandy eventually heard of her imminent release, she began to make verbal attacks on me and the pointlessness of having people sitting around doing nothing. For a couple of sessions, I felt in a very precarious position as other women joined in the 'rubbishing' of the art group. Despite this, as I finally said goodbye to Mandy, I experienced considerable affection

and loss. I can only speculate that, in terms of the counter-transference, behind her bravado she had made an attachment to me which was threatened by her release. With her inability to trust, attack was her means of self-preservation.

Related to the above are thoughts about my own difficulties in 'actively doing nothing' in groups in the prison. Although prison does make inmates idle because there is nothing much to do, there is still an expectation from unit staff that those attending a group will be 'usefully occupied'. It is important to communicate to staff the reasons why I appear inactive when some women are not obviously engaged in a recognisable activity. Without this understanding, untimely staff interventions can inhibit a woman's progress towards engaging in the process.

Working in the prison, there are inevitably questions about my motives and partiality; whom am I there to help? As part of a triangular relationship with the inmate and the prison, I am working not only with transference issues concerning myself, but also the inmates' feelings about the prison.

When a woman is able to absorb herself in making an image, there can be a powerful sense of relief. For a short while, she can leave her preoccupations behind and play with the imagery. However, the group may be experienced by women as an extension of the prison environment, which they do not trust, and this can affect their ability to use the group in this creative way.

For women with children or other dependents, their feelings of helplessness may be accentuated by the loss of their children and the caring roles they had before imprisonment. So in the art group we are dealing with feelings of disempowerment not only related to institutionalisation, but also to personal losses and role changes.

There will also be individual responses to being in a group. For many women in Holloway, their early experiences of family and other groups were not of secure and nurturing environments, so any group setting will provoke considerable anxiety and insecurity.

This powerful combination of institutional and group dynamics may be very difficult for a woman to cope with. Comments about the strangeness of playing around with materials, or that 'the kids could do better' seem to indicate associations with childhood and the possible risk of criticism and failure. Images can help to make these feelings more conscious and offer a tangible means of containment for them.

Extending the work

A woman staying on the unit for several weeks or months may become a regular member of the art group. As trust develops she may choose to share more of the content of her images. Others who return to Holloway on subsequent charges, may reappear in the art group with clear memories of important pictures left behind from earlier periods in prison. When a woman returns to a picture she has done previously, I am often surprised that it seems able to provide some fragile continuity in a fragmented life. It may be particularly helpful to a woman who sees her return to prison solely as a depressing reminder of being stuck in a destructive pattern of offending, to have this tangible record of being able to engage in a trusting and creative relationship.

The next section looks at two pottery groups, in which women were able to address some of their needs for care and nurturing through the creation of clay objects. I will describe a session which became stuck with feelings of abandonment, but which came alive as women in the group were able to make these feelings concrete through their clay images.

Pottery groups

Background

The two groups are held in the pottery room in the education department, one in the morning and one in the afternoon of the same day. The education department is a busy place, with about ten classes going on each morning, afternoon and evening session. Prison officers responsible for disciplinary matters are not present in classrooms, but are available on the relatively rare occasions when disputes or security problems require their intervention. Teaching staff are therefore able to maintain a relatively neutral and non-disciplinary role.

Women from the medical units may choose to attend one or both pottery sessions as part of their education programme. Some come for a few weeks during a short stay in the prison, others use the groups over a longer period of time. Attendance is affected by court appearances and the movement of women from the medical units to other locations. Consequently it is unusual for the group to have the same members for more than a couple of sessions. As with the art groups held on the units, there are regular disruptions as women are called for visits or other appointments.

The decision to come to the education department is a significant step for women who have previously been restricted to unit activities. This move will be negotiated between the woman concerned, and unit and education

staff. Some may find the new environment and the general prison population quite intimidating at first. I try to keep in touch with inmates on their unit, before they attend and in between groups. This liaison and the small size of the groups can help to make the transition an easier one. Women need a certain amount of motivation to be organised and ready to leave the unit at the specified times for education. Commitment to attend does help the groups become a place where women are prepared to contribute and share feelings.

I encourage women to try out personal ideas, teaching techniques as they are needed. Working with clay can sometimes be less worrying than a blank sheet of paper, as there is already some colour and texture to respond to. It is possible to manipulate the material and vent frustrations on it. It can be usefully messy for some women, while others may need help to keep it manageable. Here, offering some technical advice can help a woman contain the potential chaos. Shared responses to the physical qualities of the material, worries about what to make, and not being able to finish work (in both practical and psychological terms), can provide an immediate focus for the group, despite changes in members from one session to another.

The slow cycle of making and firing clay work does not always fit easily with schedules imposed by court appearances and transfer of inmates at short notice. Uncertainties of being able to finish work can be too frustrating for some women to cope with, but others may be able to use these realities to explore the uncertainty of their own futures. It is as if the making and firing cycle, which cannot be hurried, acts as a metaphor for the waiting and delays experienced by many inmates.

Concerns about leaving Holloway and availability of after-care were issues raised in two consecutive groups that took place on my return from holiday one Easter. There were four women in each session, morning and afternoon. Two women, Jennifer and Lena, were present at both groups on that day.

The two groups

Jennifer was due to be transferred to hospital, but this had been delayed several times for lack of a suitable placement for her. She came to pottery over a period of several months, during which time she appeared regularly in court, awaiting the decision about her future. In the week preceding a court appearance, she would become quite anxious and more inclined to get into trouble for breaking prison rules. Sometimes she would injure herself, which she said stopped her from feeling anything. In the pottery groups she made a series of small clay figures and creatures which seemed to convey

feelings about being stuck in her present circumstances. Sometimes she attributed freakish qualities to these creatures or talked about their slowness.

Lena was on remand and had been attending pottery over several months. In earlier sessions she had often expressed anger towards me for not taking over when she felt unable to cope with her clay work. During her outbursts she emphasised how much she liked other members of staff. Lena had a tendency to split her good and bad feelings between members of staff, and had difficulty in sustaining relationships. I offered her support and advice, but resisted her repeated demands that I should do things for her. As she gained confidence in using the clay, she reached the point where she had several finished pieces of work to her credit, and was able to reduce the demands she made on me. She drew my attention to this one day, as she embarked on a new piece of work, by telling the group, with a mixture of playfulness and wry humour, 'I suppose I will have to do it myself'.

Through making clay objects, Lena seemed able to recognise her growing ability to be independently creative, a marked contrast to her earlier demands for attention. In the last group before my holiday she announced 'I'm going to make something totally by myself,' and wanted me to guess what it was. She seemed determined to exclude me from her activity in this session, as proof of her independence, and told me with satisfaction that the object was a plant holder.

The first session after my holiday began with Lena talking angrily about not getting the attention she wanted, in a class the day before. She told me how she had had to get on with things on her own, because the teacher ignored her. I took this as a comment on my two-week absence. She dominated the group with expressions of anger and helplessness, but finally began to paint the plant holder she'd made three weeks earlier.

Jennifer, too, was finding it difficult to settle, and said she did not want to do anything. She announced to the group she was definitely going to hospital from court the following day, but seemed worried about her court appearance. It was possible that there still was no hospital place, despite her show of saying goodbye to friends. Jennifer said how much she would like a coffee, and asked if I would buy her one from the drinks machine next door. She commented that all the other teachers provided coffee, but in pottery there was nothing. (I chose not to provide facilities for making drinks in the group, because it is a relatively short session. It was a group boundary that Jennifer had questioned on a number of occasions.)

That day, as on previous occasions, I felt there was an underlying issue for Jennifer about what care was available to her, not only in the group but elsewhere in the prison or in the hospital system. Indeed, I felt like an

'uncaring mother'. She wanted to go and say goodbye to other teachers, and it was clearly very difficult for her to stay with the group and her feelings.

Frustrations seemed to be escalating, everyone had stopped working and I experienced feelings of hopelessness. I commented that there appeared to be some feelings around about not being looked after, reminding them that I had not been there for two weeks. The group was silent and felt stuck. I remembered another art therapist telling me a story of being 'rubbished' in an art group for his failure to provide the 'right' things; he had survived by acknowledging with humour the hopelessness that he was experiencing in the group. So I made the observation that I was feeling fairly useless to them today. It felt risky, as I mildly 'sent myself up', pointing out that I could only offer them clay, and not what they really wanted. It was Jennifer who responded, with a noticeable change in her mood. Suddenly she was paying attention to what was happening inside the room instead of expressing her wishes to be elsewhere. Agreeing how useless I was, she repeated my 'send up' with humorous exaggeration.

Then one of the group quietly started to make a cup and saucer from clay. Jennifer made some sugar cubes. Playfully the others contributed a clay sugar bowl, teaspoon and biscuits, placing them in the middle of the table. The group members joked about getting their own drinks. As they organised their own 'tea party', they seemed able to contemplate taking care of themselves and each other. As she joined in the 'tea party', Jennifer reflected on the first time she had met me, three years before, in an art group, and she reminisced about the drawings she had done then.

That afternoon Lena decided to make a press-moulded dish, and worked with unusual concentration, no longer dominating the group as she had in the morning. Half way through the session, she announced that she had brought over her own coffee, and proceeded with much ceremony and enjoyment to make drinks for everyone.

Jennifer, after her difficulty in staying with the group in the morning, came back to make a present for a member of staff. She then asked if it was possible to make a cast of her face, to leave with a friend on the unit. This was a woman who had 'adopted' Jennifer as her 'baby'. In remembering her first days in Holloway, and expressing the wish to leave behind a cast of her face for her 'mother', she seemed to be showing her ability to hold on to the good relationships she had experienced at Holloway.

There was no appropriate material for Jennifer to make the mask, and she was not interested in finding another way of creating a replica of her face. The importance she ascribed to this task emphasised her need to find a way of tolerating the anxiety associated with moving to hospital.

Further thoughts about the 'tea party'

I speculate that the 'tea party' was an enactment of mutual feelings about caring and separation that could not be spoken about. With the clay it was possible to make these feelings concrete.

For Lena, the group and the clay itself acted in a 'holding capacity' for her feelings of anger and frustration. When these feelings surfaced after my holiday, with her thoughts about being 'ignored', she seemed able to use her clay object, literally a 'container', to hold on to her potential destructiveness. It appeared to act as a defence against anxiety concerning my absence, feelings which she was not, at that stage, able to explore. Following the 'tea party', Lena's pleasure at making real drinks for everyone in the group seemed to me an unconscious expression of her angry feelings towards me.

Holloway was a place where Jennifer felt at home. This was not her first stay in the prison, and she had established a number of good relationships with inmates and members of staff. She seemed torn between staying at Holloway, where she could be cared for as the 'baby', and going to a hospital where she could start moving out of her cycle of offending and imprisonment. The pottery group offered her the opportunity to express her anxiety and confusion about this move. When I acknowledged my 'failure' to look after her, she was able to explore, through the 'tea party', the possibility of moving on to an alternative form of care, whilst holding on to her relationships in Holloway.

This group was available for women such as Jennifer to use intermittently over an extended period of time. In contrast, I go on to describe four sessions which were part of a specific contract of individual art therapy.

Maria

The work of the Art Therapy Project is to look at when, and for whom, art therapy can be a useful intervention within the prison. For example, how does waiting for trial affect a woman's ability to make use of art therapy? Is it practically possible to adjust the timing of therapy to a woman's progress through the criminal justice system?

Some women may start art therapy while on remand, if they can tolerate the uncertainty. Such work is planned around the anticipated court date. Others wait until they have been sentenced, and art therapy can continue over a longer period of time, working towards a release date. The prison allows women to remain in Holloway to complete their therapy, rather than moving them elsewhere as in the ordinary course of events soon after sentence.

I started seeing Maria with the latter expectation, as she was serving the last few months of a three-year sentence for an arson offence. However, during the first month, and at quite a crucial time in her therapy, Maria broke prison rules while on home leave, and as a result lost her prison job. She was transferred to another prison as a punishment, and her therapy ended abruptly. I will describe the four art therapy sessions she attended, and highlight some of the difficulties of psychodynamic work in this setting.

Outwardly Maria appeared to cope well with prison, living on a non-hospital unit and doing work that demanded considerable responsibility and trustworthiness. However, in her regular sessions with a psychologist, she indicated a state of general confusion and difficulty in accessing her feelings. She had a history of eating disorders and did not make friends easily. Despite her inability to talk about her problems, Maria seemed to want help, so art therapy was suggested as a possible way for her to get in touch with her feelings.

In her assessment, Maria talked in a confused and fragmented way about an argument she had had on her unit. Returning to the present, she said that seeing the paper in the art therapy room reminded her that she wasn't currently able to put more than a couple of sentences down on paper. She described 'holding things in', how her words came out wrong, and 'feeling blank' when asked a question. She seemed to have considerable anxiety about externalising thoughts and making them concrete in any way.

Maria said she did not really know anyone in prison, and similarly, 'outside' she had spent long periods of time on her own. She felt suspicious of the motives of staff and other inmates when they spoke to her. She described the prison as 'a house with a garden, everything in one place', which made it possible for her to work there. The containment of prison seemed to help her cope in a way she could not manage outside. She felt there was nothing 'outside' (the prison). I offered Maria six weekly sessions, to be followed by a review.

First session

Maria started talking but became confused and hesitant. She said she could not describe her thoughts about moving between being hidden in her room and being 'outside'. (I understood the latter to mean the prison in general, but later thought she might have been referring to the art therapy room.) I suggested she might use the materials as an alternative to speaking. For a few silent moments this appeared to create its own confusion. I suggested she chose a piece of paper. Hesitantly she selected a sheet of cerise sugar paper, telling me, 'It stands out'. Indeed I was surprised by her choice, as it really

did stand out. Then she took a second sheet, this time black, 'to cover it up'. She linked this to her room where she could hide. Maria sat, staring thoughtfully at the two pieces of paper she held on her lap, finally asking, 'Can I work with the colour?'. I was surprised that she had literally 'taken hold' of the materials. The permission-seeking question also appeared to be a signal that she was ready to go ahead.

I asked her where she'd like to put herself on the paper. She drew a small circle in the middle of the pink sheet, then re-covered it with the black sheet. She said she was thinking where she would put herself 'outside', then moved as if to draw something in the middle of the black page, but stopped and explained it was to have been 'family'. Instead she drew a box around her circle, this was her room, 'surrounded by noise'. She described leaving the room to get away from the noise but being driven back by 'other little things'.

Maria had started the session with thoughts about the move between being hidden and being outside. The coloured paper offered her a ready made 'container', a space with fixed boundaries in which she could explore these ideas. Her choice of bright pink paper was perhaps a surprising experience for her, as well as for me. Having made herself visible as a small circle on the paper (and by attending the session), she subsequently needed to disappear under the black sheet.

Although Maria appeared to want to use the session creatively, her need to hide could be seen as an indication of her difficulty of allowing feelings 'outside'. Further thoughts about being outside, on the black paper, led to associations with her family and the need to create the boundaries described as 'her room'. This enactment could also be seen in terms of her future release, moving from the security and containment of prison to 'nothing outside'.

I kept these thoughts to myself, not wanting to inhibit Maria's use of the materials. She had moved on from confused and hesitant talk at the beginning of the session, and became tentatively playful as she engaged with the image. Even when the confusion returned, with the description of escaping the noise in her room and being driven back, she managed to make this experience a concrete part of her image. At this early stage, the materials offered Maria a way to externalise ideas that would not have been possible with words.

Second session

Maria's circumstances had changed: she had a new job in the prison and had moved to a different room on her unit. Her boundaries in the prison had changed considerably! Returning to the previous week's drawing, she lifted off the black paper cover, saying 'The room could be bigger'. After a long

pause, she added a larger green rectangle around the existing circle and box. The green was 'temporary'. I asked about her position in this larger room, and she responded by drawing a correspondingly large oval shape. She had become bigger to fill her new environment. Later she said, as if it was a matter of fact, that today she was somewhere near the edge of the paper, where she didn't react to what people said.

Through her image, Maria made a link between the experienced change in her physical boundaries and her lack of contact with her feelings. As we talked about the drawing, I commented on the expanding and contracting feeling of her image, and she made an immediate association with the way she saw her body, sometimes fat, sometimes thin, although unclear about the precise definitions of these words. She told me she had seen a television programme about eating disorders, and had sent off for some more information.

Maria had said she did not trust herself in her new job, which carried more responsibility with its location in a less secure part of the prison. This could be a metaphor for her experience in art therapy, feeling insecure after taking responsibility for externalising some of her confusion.

Towards the end of the session, she drew a line inside the temporary green rectangle; emphasised in red and labelled 'DANGER', it was where she spoke 'the truth'. She said it was explosive and dangerous for her and others in this place, adding that this described her family. There seemed to be a connection between these thoughts about dangerous space and the box/room from the first session, her ambivalent place of retreat. The session felt very alive as Maria explored her imagery, yet precarious in her references to work and family.

Anxieties about being visible emerged in another form at the end of this session. Maria asked who would see the pictures, as she didn't want them to be seen by anyone who would recognise her.

Third session

Maria said she wanted to tidy up her folder and tape up the edges, so that things didn't get lost. I reminded her of her question the previous week about other people seeing the pictures. She became preoccupied with being seen to need help, and therefore untrustworthy. In the light of her difficulty in using the help offered by other professionals, and the progression of this particular intervention, I speculated that her anxiety here was about her inability to trust the therapeutic relationship, and a fear that the boundaries were not adequate to prevent her falling apart.

She taped up the edges of her folder with uncharacteristic decision and erased her first name from the cover, as if putting a halt to any further exposure. She spoke of her worries about 'what happens outside' (explaining this was 'after the sessions') and about 'going to pieces'. As she talked about surviving two weeks' trial in her new job, I wondered if she felt 'on trial' in our sessions. Taping up the edges of her folder appeared to be Maria's way of physically holding her images and herself together. It also stopped any further engagement in the therapy process, which could lead to 'going to pieces'.

Fourth session

Taking sheets of white and blue paper, Maria said they 'looked nice together'. She moved them around, separated them, alternated the one on top, then announced she was outside the edge of the white paper 'out here on the table'. She added that her problems outside the prison were the same as 'in here'. With sudden clarity, she said she was fed up with the confusion and explained why she'd chosen the white: it reminded her of her difficulty in getting her white work clothes sorted out, 'Everyone else manages, perhaps it is me who causes the problems'. Maria seemed to be implying she could no longer be held by the boundaries of the paper and the therapy session itself.

Further thoughts about creating a sheet of half black, half white paper, turned into wanting to 'scribble over the black, make a mess all over'. She scribbled with pencil along two sides, then stopped abruptly, upset and tearful. Trying to tidy up the lines, she said she felt stupid, 'like a child' and fed up with feeling upset. With this chaotic activity, Maria seemed to be retreating from the anxiety created by being 'out there'.

As the session drew to an end, she became anxious to continue. Asking if she had time, she scribbled frantically over another portion of the paper, then stopped again and talked about her indecisiveness. I felt she had used those last few moments to disgorge something before putting the blue and white sheets together in her folder. There appeared to be a growing danger for Maria of things 'falling apart' as she experienced the exposure of her feelings.

The ending

These four sessions describe how Maria started to use art therapy to get in touch with her difficulties in externalising feelings. The materials enabled her to illustrate some of the confusion about her own boundaries, and to

begin relating this to experiences in her family and in the prison. However, her desperate state at the end of the fourth session suggested her growing anxiety at engaging any further in the therapy process.

Before her next session, I heard that Maria had broken prison rules by returning drunk from home leave (normally granted towards the end of sentences of 18 months or more). As a result, she lost privileges, including her job, and was transferred to another prison. In this instance the prison was not prepared to allow her to stay for the continuation of her therapy.

It seemed that Maria had acted out her anxiety about her work and her therapy during her home leave, beyond the containment of the prison. I was worried that she would experience these events, and her transfer, as the failure of others to protect her adequately.

Maria's transfer could have confirmed her pattern of relationships ending in disastrous circumstances over which she had little control. While her anxieties about falling apart could be held within the art therapy sessions, it seemed they became too overwhelming on the 'outside'. The potential for Maria to blame the prison for her transfer was clear. However, I was able to have a short meeting with her before she left, and despite her anger at being moved to another prison, Maria felt she had some responsibility for the events leading up to this. She spoke of the art therapy sessions as having given her a thread of hope.

Conclusion

Finding a way of working as an art therapist at Holloway has involved exploring issues of offering space for contemplation and change, in an environment usually associated with punishment. Adding to the complexity, there is the unconscious need of many inmates for the containment that prison offers.

Much of the brief work in art groups on the medical units focuses on helping women gain enough trust to use their images for dialogue with themselves and, in time, with me. The materials and images function in a 'holding capacity' for the fears and anxieties that arise as women engage in the therapeutic relationship. This is particularly useful where previous relationships have been experienced as destructive and lacking in security. For women who are not able to participate elsewhere, the art group is a first step which may enable them to seek out further help while in the prison, or after release.

The latter part of the chapter looks at the problems encountered where anxiety is acted out beyond the confines of the therapy session, and therapy ends prematurely. Although an abrupt ending is by no means exclusive to

work in prisons, it may be experienced as particularly damaging, because of the dependency created by imprisonment. In Maria's case, there was a recognition of events as part of a larger pattern of behaviour.

The difficulties of working in this environment of transition and uncertainty are compounded by rarely being able to conclude work. The images provide a way to hold on to the progress that women have made through art therapy. They offer a record that women can find more appropriate ways to express their feelings and make changes through an understanding of their personal imagery.

Note

The opinions expressed are those of the author and do not necessarily represent the opinions of the Home Office or the Prison Service.

References

Carlen, P. (1983) *Women's Imprisonment. A Study In Social Control.* London: Routledge and Kegan Paul.

Day, E.S. and Onorato, G.T. (1989) 'Making Art in a Jail Setting' in H. Wadeson, J. Durkin, and D. Perach, (eds), *Advances in Art Therapy.* New York and Chichester: John Wiley.

Out of Line

Art Therapy with Vulnerable Prisoners

Shân Edwards

Introduction

In this chapter I present Bedford Prison and explain how teaching art there led to my art therapy training. This initial link subsequently informed the approach to art therapy on two of the prison wings. This approach was also influenced by the client group and its unique environment.

I have tried to be fair in explaining the difficulties and constraints of working in this setting, especially with vulnerable prisoners. It is a difficult and taxing situation for staff as well as prisoners, and this is not always appreciated well enough to inform prison policy concerning such offenders.

I have included attempts based on the 1983 Mental Health Act to keep these offenders from serving prison sentences. Certain prisons, such as Pentonville, Littlehey and Grendon, have initiated therapy programmes for offenders. It is part of their strength that this initiative has come from staff, in response to the lack of Home Office policy in this area. However, prison-based initiatives can also be a weakness, as is shown by the closure of C1 wing in Bedford.

With current cuts, the threat of privatisation and the unknown future direction of the prison service, these programmes remain few, and are not available to the vast majority of prisoners. Progress in this area is consequently slow and haphazard, and continues to be marginal rather than mainstream. It is from this awareness and concern that I chose the chapter title.

Bedford Prison

Bedford is a local prison, which means that it serves the local community by holding remand prisoners in custody until they are either bailed or brought

to trial and then convicted or released. On conviction they are held there until transferred to their long-term prison. Some men are held on remand for many months, depending on the complexity of their case or the backlog of cases waiting to be heard by the courts. It can be the most difficult time spent in custody, because the prisoner does not know what the outcome will be. He may hold on to the idea of a 'walk out' or acquittal; he may be over-pessimistic and anticipate a long sentence.

Prisoners discuss the severity or lenience of each judge, and seem to know as much about the law as their barristers, for many of our students are recidivists. They watch with interest the process and result of each trial, and conversation in the art class is often directed, usually with much humour, towards actual or imagined sentencing. Humour is much used as a release of tension and anxiety.

Relief is most noticeable on conviction and sentence. Prisoners generally have little patience for those who find their sentence hard, unless it is thought an unnecessarily harsh or unfair conviction. 'Don't do the crime if you can't do the time' is a prison saying about the inevitability of eventual imprisonment for law-breaking.

These are the issues and concerns which are very close to the surface for the remand prisoner. As a consequence, they are often the most willing students, keen to get involved in an activity which may help to take their mind off their problems and pass the time productively. It also provides more time with fellow prisoners and staff, who can bring in a sense of the outside world.

This last point can also be the reason why other prisoners choose not to attend education classes. Some men prefer to use the prison as a cloister and segregate themselves from the outside world. Finding it too difficult to combine the two, they may sever all outside links, even with family, in order to feel able to serve their sentence. However, education in the prison is voluntary and most students have positive intentions in attending classes.

My introduction to art teaching in the prison

I began teaching in Bedford Prison after leaving art college ten years ago. I had heard that the education department was looking for someone to teach modelling in the segregated Rule 43 wing[*]. I was interviewed, offered the job, and shown the room where classes were held. On asking where the clay

[*] Rule 43 is a provision available to prisoners segregating them for their own
 protection. Many, but not all, Rule 43 prisoners are sex offenders.

was kept, I was told that 'modelling' meant 'match modelling', and not to worry that I had never done any, most people had not, but I would soon pick it up!

This was my introduction to the major prison art form, and I am continually amazed by the variety and quality of the match items produced. It took eight years before clay was cleared for use in the prison. I introduced the use of other art materials to that class, and later also taught in the main education department of the prison.

While teaching the segregated Rule 43 prisoners, I found that many people needed to 'off-load' about their personal life and problems, their crime and how they felt about it – and they did this either directly, verbally, or through their work. It seemed inevitable that, by encouraging students to produce personal art work, many issues would be raised which I felt increasingly inept at dealing with.

Even if a soft toy or match jewellery box was being made to hand out on a visit to a partner or child, that person would be brought into the conversation, along with the sense of loss, sorrow, anger and guilt which surfaced. Those first students taught me a great deal about imprisonment, segregation and crime. I was probably naive and maybe a good pupil because of that.

Art therapy training

Working in the prison finally decided my move to study art therapy. The head of the education department gave me full encouragement. I received funding from Grants for In-Service Training, and began part-time post-graduate study in art therapy at St Albans. One condition of undertaking part-time training is that the workplace must provide work experience in art therapy. I was contracted to run two art therapy sessions, one with the Rule 43 prisoners and one on the main wing. This was later altered, owing to timetabling difficulties, to C1 wing, an annexe of the prison hospital.

New and innovative work is often regarded with suspicion or even hostility in prisons. Fortunately I already held a position and was known, so that the PR work was, in effect, already done. For this reason, however, art therapy was and still is seen as education based, and clients are called to 'classes' by the prison officers.

In some ways, what the group is called is irrelevant. What is important is what goes on during that time. For security reasons I cannot hold groups without some officer involvement. This is at best transitory and at worst disruptive, depending on the individual officer, how I am received, how

therapy or education for prisoners is seen, and any general personal bias concerning the prisoners.

More awareness of my aims and objectives, and officer involvement in these, is planned on both wings for the future. As a result I am currently organising some art therapy training workshops with officers who work on the wings where sessions are held, in order to give some information and insight into the theory and practice of art therapy. I hope that this will lead to more appropriate referrals, fewer interruptions, and more sensitivity concerning comments on work being produced.

Mental Health Act 1983

> It is beyond question in our view that people who are mentally ill and severely mentally impaired as defined by the Mental Health Act should be in hospital and not in prison. (Richer 1990, 15)

This statement of the Social Services Committee was made during their review of the Prison Medical Service in 1985–86. However, the continuing presence of such people in prisons confirms the fact that the provisions of the Act do not ensure diversion to hospital. Prison medical staff are left to deal with the problem with no clear policy, funding or training.

Most of the mentally vulnerable in prisons do not fall within the terms of the Mental Health Act, and must serve out their sentence in the prison system. Under the Act only treatable cases may be transferred to hospital. Those whose diagnosed illnesses are thought untreatable therefore do not qualify. Another restriction is the lack of beds in hospitals which, together with the loss of locked wards, limits the number of transfers possible under the Act.

Statistics are of little use when it can be seen from the information given that the medical service has little incentive to search out the mentally ill from prisons and arrange treatment. The so called 'borderline' cases who are harder to assess would certainly not be diverted from prison. In 1985 the British Medical Association estimated that 'borderline mentally abnormal prisoners may constitute between 20 per cent and 30 per cent of the sentenced population and they are people who are rejected wherever they present' (Richer 1990).

Added to these prisoners are the increasing numbers of 'inadequates' entering prison. They are often remanded in custody because they are homeless or serve recurrent short sentences for relatively minor offences. They may have problems with alcohol and drug abuse, have personality disorders or learning difficulties. It has been suggested that the increasing

entry into prison of these 'vulnerable' people is a direct consequence of the policy of closing down long-stay psychiatric hospitals.

The monitoring of the experience of people from ethnic groups needs to be undertaken:

> Recent statistics from the Home Office Research and Statistics Department (Ward 1990) indicate that 23 per cent of the 252 sentenced prisoners who were transferred to hospital under s.47 of the Mental Health Act in 1987 and 1989 were from ethnic minorities compared with a proportion of 14–15 per cent in the general prison population. Afro-Caribbean men are also over-represented amongst patients detained under Part 3 of the Mental Health Act in locked wards and secure hospitals. (Grounds 1990, 36)

Alternatives to custody

There are alternatives to custody for the mentally ill offender. In Luton, the courts are served by a panel whose aim is to divert as many mentally disordered offenders as possible from custody, by offering appropriate and well worked out treatment plans. Its stated aims are:

> To improve the quality of assessment by sharing information gained from individual work.

> To maximise the choice of the most relevant agency or combination of several.

> To maintain and promote the notion of shared responsibility by all agencies concerned for these offenders.

> To prevent recidivism and relapse by extending this responsibility beyond the point of assessment, to subsequent management or appropriate treatment of individuals in this client group.

> > (Luton Inter-Agency Assessment Panel for
> > Mentally Disordered Offenders, Information leaflet)

The panel consists of a coordinator who is a probation officer, a consultant psychiatrist, a clinical psychologist, a social worker and a community psychiatric nurse. (The CPN works in the prison hospital and the court. This is a newly created post in the prison.)

The coordinator forwards a request for psychiatric assessment from the courts to the consultant psychiatrist and/or psychologist and the community psychiatric nurse. They, along with the probation officer, prepare individual assessments for the next panel meeting, when the case is discussed. Various

other professionals who have known the client/patient, or who are likely to be involved in a treatment plan, can be invited to attend. Following discussions, a Psychiatric Report and Social Enquiry Report (now called Pre-Sentence Report), containing a coordinated management plan, is submitted by the psychiatrist and the probation officer.

The panel meets during the fourth week of every month. It can also be convened whenever deemed necessary. When psychiatric assessment is requested, a six week adjournment period is usually required. If a defendant is remanded in custody, the adjournment period is reduced to three weeks. This is not a nationally coordinated plan – its principles may apply to similar panels in other regions, but I understand that, as yet, there are few.

Bedford Prison receives men from police custody and through other courts which may not be informed or able to provide such alternatives to custody. The crime committed may be too serious to make any alternative to custody a viable proposition. As a consequence, vulnerable and mentally ill offenders continue to be held in the prison.

History of C1 wing

Bedford Prison is in a difficult position regarding care of the mentally ill and vulnerable offender. It is a local prison and as such is obliged to receive all those presented on remand for detention, whether it is adequately equipped to cater for them or not.

As a consequence C1 wing was set up in 1990 by the prison doctor, governor and existing staff in an attempt to deal with men on remand who had a diagnosis of mental illness, learning difficulty, or who became ill after their imprisonment. Dr Jones also intended the wing to provide for registered drug users and alcoholics, who would undergo a detoxification programme.

For these reasons, the wing was closely linked with the prison hospital and was run by the hospital staff. If a closer watch was needed on any prisoner, he would be removed to the prison hospital itself, as C1 was periodically left unattended when the men were locked away.

The initial plan for the wing was to provide a therapy programme, especially for those who were drug or alcohol dependent. This was initiated by Dr Jones, and prisoners were expected to participate in the programme – being on the wing was seen as a privilege. I was employed by the education department, which was already running classes on the wing, so had no contact with Dr Jones. The art therapy sessions ran parallel to the programme already established by her.

I was hopeful at the prospect of running an art therapy group on C1 wing. It was the one area in the prison which seemed to have a real concern

with rehabilitation, and had made a serious attempt to establish a policy of treatment by responding to the needs of its clients. The staff were genuinely concerned at the plight of their clients, and relationships between them were seen as being an important part of the programme. The unit's small size and staff continuity enabled this to happen. I looked forward to working 'in line' with a rehabilitation policy, rather than 'out of line' with the purely custodial nature of the rest of the prison.

There were always difficulties, however, given the nature of the institution as a remand and local prison. When a person enters the prison regime, he does not bring medical notes with him. There is often no information concerning drugs he has been prescribed, or what his mental health diagnosis is. A vulnerable prisoner can easily be overlooked at the reception stage if there is no indication through behaviour or speech and the information is not volunteered by the prisoner himself.

For the art therapist working in this setting, obstruction of information by staff is not the problem, it is not having any information at all to work with. Medical staff can often only re-iterate what the therapist gathers by working with the client in the first few sessions.

Initially the unit worked well, and staff were committed to the work. However, when Dr Jones was transferred to another institution and not replaced because of cutbacks within the prison service, the use of the wing began to change. Bedford is renowned for overcrowding, and the spaces available on C1 were increasingly used for 'lodging' prisoners who could not be housed elsewhere.

This changed the nature of the wing quite drastically, often setting up hierarchies of more to less able prisoners. From a therapeutic point of view, it was disastrous. That period was also the most difficult for the other staff, who were fighting a losing battle against the pressures of overcrowding in the rest of the prison. They were increasingly called away to other duties, and sessions were cancelled at short notice or had to end before time.

It may have been rather ambitious to describe C1 as a therapeutic unit. The therapy programme was unclear, as was wing policy and inmate referral. No extra money had been made available for staff training. This meant the unit was rather too dependent on being sustained by the interest of the Dr Jones and, when she left, the little remaining structure crumbled under the pressures of the rest of the system.

This was difficult and frustrating for staff and inmates, but it informed the basis of an evolving, realistic policy of care on a new hospital wing. C1 was closed, and the new hospital wing opened in part of the prison extension building. It takes prisoners in need of medication and surveillance, those

who are physically disabled and the vulnerable prisoners previously housed in C1 wing.

One very significant change is in the surroundings. The old wing was below ground and, although the cells had some daylight, the 'association' area and the space for classes and therapy groups had no natural light or ventilation. It was rather like being in a dungeon, isolated from the rest of the prison. A mural of a garden had been painted on one wall in an attempt to give a feeling of space and a reminder of the outside world. The overall atmosphere was of claustrophobic seclusion.

The new wing, by contrast, houses the prisoners on the first floor of the block. The space is light and airy, and has large windows overlooking a garden area and exercise yard. People can be seen going about their business, and above the prison buildings the sky is visible.

Another significant change is the appointment, on a part time basis, of a community psychiatric nurse. Her work overlaps my own and I find her a good professional ally. She seems to be a bridge between the various agencies working within the prison, as well as acting on behalf of prisoners and the courts. I find her information on clients invaluable and am less isolated in my work. This means I am less 'out of line' and in a better position to encourage clients to open up. In between art therapy sessions clients also meet with her as a group, and on a one-to-one basis if necessary. The foundations are being established for a more substantial and lasting policy for care of our vulnerable prisoners.

An approach to art therapy

The art therapy session on C1, owing to the wing policy of expected involvement in all activities, included all prisoners, both remand and convicted. There could be as many as twelve, the total number catered for on the wing, or as few as two.

In a remand prison, the therapy session is often interrupted by legal visits, probation visits and appearances at court. Between one session and the next, prisoners may attend court and be released – or sentenced and moved on to their long-stay prison. There is often no warning for this. It can be most disconcerting for the prisoner, the group and myself to find that one or even several prisoners have disappeared, only to be immediately replaced by more. This makes provision for ending therapy difficult and erratic. The allocation of prisoners to long-stay prisons takes account of little else except numbers. It is even possible for a man to be moved on, only a few weeks before the end of his sentence. This occurs especially when the court case is held up, and most of the sentence has already been served on remand.

Because of these circumstances, the group was open and non-directive. We met once a week for two hours. Various needs had to be catered for, and I introduced the session as being an opportunity to use the art materials in a free and expressive way. I restricted the use of materials to clay, pencils, paints, pastels and crayons. I wanted to establish a difference between this group and the art and handicraft classes, where match-modelling, fabric painting and soft-toy making were done. There is a tradition of prisoners making items for handing out on visits or for charities, whereas I was trying to encourage the idea that art could be explorative and done for oneself, and that skill in representation was not the main concern. I made it clear that the work would not be judged or marked.

Participation was by attendance, and I did not coerce the men to be productive, as I felt engaging with the materials needed to be done on a voluntary basis. Other members of the group would often cajole and encourage more active participation, having found it a useful experience themselves. In looking back over work produced at this time, it seems to reflect the creation of a safe enough environment for most people to engage in art making.

Once the 'lodgers' moved in, this enabling environment was altered. There was no trust within the group. It was difficult for them to work, even independently, within the space shared, as their needs and abilities were totally different. A pattern emerged in which the 'lodgers' were active and worked with the materials, while the vulnerable prisoners sat and watched. This inactivity and lack of engagement may have occurred anyway, but what was being compounded was a sense of otherness and difference.

As I became more aware of the inactive members of the group, I tried to act as a bridge across the division. I sat with the vulnerable group, but joined in with conversations of the active participants, occasionally going over to look more closely at their work. On one occasion a vulnerable prisoner moved across with me to the table, took paper and pencil and produced a drawing of a head partly encased by a helmet. He stayed with his drawing for the rest of the session, as though it represented a pass for being on that 'side' of the group. He never produced another image and a few weeks later was transferred to his allocated prison.

Developing skills and methods of working

Having made the distinction between art classes and the art therapy group, I felt a little uncomfortable when some prisoners asked for tuition. To me this was a very minor aspect although I had taught some clients basic colour mixing as their limited knowledge restricted their use of materials.

I was still relatively new to the role of therapist, and consequently needed to maintain for myself what I thought that role was about. As I became more confident in my 'therapist' role, the links between art teaching and art therapy (which had been my reason for taking on art therapy training in the first place) resurfaced. I took the issue to supervision.

My supervisor was a very astute senior probation officer, who had done some training at the Tavistock Clinic, but who had no knowledge of art therapy. He agreed that still-life drawing had no part to play in art therapy, that tuition and therapy were different. However, for me the issue was more complicated. We began a fruitful debate concerning the use of art, the development of personal style, the reasons why anybody wants to learn to draw or paint, the restrictions which can be the result of following a particular school of art. In talking with him about the broad issues of art and art-making, I was able to redefine my code of practice for art therapy with this client group.

In these art therapy groups, teaching can take place, encouraging clients to look and copy, to see everyday objects and people in a fresh way, and translate what is seen on to the paper. This can give confidence in art-making, and opens the way to experimentation and exploration with other art materials.

I find it strange now to withhold the knowledge I have, and can teach or share. In my experience, a lack of engagement with the image can be a result of the client seeing his lack of skill reflected back in that image. What is the point of the therapist being able to see and give meaning to the content of the work, when the client sees only his inept attempt at depiction? With some vulnerable clients especially, improving their artistic skills gives an increased confidence. If they are learning and achieving in this area, other achievements in their lives may begin to seem possible.

Recently one client was determined to 'get it right', and I wondered whether I had overplayed his need to look carefully and draw accurately. He suffers from acute anxiety attacks, but is no longer anxious about his drawings, because he has learnt that he can look again, and make a different mark which may work better. He enjoys this test of his observation skills, which are improving. It may be that there are other areas of his life which he would like to 'get right'. He may have been punished for, and lost self-esteem by, getting things wrong, and learning to draw has given him one area where he can get it wrong and then put it right. In this way, the language used in the group can often reflect other issues of life.

Some clients need to learn traditional art-making skills before they can move on to more expressive art making. It is as if 'realism' needs to be within

grasp before 'abstraction' can be investigated. The development of Picasso's work (and the development of art in general) reflects this process. Furthermore, some people need to be able to depict what they see, before they can depict what they feel.

I am not advocating that teaching in itself should be a priority in therapy groups, but that the sharing of skills and information should not be withheld from a client who wants to learn. Similar learning may take place in literacy. Someone who can speak the language, may still be inhibited in experimenting with words by a lack of awareness of language form. By looking at other writers and learning about word choice, rhythm, rhyme and so on, students can begin to express themselves in a more creative way. I am convinced that there is a link between learning about creativity and therapy.

When the group meets, I introduce myself to any new inmates and explain that the group meets twice a week for the purpose of using art materials freely and experimentally. I suggest that the activity or process can be more important than the finished item; that it is quite normal for art-making to bring back memories or feelings which can be talked about if the client wishes. I also mention that what is being communicated is more important than the skill of the artist/client. I try to encourage the playful and exploratory aspects of art-making. I make it clear that although I am not a teacher in this context, I will fit in with individual needs, including teaching if desired. All these aspects will usually be taken up at some point during the sessions.

The open aspect of the group may limit any 'text book' art therapy, but my aim is for a relaxed and welcoming atmosphere which can, as it must, cater for a variety of needs.

When the client feels safe enough, a meaningful exchange occurs with the image or object as a focus. For example, one client, who found it difficult to talk about himself, began to model clay figures of animals with different characteristics. A donkey turned into a rabbit. I felt they both represented aspects of his character, and he articulated this after making them. The art-making process enabled him to make this connection.

Another of my clients is making a large coil pot. For weeks he has been struggling with its growing size and the difficulties of keeping it whole, moist and workable. Achieving this task has been the goal for him, and the pot seems to have become a symbol of survival for the whole group. Each time it is taken out of its bag, it is carefully examined for cracks, bumps and unanticipated changes.

It is large and round, and has a base almost too small for its size. Its roundness and richness remind me of the prehistoric fertility symbol called

the Venus of Willendorf. Another person in the group said it looked like a turnip; he enjoys gardening and the idea of harvesting.

The maker is proud of his achievement, never imagining that he could produce such an admirable object. He has learnt about what is possible, what the clay will and will not do and, more important, he has the pot as evidence of his achievement. His biggest worry was that he would make unredeemable mistakes. He needed teaching as he lacked confidence in his own ability to experiment and try things out.

This client had suffered brain damage as a small child. While building his pot, he told me that no allowance had been made at school for his disability – his lack of concentration and misunderstanding of instructions. As a result he was bored, 'played up' and acquired the added label of 'difficult child'.

The discovery that he is able to learn, especially skills he imagined were beyond him, and enjoy the process, means that he now sees himself as equally able, although different from others. He is now more willing to negotiate for himself, make decisions, take risks and step out of his 'unable' or 'difficult' role. This is not the assumed confidence often presented in prison, but a confidence which combines with courage and can enable a person to make profound changes in life.

There is another aspect of the teaching of art which overlaps with therapy. Many of my clients do not know how to 'read' images or forms. They seem to be unaware of the possibility of responding to art work and discussing it. They do not realise that it can have layers of meaning which can alter depending on themselves and what they bring to it. This awareness is dormant, but can be awakened.

Sometimes we look at other artists' work to introduce the idea that art communicates something more than the skill of the artist. Reading the ambiguity in art can also help break down the rigidity of response to life situations. Learning how to debate what 'is' in a picture for oneself, and hearing and seeing what 'is' in the same image for other people, can demonstrate the existence of other points of view. This may be a difficult concept for many, and talking around art is a safe method of discovery.

One important aspect of learning through debate is that the client is acquiring skills for himself, through his own active participation. He can then go on to make his own images, or choose images to investigate and discover their meaning. Some clients seem to need this conscious learning process to allow the emergence of the sub-conscious. It may sound patronising, but many of my clients have never thought about themselves in a reflective way.

The coercive nature of prison means that inmates have no choice in where they are and what they do. Similarly, they do not choose to participate in a therapy programme in the way that a free person can choose to undertake personal therapy. They are expected to participate in the programme, and may be penalised for refusing (Kopp 1974). This is still wing policy, to prevent the prisoners from spending all day in bed, which some are inclined to do.

To achieve as much 'voluntariness' as possible in the art therapy group, I make it clear that attendance is all that is required. I work with whatever form their involvement, or lack of involvement in the group takes.

A more subtle consequence of the coercive culture is that I often feel that art work is done for me, because of my position, rather than for the artist himself. This is also quite common in schools, and a re-education or 'de-education' is needed to allow meaningful engagement, in which work comes from the client's involvement or enjoyment.

The newly-imprisoned person is expected to deal with his pending trial, his loss of freedom, family and friends (sometimes permanently) and everything else that imprisonment means. The art therapist in a remand prison is dealing with all the resulting feelings, and may never get beyond these to any medical diagnosis or work concerning the offence.

As an art teacher in prison, I was aware of my inability to deal adequately with the content of the images and communications of the students. As an art therapist, I may not appear to be working any differently, but 'the difference lies in the confidence and ability to deal with whatever comes and to use the experience in a reflective way' (Schaverien 1992).

Conclusion

In presenting the work done in Bedford prison with vulnerable prisoners, one of the main issues seems to be that 'nothing quite fits'. The strategy for a comprehensive care programme is lacking, and the different agencies in the prison have little real communication or common sense of direction, or include the prisoner. This may be due to the nature of prison, the place of vulnerable prisoners within it, and (as I hope I have shown) the lack of clear policy on care and rehabilitation of such prisoners. There does seem to be a cycle which still needs to be broken.

John McCarthy, once Governor of Wormwood Scrubs, who resigned after writing to *The Times* describing conditions in his prison as a 'penal dustbin', is now working with the Richmond Fellowship which supports ex-offenders and the mentally ill, and pleads that:

It is just no good asking about the best form of aftercare, or what problems ex-prisoners face after release until the actual process of imprisonment is changed... the systematic aridity of imprisonment [is] irrigated with occasional benevolence. If aftercare is to be effective I believe inmates have to leave prison with a sense of self respect and a sense of responsibility for themselves and others. To do this, the same qualities must be held and given to all staff, these qualities support the growth of an individual who holds the soul of the prison service... I have met many such staff but have never found the collective prison soul that speaks and acts the truth.(McCarthy 1990)

Art therapy within the prison system holds an important place, but until Home Office policy places therapy and rehabilitation at the core of its penal policy, its effectiveness will remain limited.

References

Grounds, A. (1990) 'The Mentally Disordered in Prison.' *Prison Service Journal, 81,* Winter, 29–40.

Kopp, S. (1974) *If You Meet the Buddha on the Road – Kill Him.* London: Sheldon Press.

Luton Inter-Agency Assessment Panel for Mentally Disordered Offenders. Information Leaflet. Available from Luton Magistrates' Court.

McCarthy, J. (1990) 'Recall.' *Prison Service Journal, 81,* Winter, 12–13.

Richer, A.D. (1990) 'Should the Prison Medical Service Develop its Role in the Treatment of Mentally Ill Offenders?' *Prison Service Journal, 81,* Winter, 15–18.

Schaverien, J. (1992) 'Art Therapists and Artists in Hospitals.' *Mailout,* April/May, 1992, 22.

Ward, P.W. (1990) 'Diversion of the Mentally Disordered Offender from Custody: research and statistics available centrally.' Paper presented to Mental Health Foundation Conference on 'Diversion from Custody: the mentally disordered offender: needs and alternatives', Harrogate, 28–30 Sept 1990.

Working as an Art Therapist in a Regional Secure Unit

Barbara Karban
in conversation with Adrian West

An extreme setting

There is a wall around the Regional Secure Unit (RSU) because the patients within it are compulsorily detained there under sections of the 1983 Mental Health Act. They are considered, either by the courts or by referring psychiatrists, a potential danger to the public (and often to themselves), and to require conditions of security. Their diagnoses cover a narrow range of mental illness and personality disorders, although their own histories are obviously more diverse. What they have in common is that they have usually committed a dangerous, sometimes fatal, offence, usually of violence.

For some patients, admission to the RSU is the last resort before admission to conditions of even higher security within a special hospital. For others, arriving at the RSU from a special hospital marks the beginning of a critical time of testing out their progress in rehabilitation towards living within the community. Thus the RSU functions to protect society from people who have offended while mentally ill, and at the same time provides offenders with therapeutic help and treatment. Therapists therefore have a dual role of policing and healing, and although the policing aspect might be less pronounced for the art therapist, it nevertheless influences his/her way of working with patients.

The RSU where I work is a purpose-built secure facility within the grounds of a general hospital. It provides 40 beds in single-room accommodation on four mixed wards for adults. Just under 20 per cent of the patients are female. (However, for the purposes of economy, in this chapter

the use of he/she will be dropped in favour of he.) The aim is for patients to stay on the unit for an average of 18 months. Apart from an airlock system for entering and leaving the unit, the most obvious sign of high security is the high staff ratio.

I have heard it said that working in a special hospital or RSU is an opportunity for some people to deliberately, if unconsciously, place themselves in an extreme situation in order to explore the more extreme aspects of themselves. That might be so, but I can give no such clear motivation for taking this job, other than that I had been looking for a post for nine months and this one came up. However, I did not know how extreme it would be.

The most accurate expression to describe starting the job was 'jumping in at the deep end'. The patients I met were mostly likeable, and it was difficult to put them next to the offences they had committed. It only slowly started to dawn on me what these people had done. I had this paradoxical feeling that, on the one hand, I could not forget what they had done, yet, on the other, I had to treat them just like other human beings relating to me. It was quite a task not to be afraid.

A confrontation with fear

Looking back, I realise that the 'jumping in at the deep end' also involved a confrontation with fear: fear of the place, fear of the patients, patients' own fear of themselves and their index offences,* fear of the staff, staff fear of the patients and the fear of staff of each other. This level of fear was quite different from anything I had encountered before. I felt it as soon as I entered the building every morning. It felt like going on to a boat that was leaving the outside world, as I left my normal reality and entered a far more intense environment.

During my art therapy training I had worked in various other settings, none of which were as extreme, perhaps with the exception of a much under-resourced hospital for people with learning difficulties. Moreover there was hardly any mention in my art therapy training of forensic psychiatry. At that time, I had not met any other art therapists who worked in this field.

When I started the job, not only art therapists I knew, but even friends, were taken aback if not threatened. This reaction seemed related to a very natural and justifiable urge to reject the aberrant members of our society.

* Index offence: the last offence the patient was charged with, which led to him being sectioned under the 1983 Mental Health Act.

Even now when I talk about my work, there is usually a stunned silence. I hope this chapter will convey to those who still feel threatened that art therapy can exist in these extreme settings and has an important function there.

The role of art therapy

In the RSU, I am the art therapist member of the multidisciplinary team (MDT), which also includes psychiatrists, nurses, social workers, occupational therapists and psychologists. Collectively, our task is to assess patients continually, and help them achieve their potential, so that they are no longer a danger to themselves or to the community.

For some patients, no psychotherapeutic intervention can work until they gain some stability from mental illness – and that stability sometimes has to be achieved and maintained with medication.

Effective treatment is dependent on as clear an understanding as possible. Thus the main concern of psychiatrists and psychologists is to understand the aetiology of the presenting illness, and make a formulation of the problem. Inevitably they focus on what has gone wrong in the patient's past, both the bad things that have happened to patients, and the bad things they have done to others, to try to answer some very fundamental questions. For example, having considered a patient's understanding of his past offending, how dangerous will he be, if he returns to the community?

However, art therapy has a complementary but different emphasis. Its focus is primarily on a patient's integration and potential for the future, rather than the problem, the symptom, the index offence and the past. Moreover, whereas conventional psychotherapy focuses on the transference relationship between the patient and the therapist, with its emphasis on past relationships, art therapy has to be totally in the present. Art therapy therefore has an integrating rather than an analytic approach. Consequently, although I obviously need to be aware of the relevant aspects of a patient's past, I have to put them into a separate mental compartment. They remain in the background of my mind.

This 'complementary but different' emphasis of art therapy is apparent in the information I bring to the weekly ward meeting with the MDT. Sometimes, with the knowledge and permission of patients, I show their art therapy work. I do this because it provides new information, about the non-verbal rather than the verbal side of patients.

The art work often surprises the MDT, because it can show a patient's process of integration, and also fluctuations and phases of disintegration and stagnation. It seems to mirror not only mental processes, changes and

side-effects of medication, but even more poignantly, emotional states and mood swings.

An acute psychotic patient, for example, initially exhibits a mentally disorganised state, which then, over a period of time, becomes more organised, but often less colourful and spontaneous. Many psychotic patients, despite the negative features of their illness (apathy and passivity) and the side-effects of medication, still manage to keep their artistic worlds intact. For these patients, art therapy is not only a temporary therapeutic tool, but also a means of creating meaning in what is otherwise a bleak existence.

The knowledge that patients' art therapy work is sometimes shown to the MDT, and taken seriously by them as well as by the art therapist, becomes part of the therapeutic process for them. It is also important to them that their art work is exhibited, not only on the art room walls, but also on the corridors and wards of the RSU.

The forensic patient has to learn to accept that there is nothing to hide any longer, that he is known for his index offence by himself and by most of the staff. The less he hides from himself, the more the staff feel they know him, which is important for his progress through the RSU. The exhibiting of the art work thus has a therapeutic rather than an aesthetic function. For this reason, I was allowed to convert the corridor outside the art room into a gallery. The frames are like photographic frames, so that art work can be changed periodically, and all patients can have their work exhibited.

The three-way relationship

Since the overall aim of the RSU is to reintegrate people into the community (or the least secure conditions that their mental disorder permits), the gradual exposure to and tolerance of freedom is a very important part of their assessment. The role of all therapies in the RSU can be seen as bridging the patient's need for containment and the development of his ability to cope with freedom. This involves learning or re-learning the ability to make choices and take responsibility.

It is in this area that art therapy has a special function in the RSU. Art therapy has its focus in what I call the three-fold space or three-way relationship: the art room, the pictorial space (the piece of paper the patient works on) and the therapeutic space in the relationship with the art therapist. Together these create boundaries and containment, while at the same time encouraging freedom of movement (spontaneity, creativity and decision-making) within such boundaries.

'Evil comes from suffering and makes others suffer'

Most patients come from very disadvantaged backgrounds. They have often been rejected by their parents, their families, their communities and ultimately themselves, because of what they have done. Therapeutic work is not about rejecting them but accepting them. Yet we who work with them still have to deal with a powerful and sometimes natural urge to reject. Somewhere in the background are the victims of their offences. A personal way of dealing with this ambivalence is needed in order to go on working with these people.

My own personal philosophy is linked to what one patient said to me 'Evil comes from suffering and makes others suffer.' That is largely what they all share. Rejecting their own lives and themselves, and inflicting the suffering they suffered on other people, is often the only way they feel avenged. What they have done in their offence is project their own suffering outwards, resulting in the total rejection of others.

At the same time, my philosophy does not discount possible underlying biological or neuropsychological processes, nor does it in any way signify collusion.

The process of art therapy

One of my main tasks as an art therapist in the RSU is to overcome obstacles in communication. The art room is a space to which patients come voluntarily to be contained, and this is quite different from the involuntary containment that the environment otherwise provides.

Yet, despite this fact, most of them initially come without any motivation to do anything. Both patients and staff are still inclined to call my sessions 'art' rather than 'art therapy', and bring their preconceived ideas (and sometimes bad memories) from their experiences of art at school. They say they cannot draw, and ask me what art has to do with their rehabilitation process. The first obstacle to overcome is to help them find a reason for being there.

For this reason, anything which appears on a piece of empty paper is a phenomenon which I greet with great enthusiasm. I often overcome a patient's initial resistance by starting a conversation with him on an empty sheet of paper. This helps to overcome his feeling that he cannot draw or make marks on a sheet of paper.

This 'conversational drawing' is akin to playing chess with lines, dots, shapes, squiggles and colours. It asks for a similar kind of concentration to make the next move, always having in mind the whole picture being created

with another person. I encourage the patient not to think, but rather to experience this 'moving through space' and enjoy it.

In most cases this activity achieves a liberating effect without too much effort on the part of the patient. It also convinces the patient that no special skills are required to make choices and decisions on a piece of paper. The patient is already potentially creative. This simple therapeutic tool often initiates a creative and therapeutic process which can lead to astonishing results. The following personal account illustrates this:

Art therapy

My first artistic attempt on the Unit was to try copying an Old Master from a book, in pencil. It was a very poor copy, allowed me no room for self-expression and did nothing apart from passing a couple of hours. It was shortly after this that Barbara invited me to join her in doodling; she would draw one shape, and I would respond by putting on paper whatever came to mind. And so on until the sheet was full. This was the beginning of release from the concept, drummed into me at school, that I should be trying to produce 'good art', but that this was not possible, as I was not a 'good artist'. I quite quickly came to be impressed by what I was producing. I remember in particular an early drawing which was reminiscent of my doodles with Barbara, but which had a very individual quality. It was intricate, painstaking, yet perfused with the emotions that I was experiencing at the time. This was followed by a succession of abstract paintings, the 'best' of which were successful in giving me an outlet, not only for my emotions, but also for my view of the world, which was becoming less pessimistic, allowing the possibility of growth, both in myself and in others. In later weeks, I began to paint in a more representational way. In particular, I produced a picture of my home, peopled by important people in my life, including my mother. This was a significant step in the process of my coming to terms with the events of the past.

In more recent months, I have been having individual sessions with Barbara. We talk while I work with clay: as I have become more at ease with myself and felt less threatened, the form of the objects I have produced has become freer, and the style more exploratory. Throughout, our conversation has been of equal importance with the artefacts I have made. During my stay on the Unit, I have been engaged in a process of self-development in which art therapy has played a very substantial role.

(This patient now lives in a hostel in the community and is doing very well.)

Once patients are introduced to art therapy through 'conversational drawing', they are often really keen to get their hands on something to do for themselves, and some of them make incredible progress, even in artistic and skill terms. With this progress, they develop a feeling of self worth; valuing what they can do reflects back to valuing themselves.

The most satisfying patients to work with are those who have some insight and are able to make connections, not only with their past, but also with their inner world and their potential. The ones who respond to art therapy are often those who come with the willingness to confront themselves, and in this way are able to discover their creativity.

When facing an empty sheet of paper, a patient, like any other person, has to confront his own nothingness. Some patients are not able to cope with this, and do not come back. That is why it is so important to have an atmosphere of total trust in the art room.

I do not make any overt judgement or comparison (which I personally believe to be a form of aggression) because this creates fear. I also do not allow patients to 'rubbish' their own work, or the work of others, and I am quite directive in that. This leads to an atmosphere of tolerance in which patients accept each others' work, regardless of sophistication, childlikeness, skill or talent.

Otherwise, I work in a very unstructured and non-directive way. This has evolved through my experience of working with these patients, and from what they have told me about their needs. Most of them find it difficult to work in groups, and group cohesiveness is a problem for them. They prefer to remain individuals within a group, so it is the group spirit rather than a formal structure that contains the group. Patients produce work but we do not come together in a circle to discuss it. Sharing is very difficult for them, so I work separately with each individual in the group. Nevertheless, they do communicate with each other, and look at each other's work.

I encourage them to let whatever comes appear as if by itself. Of course there are certain patients who need more structure, and then I suggest they draw a plant or the room, or look at a book for inspiration. My main function is to encourage whatever they do and not criticise it.

Occasionally I will ask what the image says or means to them, but leave it to them to decide if they want to talk about it or not. The one who interprets is always the patient, never me. I do not set myself up as an expert who can interpret their pictures. (I might, for example, think the colour red means anger, but for the patient it might mean something entirely different.)

These patients have taught me to respect their defence mechanisms like no other patients before, and I make no attempt to break them down. They are there for a good reason, and I wait for the patient to tell me when he is ready to lower his defences, or talk about them. In most cases, I know their index offences, and what they tell me is no worse than facts I already know.

However, the main emphasis has to be on the 'here and now'. Creativity is spontaneous and new, and that is where its healing potential lies. If the patient, even for a very short time, can stand aside from his past, he starts to feel that he is still, despite everything, a whole person. This is not the same as allowing a patient to deny his past or his index offence, or to repress to such an extent that he can cut off and dissociate himself from the harm he has done. On the contrary, if a patient is able to be in touch with his wholeness, his totality, then the index offence is included and is a part of him. It can never be forgotten.

The therapeutic process is like a conversation between two people, in which they are looking together for the truth. The search for truth does not depend on the intellectual brilliance of the patient, but on the trust, honesty and perseverance of both the patient and the therapist. This often involves a long-term commitment from both parties, in order to acquire gradually the strength to face up to the brutal facts of a patient's past and present reality.

On not amplifying fear

One of the most important lessons I have learned is not, under any circumstances, to amplify fear. There is a certain choice between responding and not responding to fear. I know it is there, but I try not to add to it, and I try not to be scared. In the same way, I try not to amplify fantasies about the patient's past offences and potential for violence. I regard this as an inner discipline. I have to approach the patients as if they have done nothing, and yet, at the same time, they know and I know that they are in the RSU for a very good reason, and that society has to contain them because of what they have done. This awareness of fear and of the violent potential of patients creates natural boundaries. I know that however much I may end up liking these people, I can never forget where I am.

Self-disclosure

There is an understood acceptance of boundaries. I tell the patients very little about myself. Sometimes they ask me how it is that I know so much about them, whereas they know nothing about me. I always reply that they know my function is to help them get to know themselves better, and that we are

not here to talk about me; and they accept that. I am not deliberately covering myself up psychologically, but I remain something of an unknown quantity to them, in terms of my own past and my life outside the RSU. The fact that I am fully there for them in the present moment helps them to see me as another human being who is open and vulnerable. Remaining vulnerable and open in the presence of potential violence and fear is a powerful therapeutic tool.

About sexuality

I am a woman and most patients in the RSU are men. They know and I know that we are sexual beings. There is a certain kind of vulnerability in accepting each other's sexual presence and not acting on it, not amplifying it. Sexuality is there as much as fear, as is also the fear of sexuality. There is no way you can deny it, although most people do. For example, I have noticed that patients in the RSU are very aware of what people wear, especially members of staff.

I remember one incident when a patient was distressed by a slightly open zip on my blouse (although I wore a T-shirt underneath) and asked me to do it up. It made me realise that every little thing counts. The clothes that I wear are not in any way revealing or seductive, as I am aware of the need to be covered up. Other people sometimes surprise me by their lack of awareness in this respect.

In the same way that I believe there is a choice about whether to amplify fear or not, there also needs to be an understanding between the patient and myself not to amplify that sexuality. The issue of sexuality is in the open. It is not anything I have to hide or look away from. Thus, I am not defending myself behind authority or the therapist's position. I am allowing myself to be vulnerable.

Confidentiality

One cannot establish a relationship of trust if the patient knows that everything he says will be reported back to a number of other people. However, at the same time, because of the setting and the severity of their offences, patients have to accept that some things may have to be disclosed. It has to be mutually agreed from the outset, that if they tell me anything about endangering themselves or other people, then I have to report it.

Personal costs

When I began working at the RSU five years ago, I was more enthusiastic than I am now. This might have been because of a certain naïveté, as well as an unconscious defence against the damage within the patients and the prevalent level of fear. I see the same kind of exaggerated enthusiasm in some new staff arriving at the RSU now. Defending oneself against the intensity of the atmosphere can in itself be exhausting. With the added involvement of relationships with patients, this can become overwhelming without one even realising it. It is therefore necessary to nurture oneself in whatever way is helpful. For me, this means not losing touch with my own creativity, and also involves meditation.

Case examples

In offering these practical insights, I am aware of the temptation to theorise and arrive at more solid conclusions. However, art therapy, especially in forensic psychiatry, is still a pioneering field. More experience, data and discussion are needed to achieve maturity. Case studies are of great value here, and the following examples will tie together the various dimensions discussed so far.

Mr A
MEDICAL HISTORY

> Age: 45
>
> Admitted to the RSU from remand prison sixteen months ago.
>
> Conviction: Manslaughter of common-law wife
>
> Diagnosis: Paranoid schizophrenia
>
> Born in Great Britain, eldest of four siblings. Parents separated when Mr A was four. Mother supported the family and was an overpowering presence in the lives of her children. None of them married until after her death. She appears to have been an untreated schizophrenic hearing voices all through her life. Mr A developed schizophrenia at the age of 30, and since then has had a long history of admissions to psychiatric hospitals.
>
> Mr A lives in constant fear of being killed, either by himself or by others, and the thought of being on the 'outside' terrifies him. Initially he was not only a danger to himself, but also to anyone who suddenly took on, in his mind, the features and role of his delusional persecutors. Yet, at

the same time he is a middle-aged, kindly, soft-spoken man who cannot help being a model patient.

ART THERAPY WORK

Mr A liked coming to art therapy group sessions from the beginning; he feels easy about using art materials and has considerable talent, possibly inherited from his mother, who was an artist.

The only way for Mr A to deal with his fears, apart from medication, was to learn 'not to be afraid of being afraid'. Although Mr A cannot share his fear verbally, he can nevertheless communicate and share it with others through his art work. He used the art therapy group sessions very effectively to help him confront his fears, and his work clearly demonstrates this.

In the initial stages, he was preoccupied with his persecutory thoughts, and all he could do was to repeat over and over again the painting of various national flags (English, Canadian, and so on). I can only assume that a flag, as a symbol for national identity, gave Mr A a feeling of identity, and maybe of belonging and safety.

Things started to change when Mr A took up my suggestion to design a flag for himself, and he put his name and favourite brand of cigarette on it. Then he surprised himself by drawing a cat (after we had talked about his liking for cats in the past), and started to connect the image with his feelings (see Figure 7.1).

Without reading too much into it, the cat's posture and facial expression seem to reflect Mr A's wary and fearful attitude towards life. This was confirmed by the next two pictures, which express a phase of suicidal thoughts Mr A told me about at the time. The first was of a sad-looking bird surrounded by emptiness (Figure 7.2).

Figure 7.1 Mr A: Cat

Figure 7.2 Mr A: Lonely bird

Figure 7.3 Mr A: Gallows, spider, cat, butterfly, snake

The following drawing (Figure 7.3) showed a gallows, a spider, a snake, and a cat watching a butterfly.

The shark came quite suddenly and made Mr A smile with recognition. 'He is my guardfish,' he said proudly. 'Like other people have guard dogs, I have a guard fish. He is my mate Alfie.' (See Figure 7.4)

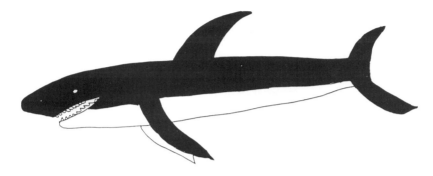

Figure 7.4 Mr A: Shark

By making the shark his 'mate', and even giving him a name, Mr A managed to confront his fear of being afraid, and also his fear of his own dangerousness.

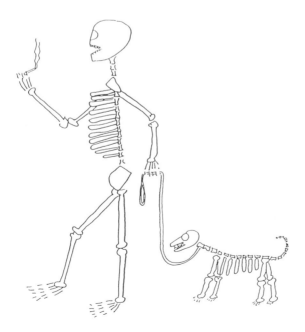

Figure 7.5 Mr A: Skeletons

A further exploration into his preoccupation with death was a drawing of a human skeleton (smoking a cigarette) walking a dog skeleton (see Figure 7.5).

He expected I would be shocked at his drawing a skeleton, and was greatly relieved when, on the contrary, I saw it positively. I pointed out to him, that the one thing we all have in common is that we are all skeletons underneath our flesh and clothes, looking very much alike. This idea greatly amused him and all the other patients who came to see his new mate, 'Alfie the skeleton'. ('Alfie' was the name he gave to all his imaginary 'mates' – this seemed to be his way of making friends with his own dangerousness). For the first time, he had an experience of feeling momentarily one with others, as they laughed about something they all had in common. This helped to overcome his terrible feeling of isolation and fear.

Mr A's choice of doing a tortoise could signify slow but steady progress after his medication was changed, or alternatively feeling slowed down by the side effects (see Figure 7.6).

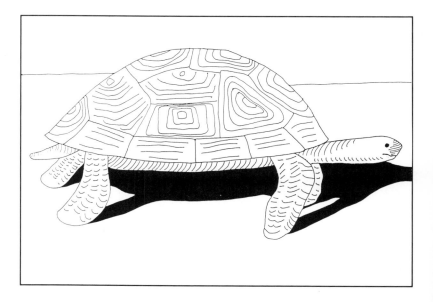

Figure 7.6 Mr A: Tortoise

His latest images, after a brief very dark set-back, look much brighter and the 'mice at supper-time' (Figure 7.7) appear to show his increasing ability to join in, reflecting a reduction in his paranoid preoccupations.

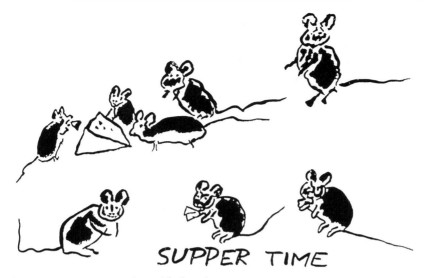

Figure 7.7 Mr A: Suppertime with the mice

Mr B
MEDICAL HISTORY

Age: 27

Admitted to the RSU from special hospital four years ago.

Conviction: Possession of an offensive weapon, common assault and assault occasioning ABH (Actual Bodily Harm)

Diagnosis: Schizophrenia

Born in Great Britain. Illegitimate child of West Indian parents. Parents separated when he was five. His father had little contact with Mr B in the early years, but visited him quite regularly later on. Mr B's mother suffered from a psychotic illness, probably schizophrenia, and was never treated for her mental illness. Mr B was brought up by his mother. Because of her mental illness, she did not care for him adequately, either emotionally or physically.

He wet the bed until the age of ten, and has a history of being destructive and violent. He attacked his mother severely on several occasions, and later assaulted fellow pupils in schools and inmates in prison. The main difficulties identified in his medical records are: difficulty in trusting people, fragile grasp on reality, and aggressive thoughts in the context of mental confusion.

Mr B made good progress and was offered a place in a hostel after three years in the RSU. He is extremely sensitive to changes in his relationships, environment and medication. It is now thought that, with this sensitivity to change, he may have been discharged prematurely, as he was re-admitted to the RSU after only four months. This followed a deterioration in his mental state, which led to an assault on a fellow resident in the hostel. After his readmission to the RSU, it has taken a year for him to regain some stability.

ART THERAPY WORK

Mr B had come to art therapy group sessions from the beginning of his stay in the RSU. He had also had individual art therapy sessions for two years until his discharge to the hostel. Work with Mr B had been very slow, but had shown definite signs of progress, until his deterioration after leaving the RSU. Six months after his readmission, I started individual sessions with him again. It was felt that, as he had worked with me before, with some success, this might help him regain some trust and emotional stability.

When I came to the RSU, Mr B had only a few unfinished pencil line drawings in his folder. He had no motivation to do anything, his concentration was poor, and he lacked literacy skills. As soon as he had drawn a line, he erased it because it was never perfect enough for him.

Despite the meagre output on paper, his few lines were organised and intelligent. This was a clear indication that, somewhere in himself, he knew what he wanted to do. I was struck by his ability to draw animals and by his feeling for getting their shape right without copying.

He seemed to forget from one session to the next, why he was in the art room, what (if anything) he had done already, and what it had to do with his treatment. It was a continuous battle for me, not to give up on him and his wholly negative attitude towards any form of activity.

Eventually, I asked if he would allow me to push him a bit, and as he liked my attention and appreciation, he agreed. The individual art therapy sessions, together with the group sessions, created the continuity he needed, along with medication, to achieve stability.

The following line-drawings are all from his individual sessions. They show how, as soon as he believes what he is doing has meaning, he improves in concentration and drawing ability, and, moreover, seems to find an outlet for his feelings of violence, grief and hope.

Figures 7.8 a, b, c, d and e were all drawn on one huge piece of paper (too large to reproduce as a whole), over several sessions.

Figure 7.8a Mr B: My house

Figure 7.8b Mr B: Dinosaurs

Figure 7.8c Mr B: Toys

Figure 7.8d Mr B: Superman

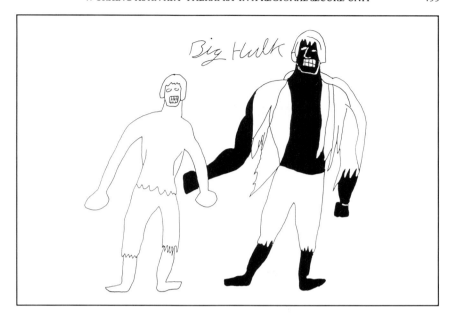

Figure 7.8e Mr B: Big hulk

In the first individual art therapy session, I suggested Mr B might focus on images associated with good memories from his childhood (Figure 7.8a). This seemed a novel idea to him, because he feels very resentful about his disadvantaged upbringing and is still very angry with his mother. He became animated as he started to tell me about playing next to a red-hot stove (right-hand side of Figure 7.8a), and the surprise that he never got burnt.

He remembered a book on dinosaurs (Figure 7.8b) which fascinated him. (The theme of extinct animals recurs again and again). I was startled by the change in style from the matchstick-figure drawings in the first session to the almost accomplished dinosaurs in the second.

Figure 7.8c shows the toys Mr B had loved, such as a pink and blue aeroplane and a knight on a horse, which his mother had thrown away. This brought up deep feelings of anger and sadness.

The 'Superman' (Figure 7.8d) and 'Big hulk' (Figure 7.8e) were his childhood heroes and role models, with which he still identifies in his ideas about defending good against evil.

Mr B is the patient who said 'Evil comes from suffering and makes others suffer' (see Figure 7.9).

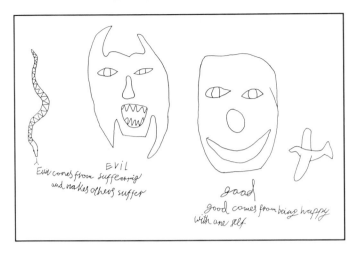

EVIL
Evil comes from suffering
and makes others suffer

good
good comes from being happy
with one self

Figure 7.9 Mr B: 'Evil comes from suffering and makes others suffer'

As he drew this picture, he put both arms over the drawing of the evil mask and the snake, so that I would not see his 'evil side'. Only when he realised that my acceptance of him had not changed because of this disclosure, did he have the courage to go on looking at himself further. This acceptance also helped him to see there was another side to him, and that he had a personal choice about which side he identified with.

There were several images addressing his anger and violence. He said the two angry faces in Figure 7.10 could be how his parents looked at him.

very angry

Figure 7.10 Mr B: Two angry faces

Other images displayed his grief, as in Figure 7.11, which shows an extinct bird. He told me that, when he first heard its story, he cried inconsolably, but his mother did not ask him why he cried.

Figure 7.11 Mr B: Extinct bird

Even more poignant were the images of the black crow (Figure 7.12) and the black octopus (Figure 7.13), which made him aware of, and own, his dangerousness.

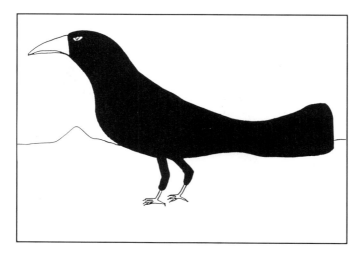

Figure 7.12 Mr B: Crow

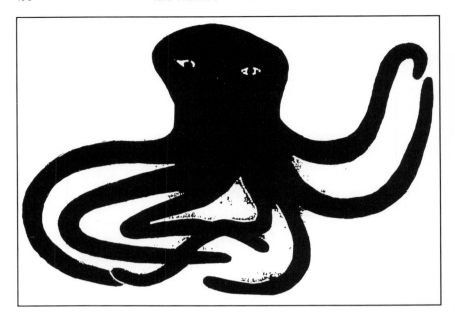

Figure 7.13 Mr B: Octopus

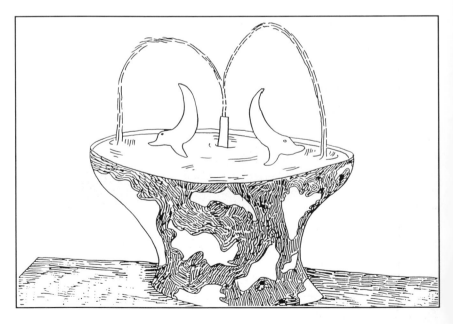

Figure 7.14 Mr B: Two dolphins in a fountain

The last drawing before his discharge into the community, on trial leave, was of two dolphins in a fountain (see Figure 7.14). He told me the dolphins represented his mother and himself unified and together in life, which is symbolised by the water. He felt optimistic about meeting his mother again and hoped she would understand and forgive him, which unfortunately was not the case.

Ms C

MEDICAL HISTORY

Age: 35

Admitted to the RSU sixteen months ago.

Conviction: GBH (Grievous Bodily Harm)

Diagnosis: Paranoid schizophrenia/personality disorder

Born in Jamaica. Brought up by her grandmother there, after her parents moved to England. Ms C remembered her early childhood years as happy, a sharp contrast to her experience of coming to England at the age of five, to join her parents and younger siblings; they had formed an established family where she felt unwanted. She felt ambivalent towards her mother, and that her mother had failed to provide her with adequate, reliable, emotional support. This was central to her psychotic attack on her mother which led to her admission to Broadmoor Hospital, where she had been detained for ten years because she had problems with staff and also heard voices. She had already been detained longer than many convicted of more serious crimes, so came to the RSU as a halfway stage before discharge into the community.

ART THERAPY WORK

Ms C came to art therapy and pottery group sessions from the beginning of her stay in the RSU. She also had sixteen individual art therapy sessions with me before being discharged. She was the most difficult patient I have worked with so far, but also the one from whom I probably learnt the most.

There was always a strong transference in the therapeutic relationship, as Ms C saw in me the mother she would have liked. At the same time, there was the possibility that she would test to the utmost the qualities of love, dependability and trust; and if these seemed lacking, there was the danger she would set out to destroy me, repeating the pattern with her real mother. The MDT was aware of this danger, and only reluctantly and with extra

supervision, agreed to individual art therapy sessions for Ms C. She waited patiently for a whole year.

Ms C loved coming to the art room, and said she would come every day if this were possible. Despite extreme mood swings, severe pre-menstrual tension and hearing voices most of the time, she produced about 40 images (including some oil paintings) and 20 imaginative clay sculptures. She gave most of her artworks to her boyfriend and members of her family as soon as she had made them.

Her ability to give away something worthwhile she had made helped to balance her feelings of emptiness and lack of self. The reality of the art materials brought her into contact with her own reality, from which she felt cut off. 'Everything you make is beautiful because you are real; I am all imagination,' she once said to me sadly.

She was very talented, and had an extraordinary sense of beauty, which even her illness, her depression, her impatience and her rebellious nature could not entirely suppress. Her personal appearance was always a surprise, and at times stunning.

The art room, her artworks and her relationship with me reflected this sense of beauty, even while she could not connect to it as part of herself and her reality. I drew several portraits of Ms C, showing the stages of her progress in the RSU, and she treasured these.

The only problem she encountered with her work, and for which she reluctantly asked for help, concerned making things substantial enough to stand up on their own. She overworked the clay, so that her work became floppy and collapsed or disintegrated, unless I was there to reinforce it. At that point, she always wanted to give up, and became very angry with me, blaming me for her failure. However, each time her work survived and turned out well, she was as happy as a child in front of a Christmas tree.

This describes Ms C's constant state of anxiety about being criticised and rejected, and her desperate search for acceptance and love, the crux of her personal problems. Whenever her sense of her own reality faltered (usually when she felt rejected), unless she received immediate re-affirmation from someone or something, Ms C started to feel suicidal. She was rarely free from such thoughts.

Ms C's choice of subject matter was extremely varied, but shows how differently women and men in the RSU appear to use the process of image-making. Men tend to project their needs outwards, concentrating on external objects such as landscapes, animals, plants, abstract geometric patterns and other forms of mental escape from the reality of their being confined. Women's subject matter is often associated more concretely with

their bodies, their physical and emotional needs, and related rites of passage; and feelings of being locked inside themselves. Thus drawings of clothes, shoes, weddings, and a mother holding a child are frequent. In this way art therapy reflects and amplifies the differences between men's and women's lives.

This may extend to the way destructiveness is expressed, with men tending to project it outwards, often on to other people; while women frequently turn it against themselves, their bodies or those close to them emotionally, such as babies or mothers.

In the art therapy group sessions, Ms C produced work which expressed her desire for more integration; whereas in her individual art therapy sessions, which she perceived as private, her images expressed her sexuality and destructiveness directed against herself. Her body image often appeared headless, dismembered and androgynous; because of their extreme nature, these images are not included here.

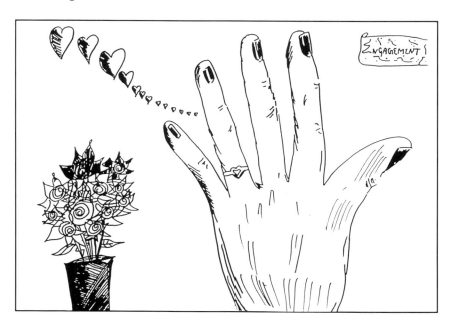

Figure 7.15 Ms C: Engagement ring

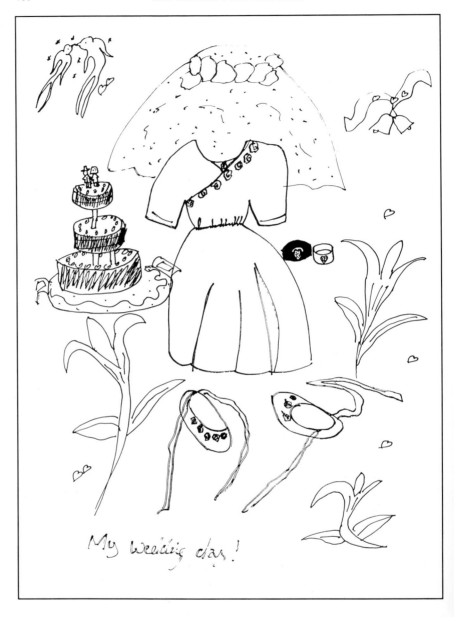

Figure 7.16 Ms C: Wedding dress

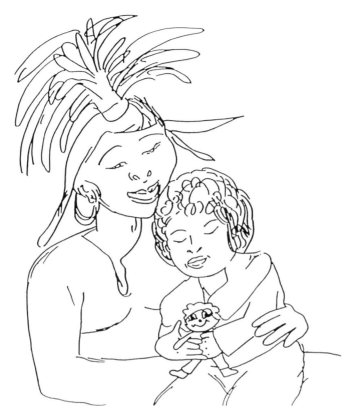

Figure 7.17 Ms C: Mother holding a child

Ms C had a boyfriend still in Broadmoor, and during her first months at the RSU, was still hoping to marry him. Her images of the engagement ring (Figure 7.15) and the wedding dress (Figure 7.16) illustrate some of the points made above.

A reversal of the public and private nature of Ms C's images took place in the later stages of the therapeutic process. Gentler, more integrated images of whole (instead of fragmented) bodies appeared in individual sessions, while more private images emerged in the group sessions. Two of the latter were of a mother holding a child (Figure 7.17) and a couple making love (Figure 7.18).

In the context of the therapeutic process, these images may be less about Ms C's desire for a child or physical love-making, and more about her desire to mother herself better, to be held and understood by herself, and to feel at one with herself.

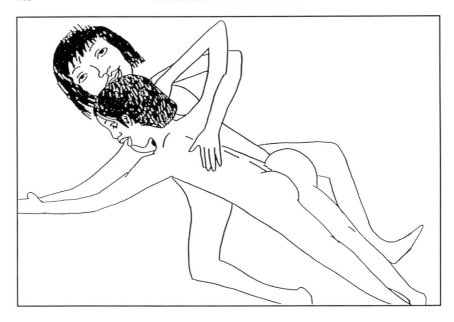

Figure 7.18 Ms C: Couple

Her self-portrait with a turban (Figure 7.19), from one of the last individual art therapy sessions, is significant in being a drawing of the whole person, which is also reflected on the piece of paper in front of the seated figure.

Ms C finally seemed to have arrived at a whole self-image, showing her, at her present age, rather than as a small girl, as she had drawn herself previously. While doing this picture, she realised that her whole life until then had been an escape into dreams, because she had been unable to accept her reality. She had also let others decide her reality – first her mother, then her aunt, and now institutions.

There were many such glimpses of hope and insight, and an equal number of times of hopelessness and despair. Recently, Ms C was discharged to a hospital near her family, to enable transfer to a hostel in the community. Shortly before she left the RSU, Ms C came to tell me how important our working together had been for her, and how much she felt it had changed her. The way she said this was mature and sincere, and made me feel proud of her, and happy that we had both survived.

Figure 7.19 Ms C: Self-portrait

Conclusion

This chapter has described my experience of working as an art therapist with forensic patients in a Regional Secure Unit, and sets out what I have learned, predominantly from the patients. I have attempted to show the value of art therapy alongside other therapies. With its emphasis on integration and the 'here and now', art therapy offers a possible awakening of a person's creativity, and the potential to experience himself (or herself) differently in relation to the world.

Such experiences need the recognition of enlightened people in management and administration. Their support and encouragement are vital to ensure that art therapy can take its rightful place in the treatment of dangerous people and their rehabilitation.

This chapter is the result of a taped conversation between Barbara Karban and Adrian West, following which the transcript was developed by both contributors.

Fear and Loathing
Art Therapy, Sex Offenders and Gender

Lynn Aulich

In this chapter I will discuss the contribution art therapy can make to the treatment of adolescent sex offenders. I will use illustrations and case descriptions to draw out various aspects of working with this client group particular to their having committed offences of a sexual nature.

Work with sex offenders invites discussion of the construction of gender roles and attitudes to sexuality prevalent in society and within the microcosm of the multidisciplinary team offering treatment. These in turn affect the psychodynamics between client, artwork and therapist. Therapists working with sex offenders are faced with a personal challenge, to look at their own attitudes to sexuality and gender roles, and to face their own feelings of hate, revulsion, rage and fear engendered by the issues arising in sessions. The fundamental expectations and basic assumptions of unconditional love and non-judgemental attitudes from the therapist, and motivation and input from the client can be put under severe stress. In these conditions, the relative positions of therapist and client need to be addressed in order to achieve an understanding of sex offenders and develop effective treatment.

There is growing public and professional interest in work with sex offenders, and an increasing sense of urgency as more information brings to light the nature and extent of sex offences and the people who perpetrate them. As more attention is focused on working with the victims of sexual abuse, so the other half of the equation, the treatment of the abuser, needs equal attention. This is important, as without effective preventative treatment, a victim can become an abuser.

Public perception of sex crimes

The treatment of sex offenders is complicated by the moral and political implications of their having committed a serious criminal offence, in addition to their being emotionally and mentally disturbed or suffering mental illness. Public debate seems to polarise around whether or not such damaged people are deserving of the time, effort and money involved in running treatment programmes as opposed to a prison sentence.

As a society we have difficulty in dealing with sex crimes. The public perception of sex offenders is largely structured and coloured by the media, which produces pages populated by sex beasts, monsters, fiends and other creatures from the darkest reaches of human fantasy and imagination. These are people who have transgressed the most essential and cherished taboos, crossed the boundaries of acceptable behaviour and acted out the unspeakable.

The frequent unspectacular rape and abuse cases are not reported, so that demand for real political debate, which could effect changes in legal and public policy, is avoided. Preventative actions, such as improving educational opportunities and social and environmental conditions for men, women and children, and a thorough examination of the realities of treatment and punishment for perpetrators, are not in sufficient demand.

Moral outrage and calls for severe retribution are elicited by manipulative reporting and emotive material which focuses attention on rare extremes, the serial killers and attacks by strangers. The irony is that, unless sex offenders receive treatment, brutalising spells of imprisonment, with a life spent as a scapegoat, will surely breed these most feared and inhuman fiends. According to recent surveys, most victims of serious sexual assault and rape feel that treatment would be the best disposal for the offender (Soothill and Walby 1991).

It is generally accepted that punishment alone does little to deter a sex offender from continuing to offend. This is most important for the adolescent sex offender, who has a life ahead of him or her as a sexual being. Current research shows that sex offending is cyclic, repetitive and premeditated. It is based on fundamental distortions of thought processes, gross misunderstandings and misinterpretations of other people's actions and attitudes. These distortions then result in deviant and unacceptable behaviour towards others.

Often, sexually abusive offending behaviour moves along a continuum of practices, increasing in severity and maybe frequency as the person matures. A significant majority of offenders have disclosed that their offending began as adolescents with the onset of puberty, and many report that

their abusive behaviour began in childhood. It is learned through attitudes to sex, sexuality and gender in day-to-day life at home, in school and in the wider community.

There is a reluctance on the part of individuals, families, teachers, carers, health and social workers to recognise, report and act on sexually abusive behaviour when it is seen among young people and children. It is often disregarded, and seen as not being serious; just sexual curiosity, sexual experimentation or even play.

The Report of the Committee of Enquiry into Children and Young People who Sexually Abuse Other Children, published by the National Children's Home in 1992, offers a definition of abusive behaviour, and contains a summary of the current work being done and recommendations for treatment needs of young sex offenders.

How can a prison sentence alone help an offender to unravel their motivations for such behaviour, gain knowledge about sexuality, gain insight into their feelings, and weave themselves new and healthy patterns of behaviour, hopefully to be safe enough to rejoin society? It is vital to address the offending behaviour of adolescents whose personalities are still developing, who are more receptive to education, and who are more open to changed perceptions and patterns of behaviour, if they can be encouraged to let go of their dysfunctional defences.

Context: treatment in security

For the adolescent referred to the Adolescent Secure Unit, community treatment is considered unsuitable either because the young person is not mentally, intellectually or emotionally capable of undertaking it, or because the severity of the offence makes the client too dangerous to be allowed to remain in society. The Secure Unit provides the necessary external control for clients who lack sufficient internal controls to prevent them from harming either themselves or others during assessment and treatment. The Secure Unit also provides security in the other sense of the word: the physical and emotional care and protection in as homely an environment as possible in an institution. It can come as a shock to realise that, for severely deprived clients, this is the most caring, empathic and supportive environment they have ever experienced.

The Adolescent Forensic Mental Health Service provides a specialised 16-bed secure unit within the National Health Service for assessment and treatment, and also operates a community service for out-patient consultation. The unit takes young people between 11 and 18 with severe mental and emotional disorders. Referrals to the service are taken from many

different agencies including education, justice, health and social services on a nationwide basis.

The unit is multi-disciplinary and includes medical staff specialising in child, adolescent and forensic psychiatry. Other staff have training in nursing, psychology, social work, art, music and occupational therapies; and there is a school with teachers trained in special education. Clients are also offered neurological tests to determine any organic factors contributing to their behaviour.

The work of the unit is twofold: first, to assess the treatment most suitable for each individual client, and to recommend a suitable placement, taking into account how dangerous a client is, and how likely he or she is to reoffend; and second, to provide treatment. Before a client is discharged, it is very important to assess the risk of reoffending, to protect and ensure the safety of society.

The treatment programme is designed to ensure physical, emotional and mental health, healing, education and development for each individual client. The unit makes use of behavioural, cognitive and psychotherapeutic approaches to treatment. The unit takes male and female adolescents with a variety of problems, of which only a proportion are sexual offences. The clients are advised not to disclose to each other the reasons for their admittance. Consequently, the various groups that take place are named according to their purpose or activity, without any labels relating to the clients themselves. Offence or problem-specific work takes place in individual sessions. At the time of writing, a group programme for sex offenders is being developed and implemented for out-patient referrals to the service.

Escorts

This is a forensic secure unit, and many of the in-patients are considered dangerous to others or to themselves. The nursing staff usually conduct their therapy work in pairs, a male and female as either key or co-workers, depending on the gender of the client. On an everyday living basis, the nursing staff take on the role of parenting the clients. The male-to-female ratio of staff to clients is crucial to the running of the unit. Staff from other disciplines usually have a member of the nursing staff as an escort for individual sessions – for example, a female client working with a male therapist would have a female escort, and vice versa.

The escorts are seen as protection for the staff, from assault or allegations. Where clients are perceived to be a danger to themselves rather than others, the escort provides protection for the client. In groups, escorts take on active roles, whereas in individual sessions, the escort is generally passive.

As a female member of staff working with male clients who have committed sex offences, the escort is a significant factor in the dynamics of a session and in the kind of therapeutic relationship achieved. The personal safety of staff members cannot be sacrificed under any circumstances.

The cherished ideal among art therapists of the therapeutic relationship which develops within individual sessions has to be adapted to fit this situation. The client has already transgressed the boundaries of acceptable behaviour, so until it can be proved otherwise, it is assumed that, under the stressful circumstances which are inevitable in an effective therapeutic situation, the same could happen again. Escorts are not always necessary once staff are confident and feel safe alone with a client. Art therapy sessions in the unit are with individuals rather than groups, so the work I will be discussing has usually taken place with an escort present, with the exception of out-patients.

Although occasionally escorts are active and take part in the session, usually they are passive and remain out of the room, next to the open door. The presence of the escort leads to a significant reduction in my anxiety levels, and allows me to be more relaxed and broader with my limit setting than I would be otherwise. This is especially important in allowing a client to express angry feelings, which might be dangerous if I were alone.

The escort can also act as a 'witness' to give feedback about what happened in the session. On the negative side, the escort can be manipulated by the client into colluding with him in undermining the therapist's authority, or providing the client with a distraction to avoid working in the session.

Again, the presence of an escort can impress on a client that he is considered dangerous, and this can help overcome the denial of the seriousness of his behaviour. Conversely, it can also reinforce a client's feelings of power and self-importance gained through offending. However, clients usually become so involved in the session and the process of art therapy, that the presence of an escort does not inhibit either the work or the clients' behaviour.

Art therapy: part of a team. Assessment and treatment

Art and music therapy in the unit both offer a non-directive open-ended psychodynamic approach which complements the highly-organised, task-orientated cognitive and behavioural sessions offered by other disciplines, in assessment and treatment.

Assessment: art group

The unit assessment period is usually four weeks, although this can be extended if necessary. All the disciplines make their own assessments, and discuss their recommendations with the referring agencies. Assessments are usually conducted in individual sessions in the form of structured interviews, written questionnaires, and psychological, physical and neurological tests. In addition, observations are made during everyday living on the unit. The art therapy assessment takes place in a weekly art group. The group is for all the clients currently being assessed. The work in the art group is very individually orientated.

Four weeks is not long enough for a group identity to form or to work with clients psychodynamically, although it is possible to observe the alliances and relationships formed through everyday living together on the unit. The initial aim in assessment is to encourage clients to use the art materials to explore whatever issues they choose to bring to the sessions.

Very open-ended themes or exercises are offered, with the option to use their own ideas, or do nothing at all. The group is very flexible in its internal structure, but has firm external controls. Everyone assessed is expected to come to the group. Those who refuse are encouraged to explore their reasons in depth. Clients in the art group rarely make pictures related to their offences, for reasons of confidentiality.

The work is often concerned with their response to being locked up, being away from home, family, friends and familiar carers. The unit may be experienced as a sudden wrench from home, or just another short-term placement, or sometimes as a 'rescue' from an adult prison.

These responses to being on the unit vary depending on the individuals and the combinations of personalities present, and may be quite extreme. The art group is often explosive, being a place where there is the opportunity and the means to express feelings of intense rage, frustration and fear – and in a safe, harmless and potentially creative manner. Paint frequently hits the ceiling, the floor, walls and furniture, in addition to pieces of paper. One of the few rules is not to infringe anyone else's person or work, and it is very rarely broken in the context of the group. By contrast, the group can sometimes be very withdrawn, resulting in complete visual and verbal silence, in which only the staff have any work at the end of the session time.

These sessions are used to gather information from a visual, and largely non-verbal, standpoint by observing interactions between people in the group, as well as looking at the art work and listening to discussion and comments made about it.

The assessment looks at a client's suitability for treatment using art therapy, as well as treatment on this unit or elsewhere. If the unit is recommended, I use a client's response to this group to determine my approach to individual art therapy treatment. Clients offered treatment on the unit have a detailed plan devised, with input from all disciplines involved. This may or may not include art therapy, depending on the initial assessment and a client's wishes.

These arrangements were initiated in 1989. Before this date, the assessment period was usually three months, and the art therapy assessment was made through individual work. Some of the clients described came to the unit before 1989, and others after this date.

Treatment

Treatment takes the form of group and individual sessions according to the needs of each client. Treatment in art therapy is individual, although group work can be organised when necessary. Adolescents in this particular situation often find art therapy threatening as it appears to have no defined agenda and is often unfamiliar as a form of communication.

Art is often associated with school, and for many this has been a negative experience. It is often regarded as being childish and an activity only suitable for 'little kids', and this does not fit with the image an adolescent wishes to present to his peers.

Those who have received praise and gained self-esteem for being 'good at art' can find art therapy confusing and undermining initially, because they find it difficult to get away from the desire to impress others. It is hard to use an activity in which you have achieved status and self-esteem to explore painful and uncomfortable feelings. Art therapy is about learning and gaining insight into how you see, understand and interpret the world around you, in terms of the inner world of emotion, memory, experience and relationship. The change in emphasis from a public to a more private activity can be problematic.

Sex offenders are almost never self-referrers. The offences come to light through victims' requests for help, or the reporting of a rape or assault to the police. This has important implications for treatment in that consent is not always given out of a desire to change, but rather to satisfy the court's conditions. It is imperative that society, through the criminal justice system, lets the offender know his behaviour is unacceptable, and makes treatment a requirement, even if it fails.

The degree of compliance with treatment is an important indication of how dangerous an adolescent offender is now, and is likely to become in the

future. The Butler Committee (Home Office and DHSS, 1975) defined dangerousness as a 'propensity to cause serious physical injury or lasting psychological harm... Physical violence is, we think... what the public are most worried about, but the psychological damage which may be suffered by some victims of other crimes is not to be under-rated' (quoted in Mackay and Russell 1988).

Adolescent sex offenders often deny the extent of their offending; they also minimise or completely fail to understand the impact of their actions on their victims. The motivation to agree to treatment is high – eventual freedom – but actually taking part in the uncomfortable, confronting, painful processes involved, and making genuine, significant changes in attitude and behaviour meets with powerful resistance.

The first art therapy meetings are about myself and the client defining how to use the sessions. I try to explain what art therapy is, what materials are available, and how the sessions will be organised in terms of the timetable. Sessions begin by orientating the client in the room, explaining which cupboards contain which art materials, where to find the clay and the water pots, and so on. Not all the art materials are out on the table at once. Time is spent encouraging clients to initiate their own work from the beginning. This is usually achieved through conversations about their experience of art, their interests and how they are feeling on the unit in general. It is too much to expect a client to launch into work from cold, so I suggest warm-up exercises and open-ended themes that emerge from our conversation.

Art is offered in school time as part of the educational curriculum, in occupational therapy, and in leisure activities in the evenings or at weekends. Clients always sense a difference between these and art therapy, but this is often denied or misunderstood. Many are terrified by the prospect of deciding how to use the time and materials. Some try very hard to manipulate me into telling them precisely what to do. Others bring in books to copy from, or pictures from school or occupational therapy to finish off, or reproduce a picture done before in a previous placement.

All of these are understood as a means to feel safe, and are allowed and used as a basis for discussion and visual development. Every effort is made to avoid the situation where a client is paralysed by panic and fear. As clients gain in confidence, begin to understand the nature of the sessions and trust me to support them, they become able to develop creatively without the use of these defensive props.

In the art therapy sessions, there are as many opportunities for clients to make their own decisions and take responsibility for the consequences as possible, within the limitations of a secure unit. The response to this freedom

varies with each individual. Some clients really want to be told exactly what to do. Other clients are out of control of themselves and need firm external limits to contain the mess and chaos, and to be able to experience it knowing it has an end. A few need to be in control of the session itself, sometimes to the extent of systematically deskilling and deroling the therapist. With clients who are sex offenders, the issue of power and control in art therapy sessions is especially significant – it is usually the sex offender who wishes to take control of the session and, more important, the therapist.

There comes a time in a period of treatment with the adolescents when they decide they no longer wish to come to sessions. This is expected, and dealt with by spending time discussing clients' feelings about the sessions and their reasons for not wanting to continue. This is important with the clients who have committed sex offences, since the levels of denial are especially high. In my experience, they find it difficult to accept that there is a reason for being referred to the unit, that their behaviour has hurt anyone, or that they are in any way responsible for things they do or for other people's response to them. The difficulties in acknowledging painful feelings makes them more likely to perceive a threat from art therapy, and to refuse the sessions.

The confrontation over coming to sessions nearly always takes place in public, rather than within the session, and the refusal is often framed in terms of not accepting female authority: 'No woman tells me what to do'; 'I'm not doing what she says'. These distinctions concerning gender are an important consideration in the way staff behave towards each other. Working with sex offenders demands rigorous awareness of gender roles and interactions between male and female staff.

The time and effort needed to encourage a client to continue art therapy is probably higher than most art therapists would find acceptable in other fields of work. After a confrontation, clients may perceive their attendance and cooperation as a loss of their own power, leading to feelings of helplessness and humiliation. Their need to regain control becomes an element in the session, and the visual contents are often pertinent to the clients' offences.

There follows a description of work with a client whose behaviour towards me can be seen as an attempt to gain control of the session through deroling, deskilling and humiliating me. His difficulty in forming positive, warm, appropriate relationships is expressed both in the work and our personal interaction.

Case description: power and control

Graham was a small, stocky, muscular 15-year-old referred for the three month assessment. In our preliminary meeting he was enthusiastic about trying art therapy. From the moment he walked through the door in his first session, he appeared to take control, leaving me with no opportunity to explain what we would be doing, or show him the different materials available.

He brought a large briefcase full of his 'treasured possessions' from home, and from it chose a project about cars he had to complete at school. He picked out his favourite picture and traced round the car on to a piece of paper. New elements were added to the tracing, a house behind the car, grass and sky. I talked to him about the sessions while he worked; he appeared not to listen, being engrossed in his work, and shut me out completely. As he left the room, he commented that art therapy was as bad as he had expected, and very boring.

In the second session, Graham followed me into the room, keeping uncomfortably close behind me. He took his previous week's picture from his folder and continued with it. Again he took the lead, ignoring my social introductory conversation. This time I began to work beside him.

Continuing from the previous session, Graham began to add watery brown paint to his house, in very marked contrast to the tight, detailed pencil-and-ruler drawing. He began splashing carelessly. Taking the cue, I dipped a sheet of paper in water and spread it on the table, blending colours into each other. Graham wanted to do the same. He painted a large purple pear-shape with an elongated neck, hands, feet and face, calling it 'Mr Greedy' after the children's book character.

He began another on a larger piece of paper with increased speed and enthusiasm. As he worked, he left a trail of pictures round the table gradually getting closer and closer to me. Eventually my work was surrounded by his. He began to flick paint over his pictures, using a big brush and large gestures. While working, he told me he had done this sort of thing before, and felt fed up about having to do it again. He suddenly stretched out an arm and painted a large black diagonal line across my picture.

I talked to him about what he had been doing since he came into the room, and told him how I felt about him invading my space and painting on my picture. He ignored me, not telling me how he felt, picked up his work and stuck it on the cupboard doors. He sat down and continued with his first picture, adding more details, such as curtains and doors. He announced, 'Niggers live here, pigs, black cops'. He made no response to my enquiries about the picture, his comments or his feelings about the session.

As he left, he wrote his name on all his pictures and then on mine. After this session, I spent a long time reflecting on what had happened, and how I felt in that situation with Graham.

I thought about his behaviour and mine, and how it related to his offence. My enquiries had taken the form of open-ended questions about the contents of his pictures, taking the cue from remarks he offered. I had asked questions which might have led to him being more specific in his comments. Everything I said appeared to irritate him, as if my questions were really stupid and I ought to have known the answer already. For example, I asked him who 'Mr Greedy' was and what he did. In response to his 'I've done this sort of thing before', I asked him to describe his experience. When he painted on my picture and then signed his name on it, I explained that I found it threatening, and wondered if he would rather I wasn't there at all.

Graham was placed on a care order for grievous bodily harm and two indecent assaults, but claimed he had indecently assaulted women and girls 30 or 40 times. He had described to his key worker how he chose his victims and went about the assaults.

All were female and between 13 and 40. He chose a woman or girl and watched her movements, checked if the coast was clear, then moved closer and closer until he finally ran up, touched her breasts and ran away again fast. It was also clear that he was planning more serious attacks and waiting for the opportunity to commit rape. He felt that he ought to be having sex, because all his mates were, and so he had to get a girlfriend quickly.

In the session I felt like one of his victims, someone stalked, then invaded – a person who was inconsequential, whose identity or feelings did not matter, and whom he did not wish to know in order to gratify his desire to behave with aggression towards a woman.

Graham would not be so foolish as to attempt to assault anyone sexually while he was being assessed, especially with an escort present. However, I felt he had achieved an end similar to the one he desired, in asserting himself and taking the power and control away from me, in whatever way he could. Although he was very aggressive in invading my space, painting on my work and taking it over for himself, his behaviour displayed an inability to relate to me as a person, especially as a woman in authority.

In these first two sessions, he established that his concerns centred around the issue of control, which appeared to mask his difficulty in forming a collaborative relationship. His briefcase of treasured possessions seemed to symbolise his uncertainty and fear, something to bridge the transition from one place to the next, but which also obstructed new possibilities. His picture of a house and car appeared to be about himself moving to a new place and

feeling threatened by the unit staff, hence the insults and racist comments about the occupants of the house.

The third meeting began with a pencil drawing of an elaborate decorative dagger with blood dripping off it. He seemed more relaxed, but still ignored me, working in silence and taking the lead. I began to feel anxious about my role in the session. I felt he needed me to be inactive, and to accept his pretence that I wasn't there, in order to work. I decided to hold on to this feeling until he indicated otherwise. I also felt very uncomfortable about being excluded and powerless to make any effective intervention or even decide what intervention was needed. I could only wait.

After the dagger he drew a 'horrid face' with a penis on top.

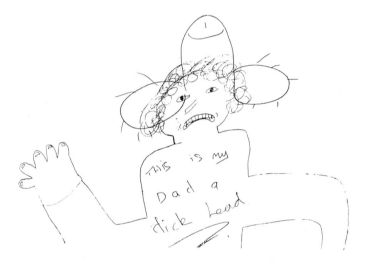

Figure 8.1 Graham: Dick head

He thought the face was either his older brother or his step-dad, or most likely, his dad. He ignored my questions and comments, and began to pace round the room with a table tennis bat and ball. He paced in ever-decreasing circles centred around me. I stopped this and suggested we work on a picture together. He divided the piece of paper with a line down the middle. Graham proceeded to stab his brush up and down on the paper, repeatedly making a mess of brown and red marks. I linked this action with the dagger drawing in the beginning, the male face and his threatening behaviour towards me, leaving any conclusions until further sessions. He left looking angry and miserable, but unable to talk to me about it.

In the following session, Graham was much warmer and more sociable. I felt he was beginning to acknowledge my presence. He took control immediately by dividing up a lump of clay and telling me to do everything he did. One of the (male) occupational therapists had taught him how to make heads and, being pleased to have learned something new, Graham wanted to make another one. He effectively blocked whatever I suggested, and assert his and another male's control.

He made a 'punk' head, with spiky hair. He added a large clay penis on top and called it 'nobhead'. He said it was his brother, then he took the penis off and decided it was himself. He modelled it into a full figure, with a body and two spindly legs which did not support the weight adequately, so that it kept falling over.

In the next session he wanted to paint the model as a present for his mum. While he worked, he chatted about mum in a friendly open manner. 'Everyone in my home town knows my mum, loads of people go round to tea and visit her.' It was the first time he had mentioned his mum at all.

Suddenly he announced, 'I'm going to be bored in a minute!' He continued painting, but the brush he chose was bound up with glue and wouldn't work. He began shouting at the escort by the door, calling him a 'dickhead' among other sexualised insults. His anxiety level was so high that he used the escort as his safety valve.

His anger escalated and he began to stab his brush on the table, and then destroyed his model bit by bit. He began to cry and say that his mum wouldn't want it anyway because he, Graham, was a 'nobhead'. He ran out of the room crying, unable to accept support from me. He curled up in a chair and spoke only to his key worker.

He refused to come to art therapy for the next session, so I spent the time talking to him on 'neutral' territory. He told me that the sessions were boring, I couldn't do my job properly, I upset him and made him angry by getting him to talk about his mum, step-dad and brother, which he never wanted to do. He said he hated me and called me a dragon.

He came to the next session early, with a smile. I wondered if we had made some kind of breakthrough. He drew a man's head with an even larger penis on it, and asked me to go through exactly what was said in the previous two sessions, to remind me of how I had upset him. He reversed the roles completely. I didn't comply, but commented on his suggestion. I noted that the painting I had done during the previous session was a battleship full of women, with shields raised at chest height. Graham commented on the poor quality of the work: 'It looks like nothing, like kids' stuff'. He became angry and vehement, as he described his experiences at school, fighting other boys

all the time. He went on to how he hated all girls and women, especially his mum.

He made a picture to show what he thought of me. 'Lynn in art...' I had to try and guess what it was. The picture was of ivy – 'creepy, nasty stuff which won't leave anything alone'. He added flowers as I watched, and then 'Love is... Music for Lynn and James.' (my husband) He said, 'I still hate you, you ask horrid awkward questions all the time... that's all.'

The following sessions prepared Graham for leaving the unit. It was decided that he needed a highly structured behavioural approach to treatment, on another secure unit. He brought in a magazine picture of a very fat man running, looking out of breath and uncomfortable. The picture was absurd, even funny. The man was holding an egg on a spoon in a race. Graham changed the meaning completely, by cutting off the egg and spoon, leaving the extended fist.

This was his real dad, who had left the family when he was about two. Graham did not want to discuss the picture, but apparently his father had contacted him after many years of complete absence. On discovering that Graham was in trouble for sexual offences, his desire for more involvement with his son had cooled.

He spent most of this session talking about a sex education video he had seen in school, about babies being born. His conversation moved from fact to fantasy, as he described a female teacher reciting 48 slang names for a penis. Before he began telling me these himself, he shouted to check if the escort was still there! He was. Graham, looking very angry and tense, began to scrape at the felt pens with the scissors used for collage.

I felt alarmed by the speed and ferocity of the change, from talking about his dad and the collage, to the sex talk and the angry, destructive behaviour. In this situation and at this point in his assessment, I felt it unwise for me to pursue the recurring connections between Graham's feelings about his family and his sex offending. When he became very angry, he was also sexually aroused, and my feelings of fear and discomfort would have been too dangerous to ignore.

I chose to defuse the situation by offering Graham the opportunity to review his work as part of the leaving process. He was so upset that he tied multiple knots in the strings on the portfolio, so that no-one could have access to his work. He wanted to shut the evidence of his disturbing feelings away and leave them behind on the unit, when he moved on to his next placement.

Before his final session, Graham had been in 'time out' for using abusive language to the staff. He was late, and began work on a large painting,

splattering, pouring and smearing paint on to the paper. He warned me not to come anywhere near him... or else. As the picture progressed, any imagery disintegrated into a brown mess which he called 'Shit'. He said he'd like to wrap this picture of shit round me. He began to advance towards me, with hands covered in brown paint and arms outstretched, directed at my breasts.

This was done in a semi-joking manner. I moved to the other side of the room. He retreated and began adding purple and red, making a lurid purple flood of paint. He soaked up the excess by taking multiple prints from it. He cleaned up using copious amounts of water. He become so engrossed in this cleansing process that I extended the session time, until he was satisfied he had washed away all evidence of his mess and rage, except for the painting and prints, which he left to dry.

In retrospect, these sessions produced several themes which led me to wonder if Graham had been sexually abused, but at an age when he was too young to remember the experience. My humiliation and loss of role, autonomy and control, the constant reference to and drawings of genitalia, and his contempt for and anger towards women – could indicate abuse by males in his family, where his mum had failed to protect him. Had Graham remained for treatment, this might have been explored further in relation to his offending.

The most striking aspects of these assessment sessions were the intense need for Graham to gain and maintain control, to defend himself against his feelings of inadequacy, and his inability to form a constructive relationship.

Another important aspect of these sessions is the explicit sexual contents – such as the 'Mr Greedy' purple penis, the angry messes of the colour of a tumescent penis, the pictures of male relatives with penises on their heads, and the constant use of the work 'dickhead'. The sexual references were expected, as the reasons for Graham's admission were his sex offences. The way he used them was significant. They were used to express anger and contempt for his stepfather, his brother, his natural father and himself.

His less overt sexual references were directed towards me, perhaps to scare me off working with him, perhaps as the only way he knew how to relate to women, or as the only behaviour he believed appropriate towards women. According to staff who visited his home and family, overtly sexist and denigrating behaviour towards women was an acceptable way for men to behave. This was also true of the community he came from, which formed his own attitude: all women are inferior, always sexually available and good for nothing but housework.

Another aspect of these macho attitudes was a fear and hatred of homosexuality. If he had hidden homosexual feelings, this might further complicate and distort his perceptions of, and relationships with, women.

The unit recommended that Graham receive a further two years of treatment at another institution with a behavioural approach. However, our recommendations were ignored and he returned to the community. It transpires that he was arrested for another kind of offence and is currently in custody, but not receiving any treatment for his sex offences.

Anti-therapeutic art therapy?

The following case illustration shows how it is not always appropriate for a female art therapist to work with a male sex offender beyond the period of assessment. A male therapist might have been more successful, since art therapy was not the problem – however, combined with the gender of the therapist, it became dangerous and destructive.

Observation of a person's behaviour on the unit during everyday living is not always enough to assess the risk of reoffending. The unit is a very specialised environment. Certain stresses and temptations are removed, and clients can often develop and excel at things they have not had the opportunity to do before. It is very easy to be lulled into thinking they are no longer likely to offend since they have made so much social, creative and intellectual progress.

Achievements in these fields are excellent in terms of a person's development, but we have to be aware that these very positive changes can also make a person more skilful at gaining access to, and power over, potential victims. As an art therapist, my job is to work alongside a client, to help him uncover his experience, explore his history, look at the way he sees, understands and interprets the world, what he feels about himself, other people and events – and to do this through the use of art materials, and in relation to myself.

I began work with Clive within a month of my taking up the post of art therapist. He was 14 and had attempted to rape mature women on two occasions. His progress on the unit was exemplary. Staff felt that he had matured and developed considerably since his admission.

As the female working with Clive, my sessions were a complete contrast. I became increasingly isolated in my negative view and actually afraid of him. His behaviour towards me became increasingly persecutory to the point of being physically threatening. For example, in one session he picked up a dirty wet mop, named it 'Lynn' and banged the head repeatedly on the floor,

while addressing it with derogatory female sexual language. He then advanced towards me, aiming the mop head at my face.

It was decided by the MDT that the art therapy sessions were 'anti-therapeutic', in that they constituted a struggle for control, a struggle which was destructive to both him and myself. I felt inexperienced in dealing with such powerful hostility, and a lack of support in turning this to a therapeutic advantage. Clive behaved as if his release from art therapy was a major triumph, and believed his hostility and threatening behaviour had paid off in getting rid of me.

In this instance, although the assessment was useful, any treatment using art therapy would be more constructive with a male therapist, ideally with both a male and a female therapist working with him together. Clive moved to another unit with a strict behavioural approach, for a further period of treatment.

In retrospect, it is easy to see when work with a particular client became anti-therapeutic, as may have been the case with Graham as well as Clive. It takes experience and skilful supervision to disentangle the issues at play, and define exactly what is anti-therapeutic, while still involved in the process. The current four-week assessment period is not always sufficient time to determine whether art therapy may raise issues which are unworkable in this context. It may take a further three months in treatment to assess the value of the work with the client.

Case description: an abused abuser

Ted came to art therapy for two months as an in-patient, and for three months as an out-patient. He was a 16-year-old who had abused a neighbour's daughter while babysitting. He lived with his natural mother, stepfather and two half-sisters. He himself had been abused by his natural father, with whom he had lived until his father's death a few years before.

As an in-patient, the focus of Ted's work was his abuse of the little girl. Inevitably his own abuse forms part of the picture – but it was felt important that this was not used as an excuse, to minimise the fact that he chose to victimise someone else.

In the art sessions, Ted chose to explore the abuse he experienced from his father, his conflicting feelings about him and his grief for him. His family's attitude was that his father was better off dead, having been an 'unpleasant, violent and useless person anyway'.

Ted's paintings were mostly about his body – his limbs and orifices and his ambiguous sexual orientation. At 13 with the onset of puberty, he had a hormonal disturbance which caused him to begin to develop female breasts.

Treatment for this was successful, but his family's attitude to his condition seemed less than helpful. His paintings made only slightly disguised visual references to anal intercourse with his father, whom he described as 'an angry, drunken monster who was out of control, because of being injured and in pain' (see Figure 8.2).

Figure 8.2 Ted: Father as a monster about to crawl into his hole

Ted was sensitive to his father's pain, but had little understanding of his own. Ted inferred that he had used sex to try and placate his father's terrible rages, and felt that he had instigated his own abuse and had only himself to blame for it.

The staff working verbally with Ted on his offences reported that he attributed adult feelings and behaviour to his eight-year-old victim, and that he felt she had not only consented to what happened, but was an equal and willing partner. This was a total denial of the reality of the situation, a complete distortion of the actual events and the real feelings and behaviour of the little girl. Ted seemed unable to make the imaginative and empathic leap from how he felt to how his victim might feel, because he was unable

to formulate his feelings in relation to the abuse by his father. Feeling that the abuse he had experienced was his own fault, Ted in turn attributed blame to his victim.

Ted's feelings of self worth were extremely low, and he continually irritated both his peers and adults, with grandiose fantasies and stories of heroic exploits, in a bid for admiration.

After six months' assessment and treatment, Ted had made good progress, and was no longer considered to be a risk to others. He could therefore not be legally detained in secure conditions any further, and preparations were started for his discharge into the community. However, Ted had still not resolved his own abuse, so he was offered continued support from the Community Team for three months. He left the unit to live with foster parents, and was also able to maintain contact with his mum.

As an out-patient, Ted made a long and tedious journey to the unit on two different buses, to attend a day of sessions every week. He habitually arrived early, wanting to socialise with the other clients. He was lonely, missing his own family and trying to adapt to living with the foster family.

His paintings continued to be about his body, breasts, anus, penis, and so on – often as isolated elements, rather than within a context of the whole body or with other non-sexual parts. He mixed earthy colours with satisfaction, expressing shame at the mess, but enjoying being out of control with the paint. The mess represented the chaotic undefined feelings, the mixture of good and bad, the love, hate and grief he felt for his father, and the rage at his own helplessness.

He made up stories to go with his pictures, about outer space, being spun down a vortex or a black hole on to another planet, which was dirty, polluted and dangerous, but very exciting and nice. He described the vortex as being very hot and difficult to get in and out of, with a painted rocket – Explorer 1 – ready to enter the vortex.

The stories appeared to be about his sexual experiences. He found it very hard to talk about his own abuse, but easy to use symbolic imagery. The converse was true of his offence; he could talk about it to key workers but had no images. He described wanting to travel back in time and get his family back together, his mum and his real dad, before he got into trouble, and before his parents split up.

Ted's three months as an outpatient were coming to an end. In his last few sessions, he became angry with me and the unit for what he perceived as a rejection, as he felt we were abandoning him. He was late, cold and hostile in manner, and painted pictures full of aggressive content. It seemed

as if anger towards his father for the abuse was being expressed through hostile retaliatory behaviour.

He made a picture with a large hole in the ground, with an explosive radioactive centre and a large 'thing' to attract monsters so that they fell into the hole, blew up and were destroyed. He drew a whole row of three-legged monsters floating through the air towards the hole. The monsters were mystics (taken from a comic-book story) and could transform themselves into anything – trees, animals or people. This picture gives the idea that he wanted to lure people to their destruction with his sexuality (see Figure 8.3).

Figure 8.3 Ted: A vortex with a big boulder in the way, monsters waiting to go in

In his last but one session, Ted painted a golden cave under the sea. He described the cave as being flooded and would say no more. Apparently Ted was having problems in the foster home with the foster mother's own sons, who were about the same age. He was feeling worried and anxious about the possibility of being asked to leave this home, as well as having to end his out-patient sessions.

He missed two sessions before the final one. I felt it important that he didn't drift away and leave without a proper ending. I telephoned his foster mother and insisted on speaking to him. Ted came, feeling hostile and resentful, but also pleased that I had bothered.

His picture looked bleak, cold and desolate. He said it was winter and everything had gone dormant, and was resting. He said he was relieved to

be leaving, and no longer having to come all this way for useless sessions, especially as the other sessions had already finished. I had a very uneasy feeling; there was a lot held back and left unsaid.

Rumour, supposition and vague hints suggested that someone in his foster family had been quietly sabotaging the sessions. The foster mother had shifted her position, from encouraging Ted to attend his out-patient sessions, to supporting his negative view that they were useless and upset him. Despite this, he had attended most of the sessions agreed in the contract with the unit.

Some months later, there was a rumour that Ted had left his foster home and become involved with the making of pornographic films, possibly involving children. Staff were left with the sickening feeling that sexually exploitative behaviour in society feeds on damaged lives, and is often legitimised as a financially rewarding industry.

The addictive nature of sexually abusive behaviour has been well documented recently. As part of a cycle, long-term repeated abuse as a victim can also have addictive and dependent elements. Ted felt himself to have the power to please and placate his father, but instead of seeking out an abusive relationship where he was the victim, he took control by abusing someone else, projecting on to her his own desire, with the distorted idea that his victim enjoyed it. The pornography industry, which exploited him and fed on his vulnerabilities, allowed him to be an abuser and to have this condoned.

In Ted's family and social circle, homosexuality is met with derision: it is unacceptable. Ted was on the receiving end of cruel family jokes about his father, and about his development of breasts and 'feminine' mannerisms. In this situation, abusing a female child might assert his masculinity, and deflect attention from the possibility of his being homosexual.

Another element in the already tangled picture (he produced many) is his mother's role – she left Ted with his dad after the divorce, taking her daughter into the new relationship with her. Ted only went to live with them after his father's death. Early loss, by death or otherwise, is believed to be a contributory factor in the make-up of a sex offender. Ted had to deal with the loss of both parents.

Six months of therapeutic work helped to bring some of these issues to light, but did little to resolve them. Ted's fate in the sex industry indicates our failure to help him heal his damaged inner self and develop his ability to form equal sexual relationships.

At this point, I quote Gail Ryan who writes, researches and lectures on the treatment and rehabilitation of sex offenders in America.

Victims without therapeutic intervention are often destined to a future of repeated victimisation themselves, an inability to protect others or the development of similar abusive behaviour towards others. (Ryan 1987)

Here she refers to both girls and boys. She goes on to discuss how a boy who has been sexually abused is more likely to become a perpetrator at the onset of puberty as a means of undoing or protecting himself from the implications of his own victimisation. Men and boys are expected by conditioning to be able to protect themselves, so being rendered powerless, exploited and manipulated is an assault on his masculinity as well as his body. Social conditioning also makes it difficult for a boy to ask for help, or look for protection from others, for fear of having his weakness and failure as a male exposed. The developing sexually abused boy is more likely to identify with the aggressor, the perpetrator of the abuse against himself, rather than with the victim.

So far in my practice I have not, to my knowledge, worked with any girls or young women who are abusers, but they exist. Evidence suggests that girls who are abused are more likely to repeat the victim role, and fail to protect children in their care, than become abusers themselves. Again, this is probably due to social conditioning.

Ryan explores the aspects of being a victim of sexual abuse which are easily transferable into becoming a perpetrator. Women may seek to regain control, lost through being abused, by developing eating disorders, fire setting and self-destructive behaviour.

Sexual imagery

Sexual imagery is an important aspect of art therapy work with sex offenders. A substantial majority of sex offenders use sexual imagery as their most potent means of communication. In all the cases described so far, sexual imagery has played a significant role and warrants further discussion.

Where sexual imagery is used in art therapy sessions by sex offenders, its significance lies in how it is used, as well as the image itself. A sexual image can be used to confront and attack the therapist as an act of aggression. The purpose is to stop the therapeutic work, which is felt as a threat. Sometimes the most threatening aspect is that the therapist is a woman. General contemptuous 'macho' attitudes towards women and girls are often expressed in this manner. The example in Figure 8.4 is reductive, as in the kind of pornography which is degrading to women.

Figure 8.4 A picture of the therapist by a sexually aggressive client

Figure 8.5 Penis/child

In this picture the woman has been reduced to her sexual parts. The client said that the arms are so long because he can't get away from me or the session.

In some cases, visual sexual imagery is used in the same way as sexual swear words, terms of contempt or anger which is sexualised. An example of this is found in Graham's work, described earlier in this chapter, where he drew penises on heads, as in Figure 8.1.

Figure 8.5 shows a picture painted by a boy whose verbal ability was extremely limited. He produced a constant stream of interrelated pictures which clearly described his feelings and experience. He had been accused of sexual offences against children, and came from a family with a history of incest which spanned generations. The penis shaft he has drawn is also a child, with arms, feet, hair and a face which has been crossed out.

Sexual imagery is used by sex offenders who have been abused themselves as a personal exploration of what has happened to them. In this case, the sexual imagery is not used as an aggressive tool against the therapist, but can still be used as a means of retaliation against the person who abused them. In these instances, sexual imagery is equated with anger and a need for revenge, and so links in with the abuse of others. Where it is part of our culture to use women to express contempt for, and fear of, sex and sexuality, men cannot be seen to be victims of sex, only as masters and controllers of it.

Self-image

An examination of the background of young people who commit sex offences often reveals difficulties in family relationships, early parental loss (death or separation), feelings of helplessness and inadequacy, poor self-image, poor social skills, and physical or sexual abuse. An offender may appear to be very like a victim. It is important to address these issues and feelings from the past, and to examine how they relate to the present abusive behaviour.

It is also vital to ascertain how much clients understand what they have done, to what extent they feel remorse, and whether they are able to see the offence from the point of view of the victim. The more serious, dramatic and horrifying the events which brought them to the unit, the more this is an overt issue.

With the majority of sex offenders working with art therapy, the ability to empathise with the feelings of the victim, and genuine feelings of remorse, rarely emerge. Sorrow and regret for what they have done is often thinly disguised self-pity for having been caught and locked up, used as a

resourceful move towards eventual discharge, especially if the offender is reasonably bright.

Another problem is the emotional immaturity of adolescents. It is not always easy to determine how far a person's lack of understanding of the effects of their behaviour on others, is due to emotional immaturity, and how much they are likely to be able to develop empathy when specifically educated. A sex offender who has little or no insight into his own feelings is not likely to be able to comprehend those of others.

Art therapy can begin to address adolescent sex offenders' own pain by becoming part of their world and helping them to identify their own particular experience, before expecting them to develop a capacity for empathising with and respecting the feelings of others.

The bottle

Stanley was a very quiet, physically strong 16-year-old. He had been deprived emotionally and materially as a child, and was with supportive foster parents before coming to the unit. His father died when he was two and his mother abandoned him at six. The paintings he made were about how angry, frustrated and isolated he felt. He painted himself as a huge person in a bottle, which cuts him off from other people (see Figure 8.6).

Figure 8.6 Stanley: The bottle

He was literally separated from others on the outside of the secure unit, but also emotionally separated by his own glass wall.

Stanley described himself in the picture as smiling and happy on the outside, but all bottled up inside. In the painting he is trapped and contained in the bottle. From this point, he began a series of pictures of himself as a person with a rage and potential for destruction so great that he had to be locked up in a cage. The nurses are portrayed as gaolers with enormous keys. It was as if he had to lock away his rage to prevent it from overwhelming himself and everyone else.

The fortress

Although Ben was reasonably bright, very pleasant and sensible, he had no vocabulary for articulating feelings. After many months' work in art therapy, Ben began to talk about his parents' behaviour towards each other, his mum's physical abuse of him as a small boy, and the terrible frustrations and highly charged emotions which gagged him and his family. Ben's offences were attempted rape and self-exposure. I'm not sure how far his work went towards resolving sexual issues, but his art work revealed an unfolding of Ben's sense

Figure 8.7 Ben: The fortress

of himself. His work began with pictures copied from fantasy magazines in which he became the hero. He moved on to images of himself as tight impenetrable fortresses (see Figure 8.7).

Ben made pictures of being locked in the unit; these also stood for being locked inside himself. He eventually moved on to pictures which revealed a more sensitive, multifaceted personality.

Clients receiving treatment on the unit often reach a point when they no longer need to be in a secure unit before they have resolved many of the issues which arise in art therapy. Clients are referred to other secure units, to open units, foster parents, hostels, their own accommodation or home, with other provisions made for further treatment. Where possible, the community team provides support and out-patient treatment.

Art therapy can help the client gain insight into the most urgent and pressing issues. However, all too often there is only time to find out what these are, without the time to work through them.

Fear and loathing – the therapist's process

It is sometimes difficult to see and acknowledge the amount of pain, sorrow and anguish which is felt by this client group. The sessions are so often persecutory, fraught with aggression, conflict, anger and hatred which is acted, painted and drawn out, often directed at or about me as the therapist. My concerns for my own safety and emotional strength are sometimes in danger of overriding what the client is trying to tell me. This brings me to the issue of hate.

Hate in the therapeutic alliance has been discussed by many therapists, and examined in detail as a counter-transference issue. Working with sex offenders and the kind of material they bring to sessions makes it an imperative to consider the hate, fear and loathing felt by the therapist towards the client. Does this failure of unconditional love destroy the whole premise of therapy? The therapist needs to be aware of these feelings to avoid being persecutory and liable to abuse the therapeutic situation, and also to avoid the danger of colluding with clients in denying the full horror and extent of their offences.

As Alice Miller says in *The Drama of Being a Child*, although the client experiences the therapist as hostile, the therapist must never be so in reality. Yet, the therapist must not deny the reality of the person they are working with and allow the full extent of their disturbance to manifest itself and to feel their experience as they have felt it. The therapist needs to remain aware that disgust, horror and aversion are necessary as part of the counter-transference and that the client intends us to feel like this. The therapist needs to

be able to reach beyond their own feelings to the client's feelings of being hated, despised and manipulated as a child. (Miller 1987)

In working with sex offenders, it is essential to trust fellow staff to provide the exterior physical protection, and to seek suitable supervision to work with these feelings. Hate, fear, revulsion and other such feelings, which are especially uncomfortable in the context of therapy, are absolutely valid. The therapist needs them to remain separate, to avoid becoming immersed in, or victimised by, the client's psyche. The therapist also has to be able to see beyond these feelings, into how and why the client needs to elicit that response.

The therapeutic alliance is a very special and rather rarefied experience. It is important for clients to feel safe and able to trust the therapist's ability to survive their persecutory onslaughts. The therapist needs to be able to contain her clients' perverse behaviour, their negative and destructive feelings, without rejecting them and without allowing herself to be damaged by them.

Some sessions are so intense, traumatic and confusing, as I have already described, that a systematic method of self-monitoring and reflection is necessary, not only to ascertain what feelings are aroused in the therapist, but also to remember clearly the contents and process of the sessions for future reference. Denial is not the sole prerogative of the clients; therapists have an investment in wanting clients to do well. The responsibility for assessing the risk of reoffending falls on everyone in the multi-disciplinary team, a considerable burden fraught with ethical dilemmas.

There are longer-term issues, such as coping with the accumulated feelings of being dirtied, spoiled and abused, as a result of dealing with trauma on a routine basis. A significant fear is that of losing sensitivity to clients and their predicaments, as a defence against working with yet more sadness and pain. Even worse is the fear of losing sensitivity in relationships with friends, family and colleagues outside work.

Difficulties which arise during sessions can be dealt with in supervision. Where difficulties arise in the response of the unit to what happens in sessions, it is more problematic.

A female therapist can feel she is being used as 'bait', to gauge a client's dangerousness, then left with the feelings that result from the encounter. She can feel disbelieved and regarded as a hysterical feminist, who has deliberately steered the client into revealing their psychopathology rather than nurturing their best qualities through creativity.

Therapists working with sex offenders can go through a similar process to those who work with sexually abused children and adults. This is clearly described by Janet Perry (1989) in *Sexual Abuse: The Counsellor's Process*. The personal issues which arise for therapists when they begin working with abusers intensify the longer the work continues, until these issues are resolved.

Initially, therapists feel shocked that people are capable of such abominable behaviour, and the anger is directed towards the perpetrators, with the attendant danger of persecution in clients' sessions. When working with abusers, therapists can over-identify with the victim, and are in danger of becoming victimised themselves.

It is common for therapists to start examining their own past relationships and family difficulties, and even to imagine themselves as victims of abuse. Fears arise about one's own capacity for abusing others (not just sexually, but emotionally through manipulation), particularly the abuse of clients in therapy. A particular danger in working with offenders, is collusion with a client's defence mechanisms, their minimising of the effects of their offences, their denial of the extent and nature of the offences, and the rationalisation of why they offend.

To bear in mind what a client has done, during the working process, without allowing any personal feelings of revulsion and fear to interfere with professionalism – maintaining a positive and receptive attitude – is extremely demanding. It is common to feel physically, mentally and emotionally dirty and abused by clients after sessions.

There is often a suspicion that the client has been allowed to continue with abusive behaviour, without the therapist being able either to offer any means of transformation, or make the client take responsibility for their behaviour. This is both debilitating and disturbing for the therapist and destructive for the client.

A significant effect of working with abused children and with offenders is the heightened awareness of the misuses of power and the use of violence, particularly by men towards women, and by both men and women towards children, which is woven into the fabric of our society. Society gives a whole spectrum of sexually aggressive messages which legitimise abusive male attitudes and behaviour. All the systemic institutions which structure our society – cultural, historical, economic, sociobiological, legal, political, religious, medical and educational – discriminate against women to ensure that both women and children remain in an inferior position to men. It will take generations of public and personal education to shift such entrenched structural attitudes.

An obvious example of one such message is found in the images used for advertising. We are presented with these on a daily basis, on television, in magazines and newspapers. A significant majority of the imagery is constructed to titillate and gratify male sexuality. Even sexual images of men are narcissistic, in that the handsome hunk is gazed upon by adoring women. Pornography is a contentious issue and an area of study in itself. Proving that pornography incites men to sexual violence is problematic, but there is no doubt that it is an aid to those who have the potential for sexual violence and those who are already offending. Women and children are objectified, reduced and degraded by male-orientated sexual imagery, especially where no relationship or personality is implied by the image.

Other sexually aggressive messages are implicit in society, such as the way the judicial system operates. There are numerous examples of chauvinist judges condemning victims of rape, accusing them of 'asking for it' on account of their dress. Women are constantly warned not to be out late on the streets, or to walk in certain places, because 'if they do, they deserve an attack for ignoring the warning'. Teenage boys are excused their gang rape of a schoolgirl on account of it being 'experimentation'. Publicly, it appears that victims are held responsible for what happens to them.

The extent and pervasiveness of sexually aggressive attitudes are the subject of current study elsewhere, and not the remit of this chapter. Nevertheless, the difficulties such attitudes present to those working with sex offenders are significant, and make supervision, support, education and training an essential part of the work.

It is especially important for members of a staff group to examine their attitudes to their own and other people's sexuality. Sexist attitudes and homophobia among staff need to be noticed and discussed on a regular basis, to avoid the therapists becoming overwhelmed with staff as well as client behaviour.

Within this service, the need to find the time and space to meet as a multi-disciplinary staff group to achieve this is certainly recognised. However, much discussion remains informal and fragmented, taking place within disciplines and where staff share office space. Work with the sex offenders admitted to the unit or referred as out-patients is in a constant process of evolution. The treatment strategies develop and improve as staff gain knowledge and experience.

Conclusion

Writing this chapter has required a review of work with clients who have committed various kinds of sexual offences. The relationship between myself and the client has been concerned with us as individuals, and has not always focused on the particular nature of the offence. Having said this, aspects of the psychopathology of the individual which led to the offence, are manifest within the art therapy sessions, however strongly the client resists assessment and treatment. This is because of the relatively unstructured approach taken, and the willingness to respond to whatever the client chooses to do with the time and art materials available.

Experience has taught me that with this group of people more than any other, it is necessary to be aware not only of personal safety, but of subtle reinforcement of that person's abusive behaviour. It is necessary to walk a fine line. The dynamics are allowed to develop, to the extent where the origins and depth of the feelings compelling that person to offend sexually are apparent, without allowing him to reinforce his behaviour by acting it out. The important work is in helping that person to recognise and use that knowledge constructively, to take responsibility for himself and his actions, and to develop a capacity to recognise and respect the feelings of others.

Art therapy contributes an insight-oriented, psychodynamic approach to assessment and treatment within a multi-faceted treatment programme. It is important that art therapy is seen as part of a whole, in the context of sex offence work, since the multidisciplinary team approach is the one most likely to be successful.

To survive the invidious fears of physical or symbolic attack and emotional persecution is a difficult, wearing task. Working with these individuals takes its toll on therapists' own feelings and how they perceive the value of their role in the treatment process.

Working with sex offenders challenges therapists to explore human sexual behaviour, sexuality and relationships as an individual man or woman, as part of a team and as a member of – and on behalf of – society as a whole.

References

Mackay, R. and Russell, K. (eds)(1988) *Psychiatric Disorders and the Criminal Process*, monograph. Leicester: Leicester Polytechnic Law School.

Miller, A. (1987) *The Drama of Being a Child.* London: Virago Press.

National Children's Home (1992) *The Report of the Committee of Enquiry into Children and Young People Who Abuse Other Children.* London: NCH Publications.

Perry, J. (1989), 'Sexual Abuse: The Counsellor's Process'. *Changes,* 7, 3, 93–4.

Ryan, G. (1987) 'Juvenile Sex Offenders: Development and Correction'. *Child Abuse and Neglect, II*, 385–395.

Soothill, K. and Walby, S. (1991) *Sex Crime in the News.* London: Routledge.

Group Art Therapy with Adolescent Sex Offenders

An American Experience

Maralynn Hagood

Introduction

As a Scot-American, I have lived in the United Kingdom for nearly five years. I am of Scottish descent, born in California in the San Francisco Bay Area. I received my training in both art therapy and counselling psychology at California State University in the cities of Hayward and Sacramento. Prior to my move to Britain, my work consisted of seven years of therapeutic work, using both art therapy and counselling approaches with a large number of children who had been sexually abused, their mothers, and adolescent and adult sex offenders. I worked in centres where the treatment of problems related to sexual abuse was the central focus, and methods of therapeutic work were continuously being developed. In most instances, I was the only art therapist working in these centres, and I found incorporating art therapy into verbal treatment methods very challenging. Feedback I received from adolescent sex offenders was that they loved art therapy, because they could actually see their problems in front of them, instead of only talking about them.

This chapter is based on my own training and experience with adolescent sex offenders, as well as information gleaned from existing literature on the subject. My work was carried out in treatment programmes in California, where there is the highest incidence of disclosure of sexual abuse in the United States. These programmes specialised in the treatment of families of sexually abused children, including adolescent sex offenders.

My move to Britain was precipitated by a chain of events beginning in 1985, when I presented a paper at Goldsmith's College, the University of London, at the Eleventh Triennial Congress for the Study of the Arts in Psychopathology. Friendships began at that point with several British art therapists and I decided that I would very much like to live in Britain.

I returned in 1987, and looked into the possibility of doing PhD research at a university in the United Kingdom, investigating drawings of sexually abused children. I had seen the effectiveness of art therapy in helping these children to express their feelings and resolve problems. I had also had the painful experience of having children draw sexually explicit pictures, only to have them rejected as evidence in the court system. Coincidentally, during that visit, the Cleveland Incident was splashed across newspapers all over Britain, and discussions on child sexual abuse were everywhere. Surely Cleveland had it wrong – there couldn't be so much child sexual abuse in the United Kingdom!

In the summer of 1988, I was invited by the National Society for the Prevention of Cruelty to Children (NSPCC) in Warrington, England, to consult with and train art therapists, social workers, and probation officers, who were doing pioneering work in the area of child sexual abuse. I subsequently journeyed north that summer to Scotland for my very first time, to attend the dedication of the new Biggar Museum by Princess Anne. (Biggar is the village from where my ancestors emigrated to America.) During that visit to Scotland, I visited the Department of Psychology at Edinburgh University and expressed my research interests. I was eventually accepted into the Psychology Department to investigate the development of children's drawings, with reference to sexual abuse. I moved to Edinburgh in the summer of 1989.

Since my move to Scotland, I have been involved in training a considerable number of professionals in both England and Scotland on therapeutic issues of child sexual abuse, focusing mainly on the use of art therapy. As I led workshops on therapeutic work with adolescent sex offenders, I discovered that British professionals working with these boys were on the same 'wavelength' as myself.

Data now emerging from research in child sexual abuse in Britain generally reflects trends similar to the findings in America. The main difference appears to be the paucity of resources and therapeutic work in Britain, and the virtual non-existence of diversion programmes. This sadly remains the situation in most of the United Kingdom.

Adolescent sex offenders on both sides of the Atlantic report feelings of powerlessness, low self-esteem, shame, guilt, fear, embarrassment and anger. These feelings often translate themselves into behaviour problems, depression, vulnerability to drug and alcohol dependence, and susceptibility to suicide, not to mention the possible recycling of the abuse into sexually offending others. These appear to be human issues regardless of culture.

With heavy prison sentences and little possibility of therapeutic intervention, the helplessness, denial and rage of a British adolescent sex offender may be even more intense than his American counterpart, who has opportunity of a considerable amount of therapeutic help. The young American sex offenders, with whom I worked prior to my move to Scotland, were distressed when they learned that a British boy in such a situation could get little or no help at all. While there obviously are cultural differences between America and Britain in dealing with the trauma of child sexual abuse, it is my belief that the similarities far outweigh the differences. Sexually abused children, which most of these adolescent offenders are, appear to feel victimised regardless of nationality.

Currently, throughout the United States, a large number of psychotherapists, including art therapists, are very knowledgeable about treatment issues in the area of child sexual abuse. Groups for adolescent sex offenders are available in most large cities, and many individual therapists have been trained to work with them as well. A major cultural difference exists between America and Britain in that in the United States there is no longer a great deal of stigma attached to gaining therapeutic help. Slowly, however, I perceive that receiving counselling in Britain is now becoming more acceptable.

In America, in states such as California, treatment programmes are partially funded by criminal compensation money actually paid by criminal offenders as part of their sentence. This has created resources to provide counselling and psychotherapy for victims of sexual abuse and their families. The need for such work in Britain is obvious, but as previously mentioned, little is available to date (National Children's Bureau Findings 1991).

It seems obvious that work in America cannot be transplanted with a 'cookie cutter' into this culture, but I believe many approaches and techniques can be incorporated into the newly evolving work in Britain. Treatment methods in working with survivors of sexual abuse, both children and adults, are currently being developed within the United Kingdom on an ever-increasing basis, and many ideas stemming from American approaches to treatment are gradually being adapted to the British system and culture (Pattison 1991/2).

A recent survey of American art therapists revealed that 16 per cent of American art therapists are now specialising in work in the area of child sexual abuse (Gordon and Manning, 1991). Another survey of 553 sexual abuse treatment programmes throughout the United States indicated that, in more than half of these programmes, art therapy was used, along with insight therapy, play therapy, behaviour modification, cognitive restructuring, and relapse prevention (Keller, Ciccinelli & Gardner 1989). A large number of art therapists in Canada are also developing expertise in working in the area of child sexual abuse (Knibbe 1990; Marrion 1990). The implications for British art therapists in developing methods of working with adolescent sex offenders, as well as others affected by sexual abuse, seem obvious (Hagood 1992b).

Art therapy with adolescent sex offenders

Art therapists usually have training and experience in a variety of theories and techniques. In Britain, it is my impression that psychodynamic approaches are fairly mainstream (Hagood 1990). Art therapy training programmes in Britain appear to draw largely on the work of Freud, Jung, Klein, Winnicott, Naumburg, and Kramer, all of whom are psychoanalytically oriented. At the present time, however, there is a call for the expansion of theoretical approaches in British art therapy.

Much literature in the United States on art therapy with adolescents is also psychoanalytic in approach (Linesch 1988). It must be emphasised, however, that in working with adolescent sex offenders, psychodynamic approaches alone do not appear to be adequate. They may be effective in helping with resolution of feelings or in gaining insight, but there is an addictive component to sexual offending which must be addressed. In America, for example, many children who were initially treated with primarily psychoanalytic approaches, later reappeared in the system as the next crop of sex offenders (Ryan 1988). They were often helped to work through their feelings related to their own abuse with art therapy (Stember 1980). At that time, however, American mental health professionals were not aware of the phenomenon of sexual offending behaviour in young children, and hence it was not sufficiently addressed.

It is now believed that low success rates in treatment of paedophiles may be partially attributed to the fact that only recently have American therapists begun to treat paedophilia as an addiction (Nelson 1992). Techniques drawn from psychodynamic theory are invaluable. Nevertheless, it increasingly

appears that the addictive component of sexual molestation must be incorporated into treatment (Chissick, 1993).

Art therapy approaches focusing on cognitive and behavioural aspects of these boys' difficulties can be effective in increasing awareness of the situations and behaviours which lead them into molesting behaviour. Their understanding of the cycle of sexual offending behaviour can be made clearer by having these boys paint or draw the situations which reinforce each other and lead to sex offending. Art therapy can help them find ways to change their lifestyle so that they are not so vulnerable to repeating the offence.

Problem-solving is especially effective using art (Liebmann 1990). Art can provide a means for them to illustrate various situations and to create healthier solutions. Family art therapy techniques are also valuable in helping these boys with their difficult relationships with other family members. (Landgarten 1987, Linesch 1992).

Regardless of theoretical approach, however, it is essential to be familiar with issues which are directly relevant to working with adolescent sex offenders. In understanding these issues, art therapy approaches may be particularly useful. They can enable adolescent sex offenders to gain insight, resolve their feelings, correct their irrational thinking and, it is hoped, find better ways to manage their behaviour.

From a psychodynamic perspective, art expression tends to access feelings better than words alone. Art therapy can help to retrieve childhood memories and to gain insight into the present situation. Care must be taken, however, not to allow an increasing awareness of these boys' own childhood abuse and trauma to become an excuse for offending others. The use of art helps the therapist to be more aware of defence mechanisms, such as denial and minimisation, which are heavily relied on by these boys.

It is not unusual to see adolescent offenders break down and cry with the impact of looking at what they have created. They need much support when this happens, because it is embarrassing to cry in front of their male peers. Encouraging other boys in the group to be supportive is also important and, it is hoped, will help them to develop empathy.

Art therapy may provide a place for the symbolic resolution of conflicts. The defence mechanism of denial is more difficult to maintain, as artwork frequently reveals the situation more clearly. Drawings also provide a permanent record of the therapeutic process and can be referred to in order to assess the progression of therapy.

Creating artwork is an enjoyable activity and easily seems to hold the attention of troubled children. Poor attention span is common with these

boys, and the artwork appears to help focus on issues as they emerge, and to enable group members to see problems visually. It encourages sharing and feedback, and often pulls everyone into the group process. In my experience, art therapy in groups enables members to realise that they are not alone in their situation, problems and feelings.

Case study of a group

The following case study describes art therapy used with a group of adolescent sex offenders with whom I worked prior to moving to Britain. In my experience with these boys, I found them to be much like other troubled adolescents with whom I had worked, with the major difference being their sexual offending behaviour. Hence, it was not difficult to translate my previous experience to doing art therapy with these young sex offenders.

The duration of contact with these boys was ten months. The length of each weekly session was one hour and twenty minutes, and the average group consisted of seven boys with ages ranging from eleven to seventeen years of age. These boys lived in various situations, some at home, some in residential treatment centres, and some in foster homes. The groups were held on premises rented by the treatment programme where I worked, and the boys came from a variety of locations in the immediate area.

I worked with a male co-therapist, who had previously done a considerable amount of counselling with delinquent boys, including young sex offenders. It was mutually agreed that we would work together in combining verbal counselling approaches and art therapy.

Treatment programmes in California usually included weekly sessions of individual therapy, group therapy, and family therapy when families were available. Treatment staff met each week to discuss the work done in groups, and to consult with individual therapists who also worked with these boys. This made it possible to check out inconsistencies in what the boys said in the group with other staff members, in order to minimise the occurrence of 'conning'.

The group was structured, with rules established by the therapists and group members alike. It was agreed that there would be no destruction of anyone else's artwork. Issues of confidentiality were discussed, and what was shared within the group was not to be told to anyone outside it. However, it was also explained to the boys that what happened in the group and the artwork would be discussed with other therapists in the programme who were involved in their treatment in order to help them better. Rules about behaviour during group sessions were established and enforced. 'Outlawed' behaviour included arriving late, missing sessions, physical or verbal abuse

towards other members of the group, and the use of alcohol and/or drugs prior to coming to the group.

Thorough discussions with the boys regarding any possibilities of future sex offending were essential in order to try and prevent its reoccurrence. The main group rules regarding reoffending were:

1. That each boy would under no circumstances offend again.

2. That any future offences would have to be reported.

3. That there would be consequences of any remolesting, such as further sentencing, longer probation, or, if old enough, prison.

Within the group rules and structure, however, much latitude was given to encourage open sharing of feelings between members of the group, to allow for a natural unfolding of issues, and to work with the dynamics of the group as they occurred. As issues emerged, we encouraged the boys to depict them with coloured drawings and to share them with each other.

Newsprint and coloured markers were used throughout these group sessions. It was necessary to choose art materials which were portable and required minimal cleaning up because of time constraints and borrowed premises. Many other art materials are good to use with this client group, such as paints, magazine collage, sugar paper, clay, and oil pastels, to name but a few.

My approach with these boys was a mix of directive and non-directive work. As issues emerged spontaneously from the non-directive flow of group interaction, they were given as themes for drawings. After the drawings were completed, each boy shared what was depicted in his artwork. The other boys were encouraged to comment and to give feedback.

As a result of the artwork, feelings frequently emerged which had previously been blocked, and an opportunity was created to help the boys develop empathy for each other. As questions were asked, more verbalisation of problems and feelings unfolded. These boys had learned to suppress their feelings at a very early age because they had almost always been abused themselves in some way. Physical abuse, emotional abuse, and/or sexual abuse were commonly experienced in their early development.

In order to survive, their emotions had become blunted, and little empathy was displayed towards each other. Art therapy was used in a cathartic way, to help these boys ventilate their anger, pain, and sadness. The artwork was a major factor in eliciting the feelings that these boys were so adept at concealing, or even allowing themselves to experience.

Special problems arose during these therapeutic sessions, including poor attention span, hyperactivity, changing the subject, and distracting behaviour such as rocking and banging chairs, especially when discussing anxiety-producing subjects. Interestingly, these kinds of behaviour tended to diminish during the artmaking process.

These boys were adept at showing little emotional connection to what they verbalised. They learned to present to the group what they thought would impress the therapist and enable them to leave the group sooner. Time was spent helping the boys learn to negotiate, to be assertive instead of aggressive or passive, and to realise that acting in 'the opposite way to what people wanted' was not a free choice. By automatically rebelling, they were not leaving themselves free to choose. It was essential to focus on the positive qualities that each boy possessed, and to try and help him eliminate behaviour which was self-defeating as well as extremely harmful to others.

Artwork sometimes reflected blatant sexually explicit material in what appeared to be an attempt to shock us as therapists, especially in the early stages of the sessions. The boys expended a considerable amount of energy in testing group rules and our patience. In previous work with troubled adolescent boys, I had learned that much of this testing was an effort to drive me away, lest they became emotionally attached to me and then abandoned. One boy asked me if I was going to leave him 'like everyone else had done'. Developing a trusting and predictable relationship with these boys was essential. It was important for therapists not to miss group sessions without telling the boys ahead of time, in order to minimise their feelings of abandonment.

Some professionals in American treatment programmes advocate repeated and detailed disclosures in the group, of the actual molestation. It was found, however, that this fed into sexual fantasies which usually precipitated sexual offending, and thus was not encouraged in this group. For this reason, explicit sexual artwork was also discouraged.

Gaining a sense of empowerment over offending behaviour was the most important therapeutic issue. It was emphasised that each boy had total responsibility for not sexually offending: any offending behaviour could not be blamed on anyone else. Blaming parents, the victim, or the system for their own offences was simply not tolerated. One boy in the group illustrated his fears of remolesting and his need for someone else to stop him from doing so (Figure 9.1). The stick figure is saying, 'Stay away from my daughter', and some accompanying text warns, 'Watch your kids or have someone watch them for you while you are gone, if you trust them. And

make sure they aren't doing anything funny either, when there are older people around. Watch over them carefully too.' This boy needed to learn to develop his own sense of control, and to build in mechanisms to keep him from reoffending.

Figure 9.1 'Stay away from my daughter' – a boy's fear of re-molesting

It is believed that molesting other children is a re-enactment of the offender's own victimisation and a power issue ('getting-back' at the abuser). Sexually abusing another child provides temporary relief of negative feelings, and so becomes self-reinforcing and addictive. We discussed and reiterated the options available if they were tempted to reoffend, such as contacting the therapist (or other designated persons) for support, and agreeing not to be alone with any younger child – ever.

There was a tendency for these boys to isolate themselves from other people. They were asked to create a picture illustrating what they typically did during a 24-hour period of time. Figure 9.2 illustrates an analysis of time management by one of the young offenders. He depicted boredom, with nothing in life to do but work, chores, sleep, and occasional time spent with music and parties. The purpose of this exercise was to help the boys gain insight into how they set themselves up for isolation and depression, which are known precursors to sex offending.

The boys were asked to make a picture about how they felt about being in the group. Resistance to being in the group, and the desire to escape dealing with issues of sexual abuse, are illustrated in Figure 9.3, entitled *I*

Figure 9.2 Time management, reflecting isolation and boredom

think of driving away. This boy expected to be reprimanded for not wanting to be in the group, but instead was congratulated for his honesty. Much to his surprise, it was supportively acknowledged that his desire not to be there was understandable, and that it was indeed difficult to talk about sexual abuse.

Missing therapy sessions for reasons that were untrue occurred from time to time. One boy missed a session and told the group the following week that he had been ill. I personally had seen him waiting for a bus just outside the location where the group was held. He had lied to his foster parents that he was going to therapy, but went somewhere else instead. This incident provided an opportunity to confront him about his lying and conning behaviour. Group members were encouraged to express how it felt to have been lied to. Needless to say, they didn't like it, and also said that it made

Figure 9.3 Feelings about being in the group

them feel stupid for having believed him, and that they could no longer trust him. When supported, the boy was able to admit he had been lying.

In working with this group, I quickly learned that being conned by sex offenders is common, until a therapist becomes more experienced. These boys are 'experts' at conning and manipulating. As I learned to listen to my 'gut reaction' when stories didn't add up, and to notice inconsistencies between what was said and what was actually depicted in the artwork, I was conned less frequently.

I learned that these boys often felt angry toward therapists if they could manipulate them easily. Too much sympathy made therapists vulnerable to this manipulation. Balancing being supportive, caring and empathic, with consistent, firm limit-setting and gentle confrontation, was essential. Often feedback from peers was more readily heard. My co-therapist and I worked together as catalysts, but the group was encouraged to do most of the therapy.

Children who have been abused frequently adopt a habitual 'victim position'. This is an attitude resulting from 'learned helplessness' over a long period of time, leading to a tendency to perceive the world from a victim's perspective.

 The boys felt little control over their environment and believed that
negative things just 'happened' to them. Working with these young people
to help them become more assertive and see how they set themselves up for
many of their difficulties was an ongoing part of therapy. As trust gradually
developed in the group, defences softened and the boys became willing to
be more open. The artwork began to change and themes of abandonment,
loneliness, and current problems emerged. Figure 9.4 clearly depicts a boy's
own victimisation as a child and his parents' refusal to believe him.

Figure 9.4 Victimisation as a child, and unbelieving parents

He portrayed himself locked inside a brick wall, feeling lonely, scared, dirty,
and unbelieved. As he spoke about the drawing, he burst into tears and
expressed his feelings very openly in the group for the first time. The other
boys began their distracting behaviour and were unable to be supportive.

The remainder of the session was used in working with them to hear what the boy was saying and begin learning to empathise.

Relationships with girls were fraught with difficulties. One very attractive boy in the group could only relate to girls through promiscuous sex. Extremely low self-esteem, fear of rejection, and problems with social skills tend to create a fear of relationships with girls (Katz 1990). Another boy in the group was invited to attend a high school dance by an attractive cheerleader. We encouraged him to accept the invitation, hoping he might develop healthier age-appropriate relationships. His self-esteem was so low that, even though he was a very likeable and handsome boy, he was unable to accept the invitation.

Other symptoms of low self-esteem were apparent in the boys in this group, in the 'put-downs' they made to themselves as well as to each other. Unfortunately, such low self-esteem made it easier to gratify sexual needs with younger children. Some of these boys had offended sexually while childminding, instead of spending their spare time in appropriate relationships with peers.

Difficulties in developing relationships with each other were demonstrated, as the boys created a large mural together on the topic of 'Friends'. Most of the images reflected concerns with money, drugs and other superficial values, with little evidence of the 'camaraderie' usually involved in healthy friendships. Another attempt was made to bring these boys together as a cohesive group, by having them do a fantasy mural, imagining they were taking a trip into outer space together. 'Hypersexuality' was expressed, as the boys focused only on their individual rocketships, which were replete with explicitly phallic images. There was little interaction with each other during the process.

Because of their poor impulse control, depression and isolation, as well as the negative circumstances in which these boys found themselves, it was important to be alert for signs of suicidal tendencies. One boy in the group consistently chose only black for all his drawings. After several weeks, I consulted his counsellor at the residential treatment centre where he lived, and found that the boy had in fact been verbalising suicidal feelings.

Artwork cannot in itself be used for diagnosis, but clues often appear which alert the art therapist to do further assessment. Wrist slashing, dead people, graveyards, whirlpools, consistent use of black, brown, grey and dark blue are frequently seen in the artwork of suicidal people. If such symbols appear in an adolescent offender's artwork, it cannot be automatically

assumed that he is suicidal, but such images should serve as a red flag, showing that further assessment is needed.

There was a considerable amount of ignorance in the group regarding accurate sexual information, as well as a multitude of misconceptions about sex and love. The boys' understanding of reproduction, birth control, sexually transmitted diseases, safe sex, and personal responsibility for self and others was minimal, and for the most part erroneous. Much sexual knowledge had been learned from other children and involved 'street' language. In therapeutic work, frank and open discussions about sex, with accurate information, were essential. Initially these boys felt uncomfortable with me as a female therapist, but ended up respecting me as they listened to my perspective on relationships with girls.

Abandonment by parents, whether physical, emotional or both, was a theme recurring in the artwork of these boys. Figure 9.5 illustrates the efforts by one boy to reach out to his parents with love, only to be rejected.

Figure 9.5 Feelings of abandonment by parents

This boy had been promised repeatedly that his parents would take him home to live with them. He waited in constant hope and disappointment, as he continued to be left in residential care.

The relationships of these adolescent sex offenders with their fathers were explored. One boy told the group constantly that everything at home was wonderful. Figure 9.6, however, illustrates his situation somewhat differently, with a strong separation between himself and his parents.

Figure 9.6 Separation between boy and parents

Figure 9.7 Boy fishing with father whose back is turned

In Figure 9.7, the same boy depicts going fishing with his father. This boy had repeatedly told others that his relationship with his father was wonderful. When asked to talk about his picture, he said his father's back was turned on him, and began to cry, revealing that he always felt emotionally shut out by his father.

I found that images appearing in the artwork of adolescent sex offenders often included blood, gore, sadistic and/or satanic themes. Figure 9.8 illustrates one boy's desire for a girlfriend ('I need a girlfriend because I'm tired of being lonely' at top left of picture), with various graffiti, including an inverted peace sign (top right) and the esoteric 'sign of 333 or 777' (centre). It was not clear whether these symbols were linked to satanism and ritual abuse, or whether they were derived from 'heavy-metal' music.

Figure 9.8 Graffiti – boy's name in phallic shape

The phallic shape in the upper left-hand corner was the result of the boy printing his name in graffiti. He appeared to be unaware of the phallus, nor did any of the group members comment on it. Phallic shapes incorporated into artwork are commonly seen in paintings and drawings of sexually abused children (Hagood 1992a), and these boys were no exception.

Most of them listened to 'heavy-metal' music, which could have influenced the inclusion of satanic symbols in their drawings. Graffiti, normally enjoyed by teenage boys and sometimes used in art therapy, tended to encourage the use of these symbols. The problem was how to assess whether the drawings were influenced by 'heavy-metal' music, or whether the child was actually involved in satanism (Speltz 1990).

One boy in the group alluded repeatedly to his mysterious activities outside the group, and said they would shock us if we knew about them. His drawing (Figure 9.9) shows several well-known symbols of satanism, such as: the inverted Christian cross, with three 6s around it; the swastika; the inverted pentagram; and behind a hooded figure holding an axe. This boy also had a haunted and 'electrocuted' look about him. Shortly after completing this drawing, he disappeared from the area, nowhere to be found. It was suspected that he had been involved in some sort of ritual abuse.

Figure 9.9 Symbols often linked with ritual abuse

Depicting blood and gore is another means of defence against feelings, and may also be an attempt to shock the therapist. Normal, non-abused boys go through phases in their development when they may also draw such material (Uhlin 1984). It is important, therefore, not jump to conclusions about satanism, but to consult appropriate professionals if there is serious concern.

Ritual abuse has emerged in therapeutic work in both the United States and Britain. The psychological damage to children involved in this form of sexual abuse is extreme, resulting sometimes in multiple personality disorder (MPD). American psychotherapists and art therapists are currently developing their work with this group (Cohen, Giller and Lynn 1991, Putman 1989). Numerous accounts by British psychotherapists working with survivors of sexual abuse are now appearing, as symptoms of this disorder are emerging on this side of the Atlantic as well.

Conclusion

Therapeutic work with boys who have been victims of sexual abuse, and have repeated the behaviour by molesting other children, may be viewed as extremely difficult or as very challenging and rewarding. In my experience, it has been a mix of both. Within each one of these boys was a hurt child who needed nurturing and much help to overcome the results of his own victimisation, and to enable him to learn to manage his life in such a way that he would hopefully no longer molest other children.

Since I had previously worked with a number of troubled adolescent boys, I found it surprisingly easy to like these boys. I had previously worked with a large number of survivors of sexual abuse, and had indeed experienced angry feelings toward sex offenders in general. Because I did not work with any of these boys' victims, and realised how similar these boys were to their victims, I was able to view them in a similar way to the other sexually abused children with whom I had worked. It was nevertheless important not to become too sympathetic and forget their sexual offences.

Evidence is increasingly demonstrating that most sex offending begins in adolescence, or even earlier (Becker 1988). The need for treatment is crucial at this age to prevent the establishment of an entrenched pattern of molesting as these adolescents grow into adulthood. A general lack of 'outcome studies' in the effectiveness of therapeutic work with adolescent sex offenders, leaves us with the dilemma of not knowing whether working with this client group is worthwhile (Keller, Ciccinelli and Gardner 1989). As research in art therapy is expanding, there is ample opportunity to demonstrate its effectiveness in the therapeutic process with adolescent sex offenders. It is my belief that we must start somewhere in developing methods of working with these young boys, in the hope that the cycle of child molestation might be reduced.

As my work with this adolescent offenders' group drew to an end, I was preparing for my move to Britain. When the boys were told that adolescent sex offenders in Britain received little or no help, they were very upset. I

USE A (velvet HAND) AND AN OPEN MIND (Hinges)

~~Per~~ perpetrators ARE People Too So Treat them Like so. Remind them from time ~~to~~ Time That they ARe iN good hands Try to encourage them to continue counseling, Long Term counseling. IN order to talk to them your must Be kind or they wont open up. you Also <u>must</u> ~~not~~ have patience

Good Luck

Tee~~n~~ offender ~~group~~ is helping me learn from what I did, I like everybody in ~~the~~ group. ~~Their~~ my friends

good luck ☺ ~~~~ I like you

Figure 9.10 and 9.11 Letters from American adolescent sex offenders

asked them to create some drawings illustrating how they felt about it. The posters (Figures 9.10 and 9.11) expressed these boys' feelings about the therapeutic help they had received, and their hope that British adolescent sex offenders too would be helped.

The letters say:

> Use a velvet hand and an open mind. [The drawing of the head has 'hinges' labelled.]

> Perpetrators are people too, so treat them like so. Remind them from time to time that they are in good hands. Try to encourage them to continue counseling, long term counseling. In order to talk to them, you must be kind, or they won't open up. You also MUST have patience.

and:

> Teen offender group is helping me learn from what I did. I like everybody in the group, they're my friends.

> Good luck. I like you.

I terminated my work with this group, convinced that art therapy was effective in helping these young sex offenders deal with their problems. The use of art therapy supplemented counselling in a comfortable way, and the boys in the group readily and easily accepted its use. They participated willingly and enthusiastically in creating the images which illustrated their dilemmas, not only to us as therapists, but also, even better, more clearly to themselves.

References

Becker, J.V. (1988) *Intervening in Child Sexual Abuse: Learning from American Experience.* Child Sexual Abuse Conference, Social Paediatric and Obstetric Research Unit, University of Glasgow.

Chissick, R. (1993) 'She never said no'. *New Woman, February,* pp.68–71.

Cohen, B.M., Giller, E., and Lynn, W. (1991) *Multiple Personality Disorder from the Inside Out.* Baltimore, Maryland: Sidran Press.

Gordon, R.A. and Manning, T. (1991) 1990–91 membership survey report. *Art Therapy, Journal of the American Art Therapy Association, 8(2),* 20–29.

Hagood, M.M. (1990) 'Art therapy research in England: Impressions of an American art therapist'. *The Arts in Psychotherapy, 17(1),* 75–79.

Hagood, M.M. (1992a) 'Diagnosis or dilemma: Drawings of sexually abused children'. *British Journal of Projective Psychology, 17(1),* 22–33.

Hagood, M.M. (1992b) 'Status of child sexual abuse in the United Kingdom and implications for British art therapists'. *Inscape*, Summer.

Katz, R.C. (1990) 'Psychosocial adjustment of adolescent child molesters'. *International Journal of Child Abuse and Neglect, 14*, 567–575.

Keller, R.A., Ciccinelli, L.F., and Gardner, D.M. (1989) 'Characteristics of child sexual abuse treatment programs'. *International Journal of Child Abuse and Neglect, 13*, 361–368.

Knibbe, C. (1990) 'Treating sexually abused children using art therapy'. *The Canadian Art Therapy Association Journal, 5(1)*, 18–26.

Landgarten, H.B. (1987) *Family Art Psychotherapy*. New York: Brunner/Mazel.

Liebmann, M. (1990) '"It just happened": Looking at crime events', in Liebmann, M. (Ed) *Art Therapy in Practice*. London: Jessica Kingsley Publishers.

Linesch, D.G. (1988) *Adolescent Art Therapy*. New York: Brunner/Mazel.

Linesch, D.G. (1992) *Art Therapy with Families in Crisis*. New York: Brunner/Mazel.

Marrion, L.V. (1990) Art therapists' approaches to the treatment of guilt and body image distortion in sexually abused girls, ages 4, 8, and 13. Unpublished doctoral dissertation, University of Victoria, Victoria, B.C., Canada.

National Children's Bureau Findings (1991), quoted on BBC TV programme, UK.

Nelson, R.M. (1992) 'Why I'm every mother's worst fear'. *Redbook*, April, pp.85–116.

Pattison, C. (1991/2) 'Child sexual abuse – Integrating work with victims, their families, and perpetrators'. *Child Abuse Review, 5(3)*, 16–17.

Putman, F.W. (1989) *Diagnosis and Treatment of Multiple Personality Disorder*. London: Guilford Press.

Ryan, G (1988) *Victim to Victimizer: Re-thinking Victim Treatment*. (Available from Kempe National Center for Prevention and Treatment of Child abuse and Neglect, 1205 Oneida Street, Denver, CO 80220).

Speltz, A.M. (1990) 'Treating adolescent satanism in art therapy'. *The Arts in Psychotherapy, 17*, 147–155.

Stember, C. (1980) 'Art therapy: A new use in the diagnosis and treatment of sexually abused children', in *Sexual Abuse of Children: Selected Readings*, U.S. Department of Health and Human Services, Washington, D.C., D.H.S.S. Publication No.(OHDS) 78–30161.

Uhlin, D. (1984) *Art for Exceptional Children (2nd ed.)*. Dubuque, Iowa: William. C. Brown Company.

Further reading on treatment of adolescent sex offenders

Becker, J.V., Cunningham-Rathner, J. and Kaplan, M.S. (1986) 'Adolescent sexual offenders: Demographics, criminal and sexual histories and recommendations for reducing future offences'. *Journal of Interpersonal Violence, 1(4)*, 431–445.

Becker, J.V., Kaplan, M.S., Cunningham-Rathner, J. and Kavoussi, R. (1986) 'Characteristics of adolescent incest perpetrators: Preliminary findings'. *Journal of Interpersonal Violence, 1(1)*, 85–96.

Gil, E. (1987) *Children who Molest: A Guide for Parents of Young Sex Offenders.* Walnut Creek, CA: Launch Press.

Groth, A.N., Hobson, W.F., Lucey, K.P. and St. Pierre, J. (1981) 'Juvenile sex offenders: Guidelines for treatment'. *International Journal of Offender Therapy and Comparative Criminology, 25(3)*, 265–272.

Groth, A.N. and Loredo, C.M. (1981) 'Juvenile sex offenders: Guidelines for assessment'. *International Journal of Offender Therapy and Comparative Criminology, 25(1)*, 31–39.

Heinz, J.W., Gargara, S. and Kelly, K.G. (1987) *A Model Residential Juvenile Sex-Offender Treatment Program: The Hennepin County Home School.* Syracuse, NY: Safer Society Press.

Knopp, F.H. (1982) *Remedial Intervention in Adolescent Sex Offenses: Nine Program Descriptions.* Syracuse, NY: Safer Society Press.

Larose, M.E. (1987) 'The use of art therapy with juvenile delinquents to enhance self-esteem'. *Art Therapy, Journal of the American Art Therapy Association, 4(3)*, 99–104.

Marsh, L.F., Connell, P. and Olson, E. (1988) *Breaking the Cycle: Adolescent Sexual Treatment Manual.* (Available from the authors through St. Mary's Home for Boys, 16535 SW Tualatin Valley Highway, Beaverton, OR 97006).

Naitove, C.E. (1987) 'Arts therapy with child molesters: A historical perspective on the act and an approach to treatment'. *The Arts in Psychotherapy, 15*, 151–160.

National Task Force on Juvenile Sexual Offending (1988) Preliminary report. *Juvenile and Family Court Journal, 39(2)*.

Porter, E. (1986) *Treating the Young Male Victim of Sexual Assault.* Syracuse, NY: Safer Society Press.

Ryan, G., Lane, S., Davis, J., and Isaacs, C. (1987) 'Juvenile sex offenders: Development and correction'. *International Journal of Child Abuse and Neglect, 11*, 385–395.

Sgroi, S. (1989) *Vulnerable Populations. Vol. 1 and Vol 2.* Lexington, MA: Lexington Books.

Smith, W.R. (1988) 'Delinquency and abuse among juvenile sex offenders'. *Journal of Interpersonal Violence, 3*, (4), 400–413.

Snets, A.C., Cebula, C.N.M. (1987) 'A group treatment program for adolescent offenders: Five steps toward resolution'. *Child Abuse and Neglect, 11*, 385–395.

Steen, C. and Monnette, B. (1989) *Treating Adolescent Sex Offenders in the Community.* Springfield, IL, Charles C. Thomas.

CHAPTER 10

Art Therapy – An Alternative to Prison

Barry Mackie

Introduction

I believe art can be a means of resolving conflict for the artist, and have spent a number of years working both as an artist and with offenders using art therapy. What brought me to work with offenders? I can trace it back to all sorts of things. My upbringing in Southern Africa gave me the disposition of a 'courageous pessimist', a phrase used by the playwright Athol Fugard to describe the contradictory attributes of human nature from that part of the world. Offenders, on many levels, tuned into the courage and pessimism I carry as an individual.

As a child, the youngest of five in a working, pioneering, liberal family, I found sanctuary in my abilities as an artist. I went on to develop them as a young adult with formal training as a textile designer. I also acquired teaching skills, and taught children and adults.

I exiled myself to England in the early seventies, leaving Southern Africa and the emerging shadows of brutality, where prison was not far away. In 1982 I undertook my art therapy training at Goldsmiths' College, focusing on a therapeutic community for adolescents. This training consolidated the two professional strings to my bow. I felt relatively content as an artist with a developed vocabulary of media, and now also had a grounding in clinical psychodynamic theory and practice.

In the final days of my studentship, I learnt from the Art Therapy Unit that an interest in art therapy had been expressed by an assistant governor of a Youth Custody Centre in Leicester. With his support and that of other officers, civilian staff, medical staff and a teacher, I set up a contract to work with three groups and four individuals for six weeks. I was paid as a volunteer at £14 per week, and the prison provided accommodation.

The youth custody centre

I made several visits to the prison and set up supervision for the contract, both on site (in the prison) and with my own supervisor in London. I was ready to start. With my bicycle and bag, I caught the train to Leicester. I was slightly known from my visits to the prison, but the next few days were taken up with initiation into prison ways with clearance, keys, inmates and 'screws'. The officers' mess contained an accommodation block which was my home for the part of each week that I was at the prison. I had arranged my supervision so that I received my on-site session on a Monday and my off-site session in London on a Friday. Tuesday, Wednesday and Thursday were my working days with the groups and individuals. I spent the weekends away from the prison.

Setting up the groups

The three groups I ran were 'borrowed' in a sense, as they were already formed and running. Two were based in the hospital wing, and were managed by a larger-than-life woman who was both curious and envious of my work with 'her babies'. The members of both these groups were convicted young men who, for one reason or another, were contained in the hospital wing.

These groups differed in that one had a more floating membership – although it remained fairly consistent during my work – while the other group's members had deeper problems, and there was a more explicit use of medication. The average number was eight in each group. Members of both groups complied with the normal prison regime, but also met in their groups with prison officers in the hospital twice a day; mornings and most evenings. This gave the hospital a different atmosphere, and the inhabitants seemed to feel more part of a community. I met both of these groups a week before I started, as an observer and visitor to their session with the occupational therapist in the art room of the prison hospital.

The third group was a remand group willingly handed over to me by a quiet, well-meaning, teaching member of the civilian staff. Its ever-changing membership reflected its place in the system for young and unconvicted prisoners. I did not have a prior meeting with them, and the group was handed over on the day of the first session. We conducted the sessions in a set of classrooms in the Education Block.

It is important to describe the relationship between the prison officers and the working group spaces. In the case of the hospital groups, an officer remained at the end of the large occupational therapy room, as part of

normal procedure. With the remand group, the officer was in the corridor, again as normal procedure.

The character of the groups seemed to need an approach that helped to lift some of the uniformity and anonymity affecting the individuals in them. After a fair amount of thought and preparation, and in conjunction with my supervisors inside and outside the prison, I decided to use a structured approach with the groups. This was helped by a compilation of work, *Art Therapy for Groups* by Marian Liebmann (1986). With the individual work, I approached inmates with an open agenda, and worked with whatever they brought.

My choice of materials varied with each situation. The palette I chose for individual work was my own set of ordinary tempera paints, some felt pens, pencils and brushes, and white paper. In the case of the remand group, I used felt pens only, and white paper of varying sizes. For the hospital groups, I made a selection of what was available in the room – paint, felt pens, paper (white, black and tinted), as well as clay.

Sabotage

'Set up', or sabotage, was part of the work just as much as what went on in the sessions. Sabotage 'smelt' a bit, not unlike the disinfectant that wafted along the corridors of this well-run institution. My supervisor on site, a benign man two years away from retirement, was aware of this, but I did not feel he was strong enough to help, if I came up against a 'log jam'.

The prison culture was male-dominated, as was the whole institution. As a result, it was filled with games of power and physical ritual, which kept intact a sense of order on the surface. Just underneath it seemed to be the human reality, rather hidden in the world of uniforms and bars: the humanity in the relationship between the gaoler and the gaoled; swift, firm discipline; the beating in the shower; the gentle affectionate cuddle on a landing; the endless time-wasting alone in your 'shit pile'.

Outside my sessions I welcomed the opportunity to get alongside the prison officers in their work, and was open and friendly about myself and my task. Without the participation of officers, I had no access to clients. I felt at times as if I were standing at the end of a long line of obscure permissions given to one man to punish another. Here was a private, almost unseen, institution, managed with an insistence on deprivation as a tool in correcting behaviour.

It was in the negotiation of who my fourth individual client was to be that I experienced the first 'set up'. Rather than only have clients who were referred to me, I had decided to phone around and visit offices in several

blocks to raise my other clients. It was soon general knowledge that there was 'an art therapist guy wanting to "mind-fuck" one of the charges'. After contacting some officers, I was directed to a particular senior officer, 'He will sort you out'. His block was on the periphery of the prison, and after arranging a time, I set out to see him. I was met with no welcome, not even the usual clipped 'Hello' I was used to. The block door was opened by a tight-lipped officer, who disappeared as soon as he clunked the door closed. I noticed the office door was shut, a bit unusual as offices are often a hub and haunt of 'screws' as well as, sometimes, inmates.

I knocked and was told to enter by the Senior Prison Officer, who was sitting at his desk, immaculately dressed, ignoring me, his eyes fixed on a set of files. He got up sharply and I realised he was at least 6' 6" tall. He asked me if I knew who he was. I responded with his name and status, and said I was pleased to meet him, and put out my hand, which he declined. The next couple of minutes was filled with his state-of-the-art views on prisoner control and maintenance of discipline. He let me know that he was a Scotsman who had contained the worst men in tough Barlinnie Prison.

He suddenly stopped, stepped away from the desk and bellowed at me. What did I want – rising on the balls of his feet – a murderer, a rapist, a 'nonce'? Before he got back on his heels, I think I said a murderer would do. He looked at me and through me, signalled that it was the end of the interview, and said, if I went to the adjoining room, used for association, I would receive my client and could interview him there. This was my introduction to Rob 'the murderer', whose work is described later in the chapter.

I interviewed a tall young man, strong as an ox, with a nasty fresh cut over his left eye. I introduced myself and told him what I wanted, and gained his permission to work with him. He was thoughtful and did not volunteer an enormous amount, but gave me some information about his background and current offence, which was a malicious wounding charge. He possessed a quiet reflective disposition, and I felt I could work with him. On parting, I asked him what had happened to his eye, and with a gentle trembling smile, he said he had walked into a window.

The remand group

In the remand group, which had a floating membership of nine to twelve, the structures I used were as playful as possible. In the beginning, I used physical graffiti games, involving inmates getting into two teams and running up to large papered boards where there was a felt pen tied on a string. Most of this activity allowed them to release a lot of energy, and also to reflect,

in their own way, on the marks they made as individuals. This led to more centred work such as drawing around parts of the body. Florid and stark images of their culture surfaced in this work, mostly concerned with tattoos. The remand group included demanding and lively individuals who had not yet been proved guilty of any crime.

At times they were difficult to contain, and it was hard for me to stand my own ground in relation to the prison officers. This was brought into focus for me by an incident which occurred towards the end of my contract. The system for the delivery of materials and tools was to count it out and in; on this particular occasion, I had duly counted the felt pens in, and thought all was well. Unbeknown to me, one of the inmates returned the outer casing, but retained anally the inner felt out of a red felt pen. He passed the officers' searches, and back on the wing sold it in small slithers to his mates, for the express purpose of tattooing. It seemed I had been deceived in the name of body-marking.

The hospital groups

With the hospital groups, I also used a range of structures and themes with clear ground rules to enable the individuals to identify themselves and share a task with fellow members in an unthreatening way. Similar themes were used for both groups, with an accent on play. For example, near the beginning, I used a theme that enabled individuals to cast themselves in different roles in 'An Advertisement for Yourself', in which they designed an advertisement showing their personal qualities, for other members of the group.

The two hospital groups had different experiences. In the first group there was a rapid growth in confidence and a feeling of safety, enabling me in the third session to invite them to do a metaphorical portrait of the group as 'something else'. The resulting image was a collective effort, in graffiti style. The inmates advanced on this task like leaping bears, and produced a wolf-headed creature with an alarming presence (see Figure 10.1). I felt this image was emblematic of the qualities of this group of offenders: voracious, energetic, angry, hungry and humorous.

In the subsequent three sessions, this creature reappeared in different guises in individual work, as if passed around the group. Some of these creatures developed into prison officers, and one was even labelled with the name of a particular officer. This art work emerged alongside the group's rumblings of complaints of brutality in the prison.

The content of these drawings caused considerable controversy in the prison, and undermined my standing with the prison officers. The group

Figure 10.1 Metaphorical group portrait (Full size 32")

itself did not refer to the 'named officer' picture in the next session, but seemed unusually flat and depressed.

This was the situation I worked with in my supervision both on site and in London. Were the group members finding a safe and comfortable way of rooting their anger, were they 'setting me up', or both? I felt I needed to keep a firm hold on my contract. My position was that what occurred in the groups was confidential, other than in these groups and in my own supervision, until the conclusion of the groups and my contract. Only then would I return to give some feedback to the prison staff.

There was an issue about the ownership of the work produced. Although in a technical sense in that setting it belonged to the institution, I felt that what the inmates put on the paper was theirs. However, there was no ritual that I could create outside the place of performance to reinforce this, like giving them the opportunity to own their work by taking it away with them. The only thing I could do was make a point of saying at the end of each session that I considered this work theirs and, if they wanted to, they could either get rid of it or leave it in the room.

On leaving the group and making my way out of the prison one day, I was confronted about the drawings identifying officers by an officer in the corridor, who told me that I 'should get them lost'. I said the drawings were a matter of concern to me, and that I needed to discuss it with my prison supervisor, which I duly did. I was met with limp disdain. He could look into the matter. I took the pictures out of the prison, photographed them and returned them the next day.

In the last session, I invited the group members to review their work, which I made available. Some talked a lot, in a playful end-of-term way, about what was theirs in the large graffiti creation, while one individual surreptitiously 'rubbished' some of the officer pictures by blackening them in.

The second hospital group included more 'borderline' individuals, who found it impossible to sustain a group activity for any length of time. Its members were content to work individually, and had a developing appetite for art materials. There was a strong feeling of containment, and a growth in themes of expression. War games became the currency of some, in a quiet way. Other members enjoyed the oasis provided by the painting process. Even the least able was busy, half-draped over a radiator, at one point carving his own fingernail.

Introducing clay into the group in the third session seemed to accelerate the activity. It gradually became clear that a particular member was slowly gaining ownership of the bulk of the clay, by fair means or foul, for the production of a large rocket. At one point, the rocket builder stood up quite

quickly to contemplate how he could support his creation with a ruler. I was wondering what the implications would be if this clay phallus fell, when a panic button sounded, activated by the prison officer at the end of the room. Within seconds, five officers entered the room and removed the rocket man, conducting this intervention with a precision and gentleness I could respect. The group left, hijacked of its potency. The rocket man never came back but was well, I heard. Again, I took my feelings about all this to my supervision sessions.

The group survived to the end of my contract; even the human nail carver left the radiator and, sucking his thumb, visited a couple of his mates.

The individuals

Three of the individuals were referred by two psychologists from the psychology department. I had the feeling that one psychologist only put two clients my way because she was instructed to do so by her senior; however, the second psychologist was a curious man who took an interest in the work, and became an ally of mine. The fourth individual was one I insisted on negotiating myself through the prison officers. This was Rob, whose first meeting with me has already been described.

The six sessions with each individual were held weekly in my office, alone with my media bag. An officer chaperoned the client, but did not stay in the room during the session.

The individual work fell into two main types, according to whether clients named their offences or not. For those who were prepared to do this, it was often possible to find a link between the content of their artwork and their offences, and thus help them more directly.

It was interesting to note the different attitudes towards the materials, and the varied ways of using them. There was a minimal use of materials across the board. The most healthy consumption was made by Rob, who produced quite a vivid picture, in a record-sleeve format, using pencil and red felt pen. One individual did not touch the materials at all. The 'polo kid', who said his offence was stealing a packet of polo mints, made sparing use of just red, green, blue and black felt pens.

Only one person used paint, but in a special way, without water. After two sessions involving tense silences and no interaction with the media, in the third session this wiry, ginger-haired lad made an engagement. He mentioned that he had been abandoned at the age of four – then he rested back and smoked a cigarette, something he always did. He went on to talk about his fear as his release date drew near, and said he felt like hitting a prison officer on his wing, just to prolong his sentence. As a known recidivist,

he was suffering from what in the culture is called 'gate fever', and tended to 'act out' in this way.

While talking about these matters, he carefully made contact with the dried-up paint palette. He systematically picked at the paint and spent long, deliberate moments re-arranging the dried fragments into particular group-ings. When he seemed satisfied with one of these groupings, he smiled for the first time. He then picked a thread from his prison-issue jumper, split a match longways, and made a cross by binding the tiny staithes together with a thread. He placed the cross in a well of the re-arranged dry paint palette. This process seemed to help him contain his fear.

Rob was eventually able to go beyond his florid record covers, which he used to describe his experience of mothering, with idealised forms as well as lurid attacking shapes. Born in South Africa of a Welsh father and a South African mother, Rob had been brought up by his grandmother (his mother had stayed in South Africa) in a small village in Wales, where he seemed like a young cuckoo in a small nest. At twelve he had been mistaken for nineteen, his present age. He related his physical struggles, and how he had got into trouble early in his life for fighting.

He had institutionalised his physical prowess and aggressive sense of adventure by becoming a mercenary in Lebanon. This adventure involved him in savage acts which he had recorded photographically and pasted into an album, one of his few possessions in the prison. He had then joined the French Foreign Legion, and attempted an escape which failed. He recounted all this in sessions, while drawing his record covers.

He was twenty minutes late for his third session. I relied on the prison officers to bring my clients up from their cells, and wondered if the lateness was deliberate on their part. Rob was very angry and told me he was seeking special leave from the governor as his grandmother had died and he wanted to attend her funeral. He sat stewing away, occasionally looking at me. I invited him to use the available media, and he reluctantly took some paper and pencil and started to doodle, not his usual mode of operation. He was a reasonably confident artist and usually liked to show off.

As if the pencil earthed a lot of his distress, he produced a dislocated doodle, and began to relate in detail the episode in his life when he was recaptured after his attempted escape from the French Foreign Legion. He abandoned the media and began to act out the event. I became the commandant that punished him. He assumed, in the corner of the room, the distressing, punishing position he had been forced to stay in for twenty-four hours – crouched and facing the corner with his hands on his head.

After some time, still talking and gripped by the acting out of a very painful episode, he started to swear at me as if I were the commandant. He eventually slumped to the floor exhausted, lay for a while, and then slowly got up and walked towards me crying, his eyes and whole body racked with pain and despair. He then flopped into his chair, drawing back his tears and trembling.

By this time, I was literally on the edge of my seat, experiencing a whole range of emotions. I shifted closer to him and told him that his deep distress and pain were real and belonged to him, and could be seen as a strength. I brought back the issue of the death of his grandmother. He sighed a deep sigh, crumpled up his doodle drawing, and assumed an attentive but softer position in his seat. He started his wait for the institution to give him a decision to bury his loved one, and prepared for the end of the session and his long walk back to his cell with the officer.

Review

After my contract had ended, I returned to the prison to review the work I had done. This session took place in the hospital wing and was not well attended – some officers, a doctor and a few civilian staff were present, and I felt a little disappointed. I gave a general overview of the way I saw the work, and supported it with some slides. I said that I felt that art therapy could be a useful tool in the rehabilitation of offenders, as it could assist in identifying some of the feelings that lay behind their offending behaviour. Working with these feelings with strength and understanding could be useful to the individual, the institution and society as a whole, and could be a more positive course of action than the commonly used methods of denial, punitive action or control through drugs. I was asked if art therapy could be used as a diagnostic tool, and I replied that although the products could show signs of a range of psychological predicaments, interpretations of these were not always correct or even useful.

Some of the officers commented that my work had caused some unpredicted behaviour back on the wings. Nothing was said in this session about the 'naming of the officer' issue, but I discovered that the prison officer in question had moved on, which I thought was probably connected with the incident. As for the intervention made by officers over the 'rocket man', the officers felt I could have lost control, and that they needed to assert themselves. Rob did manage to get special leave to attend his grandmother's funeral.

For the next eighteen months I did not do any art therapy, but worked in drug and alcohol rehabilitation in a therapeutic community setting, as well as spending a short period in the pottery department at Holloway Prison.

The Day Training Centre

The Day Training Centre and its programme

I applied for a post, advertised by the Inner London Probation Service, as an Art Worker to join a team working on an 'alternative to prison' groupwork programme for adult offenders. I was short-listed, interviewed and subsequently appointed, full-time on an Ancillary Grade, to manage their art space. I came away from the interview with a positive feeling towards the staff and the institution. I felt it worked. The professional team seemed focused, with everyone working for the same end: some sort of health for the client group. There seemed to be a measured collective responsibility in the care and control of the people attending the programme, under a leadership which was sensitive, considered and strong. I felt the regime there would help me extend my work as an art therapist in one way or another.

The Day Training Centre had been set up in 1976, when training (usually in social skills and crafts) was being piloted by probation as an alternative to custody. It had had a challenging history under two other directors (Senior Probation Officers), and now delivered a groupwork programme, consolidated and led with intelligence by the current director.

The house in which we worked was originally built in 1910 as a large residential dwelling, and was set in extensive grounds. It was owned by the Metropolitan Police, as were the buildings on either side – its previous use was as a retirement home for ageing policemen. The Inner London Probation Service rented it for a peppercorn rent, and with the co-operation of the local community, ran what, from the outside, seemed a very unlikely alternative to prison for Schedule 11 offenders. (Schedule 11 was a legal condition attached to a probation order, requiring attendance at a centre for specified activities.)

The Centre was the professional home to 16 members of staff: a gardener, a cook and assistant, two secretaries, six main grade probation officers, four ancillary grades (one caretaker and three in charge of the workshops) and the director (a senior probation officer). In addition there were three sessional staff. They serviced a client population of about 25, on a 12-week programme, in two groups run six weeks behind each other.

The structure of the programme covered a full day. Closed groups were run in the morning, and open groups in the afternoon. Once clients were

accepted (and they would usually know this before leaving the building on the second day of assessment), they would remain under the supervision of their field probation officer until they started their group programme.

A starting group of usually 12–14 members, all having gone through the assessment (but not necessarily together), would spend each morning in two closed sessions of approximately an hour, with a break for tea in the group rooms. A community meeting followed, which involved all the staff and clients. In this large group, client group news, attendance of groups and any warnings to clients would be shared, delivered voluntarily by group members. Staff news, business of the day and community matters were also dealt with.

Lunch came next, providing an opportunity for the whole community to be together in a different way. The essential, formal 'handover' of the groups from morning to afternoon was conducted after lunch, when the creative workshops were open and staffed. Clients had the choice of where to be, what to do, and who they wanted to be with. Additional sessional inputs were arranged alongside the other afternoon activities. At the end of each day, there was a staff group feedback session.

It seemed to me that this was a programme with a beginning, middle and end. The containment was done by the whole staff team, with the support of clear and regular supervision by the director. The probation officers' supervision was conducted in pairs, and the three workshop instructors (two art therapists and a woodwork/photography technician) initially met together, with separate supervision being introduced later on. The sessional inputs were on health issues, music therapy and education, for which there was also regular supervision. With the support of an outside consultant, the whole professional team met for $1\frac{1}{2}$ hours each week for the 'support group'.

All the structures of healthy containment were in place, which, with the high calibre of professionalism, made the Centre a safe and powerful place in which to be and grow, for both clients and staff. The result was a community culture that had firm boundaries, but was also pliable enough to change.

A good deal of attention was paid to the issue of leaving, as the probation officers (the largest proportion of staff) were expected to move on after two or three years, whereas other staff stayed indefinitely. Leaving as a prime issue was handled well, with energy and skill – and this required ongoing effort of staff and clients alike.

The probation officers selected to work at the Centre had considerable experience in the field and already had some association with the place. Every two weeks, an assessment group was conducted at the Centre, with referrals

coming from field probation officers, magistrates and judges. Referrals were received continuously, and were booked in on prescribed dates. This was a two-day group conducted by two probation officers, one from outside and one from the team, with an input from the ancillary workers and clients.

The aim of the assessment was to give information about the Centre in a relaxed way, and get some sort of idea, as a professional team, of how a potential client would cope with the Centre's programme. At the end of the two days, the client, with her/his field probation officer and a Centre officer, was invited to an individual interview, and also to have a medical examination. A contract was drawn up between the client, field probation officer and the Centre. This contract included agreement on the 'rules of the house', the client's views about the important issues in her or his offending, and how the Centre environment could be used to tackle these.

It was in this area of assessment that I performed my first professional task. I co-led, with the art therapist specialising in pottery, the morning group on the second day. This session was centred around clients' offending, and the existing art therapist had introduced the use of art to enable the clients to talk about themselves and their offending more easily. It was the starting point for more involved art therapy group work. The assessment group reflected the normal programme as much as possible, and was conducted in the basement of the house. Those being assessed were given time with current clients to get a 'consumer view' of the centre, and also had a chance to meet the workshop instructors and see the workshops in action with current clients.

The clients

The clients were 'high-tariff' adult offenders, whose gender and race mix broadly reflected that of the general prison population. They were fairly institutionalised, often having been brought up by social workers and fractured families. They were highly dependent on state care provision in one way or another, and struggled to keep themselves going in a difficult world.

There was a particular issue with female users, as the staff felt the Centre was a male-dominated institution and that it was not right to start one woman alone in a group. Effort was therefore made to ensure that a minimum of two women were in a group at its outset, although this policy sometimes meant that a woman probationer would be held back, possibly putting her at more risk of offending during that time.

The offences committed by the client group included shoplifting, burglary, theft of cars and other property, and less serious offences of violence

(such as ABH – Actual Bodily Harm). Many of these offences involved the use of alcohol or illegal drugs as factors. However, the Day Training Centre did not deal with clients who had records of serious violence (such as GBH – Grievous Bodily Harm), sex offences or severe drug addiction or alcoholism as it was bound by a local resident agreement which put restrictions on such cases. Representatives of the staff team met with the local resident group once a quarter, in order to maintain open communication and share information.

Co-leading the morning group

Four weeks after I started, just as I was beginning to organise the art room, a probation officer suddenly became unavailable to co-lead the morning group. A new group was scheduled to start in a matter of days, and invitations had already been sent out. After lengthy discussions with the team and the other group leader, I relinquished my art room, and 'walked across the floor' to take up a role as group co-leader, with an experienced female probation officer. This was a disruption to the programme and team, but seemed to be the best course of action with the least amount of damage to the life and work of the community.

I found the experience difficult; for me it was a unique situation. I was one half of a co-leadership, with eight startlingly energetic group members sitting on cushions in a closed room – and it was 'harsh real life'. I was an art therapist without art materials. I relied a lot on my co-leader, but was able to provide sensitive and insightful back-up leadership. The group went through some stormy episodes, but survived, with reasonably good numbers and results. My attention was on the 'here-and-now' in the group process, but I also kept in touch with my position of art worker, for the time when I would return to my own space. I had moved across the floor and had to come back.

The group consisted of eight individuals; one female (although two had been due to start) and seven males. Three were black and five were white. Particular medical features were that one of the white males was epileptic (only fully realised after admission) and one of the black males wore a half caliper on his right leg. Their offences were not out of the ordinary for the culture, and the group was considered a normal one. The average age was 26, and the eldest, a male, had a long history of offending behaviour.

During the developing 'storming' stage of the group, there was energetic 'acting out' and a testing of the boundaries, possibly because the group members sensed a weakness in the leadership. The rage was expressed by and around one particular young, quite disturbed, male client. He tested every

boundary – sex, drugs, rock-and-roll and the time boundaries. He expressed irrational violence both inside and outside the group room, and following the normal team discussion in the sixth week was suspended from the group over an uncontainable breach of the ground rules.

The 'here-and-now' offending behaviour groups at the Centre provided a climate for the essential relentless feedback to take place in a manageable way. This feedback consisted of comments on clients' feelings, behaviour and responsibility for decisions. It was made to a powerful, demanding and capable group of individuals, and directed towards the behaviour that brought them into the room – offending.

I felt 'skinless', as one of my probation officer colleagues so aptly described the feeling of working in the group. Often I felt drained, but also invigorated. I was reminded, time and again, of the strength and health that is available to human beings if the boundaries of the group experience are held with skill and courage.

I recall one particular event in this group. During the 'storming' stage, I was sitting on my cushion next to the door, as if on the edge of the eye of the storm. The eldest member was usually quiet but a clearly felt presence, occasionally attempting to take charge of the group and make a significant impression. On this morning, in the second half of the group time, my co-leader and I became aware of him seated more prominently than usual in the group, head cupped in his hands, rocking slightly and deep in thought. After a while, he stood up, looked at me and, in an angry outburst, moved towards me, relating a prison incident in which he had 'tipped a slop bucket over a screw's head and pissed on him'. He was towering over me as he bellowed. I continued sitting quietly on my cushion near the door, and maintained eye contact with him. He raged for a while and then, as if someone had flicked a switch, turned and sat down meekly. After a minute, he stood up and announced to the group that he 'could not hack this' (the groupwork) and was going to leave the room, go down to the office, phone his probation officer, and request to serve his probation order in prison, which he did, after further discussion in the group for the remainder of the session. That incident said something about choice, the basic currency of this 'alternative to prison' institution.

The man's outrage terrified me at the time and left me feeling very shaky, and I broke down in tears during the tea break. This overdue release of tension was a great relief for me, and I was well supported by my co-leader and the staff team. The permission to feel and express the anger and pain I was experiencing, enabled me to go back to the group raw but not totally skinless.

My walk across the floor back to art therapy was tender and sure-footed, and I resumed my position in my art room. With the extra credential of the morning group experience, I felt well placed to work with clients in the art room in the afternoons. However, it took about three months before the client group, as they passed through the Centre, could let go of my groupworker role.

The art room

My professional space, the art room, was a room situated next to the staff room on the first floor of the house, looking out towards the street over the entrance of the building. My immediate predecessor in the room was the other art therapist, who was moving out to take over the pottery in the basement. She had completed her art therapy training two years before, and had done some strenuous groundwork for art therapy at the centre. She gave me, as a fellow worker and new member of the team in which we were all treated as equal professionals, essential and immediate support.

The room was institutionally furnished with Formica-topped tables and metal cabinets. The original built-in cupboards were stuffed with poster paints, nails, thread, old inks, boxes of brushes, pens and pencils – an 'Aladdin's cave' that had somehow gone to sleep, and had the life taken out of it.

I felt strong in this space, and set about owning and taking responsibility for it and my place in the team. The metal cabinets were the first to go. I moved the other furniture around, at the same time beginning to do my job, meeting and engaging with clients in the ongoing programme.

It was a friendly and sometimes muddled environment, with as many materials as possible out on display. There was a choice of hot, cold, wet, dry, shiny, dull, long, short, paint, clay, wire, fabric, beads, printing, books, paper and card. With a respectable budget provided by the Centre, I was able to offer a varied service to clients that focused round their needs, which were negotiated on an individual basis.

It seemed to me that when people were engaged in healing themselves, they needed some feeding. This became evident around choice and quality of media, as well as their use of my energy and attention. This feeding was not unconditional, as I always negotiated my developing relationship with the people who chose to work in the art room. I knew (and so did the clients) that if I had any difficulties, I could take them to the team.

'Setting out one's stall' as an art therapeutic worker takes a bit of time. I did not want to rush the process; I wanted to turn what was there slowly into something different, rather than initiate a more revolutionary approach.

I tended my part of the programme with a relaxed sense of purpose. My first emblem of ownership of the room was a graffiti board, which I placed by the door. An essential device, it became a target for an enormous range of feelings and expressions, and always seemed a lively and integrated part of the room and its inhabitants.

My personal and official authority allowed me to work in an accessible way both in my room and within the team, which enabled even the most resistant of clients to engage and work, albeit sometimes at a very minimal level. This led to clients developing a positive relationship with the room, me (authority) and their emerging products. I kept my focus on helping clients to finish their programme, rather than on the 'finish' of their products.

The breadth of choice gave clients both challenge and confusion, and this helped them develop immense courage and skill once they had decided the art room was a safe place in which to explore themselves. They could test out and rehearse new ways of thinking and being through the use of the different media, as they worked through the days and weeks of their time at the Centre.

I had brought to the art room my own skills as an artist, craftsperson and art therapist, and this was reflected in the variety of things to do. Clients used it in several ways; to serve the artist/craftsperson in them, as well as a place to be and hide in. They made products of a high standard in various materials. Some materials were always available in the room, while others were brought in specially for particular clients. They did different things with their products: they adorned themselves, other people or their personal environments; they gave them away, abandoned them, destroyed them or just played.

An issue of critical importance for any emerging product was the creator's ownership of it – not always as an end result, but as a focus for the process. It was important for me to know when to put aside the products, and allow individuals to 'get a grip' on what was going on inside themselves.

Most clients worked on their own at first, and any pairings or groupings usually stemmed from their assessment group. Towards the end of their programme, clients often also made links across the groups. The continuing character of the culture passing through the art room was represented by the marks on the graffiti board.

The beginning of the programme was an important time for new members of the community. During this settling-in period, some individuals knew what they wanted to do in the afternoon sessions, while others made several visits to assess what and who was on offer. Their struggle was to find a safe place for their chosen activity and the support to do things differently

from in the past. The afternoon programme – creative, therapeutic and mainly non-verbal – was crucial in holding the participants in the Centre.

Some individual clients and their work

In the early stages of one group, I recall a client with a strong personality bounding into the room. She was agitated and tense. She had made exploratory visits, usually in the wake of another person. I was alone in the room when she arrived this time. With a slight acknowledgement of me, she stood rubbing her arms, said, 'My veins feel like red-hot wire', and stamped her feet and swore. She then picked up a roll of wire hanging on a hook and, with strong hands, moved around the table and spun a doll-shaped effigy, incorporating bits of paint and cloth. She said it was her. She worked rapidly and feverishly as she went on to fashion a baby from some clay and place it inside the body of her doll, telling me it was her baby she had lost after five months of caring for it. She then spoke at length about her drug career, and followed this with a catalogue of snippets of her life, which had been peppered with metaphorical open manholes. (This tendency was once illustrated by her falling into a real one.) She never came back to work in the art room, but found comfort in the pottery, where she did skilled and strong work. She did, however, return every now and then to check whether her doll was okay. It found a home on a shelf.

Many of those inhabiting the creative areas presented a high level of resistance, manifested in manipulative behaviour and an apparent lack of interest in doing anything. Fortunately, there was also a core group that carried the particular culture of product-making at any given time, whether it was painting, screen-printing, plasterwork or enamelling.

One character who expressed a deep resistance to getting involved was Ben. He always arrived on time, and then spent the afternoon going from one area to another, not settling to anything. As soon as any pressure was put on him by a worker or his peer group, he moved on. As he ran out of places to hide, he became more disruptive in his passage round the building. He visited my space on a number of occasions, and took part in everyone else's business but his own. I challenged him about this and he was brazenly defiant. His behaviour was the same in both the morning and afternoon sessions, and was of concern to the whole team. I attempted, as did others, to encourage, console and confront Ben about his participation. He only made contact with the media when I challenged him to make some marks on the graffiti board. I had some large long-handled brushes in pots near the board, and used one of these to make a mark before handing the brush to him. With a thick black line, Ben drew a big penis and then left the room.

His resistance was expressed in many ways, and reached an intolerable level by the third week, when he took bits of material. At that point he left the programme.

Another expression of this resistance was exhibited by 'Big Ken', a large, pipe-smoking character who spent the whole twelve weeks in the art room in the same spot, with the same pot of water, doing the same thing. His art work in the assessment art therapy group was a demonstration of calligraphy – a skill he had learned in prison. He painted the name of another group member. He was the first to inhabit the art room at the start of his group, and used it at lunch and during some tea breaks. He spent the whole time carefully painting nameplates, but any suggestions of developing this skill by introducing other lettering styles, or of exploring any other activity, were refused. He repeated the same signs, and got slower and slower in his activity; he did not clear up around himself and was claiming more and more of the room. In the seventh week, he was confronted by his peers and by me about his 'expanding stuck state', and managed to make the link between his water jar and himself: the unchanged water signifying his unchanged state.

I consciously developed some craft aspects to the work in the art room, and introduced enamelling, screen-printing, photography and sewing (by machine) alongside painting, picture-making, clay and plaster work, as well as a library of resource books and magazines. I was also developing some confidence in responding to clients' needs and their culture.

Some clients brought skills they had learnt elsewhere in their lives. Being good at drawing inside or outside prison holds high status. In this way Fred's skills and products were intrinsically part of his own identity and his position in the group and room at the time. 'Fred the painter' spent hours devotedly painting a highly skilful portrait of another group member's child. With a small photograph stuck on an easel, he claimed a corner of the room, painting in oils on hardboard. Just before he finished the work, he visited the art room one lunchtime and broke the glowing portrait in two. An alcoholic, Fred 'went on the binge' after a short absence from the programme, and then acknowledged his drink problem. He returned to the Centre, and spent the rest of his time exploring the opportunities in the pottery, making highly imaginative clay creatures, both extending his clay technique and knowledge of himself. He visited the art room to show off some of his clay work, and took some time clearing up his past 'artist bits'. He also acknowledged the broken child-portrait, which was still where he had left it, behind the door.

Some individuals came in with a mission, like the puppet-maker who used intelligence and creative flair to create a full set of large, painted Punch

and Judy puppets, fully clothed and working. He also made a full-size puppet theatre, adding an immense amount to the immediate creative community, and replacing the theatre and puppets that had been stolen from him during his adolescent offending past. This gave him a renewed sense of wholeness. The monitoring and support of this mission was demanding, but above all it was a mission accomplished.

The abandonment of products was an integral aspect of the ongoing work in the art room, as it was in the other practical areas. This was discussed with some energy during our group supervision. I personally believed that a certain level of abandonment of products was essential to the process, depending on what was happening to the individual as a whole.

Some clients brought overt anger and pain with them to the sessions, and found a space that was safe enough and media that could comfort them enough to work through (with my support) deep-seated issues in acceptable and productive ways for themselves.

This was true for Betty, who entered the room as a result of a confrontation with her group leaders when she felt she was not being taken seriously by the males in her group. She was a loud robust woman, who appeared unafraid of speaking her mind. She took refuge in the art room after her tantrum, and I felt the room could be a useful context for her in her trauma. A fellow assessment-group member, another woman, was in the room at the time, well engaged in a sewing project. I made contact with Betty by gently touching her on the shoulder, and inviting her to sit down by her group mate, which she did. After some discussion with her peer and with me, Betty said she wanted to make some dolls for her children, 'big ones', indicating a size on a large piece of paper. I felt that, if Betty stayed, I was at the beginning of a demanding relationship. The weeks passed, with Betty making not one 2 foot 6 inch doll, but two.

She gained friendly support from her fellow group members and, during the stuffing of her first cloth body with foam chips she had cut up herself, was very vocal. She spoke in detail of her sexual abuse as a child, at the same time pushing the lacerated foam into the limp cloth skin with a piece of wood. Her management of the creation of these two dolls, dressed in precise detail as policeman and soldier, was firm.

Betty's relationship with me was demanding, as she was very precise about her choice of material. A colourful, angry, funny, and steadily more joyful and contained person emerged, as her creations for her babies came to fruition. I was aware that she was going to finish in style. In the last remaining minute, she completed the final details, leather shoes for the proud male dolls. Betty then went round the house and invited people to come and

view her work. The art room groaned with staff and clients, while the creator of these big, beautiful dolls took a star turn. She took control of her 'ceremony of completion', in demanding, and receiving, positive acclaim before she left.

The manufacturer of a product was not always so public. In most cases, when people engaged in work, they were private and timid, and I had a role in taking care of the public face of their experience. It was important to keep the whole creative environment safe.

Not all workers in my art space were interested in the end product, and some grew just in the making of a picture. Peter was a middle-aged man who brought with him all his anger, as well as his artistic skills as a pavement artist. He had a prison background that had involved considerable isolation and deprivation due to his angry protestations of innocence of his convicted crime of burglary. Peter soon made a place for himself in the art room, and there he stayed. He kept people at a distance, including me, and worked very privately at drawing. At the end of each session he disposed of his products, a practice which quite upset me. What I saw of the work was interesting, and he was clearly working something out in it, in his own way. I thought that if he needed me, he had enough trust and access to me to make a move. After some time, Peter started to talk to me, usually towards the end of the session when he had finished working on his art. I asked him why he disposed of his drawings, and his reply was simply and clearly that they were finished.

During his previous life, Peter had developed skills as a pavement artist, and had practised them in London during the summer for a number of years. As a known criminal, he was picked up and charged with a house burglary he maintained he did not do, and was sent to prison. He protested his innocence by using all the known procedures in prison. His angry outbursts resulted in him spending a large part of his sentence in solitary confinement.

In these deprived conditions, Peter's protest took the form of large graffiti drawings on a religious theme done in boot polish on his white tiled living space. He chose the religious subject matter to attract the attention of the prison Governor, who was known to be a church-going man. However, the Governor misinterpreted this gesture and expressed his displeasure at the 'fouling of Government property'. Peter was ordered to get rid of his artwork, and his confinement was extended. He produced the work again, this time turning the religious theme into an attack on the Governor. The war continued until Peter was transferred to another prison, where he served out his sentence.

In the art room, the drawings he created and destroyed were becoming physically more and more fragile. He moved from using pencil to working with talcum powder and charcoal, and then adding coloured pastel. Through a curious process of rubbing and physically pushing the dust around, he managed to model haunting faces and forms. The more fragile the works became, the more directly he related to me and others. On the last day, Peter spent his usual time in the room, a different person from three months previously. In parting, he offered me a picture, handing it to me gently. I accepted the fragile work. A breath of wind could have blown it away. My last question to Peter, as he was leaving the room, was to ask if I could preserve it with fixative. He said yes and left.

I had introduced mask-making, both as a stimulating activity in its own right and as a vehicle for venturing across the boundaries with other practical areas, such as the pottery workshop. I encouraged clients to make masks of themselves by working directly with plaster bandages over their faces, and then using the plaster casts to press their own clay impressions.

One individual responded particularly to this way of working with masks. Jay, a lively member of the group, asked me to help him create a mask of his face as, he said, he was changing, and wanted to have an impression of his face as it was. He had a typical prison career behind him, but was untypical in his open struggle concerning his sexual identity.

It was general knowledge that Jay had started the process of having his sex changed. He appeared strong and open about this endeavour, and had support in his outside life. I helped Jay complete the first stage of making the plaster cast – and he then abandoned it. Towards the end of his programme, he returned to the cast and made the clay impression, which was fired in the pottery, and which he then left behind when he left the Centre. A year later, he returned and picked it up: by this time his treatment was under way and he looked a different person.

The effect of the therapeutic work done in the room was apparent in all clients to varying degrees. There was a good deal of cooperation between the three practical areas to achieve this. The clients were also involved, sometimes taking the lead, sometimes following my suggestions.

Art therapy groupwork

Within a short time of establishing my art room for individual work, I also found a place for art therapy groupwork in the formal groupwork programme. This involved discussion with the other afternoon workers informally and in supervision, and then preparing a proposal to put to the team, which accepted my idea of a pilot group.

This process of negotiation stirred up strong feelings in the team, bringing into focus issues of authority and rivalry. Some staff felt that, if afternoon workshop staff enlarged their roles and ran closed groups (outside the assessment format), clients would become confused and feel insecure. However, building on the work done by my colleague two years before under less cohesive staff conditions, I gained enough support for the pilot to go ahead.

In fact, two groups were involved. Directed art therapy groups were offered to one group six weeks into their programme on a voluntary basis, and to the incoming group with an expectation to attend. The length of these two pilot groups was to be 10 weeks. The work was undertaken in the art room, one afternoon a week, and introduced as a different way of working. The artwork produced in these sessions was considered the clients', and was stored first in the art room and later in a cupboard outside. I introduced a broad range of themes and gave them time to work with various materials – paint, felt pens and white paper, as well as clay. Time was set aside to talk about the work. The groups progressed well, but by the fifth session attendance was declining. By week eight, both groups were too small to be workable, so I closed them and delivered a review of the work to the team.

On the surface it was a disappointing experience, but some important things were happening. I felt there was a protest by the clients at the imposition of the group in the afternoon, the space in the programme that was about choice. There was also a displacement of therapeutic focus: after getting in touch with this different way of working, it seemed that clients went to other places to work with it, away from me. They used art materials in my absence from the art room, and came to sessions later to talk about it.

This reaction by the clients to the 'plugging in' of art therapy to the afternoon part of the programme seemed reasonably healthy, protecting their right to make their own choices. However, they did learn to value the different way of working, so that its overall effect on the afternoon work was to raise the level of 'therapeutic' working. It became an 'okay' mode of working. Linking the way one felt to what one was creating, the culture benefited as a whole, licensing therapeutic involvement that was not mystified in any way.

My review showed that if group art therapy was going to work, it had to be established from the beginning of the programme, at the assessment stage, and carried forward from there. With the support of the team and the director, the concept of art therapy groupwork remained part of the Centre's programme, and I felt more confident. It was important to me that I could

operate as a therapist/ancillary worker, as I had no plans to become a probation officer within the service.

With my fellow art therapist, I co-led staff training workshops in art therapy. These allowed the probation officers to experience art therapy, gave them a vocabulary for the discipline, and helped them understand its contribution to the assessment and the twelve-week programme.

Eventually the art therapy sessions in the programme were moved to the basement, which was the physical working environment of the assessment stage. The basement was a large, slightly oppressive room, with a low ceiling and French windows that overlooked the gardens. I adapted the space for 'good enough' art groupwork, while not interfering too much with the other functions of the room. (Apart from the assessments, the room was also used for the weekly staff support group, and occasionally for other functions.) I built a table large enough to seat 16 people on hard chairs, leaving space for a circle of easy chairs and some wall space. With a simple palette of tempera paint, felt pens, crayons and clay, stored on a trolley, the room was 'ready to roll'.

I was feeling good at this time, after my evaluation from the team. Evaluations were an established practice, and were received from the whole professional team towards the end of the first year. They took place in two-hour meetings. During my evaluation, I was in the 'hot seat', while the rest of the team delivered feedback. The process was managed by the director, who wrote it up in a detailed and considered way. I was seen as a well-loved, mature team member, who was prepared to take risks, and a 'laid-back', intuitive and inquisitive individual who found it difficult to 'sell himself'. They felt I had no big investment in being the 'good guy', was a bit inhibited, with a quiet sensitivity and a good sense of humour, and was inclined to 'shoot myself in the foot'. I was an 'ideas person', liked discussing my feelings at times, and was patient and able to deal with difficult, manipulative and damaged clients. Instead of launching an assault on the barricades, I preferred to knock on the client's door, and invite myself in for a chat. I was a good 'oiler' of the team, finding it easier to give than take.

The Day Training Centre was sometimes a difficult place to be in. There were very few places to hide, and the 'goldfish bowl' aspect magnified the issues that surfaced. The successful 'working through' of these issues led to the Centre being regarded from the outside with respect and some envy.

After some further work, I set up another pilot programme of art therapy groupwork, which was more successful. This time the art therapy role was to support the groupwork in the morning part of the programme. I

introduced three sessions, each of three hours, during the life of the programme.

Two of these art therapy groupwork sessions were on the first two Wednesday mornings of the group, when a new group attended just for the morning. The third session was negotiated with the morning group leaders towards the end of the programme, and usually took place in the tenth or eleventh week, to help in the group's leaving process.

The formats for the art therapy groups were as follows:

ASSESSMENT GROUP

The group sat initially in a circle of easy chairs.

Introduction. Each person gave their name and said something about themselves. The roles of art worker and guest probation officer were identified. The introductory discussion involved: reinforcing boundaries, introducing the room, dealing with any business, absences and anything arising from the previous day, outlining tasks, dealing with 'I can't draw' issues, mapping out routines, introducing the materials, warm-up exercises and long exercises, reinforcing the issue of ownership of product and setting the theme.

Theme. 'How you see yourself and how others see you'. This was to be explored using a personal example.

The group moved to the tables and hard chairs. After settling down, they were invited to warm up, become familiar with the materials and break down resistance: using one piece of paper and felt pens, the first person started by making a mark on the paper, and then passed it on to the left, and so on, staying at the table. The work was then reviewed; the constellation of marks on paper considered and explored. After closing this discussion, there was a 15-minute break, taken away from the room.

Long exercise. The group met again in the circle of easy chairs. Any outstanding issues from before the break were cleared up, the theme was outlined and teased out, any resistance was worked through, and time boundaries and materials were outlined. They then moved again to the tables and were invited to start work on the main theme. The working time with the materials was 30 minutes, followed by 30 minutes back in the circle, with their products for review.

Review. During the review of the work, the group was asked to take some responsibility for time-keeping as they talked about their work. They started with a quick round about how it had felt (using one word or

sentence), and then volunteers were asked to spend some time sharing their work with the group, encouraging comments. When everyone had had a turn the group finished with a discussion of the issue of their ownership of, and responsibility for, what they had done. (They could take their work, destroy it or leave it: if left, it was kept and made available to them at any time.) At the very end, they were thanked for their participation.

ART THERAPY GROUP INCLUDED IN PROGRAMME
FIRST SESSION (FIRST WEDNESDAY OF THE PROGRAMME)

The group sat in a circle of easy chairs.

Introduction. As in the assessment group, each person gave their name and said something about themselves. The art worker was identified as a member of the probation staff team. The discussion included: minimising any potential splits, reinforcing boundaries, introducing the room, making links with assessments, discussing this different way of working, outlining this session and those to follow, reinforcing ownership of the products, exploring links and differences between group members, and setting the theme.

Theme. 'Inside and outside'. The group members were asked to explore their lives both inside and outside the Centre, and how they felt about themselves, inside and out.

They then moved to tables, and warmed up with games of 'paper go round' or 'clay go round' (adding to, or taking away from one lump of clay). They reviewed the exercise while still at the table, discussing what people had and had not done, and how it felt, exploring what issues and emotions were being raised in the group. There was then a short break, taken away from the room.

Long exercise. After the break, any outstanding issues were cleared up, any resistance was worked through, and boundaries and materials were outlined. The group members then moved to the tables and were invited to start work as the main theme. Again the working time with the material was 30 minutes, followed by 30 minutes back in the circle, with their products, for review.

Review. The group members were asked to take some responsibility for the time spent talking about their work. Starting with a quick 'go round' about how it felt, they shared their work with the rest of the group. The session closed with time for them to take their work up to their group room, or put it on the wall or in a cupboard.

This session had a similar format to the first, but without the warm-up exercise, and with a change of theme.

The theme was 'Metaphorical portraits'. Each person was given a large piece of paper and asked to tear it into as many pieces as there were members of the group, and then on the separate pieces of paper to draw each member as 'something' for example, 'Fred as a tree'. They worked on the large table for this exercise, and afterwards stuck the individual pieces on to another sheet.

The review of the work was done by each member standing up in the informal space of the circle, and asking the group to guess 'who was who'. When correctly identified, the name was written on the picture, and the artist explained what they had done, and why.

THIRD AND FINAL ART THERAPY SESSION

This session was concerned with reflections on the work done so far in the Centre's programme, and also with themes that were relevant for group members, sometimes prompted by the group leaders. This often started the final phase of the group's process.

Most clients responded to the art therapy exercises without too much resistance and engaged with the materials with enthusiasm. They were able, with some modelling by staff, to share themselves in a way that was safe for them, and also to make links with their offending behaviour. With practice, I kept my interpretation of clients' work to a minimum, and encouraged them to make their own interpretations.

The artwork produced generally fell into three main categories:

1. Work that related directly to the theme.

2. Work that involved a complete denial and 'rubbishing' of the theme.

3. Work that acknowledged the theme, but also moved to say
 something else; perhaps focusing on a particular event, relationship
 or issue in their lives, such as a childhood event, a relationship
 with a spouse or parent, or an issue such as drugs or drink.

The most focused image-making took place in the second session in the work on 'metaphorical portraits'. These images were imaginative, novel and very seldom attacking. The session enabled clients to explore themselves both as individuals and as a group. When the pictures were placed in their group room, there was a further opportunity for explanation and exploration of their lives during their time in the programme. According to feedback from

the group leaders, this led to the use of the metaphors created in the art therapy work to understand difficult, complicated and painful issues in other work.

Punishment or therapy?

Work with offenders demands a great deal of energy, pragmatism, hope, flexibility and imaginative technique, without abandoning the qualities of the artist – a concern with complexity, a reliance on intuition and a perceptual openness.

It can be said that crime is essentially the solution of personal problems at a childish level of conduct. If this is so, there is a need for conditions that are safe enough for individuals to deal with their personal problems, and which enable the 'child' to feel secure enough to tolerate the frustrations of 'giving' and 'taking'. It seems to me that offending behaviour is stuck at 'taking', in many ways that are harmful to the 'takers' as well as their victims.

The institutionalised punitive rituals from our past are often very apparent in our prisons. It seems to me that the traditional stance we take with offenders can encourage them to find even more ingenious routes through which to channel their maladaptive behaviour, trail-blazed by myths of 'prisons' and 'criminals'.

Not so long ago, people were hanged for stealing a loaf of bread. I am sure that fewer people got caught then, and that bread found its way into empty stomachs. Some say that a thief should have his hand cut off. Without wishing to sound morbid, I am curious to know what happens to the hand: is it fed to the dogs? Put into the fire? Buried? Whatever happens, the offender is marked. Cain was banished for his act of fratricide. Maybe the 'offender' is a hungry, one-handed, banished person.

Today (according to 1992 crime statistics), a crime is committed every six seconds. It hardly bears thinking about that this maladaptive behaviour (which comes out of loss, hunger and mutilation) has such a creative energy and a will to survive, a will which is reinforced in the punitive environment of prisons.

There is a need for 'healing human procedures' which provide and stimulate choice and permission in rehabilitation. The process of art therapy can fulfil this need well.

Art therapy grows out of a sense of humanity, and both art and therapy have 'growth' rather than 'cure' as their endeavour. In any setting, without a careful and considered fostering culture, art therapy is difficult to sustain, and this is even more true in the punitive setting of prisons. Art therapy must be protected against the potential envy of other professionals working in

the same setting, an envy which was evident around the work I did at the Youth Custody Centre.

In addition to being provided for offenders, art therapy resources are also needed for prison officers, to provide them with the opportunity to explore their own issues in the prison setting.

The Day Training Centre's sensitive and fostering environment helped me to use my sense of creativity to gain access to the 'coal-face' of the culture, where art could be used as an intrinsic part of the institution. The DTC had a strong yet flexible structure, reflecting the central tenets of therapeutic community practice – democracy, communalism, permissiveness and reality-testing (Rapoport 1960).

Conclusion

In my role of art worker/therapist one of the most important qualities I brought to the Centre was a sense of creativity. The primary focus of this creativity was not my own art products, but my work as a therapist. I invested my creativity directly in the existing working culture, helping to shape things – materials, thoughts and feelings – to enhance non-verbal and intuitive communication. As a specialist in non-verbal communication, I was continually aware of the rise and fall of the empathy I felt in relationships with clients and their emerging products. Above all, I took a position of 'I am available', 'I am with you', 'I will listen, but not take over, or be overwhelmed by you'. I attempted to inhabit and tend the ground where this therapeutic act and creative expression converged.

The continually shifting focus between product and process helped individuals to cope with their existence, and to rehearse changes in their behaviour. I reinforced the uniqueness of each individual, whether in the free-flowing activity of the art room, or in the more formal art therapy group, with the aim of working with the whole person.

This flexibility was needed to accommodate the range of pathologies, and to know which courses of action were appropriate. There were times when words and talking were as creative as employing materials with some neurotic individuals, or when the material demanded a response to draw together thoughts and feelings. With characters whose view of the world as a war zone led to highly manipulative behaviour, my efforts and materials were put into service to find a way through their emotional armour. At times I acted as a maternal agent with some depressed clients, helping them use materials to externalise conflict and create a rehearsal arena for testing out issues. There were also occasions when I needed to tolerate the use of

materials by some clients to reach dark places of underlying fears of loss and separation.

In the process of creating art products, clients could test out a range of alternative solutions to their problems. The actual creation of the product assists in 'making sense' of it, both to the creator and others. An important component of the work was to integrate the thinking and feeling functions.

After eighteen months work, art therapy practice was successfully established in support of the 'here and now' model embraced by the institution, and had its own supervision. A particular vocabulary of art therapy work was formed, supported by the staff group and by the culture as a whole.

I left the Day Training Centre after three years, with the feeling that I had done all I could. It was time for me to shift the focus of my creativity back to my own artwork and lifestyle. I kept in touch, however, and know that the art therapy work continued to move forward under the co-leadership of the remaining art therapist and the art therapists who succeeded me.

Through all my professional work as an art therapist, I (like many others) have never been officially employed as one in title, but my practice in both institutions and private practice has always complied with the principles and code of practice of the British Association of Art Therapists. I remain passionate about the work with offenders.

References

Liebmann, M. (1986) *Art Therapy for Groups.* London: Routledge.

Rapoport, R.M. (1960) *Community as Doctor.* London: Tavistock.

Figure 10.2 Untitled

Art Therapy and Changing Probation Values

Marian Liebmann

Introduction

This chapter is based on four years work (1987–91) in a probation field team, working in a generic way. As a probation officer, I was responsible for 35 to 45 clients on various probation-supervised orders (e.g. probation orders, supervision orders, suspended sentence supervision orders, parole, life and youth custody licences), and the usual team responsibilities. As a qualified art therapist, I tried to use my skills wherever they seemed appropriate, and where clients agreed. (If they did not agree, then I worked with them in a variety of other ways.)

A probation order can vary in length from six months to three years. A probation client must:

1. keep appointments with the probation officer as directed, either at home or at the probation office

2. notify the probation officer of any change of address or work

3. be of good behaviour and lead an industrious life.

A probation client is usually seen weekly in the first three months, then fortnightly, and later monthly. Traditionally, probation orders were seen as ways of helping clients in general, especially those whose social problems led to offending, but more recently the focus has been primarily on their offending behaviour. Probation clients who do not keep to the conditions are in breach of their orders and can be taken back to court. Probation orders can also be discharged early for good progress, after the halfway point.

The work I will describe took place against a background of unprecedented change for probation services. The Green Paper *Punishment, Custody and the Community* (Home Office 1988a) looked at ways of reducing the use of custody by 'toughening up' sentences which left offenders in the community. This was followed by *Tackling Offending: An Action Plan* (Home Office 1988b), a White Paper *Crime, Justice and Protecting the Public* (Home Office 1990a) and a further Green Paper entitled *Supervision and Punishment in the Community: A Framework for Action* (Home Office 1990b).

This last paper outlined the Government's aim:

> The aim of the Government's proposals is better justice through a more consistent approach to sentencing, so that convicted criminals get their 'just deserts'. The severity of the sentence of the court should be directly related to the seriousness of the offence. Most offenders can be punished by financial penalties... when offences are too serious, the courts have a choice of community penalties, such as probation or community service... (which) can restrain an offender's liberty and freedom. (Section 1.6)

This suggests a change of role for probation officers from that of 'helper' to 'punisher', which naturally did not appeal to most probation officers.

Another background factor behind this proposed change was a belief, prevalent in the 1980s, that 'nothing works' in the treatment of offenders (see Introduction), so the less time and money spent on any intervention, the better. This 'nothing works' philosophy has now been disproved by newer, more focused research, but attitudes take longer to change.

The practical effects of these proposed changes on the probation service during this four-year period were far-reaching. It seemed to many probation officers in the field that actual work with clients to prevent re-offending was no longer mentioned (except in individual staff supervision) and took second place to discussion and implementation of the managerial changes. Breach policies and record-keeping were tightened, line management was reinforced, and senior probation officers were sent on business courses to prepare for local budgets and cash limits.

As field probation officers, we struggled with an increasing flow of paperwork (concerning monitoring and measurement), which reduced time for work with clients. However, we continued to discuss our work informally, and I was fortunate in being able to attend my local art therapy peer supervision group, which was very supportive and helpful.

This chapter discusses work I have done with particular clients or groups. In each case I have reflected on the way the work has been affected by the

changing values and practices of the probation service. This is a personal view and does not represent any particular agency.

It is important to note that this work took place in one local area, and that the changes and policies discussed may not reflect practice elsewhere. Nevertheless, there are pointers which indicate trends towards changes in the probation service in general.

Four out of the five individual case studies are of probation clients who were allocated to me, and are arranged in order of length of involvement. The first, Martin, was a relatively short engagement. The next two, Gary and Brian, describe a longer series of sessions, and the fourth one, Maria, shows a two-year probation order based almost entirely on art therapy. The fifth individual case study concerns a colleague's client, who was referred to me for art therapy. The groupwork case studies were both short series of sessions, which were part of a longer-term group programme.

Individual case studies

Martin: alcohol and reckless driving

Martin was a large, manly-looking 17-year-old. He had been educated at special schools, but because of his adult appearance, tried very hard to cover up his lack of ability and understanding. In the interview for the Social Inquiry Report (now called a Pre-Sentence Report) for the Crown Court, it became clear that, although it was Martin's first time in court (for offences of reckless driving and excess alcohol), he had a serious drink problem. He seemed anxious to do something about it, felt he could not cope with a group, but was prepared to do individual work on his problems. Accordingly I recommended a probation order. Martin was given a two-year probation order, and kept his first appointment punctually.

I usually asked clients, especially where the offence was one where 'something happened' rather than a continuous state, if they would consider using a comic strip approach to look at their offence. As Martin had enjoyed art at school, and found words difficult, he was happy to do this. The result, completed over two sessions, is shown in Figure 11.1.

Figure 11.1 Martin: Alcohol and reckless driving

Frame 1: Martin is at a party (he is in the centre), with plenty of drinks around.

Frame 2: He waves goodbye and leaves.

Frame 3: He notices some keys lying on the ground by a driveway.

Frame 4: He picks them up.

Frame 5: He looks at the car in the driveway, thinks about taking it, then decides he will.

Frame 6: He opens the car door.

Frame 7: He backs the car out of the driveway. (He has never driven before.)

Frame 8: He switches the car lights on and drives down the road.

Frame 9: A car appears behind him and chases him round the bend.

Frame 10: The car draws up behind him, Martin thinks it is other kids.

Frame 11: He suddenly realises the car behind is a police car.

Frame 12: He zooms off in panic, round a roundabout.

Frame 13: The police car forces Martin into the kerb.

Frame 14: The police car draws up alongside.

Frame 15: A policeman gets out, smiles at Martin and says 'You're nicked!' Martin opens the car door, but stays in the car.

Frame 16: Martin is taken to the police station, where he is asked to put his things on the desk.

Frame 17: Martin spends the night in a police cell.

Frame 18: Next morning Martin is allowed home on bail.

This very lucid sequence showed that, despite his educational problems, Martin could readily see the chain of events that led to his arrest. When we examined the sequence in detail together, to see where Martin could have acted differently, he picked out several points. In the first place, he realised he should have left the keys where they were. Second, he admitted that if he had stopped driving as soon as he was caught, he would have avoided wrecking the car (the owner was naturally extremely angry) and been charged with a less serious crime.

However, Martin said he had been unable to make these connections at the time because he was drunk, and further discussion confirmed that he had a considerable drink problem. Furthermore, this seemed to be linked to a great fear of 'losing face' in front of his mates. Any long-lasting efforts to prevent further offending for Martin would need to help him both with his drink problem and with his need for 'bravado'.

We were, however, unable to follow this up as Martin's subsequent problems with accommodation, girl-friends and further offences needed urgent attention. As his probation officer, I had to attend to these first – and

indeed it is very difficult for any client to settle to drawing and serious discussion if, as in Martin's case, homelessness is imminent, or has just occurred.

The fact that, as a probation officer, my role was to help with practical as well as emotional problems had advantages as well as disadvantages. The obvious disadvantage, from an art therapy point of view, was that practical problems often thrust themselves to the fore, disrupting any longer-term therapeutic concerns. The advantage was that daily problems and wider issues could be more closely integrated than if they were the provinces of separate agencies or people. By working with Martin on both a practical and emotional level, I had a more all-round view than if I had concentrated on one or the other. I could also be more aware of occasions when his behaviour did not match up with what he said during our sessions.

Martin's lifestyle became increasingly chaotic, and he failed to attend several appointments. Until recent years a fairly liberal interpretation was made of the requirement to 'keep in touch with the probation officer', so that probation clients were generally only 'breached' if they vanished completely, or made it very obvious they were flouting authority. It was recognised that many offenders' lifestyles and the very problems that led to offending also sometimes made it difficult to attend appointments regularly and at specified times. Provided that clients made reasonable efforts to keep in touch, often in their own way, probation officers tried to keep a good relationship going, and kept working with them on important issues and problems. The contract between probation officer and client, although statutorily based, had a large element of 'give-and-take'. It has always been the case that probation orders constitute a three-way contract between the client, the probation service and the courts but, until recently, the first two have generally overshadowed the latter.

Recently, under pressure from the Home Office, the role of the courts has been increasingly emphasised, and the 'helping relationship' between the probation service and the client de-emphasised. Attention has primarily focused on whether clients are keeping their appointments, rather than whether they are doing anything about their lives. The argument in favour of this was that breaching wayward clients would show that a probation order 'meant business', leading to increased credibility with courts and the public.

So, when Martin did not keep his appointments, I had to follow the local probation guidelines, and 'breach' him, i.e. take him back to court for failing to keep to his conditions. This was a long process taking several weeks and, as Martin knew he was being breached, he saw no point in keeping any

further appointments. He did not keep the court appointment either, and a warrant was served for his arrest. However, due to the many calls on police time, this warrant did not receive a high priority and was never served. It seemed to me that being 'tough' on probation clients had little point if the process was long-winded and other agencies made it null and void. I never saw Martin again.

If we had been able to continue, art therapy would have been useful in helping Martin to articulate his feelings, as he clearly found drawing easier than talking. We would have looked at situations in his life where his feelings of inadequacy led to inappropriate bravado and offending, and then worked at boosting his self-confidence, searching for constructive alternatives to offending.

Gary: violence and family dynamics

Gary was convicted of possessing a firearm with intent to cause affray. This description of the offence is a legalistic way of describing an incident in which Gary ran amok with a gun in the family home and threatened to kill his stepfather, a very serious matter. He was 19, still living at home, and had never offended before. As a result of the offence, Gary had to leave home immediately, and went into private lodgings.

It became clear during the interview for the Social Inquiry Report (now called Pre-Sentence Report) requested by the Crown Court that the offence had arisen from a family argument which had escalated out of control, exacerbated by alcohol. Although it was an isolated offence, and Gary might never re-offend, there were worrying factors, such as the family relationships and the way Gary used alcohol to solve personal difficulties. This, together with his inability to complete other sentences such as a fine or community service (because he worked long and irregular hours in agency building work, and had several debts), pointed towards a probation order, which I recommended in my report. Gary was given a two-year probation order.

Although several members of Gary's family had urged him to find some counselling help, he himself could not see the point and did not want to talk about things. Nevertheless he could acknowledge that there were things that needed sorting out. We drew up a plan to work on:

1. his use of alcohol

2. restoration of family relationships if possible

3. independence and leading a life away from home, including friends.

His family situation was very complicated, and I thought that the comic strip method would help to clarify, both for me and for Gary, just what had led up to the offence, and what had actually happened, from Gary's point of view. He agreed quite readily as he liked drawing, and preferred this to 'having to talk about things'. The drawings took several weeks, and in the course of doing them, Gary found himself talking about things quite naturally.

Gary had mentioned 'arguments' several times, and that he did not get on with his mother. He had an older sister, two older brothers and one (non-identical) twin brother (Trevor), all of whom had left home but were living nearby – his sister (Sue) in the same road. So I asked him, first of all, to do a comic strip of a 'typical argument'. Figure 11.2 shows the result.

Figure 11.2 Gary: A typical argument

Frame 1: It is 5 pm, Gary has just returned from work, and dinner is on the table. Gary wants to watch television but his mother tells him to turn it off. Gary said his mother would watch her own programmes afterwards but did not allow Gary to watch anything he wanted. (I would have liked to hear his mother's view of events here.)

Frame 2: Here, Gary is deliberately 'winding up' his mother. He is drinking cider to provoke her into thinking 'just like his father' (who had left the family when Gary was three). The 'one for her boots' refers to his mother's use of cider bottles to keep her boots in shape!

Frame 3: Things become so bad at home that Gary spends more and more time in the pub.

Frame 4: Gary tries to explain, but it seems to be no use. This frame shows the point at which his mother refuses to make him any more tea, or lunch sandwiches.

Frame 5: A typical 'cannon-ball' row, in which Gary and his mother both hurl equal tirades of abuse at each other. His mother's boy-friend, Dave, is rubbing his hands with glee and smiling, glad that Gary and his mother are having a row, because he is jealous of Gary's relationship with his mother.

Already the 'fuel' for the offence is becoming evident. There is the clash of Gary's aspiring independence with his mother's routine, family history concerning his father, rivalry with his mother's new partner, and the use of alcohol both as a refuge and as provocation.

Next, Gary drew a comic strip of the offence. This took three sessions (of an hour each) to complete, and a further two sessions to discuss and draw out pointers towards the next steps. The comic strip is shown in Figure 11.3, and the notes below add Gary's comments while drawing.

Figure 11.3 Gary: Violence and family dynamics

Figure 11.3 Gary: Violence and family dynamics (continued)

Frame 1: At his sister's house, Gary and Kevin (his sister's partner) are enjoying a drink. Gary is aware that Sue is cross with them.

Frame 2: Walking home, Gary thinks women are 'all the same', always nagging. Head bowed, he feels a victim.

Frame 3: On arriving home, another row starts with his mother (similar to Figure 11.2, Frame 5).

Frame 4: Dave brings 'the gun' into the conversation. The gun was Gary's, and had been used for clay-pigeon shooting while staying with his father. Gary had brought it back to sell but had been unable to find a buyer. His mother and her boy-friend said frequently that they considered Gary unfit to be in possession of this gun. (It was, however, properly licensed.)

Frame 5: The top part shows Gary going back to his sister's, pushing Kevin out of the way, and fetching a hacksaw. The lower left section shows him being cross with his twin brother Trevor for 'telling on him' to his sister and mother about a bottle of whisky he had drunk. The lower right corner shows Gary back home with the hacksaw, intending to cut the gun up.

Frame 6: Gary takes refuge in the toilet, deciding whether and how to cut the gun up.

Frame 7: Trevor bangs on the toilet door, asking Gary to go for a drink, which Gary thinks is a bit much, after reporting him for the whisky.

Frame 8: Gary rushes from the toilet to his bedroom, his mother and Trevor watching from another bedroom.

Frame 9: Gary shakes the bed so hard that the lampshade quivers, and the pictures on the chest of drawers are falling about.

Frame 10: Dave calls up the stairs 'What are you doing to your mother?', implying that Gary was throwing her against the wall. ('I don't do that to her but he does.'). This changes Gary's feelings from 1 (bewildered) to 2 (devil). Mother and Trevor are peering anxiously round the bedroom door to see.

Frame 11: Dave and Gary are by now very angry. Dave shouts at Gary, and Gary shouts back 'I'm going to kill you, I'm going to fill you in!' (Lightning rather than cannon balls is the metaphor here). Gary mentions that Dave and he both give each other 'nasty looks'.

Frame 12: Dave headbutts Gary, who sees 'stars and little birds'.

Frame 13: Gary is left on his own, bleeding profusely.

Frame 14: Sudden thoughts of vengeance come to Gary, and he thinks again of the gun – and a cartridge, for extra effect.

Frame 15: Gary puts the cartridge in the gun.

Frame 16: Trevor comes back upstairs and tries to stop him.

Frame 17: Trevor tries to take gun from Gary, who lets go because he is worried that it might go off. (The insert at the right shows Gary's thoughts of the gun exploding.)

Frame 18: Trevor sneaks the gun away, while Gary sits down to think what to do next.

Frame 19: Gary queries Trevor's intentions.

Frame 20: Trevor and Gary struggle for the gun.

Frame 21: Trevor wins and takes the gun downstairs.

Frame 22: Gary rips things out of closet, looking for Trevor's knife.

Frame 23: Gary thinks gleefully about cutting Dave's head off.

Frame 24: There is a second struggle with Trevor.

Frame 25: Trevor throws the knife out of the window.

Frame 26: Gary is left on his own, thinking.

Frame 27: Kevin arrives, the only one who can talk to Gary and calm him down. Meanwhile, Dave has called the police, who arrive and arrest Gary, taking the gun (which is later destroyed by order of the court).

As our sessions continued, Gary seemed more involved and found it useful to himself to be able to see what was going on. He was able to identify several points at which he could have 'stepped off the escalator' – mostly fairly early on in the saga. He recognised the contribution of drink, which made him reckless and uncaring about the consequences. Together we identified several important issues:

- Family patterns
- His relationship with his mother
- His stereotyping of women
- His letting problems build up
- His use of drink to solve/hide from problems
- His need to develop other interests to keep drink under control

Gary then used these issues to write out some points of advice to himself:

ADVICE TO MYSELF

1. If you're feeling that way, talk to someone, and don't carry out what you're thinking.

2. Watch drink – don't drink excessively.

3. I shouldn't have gone home – better to go for a walk, go and see a friend.

4. Don't solve problems with drink, find a friend.

5. Don't let problems build up — talk about them first.

6. Don't mix drink and difficult situations.

Throughout this time we kept a record of Gary's drinking levels, so that he could monitor for himself when his intake rose and fell. We also looked at anger management techniques so that he could avoid potentially explosive situations and be aware of his feelings before they got out of control. Gary had also been in contact with various members of his family and relationships were somewhat restored, except for those with his mother and her boy-friend.

After this initial stage of a probation order, which usually lasts about three months, there are several possibilities. In the days of 'advise, assist and befriend', most of the probation order would be taken up with helping the client with whatever problems he (or occasionally she) had — accommodation, jobs, debts, money, Social Security, children, someone to talk to as a friend. Sometimes the original offence was never even mentioned.

With the more recent emphasis on 'offending behaviour', however, the first three months of a probation order are taken up with weekly meetings to discuss the offence and how to avoid re-offending. This is the time when it is thought offenders may be most motivated to undertake changes. The remaining time of a probation order is usually used for 'maintenance' of change, dealing with the everyday life problems of clients (which are many), or simply continuing to report (fortnightly, then monthly) to fulfil the requirements of the court. Some probation offices have a Reporting Register for this purpose.

However, from a therapeutic point of view, the process has only just begun. The use of comic strips and drawings produces far more information than verbal discussions. As it is drawn from the point of view of the offender, he or she can own it and begin to recognise the life issues that lie behind the offence. These are the issues that need further work if real change is to take place, leading to prevention of re-offending in the longer term. After the question 'What exactly happened in this offence, and what led up to it?', the next question is 'How does this offence fit into this person's life?'. Offending behaviour is not an extrinsic item which can be looked at in isolation, it has a meaning in the context of that person's life at that moment.

Some clients do not want to continue to look at themselves and prefer to 'serve their time' in a non-intrusive way. However, many offenders want to stop offending, but do not have the necessary insight into their behaviour. It would seem to make sense for that opportunity to be there in the probation

service, with its explicit brief in working with offenders and preventing further crime.

Recent developments in the probation service make it more difficult to provide this service for those who need and want it. Although probation officers have in the past had almost complete freedom to manage their caseload however they wished, this has become the subject of increasing regulation. More attention is paid to bureaucratic requirements as central government lays down guidelines for more and more aspects of the work. The Criminal Justice Act 1991 continues this process with the introduction of National Standards. As it is difficult to legislate for services which rely on personal qualities, the emphasis is increasingly on services which can be easily measured, e.g. how quickly a probation order starts, how many orders are breached, whether someone re-offends, the throughput of cases, regularity of reporting, correct completion of records, and so on.

There is thus more emphasis on the 'management' of clients (and, correspondingly, also of probation officers) and on monitoring their adherence to reporting conditions. The Criminal Justice Act 1991 makes this more explicit and requires far more time spent on monitoring and surveillance aspects.

Despite these factors, I had every intention of continuing to work with Gary, as it seemed important to him and worthwhile to me. I suspected that my senior probation officer might see this work as somewhat too intensive for that stage of a probation order, but I was always careful to allow at least three months to 'wind down' before the end, or early discharge, of an order. As Gary had enjoyed the drawings, I anticipated continuing with art therapy, especially as I had found it useful previously when looking at the stereotyping behind violence (Liebmann 1990), a clear factor in this case too.

In the event, matters resolved themselves quite differently. Gary decided to go and live with his father in a different town, and accordingly I transferred his probation order there. However, he asked to take copies of his drawings with him and his new probation officer told me of Gary's enthusiasm as he showed them to him. It must also have been a quick and effective way of introducing himself and the work he had done with me, and probably saved the new probation officer hours of work repeating what we had covered.

Brian: a vicious circle of thefts

This case started with a Social Enquiry Report (Pre-Sentence Report) concerned with an offence of 'burglary of a non-dwelling'. Brian (aged 20) and a friend had broken into a shop late at night and stolen six bottles of vodka and 100 cigarettes. The friend had run off, Brian had been caught.

There was considerable Social Services involvement with Brian's family for quite different matters, however, the social worker and the family saw Brian's behaviour as outrageous – staying out late, drinking, taking drugs, mixing with 'undesirable types'. Brian thought they were being very unreasonable, as he worked hard at a poorly paid job in a shop, and thought he was entitled to 'a little bit of fun' after working hours.

During the court adjournment of three weeks to complete the report, Brian re-offended, and two further charges were added: handling a stolen guitar, and an assault. The court date was postponed so that Brian could be sentenced for all the offences together. As if this wasn't enough, Brian then lost his job for being late, and committed yet another offence, shoplifting a socket set from an auto-centre. By this time it seemed to be becoming a habit of huge proportions, and the court would be taking an ever more serious view.

Brian kept all his appointments for the report, and talked at length about all his troubles, at home, at work, with money, and with friends. He valued this opportunity and was relieved to be given a two-year probation order when his case finally came to court. He had been very worried that he might be sent to prison. As drawing was one of his few acceptable hobbies, he readily agreed to looking at his offences by this means.

His first appointment after the start of the actual probation order was a complete surprise. He announced that he had seen the error of his ways, and had had a long chat with his uncle and aunt, who were supporting him in his desire to 'start again'. He had got himself another job, had given up his drinking and drug-taking 'friends', started paying his fines and seemed much more amenable to reason. Nevertheless, there was still a two-year probation order to fulfil, and Brian himself admitted he would need support to keep up his new resolve and cope with any unforeseen difficulties.

We decided to look at the offences one by one. Brian's first drawing (Figure 11.4) showed the burglary of the shop. He depicted himself as a kite because he was 'high as a kite', and continued the visual/verbal puns with 'They were on my tail'. The last frame shows how he had underestimated the seriousness of this crime, and how worried he was when he realised how it would be seen by the court.

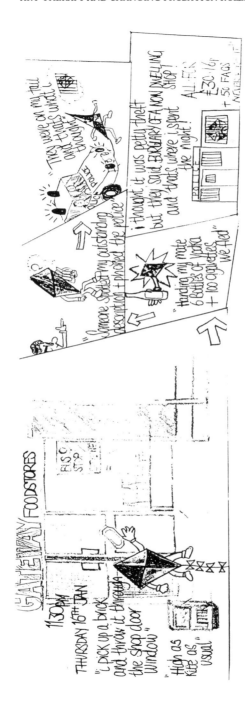

Figure 11.4 Brian: Burglary of shop

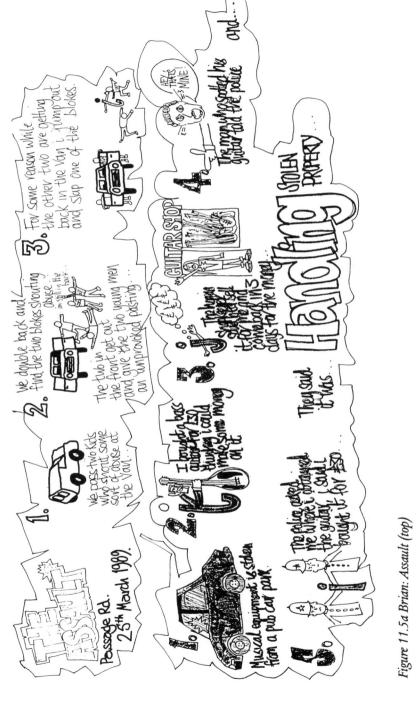

Figure 11.5a Brian: Assault (top)

Figure 11.5b Brian: Handling stolen property (bottom)

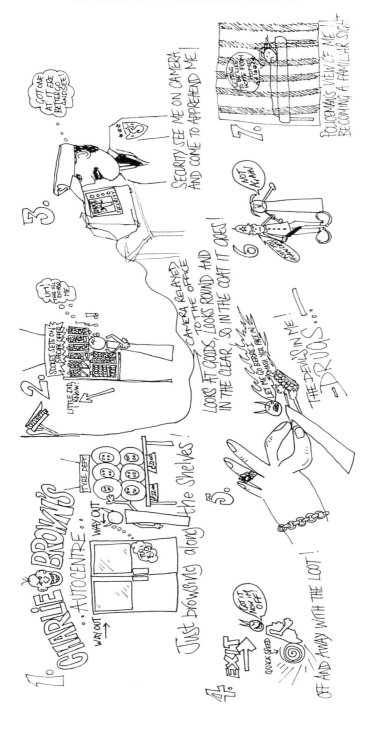

Figure 11.6 Brian: Shoplifting

Brian preferred to do his drawings at home and bring them in to the probation office. The next two he brought in were on the same sheet of paper (see Figure 11.5), and showed the assault (Figure 11.5a), and the handling of a stolen guitar (Figure 11.5b).

The comic strip of the assault has three stages, and in this series Brian has drawn himself throughout as a letter 'i' with arms. I asked him about this, but he just shrugged his shoulders and said that was how he had felt like doing it. He could give no reason for the assault, and it is interesting that, on the one hand, he seems to be just going along with mates, while at the same time he sees himself as completely different from them. I asked him about this, but he had nothing to say. Another paradox that suggested itself to me was the way the letter 'i' indicated his preoccupation with himself, while at the same time portraying himself as a 'cipher'.

The comic strip of the handling of the stolen guitar repeats the themes of the previous two. Brian draws himself as a more prominent letter 'i', and after buying a good quality guitar very cheaply, is then totally dumbfounded when arrested for handling stolen goods – something he might have foreseen.

By the time it comes to the final offence, one of shoplifting (Figure 11.6), the letter 'i' has acquired devil's horns, and Brian is now setting out purposefully to steal. In Stage 5 he ascribes the 'devil' to drugs in another visual/verbal pun. A final touch of irony shows his arrest resulting in the devil's horns flopping limply down!

Brian's wry sense of humour in his drawings showed considerable potential for seeing things from different points of view – which indeed he had managed to do for himself in his life. He rounded off the series with a glimpse of what might have happened if he had not managed to stop offending, and then wrote out the sequence of events in narrative form, called 'My View' (see Figure 11.7).

Certainly the drawings, discussion and reflection helped Brian to consolidate the changes he had made, and see the importance of the different elements of all his decisions. He enjoyed doing the drawings, and the results lent a concrete feel to his achievements.

By the time this work was completed, Brian had obtained a better job doing construction work for cold stores, which often meant working away from home. Whenever he could not make his appointments, he kept in touch extremely well by letter, as agreed with me, from wherever he was temporarily based. However, this practice was called into question when the files were inspected. One of the managers was of the opinion that, since Brian was not able to keep probation appointments, the probation order was

MY VIEW

1. GOOD JOB (TRAINEE MANAGER)
OWN CAR

2. GOT IN WITH WRONG CROWD
DRINK DRIVING
SMOKING DOPE

3. WROTE CAR OFF BAD NEWS
CAUGHT DRINK DRIVING ALL THE TIME!
JUST MADE THINGS WORSE!
SACK FOR SUSPECTED THEFT PARENTS
ABOUT
& PATROL WARNINGS (KICK ME OUT)
NO CAR TO SELL
OUTSTANDING BANK LOAN SAID I'D CHANGE BUT ALL
TURNING POINT !!!! SEEMED MORE IMPORTANT

4. TAKING SPEED, SMOKING DOPE
DRUG PARTIES
MUSIC EQUIPMENT NEEDED
LIVING BEYOND MY MEANS
NEW JOB £80 PER WEEK
— £ AT END OF WEEK

5. LOOKING FOR AN ANSWER?
STEALING FROM CARS
FROM HOUSES
FROM WORK
FROM ANYWHERE WHERE MONEY WAS INVOLVED!

6. FAMILY SITUATION BAD.
NAGGING ABOUT APPEARANCE
COMPANY
NO FOOTBALL DRINK + DRUGS
WEIGHT
MONEY

8. EVERY MINUTE, DAY, WEEK
SAME ROUTINE! WORK
2. TEA
3. OUT
WEEKENDS WERE JUST N°3.

9. STARTED GETTING CAUGHT.
1. HANDLING
2. BURGLARY
3. THEFT
ALL GOING TO COURT FOR SENTENCE
MARCH 89!!

10. CHARGED ALSO WITH ABH
WORRIED ABOUT PRISON + FINES

11 COULD ONLY TURN TO MY FAMILY
WOULD THEY HELP?
NO MORE — YES CARRY ON — NO

12. TIME TO MAKE THE CHANGE
LUCKILY HAD SOME HELP DUE TO FALLING
OUT WITH EX FRIENDS

(CHANGE WAS MADE)

1. NEW JOB — AWAY WORKING
NEW FRIENDS — NO DRUGS
PAY OFF FINES — MONEY SITUATION FINE
GIRLFRIEND
NEW CLOTHES, FOOTBALL
RESPECT AND ADMIRATION FROM FAMILY
AT WHAT I'D DONE ABOUT MY LIFE.

WHAT COULD BE BETTER

Figure 11.7 Brian: My view

unworkable, and Brian should be taken back to court to be given a different sentence. As Brian was not in a position to complete any other sentences (he could not undertake community service or attendance centre because of his irregular work pattern, and he could not afford further fines as he was still paying off the ones incurred at the same time as he was put on probation), this did not seem a profitable line of argument. It also seemed a rather negative response to Brian's efforts to keep to the spirit of the probation order, and to his real and sustained progress.

Fortunately, the probation order was by now more than half way through and, as Brian had not re-offended, I was able to get the order discharged early for good conduct and excellent progress. The early discharge did seem a very appropriate course of action in this case, as we had completed a substantial piece of work together, and Brian was no longer offending.

Although the changes in probation practice did not affect the actual work while we were doing it, they threatened to undo the positive progress made by applying a bureaucratic ruling that concentrated on the letter of the law rather than its spirit. There are fears that, if the Criminal Justice Act 1991 lays more emphasis on fulfilment of strict reporting requirements, and 'restriction of liberty', this could have implications for all clients working irregular hours, often the only work available to offenders.

Maria: issues of child neglect

Although it has been common practice in probation field teams for the writer of a Social Inquiry Report (Pre-Sentence Report) to hold a probation order that results from it, this is not always the case. If field teams are organised on a 'patch' basis, occasionally probation officers are called upon to write reports out of their area, but then to hand on the probation order to a probation officer covering the area. Some teams operate in a more specialist way, with one person writing all the reports, and then handing on any probation orders that are made by the courts. Occasionally, there are particular circumstances to take into consideration, which only become evident during the interview for the report, such as problems related to sexual abuse suffered by women clients, which may call for the consideration of a woman probation officer. In all these situations, great care needs to be taken to explain what probation means and involves, so that clients and report writers can assess whether this will be appropriate or feasible.

Sometimes a court makes a probation order without a report, and this order arrives at the probation office to be allocated. Such probation clients have little idea of what is involved – sometimes they may still be denying

the offence despite the finding of guilt – and this makes any discussion of the offence and how to avoid future offending difficult, to say the least!

Maria's probation order was one of these. Maria was a very young mother, aged 20, with four children under five. Her partner, Bob, two years older than her, was the father of all four children, but spent only part of the week with them. The family had been on the caseload of Social Services since the birth of their second child, Linda, by now in care and awaiting adoption. There were issues of neglect, ill treatment, possible sexual abuse from Maria's father and maybe others, interference/support from Maria's family, school problems, and non-cooperation with Social Services, the health visitor and the psychiatrist.

One of the incidents in this family's life, a nasty bruise on the third child, Tania, had been deemed serious enough to report to the police, who charged Maria with cruelty through neglect. Maria pleaded not guilty throughout the proceedings, and the case went to the local Crown Court. There, pressure was put on her to plead guilty – 'If you plead guilty now, you'll get probation, if you carry on pleading not guilty and are found guilty, the judge may say you have wasted the court's time and send you to prison'. Maria pleaded guilty, and was given a two-year probation order.

The case was allocated to me, although it was not on my 'patch', because of the suspected sexual abuse issues. (There was a woman probation officer covering Maria's area, but she was about to go on maternity leave.) When I contacted Social Services, Maria's social worker told me she had explained to Maria that her probation officer would be able to spend time with her on her problems, without getting involved in the surveillance aspects of Social Services (although, of course, I would have to report any actual child abuse if it became evident on my visits). Social Services were hoping I might be able to help Maria talk about any sexual abuse she herself had suffered, and through this perhaps become a better parent to her own children.

I made my first visit to Maria in trepidation, and knocked on the door. Maria opened it with a smile, welcomed me in, and introduced me to her partner, Bob, and the three children still with her – Michael (at school), Tania and baby Darren. Maria herself welcomed me as someone to talk to, but she was quite open that she had only agreed to probation on the advice of her solicitor, and adamant that Social Services had invented all the charges.

It had been agreed that I would start by making home visits, in order to acquaint myself with the family circumstances. As Maria was off my usual beat, and also had a social worker, fortnightly visits seemed more appropriate than weekly ones. Many women probation clients were visited at home for the whole of their probation order, especially if there were small children

and difficulties with transport. Maria had a toddler and a baby, and would have had to take two buses (a considerable expense, on social security), in addition to a walk at both ends, to get to the probation office.

During our first visit Maria talked at me incessantly, as if any pause would give an opportunity for the usual and intolerable criticism. I wondered if art therapy would provide an alternative means of communication, which could cut through the torrent of words and provide a safe mode of expression. I also thought that the 'comic strip' approach could provide a way in to the offences she still denied, by providing a vehicle expressing her point of view. It would also help me gain an idea of the sequence of events in this complicated family saga.

Accordingly, we started with 'The Story of Linda', and then 'The Story of Tania'. These took several sessions, with considerable discussion along the way. There were several points of interest about the drawings – Maria's refusal to use any other colour than blue, and the many drawings showing a plan-like view of furniture in the rooms. Quite often Maria would mix up her daughters' names, as if she couldn't separate them from each other. She also made remarks about girls never having a chance, and it seemed significant that the two girls had been more severely neglected than the boys – maybe reflecting how Maria felt she had been treated. In fact, three months after the start of the probation order, Maria asked for Tania to be taken into care as she was being 'difficult'. Tania remained in care and after another year Maria agreed to release her for adoption.

In our sessions we moved on to pictures of each child, together with one of Maria as a child (see Figure 11.8). Here again the boys are drawn differently from the girls, who all seem to be encased in heavy lines. For these drawings, Maria insisted the only colour she would use was red.

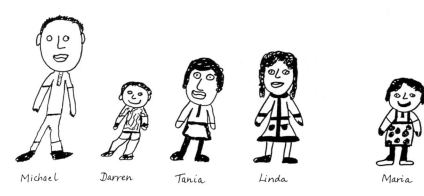

Figure 11.8 Maria and her children

Thinking about how to approach the difficult area of sexual abuse, I suggested looking at childhood memories in general, first happy ones, then not-so-happy ones. Maria was really getting into the swing of drawing now, and laughed as she portrayed childhood escapades, such as showering a passing policeman with water (Figure 11.9).

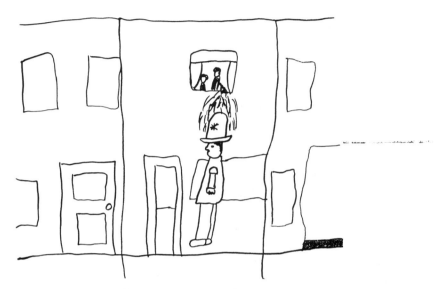

Figure 11.9 Maria: Showering a passing policeman

Figure 11.10 Maria: Cooker blowing up

We followed on with less happy memories, and in one of these (Figure 11.10), for the first time, Maria used more than one colour. The scene shows their cooker blowing up, and although most of the picture is in the usual red, the flames are in red, pink, yellow and purple. Other memories were of being run over and being hit by a brick.

I mentioned the possibility of memories of sexual abuse, but Maria could only get as far as drawings of bathtime with her two sisters, and of sharing a bed with them in a holiday caravan, leading to feeling a lack of privacy. The next session Maria said she wanted to forget any memories of sexual abuse, as remembering only made things worse. However she was happy to have a go at drawing how it had made her feel – like a caged animal. Figure 11.11 shows Maria completely caged in apart from her head.

Figure 11.11 Maria: Sexual abuse – feeling 'caged in'

Maria's next memory was a strange one. It was of a bomb shelter where she and friends played, on some waste ground. She was happy to do a picture, and concentrated far longer than usual, using all the colours. It showed Maria and two friends looking down through a trapdoor on to a stewpot containing nine little unwanted girls, on a fire. A green arm came out to grab them and they ran away. Maria was able to relate this to her own feelings of being unwanted and of having less freedom than boys.

During these months life did not stand still. There were frequent alarms about bruises on the remaining children (both boys), school problems with the eldest, reports by psychiatrists at local and London hospitals, household debts, wardship and care proceedings. Frequently I had to listen to a long catalogue of Social Services misdeeds before Maria was ready to turn to other things. However, she was always at home for our appointments, and seemed to value our sessions.

After one of Maria's outbursts at the possibility of Social Services removing all three children, I suggested a picture. The result was Figure 11.12, depicting everything Maria felt like doing to Social Services. She worked with great concentration for half an hour, using the full range of colours, and was relaxed and good-humoured as a result.

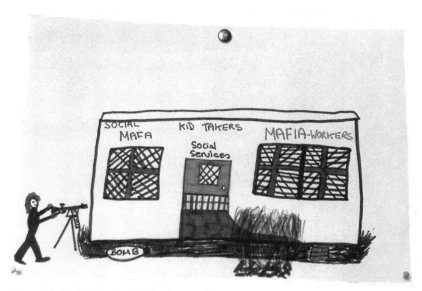

Figure 11.12 Maria: Social Services mafia

The next few sessions were ones in which Maria really used the space well, concentrating on one picture during each session. By this time, too, baby Darren was an active toddler, and I tried to keep him amused so that Maria could continue with her picture. I suggested going elsewhere and arranging childcare for Darren, but Maria would not even contemplate this. Social Services had already tried and failed, so I did not pursue it.

The next picture in this series showed the child psychiatrist (whom she hated for criticising her childcare) crucified on a cross on an island, with additional bomb and dagger. On the next occasion Maria chose to draw the empty house near the bomb shelter. After a two-month gap over Christmas, during which I visited but we had no time for pictures, Maria decided to draw her dream house (Figure 11.13). She lavished considerable care on it, used all the colours, and was pleased with the result. It is bold and colourful, but also has a shut and protected feel.

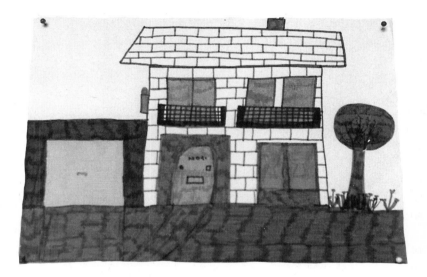

Figure 11.13 Maria: Dream house

In the next session, a fortnight later, she returned to the Social Services theme, and drew a castle entitled 'House for kids protected from social worker and from courts and care', which flew a flag saying 'Protect your kids from social workers, keep them here'. The castle's windows were heavily barred, there were battlements and a gun. The entrance was barricaded and there was no drawbridge. In the moat, sharks' fins were menacingly visible. The 'keep out' message was very clear.

In discussing these pictures later, Maria acknowledged the connection between the defences saying 'keep out' and her feelings of being continually under threat, from Social Services and the whole world. She felt she could not trust anyone, and had no friends.

As the court case concerning wardship drew near, Maria drew a cauldron on a roaring fire, boiling all the professionals in her life – social workers, health visitors, the doctor, the psychiatrist. I was relieved to see that I had been spared! There was also a picture showing press photographers outside the Crown Court waiting for the result of her case. Then, as the stress of the approaching court case increased, Maria could no longer concentrate on original work, and turned to tracing and colouring pictures of cars 'for the children'.

At about this time Maria told me her father was starting to molest her again. She had managed to tell her mother, who (by contrast with childhood attempts) had understood her situation and was trying to help.

At this point the senior probation officer in charge of my team, in accordance with new guidelines, suggested that, as over half the order had been completed without any fresh criminal offences, it was time to ask the court to discharge the order early. This was becoming common practice, and was often appropriate where work with an offender had been completed. Another reason for this practice was the increasing constraints on resources, coupled with extra demands on paperwork, so that every team was encouraged to discharge probation orders wherever feasible. However, at the next case conference concerning Maria's family this was advised against, as it would mean withdrawing from Maria the only professional worker she felt she could talk to.

The other pressure was to make Maria come to the probation office. Part of the reason for this was economic – saving time and travel for an overloaded service. At that time there was a women's group running at the probation office, and it was seen as economically expedient for Maria to be slotted into it – regardless of the fact that she was terrified of such a prospect.

There was also another factor: the new thinking that probation was more about punishment and surveillance (heralding the Criminal Justice Act 1991) than about help, even if help prevented re-offending. 'Offending behaviour' was seen increasingly as something separate and detachable from people, so that a background of sexual abuse was seen as 'irrelevant' to that person's offending, and therefore irrelevant as an area of work. Home visits were seen by some managers as being 'soft' on offenders, who had an obligation to attend at the probation office – and if they did not, then they should be taken back to court forthwith.

These considerations did not fit very well with the long-term work being attempted by myself in conjunction with Social Services. It did not seem realistic, either, to expect Maria to undertake the complicated journey to the probation office, given her lack of finances and history of non-cooperation

with statutory agencies. It was seen as a major achievement that she had managed to trust me enough to cooperate with my home visits and fulfil her probation order. Fortunately, the guidelines had not yet become rules and I continued with Maria until the end of the probation order, tailing off intensive work so that she would not feel suddenly 'dropped'.

When the case finally came to court, a care order was made for Michael and a supervision order for Darren. It took a long while to find foster parents for Michael, and it was part of my role to help Maria cope, first with the wait, and then with the loss of Michael to foster parents. As the probation order drew to a close, I tried to refer Maria to the art therapy department at the local psychiatric outpatient department, but there were no childcare or transport facilities, and it was all too difficult.

At the time I felt little had been achieved in personal terms, and events had rolled on their way inexorably. I wondered if the personal work we had done, and the art therapy, had all been a waste of time. However, I heard later via her social worker, that Maria had gone to the police about her father's continued sexual advances, and had also stood up for herself when her partner had been violent to her. Her confidence had increased, she was more open, was relating better to her children, and arrangements were in hand for Michael to return home. A feeling that she herself was worthwhile was the first step towards providing that feeling for her children. The art therapy had provided a space for this which would not have been accomplished by words.

Kim: breaking out of drink

After I had been working in a probation field team for two years, I gave a presentation on art therapy to the rest of my team. At the end of this presentation, we looked for ways of using my experience and expertise more widely. One idea was an exchange of clients if we felt we were 'stuck' in our work with them or had reached a point where another approach seemed to be needed.

The first – and only – such exchange took place soon afterwards. A male colleague had an 18-year-old female client with a huge alcohol problem; he felt he was getting nowhere as she re-offended almost weekly. He asked her if she would like to try art therapy, and she seemed amenable. We agreed to work for six sessions and then review them. (In return my colleague, who had a reputation for finding people jobs, worked with one of my clients who had been unemployed for a long time and said he really wanted to find work.)

We decided to work in the group room, a large but not very welcoming area. Kim wanted to bring a friend, Teresa, who was also one of my probation clients, of about the same age, and interested in art and writing, so this was

arranged. In the event, they both arrived drunk, accompanied by another friend, a young man called Simon, and Teresa's baby in a buggy. After a short time of abortive activity, scribbling on bits of paper, I closed the session, gave them a further appointment, but told them I would not let them in if they had been drinking.

For the next session, they arrived late (it was snowing!) but sober; three young adults but no baby, who had been left with Teresa's mother. I suggested starting with a 'lifeline' as a way to start the process. Both young women groaned, as they said they had done this before, in children's homes and at family centres. Nevertheless, Kim applied herself in a very concentrated fashion, although she refused to draw or use colours. She wrote out her whole life history, picking out significant events as she went.

Only Kim and Simon arrived for the next session. Kim finished her 'lifeline' and together we picked out high and low points. Then, as she seemed to regard everything as beyond her control, we picked out the times and events when she felt things were being 'done to her' and times when she felt things had been accomplished by her own initiative. Her only high point had been a Youth Training Scheme in hairdressing (initiated by herself), and the low points were three spells in prison, which she felt had been 'done to her'.

Kim was still not willing to draw freely, and I felt it important to respect this and leave her in control of the process, as this was such an issue for her. However, she was willing to try stick figures. She kept saying 'My offences are nothing to be proud of', so I suggested she tried 'How she would like to be'. She drew a smiling stick figure in a frame labelled 'FUTURE' (see Figure 11.14), then herself 'Now' (as a 'stick insect', she said), but could not see how to get from one to the other because 'Drink' was in the way. She had been offered an assessment appointment at an alcohol treatment centre, which required total abstinence, and could not see how to avoid drink in her current social situation, meeting friends in pubs and at parties.

We moved on to her offences, as she was concerned with forthcoming court appearances, but she could only write the words at the top of Figure 11.15: 'Kicking police cars, mouthy, ripping stuff up, smashing bottles, kicking them'. I commented that there seemed to be two Kims – one saying about her offences 'They're nothing to be proud of', the other doing all those things with relish.

In the next session, I suggested drawing 'the two Kims', and she added them to the same sheet of paper. She used colour for the first time, the 'When out of it' figure in blue, and the 'Other me' in black, with writing in green, orange, blue, brown, purple and pink. This led to a discussion of how drink

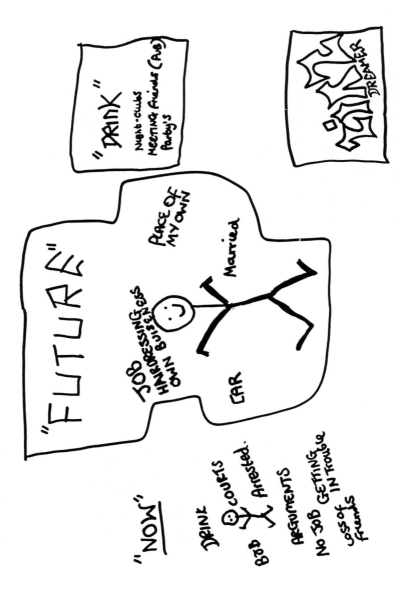

Figure 11.14 Kim: Now, the future and drink

Text within image: "DRINK" Night-clubs, Meeting Friends (A.B), Partys; DREAMER; "FUTURE"; JOB HAIRDRESSING OWN BUSINESS; PLACE OF MY OWN; Married; CAR; "NOW"; DRINK; COURTS; Bob; Arrested; ARGUMENTS; No Job; GETTING IN TROUBLE; LOSS of Friends

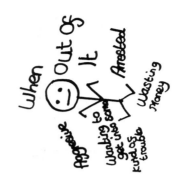

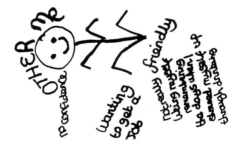

Figure 11.15 The two Kims

gave her confidence to say things she would otherwise not bring out, such as critical comments. We looked at possibilities of being more assertive rather than relying on drink for courage.

Kim did not keep the next appointment, and my probation colleague cancelled the future sessions, as he felt I should not be treated in this way. I would have preferred to leave the possibility of future sessions open, but he felt they were a privilege, which should now be withdrawn. As he was in charge of Kim's probation order, there was little I could do.

I felt that art therapy was just beginning to have something to offer Kim, both in her cautious experimentation with colour, and in her willingness to start discussing issues behind her drinking. If there had been further sessions, I would have continued to follow Kim's concerns, encouraging her to be more open, to explore visual possibilities and to make links with her personal situation.

Although on the whole the system built on individual casework works well, it sometimes also breeds a possessiveness about clients. It can be difficult for individual probation officers to give up their clients, unless they are ones who cause everyone enormous difficulty. Clients, too, are reluctant to change from someone they have come to trust, to someone they do not know, so that they have to start the difficult process of getting to know a new person all over again.

There are some exceptions to this individual and continuous relationship. Several probation services have accommodation and employment services, and some also have welfare benefits advice, all run by specialists who can give better advice than generic probation officers. Clients may also attend groups (usually as a condition of a court order), which may be run by other probation officers. There was also a Home Office suggestion (in the Green Paper *Punishment, Custody and the Community*, Home Office 1988) of a probation officer as a 'coordinator of packages' (with a privatisation proposal), who would decide which groups, facilities and services to 'buy in' for each probation client. Many probation officers also refer clients to other agencies for specific help, e.g. with alcohol and drugs. It is always a matter of discussion whether it is more effective to have as many facilities as possible 'in house' – enabling easier access for many offenders, and better coordination from the offenders' point of view – or whether it is less stigmatising to use other facilities already available elsewhere in the community.

Concerning art therapy, one could simply refer clients to the local psychiatric hospital outpatients' department, but the requirement of an 'illness diagnosis' often precludes many offenders – who may also feel that the stigma of being a psychiatric patient is worse than the stigma of being

an offender. The only client of mine who expressed a wish for such a referral then did not keep his appointments at the hospital.

One could also arrange for referrals to an art therapist within the probation service – but would individual probation officers let go of their clients? Would it be seen as an essential enough service, like employment or accommodation? This seems doubtful, especially in times of stress and financial stringency, when only the barest of essentials (and often not even those) get attention.

Perhaps in those situations where high tariff offenders are already offered treatment to prevent further offending, art therapy would be seen as a useful way of working, in particular (but not only) those for whom words have failed.

Groupwork

One way of using art therapy to good effect in probation work is through groupwork, often as part of another group such as an alcohol education group or a women's group, and usually in a focused way to look at a particular issue. I have written about two such groups elsewhere (Liebmann 1990). These were both groups which I was co-leading with colleagues over several weeks (the alcohol group) or over a year (the women's group), so knew the group well.

The examples given below are similar to these in that art therapy was only part of a longer course of groupwork, but differ from them in that I was being asked in to provide some specialist art therapy experience for groups I did not know.

Women's group: creativity and self-expression

I was asked to an established women's group in another probation office as the women (who attended voluntarily) had expressed an interest in being creative and using art materials. They wanted two sessions, the first with an accent on enjoyment, and the second to be a gentle introduction to using art to express feelings.

The group of six women met in a family centre (more comfortable and welcoming than the probation office) and had access to the paints, brushes and crayons used by the playgroup there. After a short introduction emphasising that no-one would be judging the results, we started with a chance to play with the materials. We then moved on to filling paper with scribbles and picking out shapes – they found ducks, hearts and faces. Finally, we made 'butterfly prints' with thick daubs of paint, which they enjoyed enormously.

Most of the women said they were taking their paintings home for *their* children for a change!

For the second session (with one or two changes in group membership), I introduced the concept of art therapy as being concerned with expressing feelings rather than producing beautiful pictures – and not about me interpreting their pictures. We did a warm-up exercise with crayons, passing papers round so that we all drew on each other's pictures, and this went well.

We then used paints and crayons to express current moods. One woman painted a fearsome castle and a devil, but preferred not to talk about it. Two women had so enjoyed the previous week's activities that they made further explorations with the paints. A woman who had been absent the previous week used the opportunity immediately to draw three portraits of her boyfriend, one 'moody', one 'normal' and one 'happy'. She was frightened of his moodiness, and felt she was somehow to blame. After painting the pictures and talking about them briefly, she decided to take them home and stick them on the fridge door, as a message to her partner about her fears and apprehension. The feedback I received later was that all members of the group had enjoyed the two sessions and found them very worthwhile.

At one point, most field probation offices ran women's groups or had access to one. The women's groups were started to provide something especially for women in a rather male-oriented criminal justice system. (Only 21% of offenders and 12% of probation clients are women (NACRO 1992, based on 1990 figures).) Moreover, most women probation clients were isolated, suffered greatly from poverty (often the main factor in their offending) and from domestic violence, and had often been sexually abused. The women's groups (with crèche and transport) provided an opportunity to meet others and share problems (and occasionally solutions). Women probation clients were encouraged to join them, but not compelled to do so as a condition of their probation order.

With the move towards a more strict regime, and with financial con-straints, there was an effort to apply more coercion to women to attend to make the numbers more 'cost-effective', and some women were given conditions to attend in their probation orders. The move towards compulsory attendance was resisted as counterproductive for the women, and most groups closed because they were too expensive to run (in terms of probation officer time, transport and crèche) in the new tight financial climate. The needs of women were once again marginalised as being too expensive to provide for.

Probation hostel: difficulties in being personal

I was asked to introduce art therapy to a probation hostel which specialised in 'New Careers'. This hostel catered for young men convicted of serious crimes who were likely to receive a prison sentence, who probably had already served a term in prison, but who were deemed suitable to train for a career in one of the helping professions. They had to reside for one year at the hostel, and take part in placements outside the hostel and groupwork and education in the hostel.

On the whole, the residents enjoyed their work experience in playgroups, adventure playgrounds, hospitals and day centres. They also had weekly education sessions on Monday afternoons, which were compulsory. The education worker was keen to introduce art therapy as she thought it might help the students look at the more personal areas in their lives, something which seemed difficult to approach in words. I met with the education worker, Anna, and together we worked out a programme. Anna arranged to obtain materials, but unfortunately the hostel shift system meant she could not attend the first session itself.

I arrived on the first Monday afternoon and chatted informally to the students by way of introduction. However, it took a long time to find the paints, and the staff member on duty showed little enthusiasm for the group. The six students, David (the staff member) and I worked on the large dining table in the kitchen area. To warm up, we did 'Round Robin' paintings, passing the papers round. Everyone worked well, except that two group members could not cope with others' contributions, so obliterated everything as soon as they got their own sheets back.

After break, the mood seemed to have changed and felt less stable. I suggested everyone doing a painting starting with their initials, as a non-threatening way into personal work. Most people did interesting work, but started to 'rubbish' the session. One member of the group distanced himself from everyone with his superior attitude, and then collapsed into depression. Another member, Malcolm, was immersed in his painting, oblivious to the beginnings of disruption. He surrounded his initials with 'darkness', which he said referred to his current circumstances and his recent offending (he was a fairly new arrival at the hostel).

As a third exercise, Anna and I had decided on 'What brought you here', but there were vociferous complaints at continuing after 4 pm (I had been told that we would finish at 4.30), and at the 'childish' materials (similar to paints they used with others on their work placements). Only Malcolm continued, undeterred, with a picture of 'straight' and 'crooked' ways, his drug problem, and how he wanted a different future.

Most of the group rushed off, leaving David, Malcolm and myself to clear up. David muttered something about the group's attitude being 'par for the course', i.e. the usual way they treated outside leaders, although as individuals they were much nicer. Later in the week, Anna came to apologise for the group's behaviour and David's lack of support, due to a failure in staff communication. Although quite upset at the time, I felt that the group would eventually settle and be all right. I thought that involving them more in the planning could help.

At the beginning of the next session, we discussed what had happened. Several people apologised. They said they wanted to spend longer on one thing, and really concentrate on it, which was a good sign. Anna had bought a huge quantity of scrap materials, and we made 'Self Boxes' – boxes which showed something about ourselves both on the outside and the inside. There were many different shapes and sizes of box to choose from. The group worked with concentration for an hour, after which we had a break and time for sharing what we had done.

One group member enjoyed using plasticine so much that he made a series of models rather than join in with the theme. Two others worked really hard but then became frustrated with their work and destroyed it, one because the plasticine stripes he had put on his box reminded him of prison bars. Another made an immaculate box house, complete with green plasticine lawns, white walls and white pillared gate – but with no windows or doors ('I haven't had time yet').

Again it was Malcolm who really used the session to its fullest extent. He embellished the outside of his shoe box with words: DRUGS – CRIME – MONEY – SEX. These, he said, represented his former life: stealing money and spending it all on drugs and women. He was the only one who put anything inside his box, or let anyone look in. Inside, in one corner, was a prison gate. Then there was a small box labelled 'FUTURE', which in turn contained labels: 'job', 'crime-free life', 'marriage' and 'family'. I asked Malcolm if he wanted his 'Future' box to remain inside, or become the more visible outside. He opened the large box, ripped out the prison gate and flung it across the room, then tore off the 'crime' label, and half the 'money' label ('Legal money's OK'), and the 'drugs' label. He left the 'sex' label, and picked up the box for a quick cuddle! He then opened out the small box and said, 'I want my future to be open for all to see.' It was a very affirmative statement, which summed up many of his recent thoughts and feelings, and he felt very good about it. His box was by now such a mess that there was no other place for it than the bin! The process here was clearly more important than the product, and its final destination seemed quite appropriate.

We also spent a short time planning the third session together, which was helpful. For that session we chose a theme of 'Past, present and future', linking them all together in some way. Two staff members present joined in, and the students could see that even staff lives had not all been easy rides. Malcolm's work was similar to the previous week – his 'past' showed a slanting figure ('crooked?'), with a mask displaying ££, sex and crime labels. His 'present' showed a smiley face, and he started work on a 'future' of a good family life, but it 'went wrong', and he screwed it up and threw it away.

One member of the group did an 'all-in-one' picture of cannabis, which had been his past, was his present, and would be his future if he did nothing about it. Another member, who had destroyed his work the previous week, did a very careful picture of an egg-shaped world cracking open to reveal green creepers and vines beginning to grow.

We rounded off the sessions with an evaluation. Although some members of the group still said it was useless, others said 'It helps you think about things', and had especially enjoyed the final session. There was a good atmosphere, and if there had been further sessions, more progress would have been made.

After the sessions had ended, I met with Anna, who said several students had continued on their own, using the materials that were still at the hostel. Others had talked about what they had found so hard in the sessions. Anna felt that the sessions had really opened up personal issues for them, and wanted to plan two further series – another block during their compulsory education time, but jointly planned with them, and also an ongoing open art therapy group which would take place fortnightly on Tuesday evenings.

After several months' silence, Anna contacted me to say that there was a budget deficit, so there was no money for anything extra. I later heard that, because of expense, the hostel was discontinuing its social work education emphasis and changing to a probation bail hostel (for people requiring supervised accommodation while awaiting court cases). Anna herself moved to another post. Although the new senior probation officer in charge of the hostel was interested in having some art therapy input, it was clearly a long way down the list of priorities in such a time of change.

This promising venture into art therapy was prematurely curtailed mainly by financial constraints, which led to organisational changes and turmoil. A more continuous art therapy group would allow members to build up trust in the art therapist, other group members and the process. Over a period of time, members would learn to be more open about themselves, enabling them to discuss personal problems before they lead to offending.

Conclusion

This chapter has demonstrated the usefulness of art therapy in working with offenders on probation. It can help clients identify the sequence of events leading up to their offences, and thus give them more control over the choices they make. It can provide a space in which to explore personal issues which many find hard to do verbally. Its concreteness enables therapist and client to discuss the products together, in a non-threatening way. The practical insights gained can be translated into positive action towards a life-style which avoids further offending.

Despite these positive points, the potential of art therapy is rarely reached in a conventional probation setting for a number of reasons. Clients have to be moderately settled, agree to take part, and keep regular appointments. A qualified art therapist is needed, and if such a person has dual qualifications in probation and art therapy, the latter skills need to be valued and ways found to make best use of them. There are obvious openings in field work, probation centres and hostels.

Many of the changes affecting probation during these four years seemed to militate against art therapy – and indeed against most in-depth work. The emphasis shifted towards bureaucratic guidelines, with rules, control and surveillance seen as more important than rehabilitation and prevention of re-offending. In the turmoil of preparing for 'punishment in the community', these trends seemed to push preventative and therapeutic work with offenders to the sidelines.

Now that the Criminal Justice Act 1991 is being implemented (as from Oct 1992), much of the rhetoric has subsided, but it still remains to be seen how it will work in practice. National standards have been laid down, but the handbook for probation officers, *National Standards for the Supervision of Offenders in the Community* (Home Office 1992b) does not actually mention the word 'punishment'. Pre-sentence reports (PSRs for short) for court are to assess:

1. the seriousness of the offence

2. the appropriate degree of restriction of liberty

3. the most suitable option for the offender.

The objectives of a probation order are given as:

1. to secure the rehabilitation of the offender

2. to protect the public from harm from the offender

3. to prevent the offender from committing further offences.

There would thus still seem to be a role for art therapy, both in rehabilitation and in preventative work with offenders. While restriction of liberty 'prevents' offending by external control, there is a recognition that, in the longer term, it is only when offenders 'resolve personal difficulties and acquire new skills' (Home Office 1992b) that offending is really prevented.

It is to be hoped that the creative task of helping offenders (and the public) in this way will not be squeezed out by the bureaucracy and paperwork of reporting procedures and requirements, and that when the dust has settled, the probation service will be able once more to work overtly in a humane way with clients. Art therapy, with all it has to offer, could also be made available more widely as part of probation services' provision.

References

Home Office (1988a) *Punishment, Custody and the Community*. Cm 424. London: HMSO.

Home Office (1988b) *Tackling Offending: An Action Plan*. London: Home Office Criminal Justice and Constitution Department.

Home Office (1990a) *Crime, Justice and Protecting the Public*. Cm 965. London: HMSO.

Home Office (1990b) *Supervision and Punishment in the Community: A Framework for Action*. Cm 966. London: HMSO.

Home Office (1992a) *Probation Statistics, England and Wales, 1990*. London: HMSO.

Home Office (1992b) *National Standards of the Supervision of Offenders in the Community*. London: HMSO.

Liebmann, M. (1990) '"It Just Happened": Looking at Crime Events' in Liebmann, M.(ed) *Art Therapy in Practice*. London: Jessica Kingsley Publishers.

NACRO (1992) *Briefing: Women and Criminal Justice: Some Facts and Figures*. London: NACRO.

Further Reading

Art therapy, art in prisons, and related areas
Books

Adamson, E. (1984) *Art as Healing*. London: Coventure. Distributed in the US by Samuel Weisen Inc., York Beach, Maine.

Arnheim, R. (1986) *New Essays on the Psychology of Art*. Berkeley: University of California Press.

Brandreth, G. (1972) *Created in Captivity*. London: Hodders.

Brewster, L.G. (1983) *An Evaluation of the Arts-in-Corrections Programme*. California Department of Corrections, W. James Association, S.Cruz CA, US.

British Association of Art Therapists (1989) *Art Therapy Bibliography*. Obtainable from 11A Richmond Rd, Brighton BN2 3RL.

Cardinal, R. (1972) *Outsider Art*. London: Studio Vista.

Carrell, C. and Laing, J. (1982) *The Special Unit, Barlinnie Prison: Its Evolution through its Art*. Glasgow: Third Eye Centre.

Case, C. and Dalley, T. (eds) (1990) *Working with Children in Art Therapy*. London: Tavistock/Routledge.

Cleveland, W. (1989) *The History of California's Arts-in-Corrections Programme: A Case Study in Successful Prison Programming*. Yearbook of Correctional Education, Simon Fraser University, Burnaby, British Columbia, Canada.

Dalley, T. (ed) (1984) *Art as Therapy: An Introduction to the Use of Art as a Therapeutic Technique*. London: Tavistock / New York: Methuen.

Dalley, T. and Gilroy, A. (eds) (1989) *Pictures at an Exhibition: Selected Essays on Art and Art Therapy*. London: Tavistock/Routledge.

Dalley, T. *et al.* (1987) *Images of Art Therapy*. London: Tavistock.

Dalley, T. and Case, C. (1992) *The Handbook of Art Therapy*. London: Routledge.

Dalley, T., Rifkind, G. and Terry, K. (1993) *Three Voices of Art Therapy: Image, Client, Therapist*. London: Routledge.

Edwards, D. (1987) 'Evaluation in art therapy', in Milne, D. (ed) *Evaluating Mental Health Practice*. London: Croom Helm.

Ehrenzweig, A. (1967 and 1970) *The Hidden Order of Art*. London: Paladin, 1967; Englewood Cliffs, New Jersey: Prentice-Hall, 1970.

Fuller, P. (1980) *Art and Psychoanalysis*. London: Writers and Readers.

Furth, G.M. (1988) *The Secret World of Drawings: Healing through Art.* Boston: Sigo Press.

Jennings, S. and Minde, A. (1993) *Art Therapy and Dramatherapy: Masks of the Soul.* London: Jessica Kingsley Publishers.

Kramer, E. (1978) *Art as Therapy with Children.* New York: Schocken.

Kramer, E. (1981) *Childhood and Art Therapy.* New York: Schocken.

Kwiatkowska, H. (1978) *Family Art Therapy.* Springfield, Illinois: C.C.Thomas.

Landgarten, H.B. (1981) *Clinical Art Therapy.* New York: Brunner/Mazel.

Landgarten, H.B. (1987) *Family Art Psychotherapy.* New York: Brunner/Mazel.

Landgarten, H.B. and Lubbers, D. (1991) *Adult Art Therapy.* New York: Brunner/Mazel.

Levick, M. (1983) *They Could Not Talk and So They Drew: Children's Styles of Coping and Thinking.* Springfield, Illinois: C.C.Thomas.

Liebmann, M.F. (1986) *Art Therapy for Groups.* London: Croom Helm (now published by Routledge, London in UK and Brookline, Cambridge, MA in US).

Liebmann, M.F. (1990) *Art Therapy in Practice.* London: Jessica Kingsley Publishers.

Linesch, D.G. (1988) *Adolescent Art Therapy.* New York: Brunner/Mazel.

Linesch, D.G. (1992) *Art Therapy with Families in Crisis.* New York: Brunner/Mazel.

Maddock, D. (1993) *Art Therapy with Offenders.* Unpublished MA dissertation. Norwich: School of Social Work, University of East Anglia.

Malchiodi, C. (1990) *Breaking the Silence: Art Therapy with Children from Violent Homes.* New York: Brunner/Mazel.

Milner, M. (1971 and 1967) *On Not Being Able to Paint.* London: Heinemann, 1971; New York: International University Press, 1967.

Naumburg, M. (1966) *Dynamically Oriented Art Therapy.* New York: Grune and Stratton.

Naumburg, M. (1973) *An Introduction to Art Therapy.* New York: Teachers College Press.

Pavey, D. (1979) *Art-Based Games.* London: Methuen.

Payne, H. (ed) (1993) *A Handbook of Inquiry in the Arts Therapies: One River, Many Currents.* London: Jessica Kingsley Publishers.

Peaker, A. and Vincent, J. (1989) *Arts Activities in Prisons.* Loughborough: Centre for Research in Social Policy.

Peaker, A. and Vincent, J. (1990) *Arts in Prisons: Towards a Sense of Achievement.* London: Home Office.

Quanne, M. and Berger, J. (1985) *Prison Paintings.* London: Murray.

Rhyne, J. (1984) *The Gestalt Art Experience.* Chicago: Magnolia Street Publishers.

Riches, C. (1990) *The Visual Arts in Prisons.* Conference transcript. London: Royal College of Art.

Riches, C. (1991) *There is Still Life: A Study of Art in a Prison.* Unpublished MA thesis. London: Royal College of Art.

Riches, C. (1992) *Art in American Prisons.* Report for the Winston Churchill Trust, London.

Robbins, A. and Sibley, L.B. (1976) *Creative Art Therapy.* New York: Brunner/Mazel.

Ross, M. (1978) *The Creative Arts.* London: Heinemann.

Rubin, J.A. (1978) *Child Art Therapy.* New York: Van Nostrand Reinhold.

Rubin, J.A. (1984) *The Art of Art Therapy.* New York: Brunner/Mazel.

Rubin, J.A. (ed) (1987) *Approaches to Art Therapy.* New York: Brunner/Mazel.

Schaverien, J. (1991) *The Revealing Image: Analytical Art Psychotherapy in Theory and Practice.* London: Routledge.

Simon, R. (1991) *The Symbolism of Style: Art as Therapy.* London: Routledge.

Stern, V. (1992) *Creativity in Captivity,* A Lilian Baylis Lecture. London: NACRO.

Thomson, M. (1989) *On Art and Therapy.* London: Virago.

Uhlin, D.M. (1984) *Art for Exceptional Children, 3rd edn.* Dubuque, Iowa: Wm.C. Brown Co.

Ulman, E. and Dachinger, P. (eds) (1976) *Art Therapy in Theory and Practice.* New York: Schocken.

Ulman, E. and Levy, C.A. (eds) (1980) *Art Therapy Viewpoints.* New York: Schocken.

Wadeson, H. (1980) *Art Psychotherapy.* New York and Chichester: John Wiley.

Wadeson, H. (1987) *Dynamics of Art Psychotherapy.* New York and Chichester: John Wiley.

Wadeson, H., Durkin, J. and Perach, D. (eds) (1989) *Advances in Art Therapy.* New York and Chichester: John Wiley.

Waller, D. (1991) *Becoming a Profession: The History of Art Therapy in Britain 1940–82.* London: Routledge.

Waller, D. (1993) *Group Interactive Art Therapy: Its Use in Training and Treatment.* London: Routledge.

Waller, D. and Gilroy, A. (eds) (1992) *Art Therapy: A Handbook.* Buckingham and Philadelphia: Open University Press.

Williams, G.W. and Wood, M.M. (1977) *Developmental Art Therapy.* Baltimore: University Park Press.

Winnicott, D.W. (1971) *Playing and Reality.* (Republished by Harmondsworth: Penguin, 1980; New York: Methuen, 1982).

Wohl, A. and Kaufman, B. (1985) *Silent Screams and Hidden Cries: An Interpretation of Artwork by Children from Violent Homes.* New York: Brunner/Mazel.

Journals

Inscape. The Journal of the British Association of Art Therapists. Obtainable from BAAT, 11A Richmond Road, Brighton BN2 3RL.

Art Therapy. The Journal of the American Art Therapy Association, 1202 Allanson Road, Mundelein, Illinois 60060, US.

The American Journal of Art Therapy. Vermont College of Norwich University, Montpelier, Vermont 05602, US.

The Arts in Psychotherapy – An International Journal. Pergamon Press, Maxwell House, Fairview Park, Elmsford, NY 10523, US.

Organisations

American Art Therapy Association Inc., 1202 Allanson Road, Mundelein, Illinois 60060, US.

Australian National Art Therapy Association (ANATA), 480 Newcastle Street, Perth 6001, Australia.

British Association of Art Therapists (BAAT), 11A Richmond Road, Brighton BN2 3RL.

Canadian Art Therapy Association, 216 St Clair Ave W., Toronto, Ontario M4V 1R2, Canada.

International Networking Group (ING). Contact Bobbi Stoll, 1202 Allanson Road, Mundelein Illinois 60060, USA.

Work with offenders

Allen, H. (1987) *Justice Unbalanced: Gender, Psychiatry and Judicial Decisions.* Milton Keynes: Open University Press.

Ball, K. *et al.* (1987) *Worth the Risk!?: Creative Groupwork with Young Offenders.* Halifax: West Yorkshire Probation Service.

Bean, P. (1976) *Rehabilitation and Deviance.* London: Routledge and Kegan Paul.

Brown, A. and Caddick, B. (eds) (1993) *Groupwork with Offenders.* London: Whiting and Birch.

Boyle, J. (1977) *A Sense of Freedom.* London: Canongate/Pan.

Boyle, J. (1984) *The Pain of Confinement.* London: Canongate/Pan.

Campbell, J. (1987) *Gate Fever – Voices from a Prison.* London: Sphere Books.

Carlen, P. (1983) *Women's Imprisonment: A Study in Social Control.* London: Routledge and Kegan Paul.

Cavadino, M. and Dignan, J. (1992) *The Penal System: An Introduction*. London: Sage.

Cohen, S. and Taylor, L. (1972) *Psychological Survival: The Experience of Long Term Imprisonment*. Harmondsworth: Penguin.

Cox, M. (1978 reprinted 1988) *Structuring the Therapeutic Process*. London: Jessica Kingsley Publishers.

Cox, M. (1978 reprinted 1988) *Coding the Therapeutic Process*. London: Jessica Kingsley Publishers.

Cox, M. (ed) (1992) *Shakespeare Comes to Broadmoor: 'The Actors are Come Hither'*. London: Jessica Kingsley Publishers.

Davies, M. and Wright, A. (1989) *The Changing Face of Probation*. Norwich: Social Work Monographs, School of Social Work, University of East Anglia.

Denney, D. (1992) *Racism and Anti-Racism in Probation*. London: Routledge.

Dominelli, L. (1991) *Gender, Sex Offenders and Probation Practice*. Norwich: The Novata Press.

Fielding, N. (1984) *Probation Practice – Client Support under Social Control*. Aldershot: Gower.

Finkelhor, D. (1986) *A Sourcebook on Child Sexual Abuse*. London: Sage.

Forster, W. (ed) (1981) *Prison Education in England and Wales*. Leicester: National Institute of Adult Education.

Garland, D. (1985) *Punishment and Welfare*. Aldershot: Gower.

Gocke, B. (1991) *Working with Denial*. Norwich: UEA/SWT Monographs.

Goffman, E. (1986) *Asylums*. Harmondsworth: Penguin.

Harding, J. (ed) (1987) *Probation and the Community*. London: Tavistock.

Hood, R. (1992) *Race and Sentencing*. Oxford: Clarendon Press.

Heidensohn, F. (1985) *Women and Crime*. London: Macmillan.

Home Office (1990) *Provision for Mentally Disordered Offenders*. London: Home Office Circular 66/90.

Jones, A. *et al.* (1992) *Probation Handbook*. Harlow: Longman.

Leech, M. (1992) *A Product of the System: My Life In and Out of Prison*. London: Gollancz.

McGuire, J. and Priestley, P. (1985) *Offending Behaviour: Skills and Stratagems for Going Straight*. London: Batsford.

Mackay, R. and Russell, K. (eds) (1988) *Psychiatric Disorders and the Criminal Process*. Leicester: Leicester Polytechnic Law School.

Morrison, T., Erooga, M. and Beckett, R. (eds) (1993) *Sexual Offending Against Children – Practice, Policy and Management*. London: Routledge.

Parker, T. (1962) *The Courage of his Convictions*. London: Hutchinson.

Parker, T. (1969) *The Twisting Lane: Some Sex Offenders*. London: Hutchinson.

Parker, T. (1970) *The Frying-Pan: A Prison and its Prisoners.* London: Hutchinson.

Pitts, J. (1990) *Working with Young Offenders.* Basingstoke: Macmillan.

Plotnikoff, J. (1986) *Prison Rules – A Working Guide.* London: Prison Reform Trust.

Pointing, J. (ed) (1986) *Alternatives to Custody.* Oxford: Blackwell.

Prison Reform Trust (1990) *Sex Offenders in Prison.* London: Prison Reform Trust.

Raynor, P. (1988) *Probation as an Alternative to Custody.* Aldershot: Avebury.

Raynor, P., Smith, D. and Vanstone, M. (1994) *Effective Probation Practice.* London: BASW/Macmillan.

Redl, F. and Wineman, D. (1951) *Children Who Hate.* New York: Macmillan Publishing Company Inc.

Richards, J. (1988) *In for Life.* Chichester: New Wine Press.

Rutherford, A. (1986) *Growing out of Crime.* Harmondsworth: Penguin.

Rutherford, A. (1986) *Prisons and the Process of Justice.* Oxford: Oxford University Press.

Sapsford, R. (1983) *Life Sentence Prisoners.* Milton Keynes: Open University Press.

Scraton, P. (1991) *Prisons under Protest.* Milton Keynes: Open University Press.

Smart, F., ed. Brown, B.C. (1970) *Neurosis and Crime.* London: Duckworth.

Soothill, K. and Walby, S. (1991) *Sex Crime in the News.* London: Routledge.

Staplehurst, A. (1987) *Working with Young Afro-Caribbean Offenders.* Norwich: School of Social Work, University of East Anglia.

Steen, C. and Monnette, B. (1989) *Treating Adolescent Sex Offenders in the Community.* Springfield, Illinois: C.C. Thomas.

Stern, V. (1987) *Bricks of Shame.* Harmondsworth: Penguin.

Walker, H. and Beaumont, B. (eds) (1985) *Working with Offenders.* Basingstoke: Macmillan.

Welldon, E.V. (1991) *Mother, Madonna, Whore: The Idealization and Denigration of Motherhood.* London: Free Association Books.

West, D.J. (1987) *Sexual Crimes and Confrontations.* Aldershot: Gower.

Winnicott, D.W., ed Winnicott, C. (1984) *Deprivation and Delinquency.* London: Tavistock.

Winnicott, D.W. (1986) *Home is Where We Start From.* Harmondsworth: Penguin.

Worrall, A. (1990) *Offending Women.* London: Routledge.

Biographical Details

Lynn Aulich works half-time as an art therapist for the Adolescent Forensic Mental Health Service, based at the Gardener Unit, Prestwich Hospital, Manchester. She is also one of the four artists known as 'Those Environmental Artists' (TEA) making large-scale temporary public art works.

Celia Baillie trained as a painter, taught infants and then trained as an art therapist at St Albans. She now works with young people with severe learning difficulties.

Pip Cronin studied metal and ceramics before training as an art therapist while working in the education department at Holloway Prison, London. She now has joint responsibility for the Holloway Art Therapy Project, a two-year evaluation of art therapy in the prison. She has also run groups for adolescents with eating disorders.

Shân Edwards was born in London in 1952, and studied art at the Central School, London. She has been involved in exhibitions with Women in Art for Change, the Feminist Arts News Collective and the Artemesia Group. She started teaching in 1984 and qualified as an art therapist in 1991. She is married with three children.

Maralynn M. Hagood, MSc, RATh, MFCC, ATR worked with sexually abused children for seven years, and taught art therapy at California State University. Since moving to the UK in 1989, she has trained professionals working with sexual abuse and taught art therapy at Edinburgh University. She is currently investigating artwork of sexually abused children, and is also writing two art therapy books.

Barbara Karban was born in Vienna, Austria, and studied at the Academy for Applied Arts. She worked as a freelance illustrator in New York and London before training as an art therapist at St Albans. She works at Three Bridges Regional Secure Unit, Ealing Hospital, London. She is a qualified T'ai Chi teacher and a practising artist.

Marian Liebmann is a qualified teacher, art therapist and probation officer. She has worked in the field of criminal justice for many years, at a probation day centre, with victims of crime, in a probation field team and in mediation. She is the author of *Art Therapy for Groups* and editor of *Art Therapy in Practice*.

Barry Mackie was born in 1946 and grew up in Zimbabwe. He worked as a teacher, textile designer and printer in South Africa, Europe and England. He studied art therapy at Goldsmiths' College in 1982, then worked in various settings, mostly in the Probation Service. Currently he lives in London, working as a groupworker, gardener, DIYer, and artworker, and has been known to take in washing.

Eileen McCourt works as an art therapist for the Probation Board for Northern Ireland. A probation officer since 1975, she trained as an art therapist at St Albans School of Art and Design in 1986–87. She works both in prison and in the community establishing and developing art therapy on a group and individual basis.

Julie Murphy moved from Northern Ireland in 1977 to study at Edinburgh College of Art and the University of Edinburgh. She spent six years working for the National Galleries of Scotland before completing the Diploma in Art Therapy at the University of Sheffield in 1990. Her work experience has included working with disturbed children and people with learning difficulties. She is currently working at HMP Perth and the Murray Royal Psychiatric Hospital, also in Perth.

Colin Riches pioneered the Art and Craft Centre in HMP Albany and researched its role, gaining an MA with distinction at the Royal College of Art. He is a Churchill Fellow and has received a National Art Collections Fund Award. He is a member of the Prison Department's working party on arts in prisons.

Adrian West trained as a clinical psychologist at the Warneford Hospital, Oxford. He worked at Broadmoor Hospital for four years. He now has a split post as Principal Clinical Psychologist at Ashworth Hospital and Edenfield Centre, Prestwich Hospital, Manchester.

Index